TOTAL CHAOS

THE STORY OF THE STOOGES / AS TOLD BY IGGY POP

(UPDATED AND REVISED)

JEFF GOLD

EDITED BY JON SAVAGE

TABLE OF CONTENTS

Introduction . 5

1. Before the Beginning . 11
2. The Psychedelic Stooges . 33
3. Elektra Comes to Detroit . 70
4. The Stooges . 90
5. Hit The Road . 119
6. Fun House . 143
7. On the Road Again . 165
8. Williamson In, Elektra Out . 201
9. Bowie and London Calling . 233
10. Raw Power . 250
11. Death Trip . 275
12. The End (Again) . 291
13. David Bowie's Drainpipe . 301
14. The Reformation . 307

Essays . 320
 • What Does It Mean to be Iggy Pop by Johnny Marr . 321
 • Josh Homme on The Stooges . 322
 • Dave Grohl on The Stooges . 327
 • Joan Jett on The Stooges . 332
 • About *Fun House* by Jack White . 336
 • How Michigan is the Fifth Member of the Stooges – OR – A Cultural Cycling
 Through Three-Hundred Years of Bullshit Historical Anecdotes and Arbitrary Facts
 to Argue that Geographic Demarcation Can Be Personified as the Embodiment
 of a Musician by Ben Blackwell . 337
 • Stooges 1974 - 1977: Flesh Becomes Myth by Johan Kugelberg 341
 • The Flesh Machine: Surveying the Indubitable Style of Iggy Pop by Jon Savage 345

15. Past to Present: Henry Rollins and Jeff Gold Explore Why We're Still Talking
About the Stooges . 350

Bibliography . 368
Credits . 369
Acknowledgements . 370
Biography . 371

INTRODUCTION

Total Chaos is the title of this book and a perfect description of the first Stooges show I saw. It was June 1973 at the Whisky-A-Go-Go in Hollywood. I knew almost nothing about The Stooges, but was a huge David Bowie fan. So, when I heard Bowie was involved with them— he found The Stooges management, a record deal, and mixed their album *Raw Power*—that was good enough for me.

I remember it being very short. Iggy was the focus of the audience's attention. Bare except for a pair of blue bikini panties, he seemed very spaced-out, and eventually threaded the microphone stand inside his underwear, humping it while singing a song I didn't recognize about "buttfuckers in Hollywood." He began falling down and the guitarist helped him offstage. That half hour mesmerized me.

The next time I saw The Stooges could not have been more different. It was April 2003, at the Coachella Valley Music and Arts Festival. The band hadn't played together in 29 years, and instead of the 400 people at the Whisky, they were headliners at the most important rock festival in the United States, playing to a crowd of 30,000. As Jay Babcock wrote in an *L.A. Weekly* review titled "Miracle in the Desert," "in front of an audience of what seemed like every record-collectin' geek within 7,000 miles plus thousands of curious younglings, [Iggy] did something absolutely miraculous: He didn't just turn back the hands of time—he cut them clean off, pissed on them and then danced on the fuckers in an elemental, primordial, impossible performance of pure shamanic will." It was unfathomable. Iggy Pop, Ron Asheton, and Scott Asheton (with Mike Watt on bass)—the core of The Stooges—back on stage together. A band that split up nearly 30 years earlier to almost total indifference, left disillusioned, drug addicted, and broke. And here they were, thanks to the power of an ever-growing myth, reincarnated as conquering heroes. And they were fantastic.

Of course, a lot had transpired between my two Stooges gigs: the Asheton brothers had played in numerous groups, James Williamson had left the music business for a career in high tech, and Iggy had enjoyed a successful solo career (I had the good fortune to have seen him perform many times). Still, it was almost surreal when Iggy signed to the label I worked for, A&M Records, in 1986. I oversaw the marketing and creative services departments, and soon, I was working with Iggy on the launch of his solo album *Blah Blah Blah*.

Though many artists aren't involved in the marketing of their records, it was immediately clear Iggy had a lot to contribute. In addition to being very together, he had an excellent understanding of what worked for him career-wise. So, I asked him to write his own ads for the album, which we printed in his own handwriting. He had very strong ideas for the record's videos. I'll always remember our only testy moment, which happened during the editing of his "Cry For Love" video. I suggested that he didn't look good in a particular shot and that we should take it out. He quickly shot down that suggestion—it had been a long night—saying something to the effect that I was just a record executive, not really a fan of his. I told him in 1973 I had paid $2.50 to see him sing about buttfuckers for half an hour until he finally fell down. He immediately turned to the editor and said, "take out the shot!"

We continued working together and he continued to surprise me. For the "Cold Metal" video from his next album *Instinct*, Iggy had me track down the largely unknown Sam Raimi, direc-

tor of an ultra-low budget horror film I'd never heard of called *The Evil Dead*. Of course Raimi went on to direct the first three Spider-Man movies, which grossed nearly 2.5 billion dollars. Iggy always had his finger on the pulse. Eventually Iggy left A&M for Virgin and I for Warner Bros. And while he continued performing throughout the years, I left the record business for life as a music historian/music memorabilia collector/dealer. But I always remained a fan.

A few days before that amazing Coachella show I had lunch with my old friend and Iggy's long-time manager, the late great Art Collins. I'd amassed a large Stooges collection, and brought some of the highlights to show him. Many of the most interesting things came from Danny Fields, who signed the band to Elektra and later managed them. Art was particularly interested in getting copies of the Elektra and Columbia Records contracts, and of course I obliged.

I went to the show with my friend Johan Kugelberg. He, too, had a large Stooges collection, some of which you'll see in the pages that follow. Backstage after the band's triumph, I said hello to Iggy for the first time in years. (I remember Jack White and countless others congratulating the band.) We knew after a show like that, The Stooges would receive many offers to play more shows. They did. The Stooges had been reborn better than ever.

In 2012 I did my first book, *101 Essential Rock Records: The Golden Age of Vinyl* (which included *Fun House* and *Raw Power*). Iggy contributed a great essay on two albums that were influential to him, The Mothers of Invention's *Freak Out* and Them's *The Angry Young Them*. The book did well, and Johan and I began discussing doing a pictorial book of our merged Stooges archives. One night the idea came to me. Pick 100 artifacts from our collections that told the story of The Stooges, show them to Iggy, and record his recollections, creating a visual and oral history of the band from Iggy's perspective. Johan liked the idea, so we pitched it to Iggy, who quickly said yes. And so in March of 2014, Johan and I traveled to Miami to interview Iggy. We had 100 large printouts of the things we'd chosen, and I'd put together 21 pages of questions.

Like the Stooges reunion, we weren't prepared for what we got. Iggy met us at his unpretentious, normal looking house—at least from the outside—with a large yard that backed up to a creek. He gave us a tour, showing us the extremely eclectic interior—just what you'd expect from him—including a self-portrait he'd painted on an old door, photos and posters from throughout his career, Haitian steel artworks made from recycled oil drums, and a life-sized stuffed cloth sculpture of a woman sitting on a couch.

Then we adjourned to a table and chairs outside by the creek for two of the most entertaining afternoons I've ever had. I knew Iggy was gracious, charming, funny as can be, and very smart. But of all the musicians I've worked with, I've never met anyone with the memory and career perspective of Iggy. In the interviews, he held nothing back. The photographs, documents, and posters were clearly bringing back for him the many highs and lows of The Stooges. As he said about original band members, Ron and Scott Asheton and Dave Alexander, "These guys were the closest I've ever had to having what are traditionally called friendships in my life." After the first day, it was clear Iggy was writing the book for us.

But it was a different book. We had more than just his reaction to the visuals we had brought. We were getting a full history of The Stooges from Iggy's unique perspective. And so the concept grew.

There have been a number of excellent books about The Stooges and Iggy, almost all done with limited participation from the man himself. This one is different. This is the story of The Stooges as told by Iggy Pop. Of course Ron and Scott Asheton, Dave Alexander and James

Williamson made invaluable contributions, but as you'll see in the pages that follow, Iggy was the one who willed The Stooges into existence and somehow kept them alive in the face of disaster, again and again, against implacable odds. Iggy Pop was the only member of The Stooges to be on stage for every single show the band played. Well, all but one.*

This isn't meant to be a scholarly dissection of The Stooges, nor an attempt to document their Rashomon-like existence. Our goal is to celebrate this most extraordinary group, who made three superb albums, were pioneers in sound, look, and live presentation, and along the way invented a genre—punk rock—and influenced countless others that followed. Then arose like a Phoenix from the ashes, recording two new albums and playing sold out shows around the world.

There was no precedent in rock music for what they did. They are definitely the only group in the Rock and Roll Hall of Fame who started out playing, literally, an amplified Waring blender, a vacuum cleaner, spring water bottles and a 200 gallon oil drum.

I'd like to thank my partners at Third Man, especially Chet Weise and Ben Blackwell, and Johan Kugelberg, Jon Savage, and those—Dave Grohl, Josh Homme, Joan Jett, Johnny Marr, and Jack White—who contributed.

Thanks to Henry Rollins for your insights.

And of course, profound gratitude to Iggy Pop for making this book possible, and for the music that so inspired everyone involved with this project.

—Jeff Gold

* Iggy sang during every Stooges show but one. On July 25, 1971 the band was contracted to play Wamplers Lake Pavilion in Irish Hills, Michigan, but they'd already broken up (for the first time). Iggy and James Williamson didn't want to play the show, so Ron and Scott Asheton and bassist Jimmy Recca went. They asked if anyone in the audience wanted to sing and a local fan who knew all their songs, Steve Richards, volunteered. Iggy told us, "there's a recording of it. 'What You Gonna Do?' That's him. I used to hear it and thought, 'I don't remember. I was pretty good! I don't remember,' and then I realized that was the guy."

For Jody, Cleo and Ella, who know why.

TOTAL CHAOS: The Story of The Stooges / As Told By Iggy Pop (Updated and Revised) © 2022 by Jeff Gold.

Third Man Books, LLC, 623 7th Ave S, Nashville, Tennessee 37203.

Art Direction & Design by Nathanio Strimpopulos
Layout by Amin Qutteineh

Printed in the U.S.A.

ISBN 978-1-73-73829-2-8

IF I DIDN'T MAKE A COMPLETE BREAK WITH THE MUSIC THAT WAS GOING ON, I WASN'T GONNA EVER MAKE IT AS A MUSICIAN. SO WE HAD TO STOP WHAT WAS GOING ON AND MAKE UP SOMETHING NEW. AND THE ANSWER IS IT WAS DONE WITH DRUGS, ATTITUDE, YOUTH, AND A RECORD COLLECTION.

—IGGY POP

Unganos, New York City, August 1970.
Photographed by Dustin Pittman.

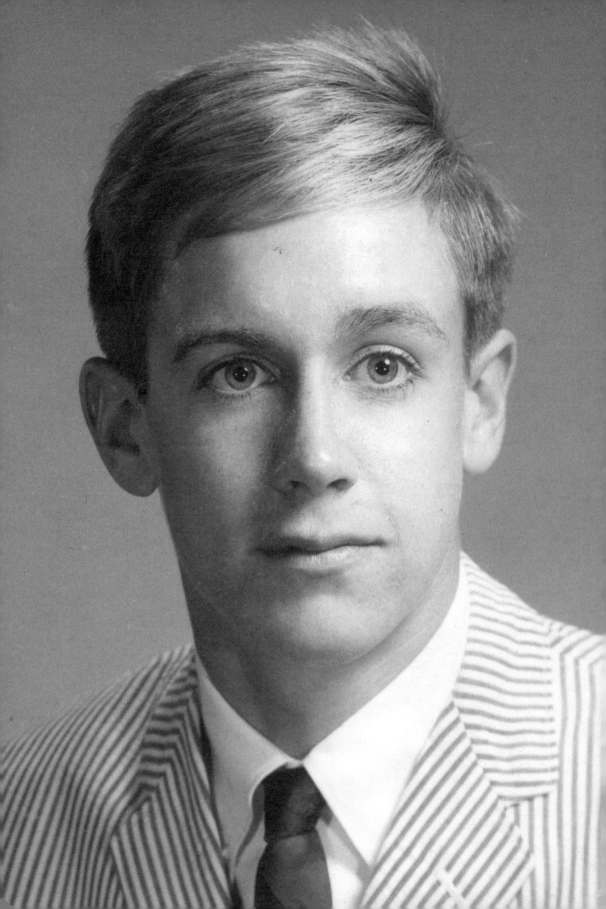

Debate team first at Flint Northern.

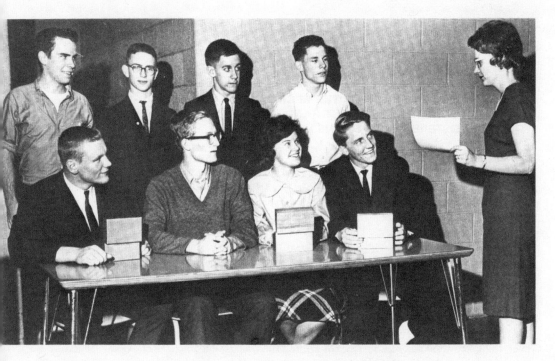

Row one: Skip Odell, Jamie Harris, Jill Wescott, James Carpenter. *Row two*: Bruce Walker, Ruven Brooks, Jim Osterberg, Bruce Charnov. *Advisor*: Mrs. Ann Eppinga.

The topic for the 1963-64 season was: Resolved that the Federal Government should provide essential medical care for all citizens at public expense. Jamie Harris, Dean of Debate, received the third year varsity award, the gold debate pin. Jill Wescott, secretary of debate, Ruven Brooks, Jim Osterberg, and Bruce Charnov, public relations director, received the second year varsity award, the silver debate pin. Skip Odell, Dick Heady, and James Carpenter received the first year varsity award, the bronze debate pin. This year's team took first place at the Flint Northern Invitational Debate Tournament and tied for first at the Easern Michigan and Western Michigan Debate Tournaments. The debate coach was Mrs. Ann Eppinga.

Left: James Newell Osterberg Jr. from the 1965 Ann Arbor High School yearbook. Don Swickerath Collection.
Above: Above: In 1964, Ann Arbor High debate team member, Jim Osterberg, was awarded the silver debate pin.

JEFF GOLD: SO LET'S START AT THE BEGINNING OF YOUR MUSICAL CAREER. HERE'S A PICTURE OF YOUR FIRST BAND, THE IGUANAS, IN 1964 WITH YOU, YOUNG JIM OSTERBERG ON DRUMS.

IGGY POP: That is middle period Iguanas when we were in high school (in Ann Arbor, Michigan). We had formed and done just a few shows. This man, Sam Swisher, was the scion of a very established family real estate company in Ann Arbor, and he's now a big realtor himself. Swisher Realty. He had business sense and connections. And through his father, we met some people at the local AF of M (American Federation of Musicians). We met a local booking agent who could get us frat gigs. They told us we had to get our picture taken to have a glossy photo. So what you see here is the band's glossy photo that we would hand out everywhere. It was taken at a professional photography shop. They would also do wedding pictures, graduation, stuff like that. And it was on Liberty Street just down the corner from Liberty and State where I later worked at Discount Records and all that, right in the campus. This is Nick Kolokithas, who was a first generation Greek-American, whose parents were immigrants. I'd go over to work on songs with him. They had the kind of home like the first Persians in LA used to have. You'd go in, y'know, everything is still and dark and quiet. All the furniture is new. Everything's covered and plastic everywhere, and there's lots of tchotchkes and flounces and that sort of thing. And they could not do enough for their boy, so he had a car. He had a guitar. He had an amp. He had all that stuff before anybody. I mean you know.

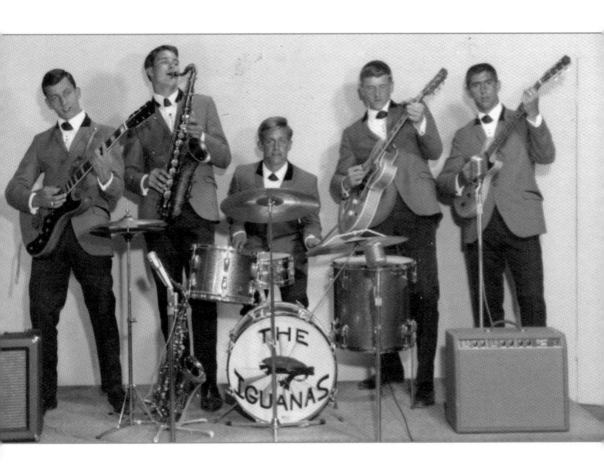

Above: The Iguanas second lineup with (L-R) Nick Kolokithas (guitar), Sam Swisher (sax), Jim Osterberg (drums), Jim McLaughlin (guitar), and Don Swickerath (bass). Don Swickerath collection.

This boy, Jim McLaughlin, was the son of a ham radio and stereo enthusiast, and his father bought him a guitar so that he could play things through his father's system. Luckily for me, he lived directly across the street in a nice, middle class, wonderful American family neighborhood on Shadford Drive near Tappan Junior High (in Ann Arbor). And I met him in junior high and he lived right across from Sam. So the group started when he and I formed a duo. I would go over to his house and I thought, "Wow, I should get a set of drums!" I had been playing on a single drum. The school music had been introduced in the boonies where I lived, in an unincorporated district, only when I was in fifth grade, and the only cool instrument they had for me was the drums. And they'd bussed me somewhere to learn the drums, so I bought a set, and I would go to his house. And we practiced playing "What'd I Say" by Ray Charles and something called "Let There Be Drums" by Sandy Nelson, which was my idea because it was a drum solo, right? And we played in the ninth grade talent show... The Megaton Two. I named it. I've always been into naming stuff. And immediately, y'know, I took a level up socially in my encounters in the hallways [laughs]. Yeah, the chicks were a little nicer and the guys were—"Hey, that was pretty cool, Osterberg." So this guy played the sax. Swisher. Played an alto usually. Better than a tenor. And he already knew songs like, "Perfidia," "Blue Moon," "Summertime," stuff like that. And little by little, we enlisted him. It was the three of us and we learned some of those, and then we went from there to getting the other two in and starting to learn rock songs. And we would always practice from that time on in the basement, Swisher's basement, because he had the biggest house and he was more or less the manager for the group.

And then, this guy is a nice, nice person, sweet as pie, wonderful guy named Don Swickerath. He lived directly across from Ann Arbor High School, which is where we were all in high school: Catholic boy, doting mother, working class Catholic people, just a real nice guy. And we played gigs, and made very decent money that went up and up for kids in those days. A typical good weekend for us by the time I was a late junior or senior in high school, during when school was in, would be we'd play Friday afternoon at what they called the TGIF (Thank God It's Friday). It'd be a keg of beer, a bunch of fraternity guys, four in the afternoon, one of the guys madly pumping the thing to get past the foam 'cause it's a few sorority girls hanging around like, "What? Is this the party?" Right? And we'd play for two hours and a standard rate was about eighty bucks. We had no living expenses. We lived at home. And no upkeep for anything, you know.

And basically we'd do that in the afternoon. Then we'd take a break, and we'd go take the stuff to another fraternity house for an evening party. Friday night was worth usually a hundred to a hundred and twenty-five, and then you'd play Saturday night. That was like usually a hundred-fifty. And that was every weekend when things were going well, and so all of the sudden I was..."Hey, I bought a car." And finally we did for the senior prom or graduation or something. We played at our school for some sort of a dance or something. And y'know by this time I was thinking, "Well, what could we do to really, y'know," and I decided I needed a drum riser.

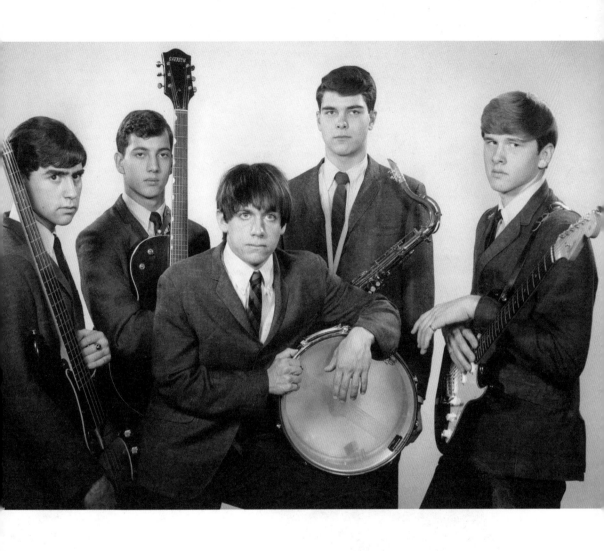

Above: The Iguanas ditch their matching uniforms and short hair; Jim Osterberg center, 1965. Don Swickerath collection.

Senior Talent

The Senior Talent Show for '65 was composed of eleven acts and the grand finale. The first act announced by Master of Ceremonies Rick Hodges, who was assisted by Hyacinth, was The Iguanas, who also played before and after the assembly. The successive acts were: The Senior Chorus Line, The New Nose Pickers, Barbara DeHart, The Hungry Five German Band, Dennis Polk, The Saxons, The Spiritual Singers, TW3-1+Y, Jim Wilson and The Entertainers, and The Swabs. The show ended, as wild as it began, with everyone on stage for the Grand Finale.

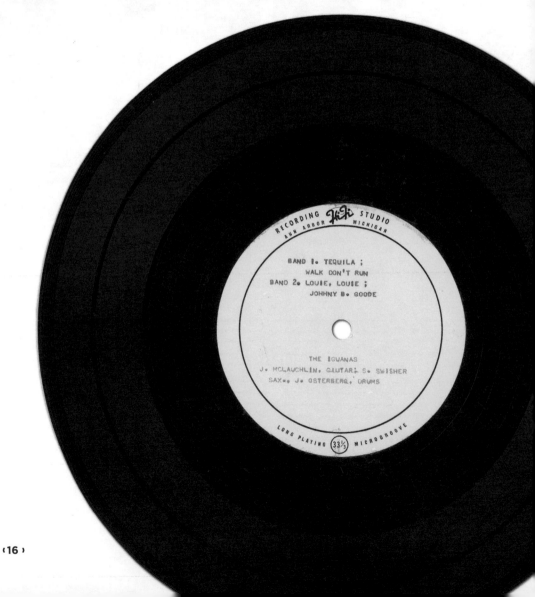

RECORDING STUDIO
ANN ARBOR MICHIGAN

BAND 1. TEQUILA ;
WALK DON'T RUN
BAND 2. LOUIE, LOUIE ;
JOHNNY B. GOODE

THE IGUANAS
J. MCLAUCHLIN, GUITAR; S. SWISHER
SAX., J. OSTERBERG, DRUMS

LONG PLAYING 33⅓ MICROGROOVE

J: DID YOU ALWAYS USE A HIGH DRUM RISER LIKE IN THAT PICTURE?

I: When you pounded the drums, that thing was shaking, but I didn't fall off. It was ridiculous. And then that summer, Swisher had connections, got us a gig at this teen club, which was in Harbor Springs (Northern Michigan), which is where the DuPonts had a place. Y'know big American money had summer homes along there south of Traverse City. Michael Moore now has a place there. So beautiful little town, and when the kids wanted to slum, they could come see us at this place called the Ponytail. And the guy was a hard-bitten old grumpy American bar owner type of guy named Douglas, and I remember right away he took a disliking to me because he thought I was a spoiled rich kid 'cause my parents made me rich without money. They drove me to and from my drum lessons. When I was learning to play, that entire kit took up the entire living room of our home, and I monopolized it all day every weekend. And they never said boo.

Top Left: The Iguanas on stage at the 1965 Pioneer High Senior Talent Show with the "ridiculous" drum riser. **Bottom Left:** A probably unique 10" acetate record featuring the first recordings of the future Iggy Pop. His band, the Iguanas, featured Jim Osterberg on drums, Jim McLaughlin on guitar, and Sam Swisher on saxophone. Recorded in 1963 in the home studio of Jim McLaughlin's father. Jeff Gold collection.

J: AND THOSE STORIES ABOUT YOU PLAYING PICKUP DRUMS FOR MOTOWN ACTS AND STUFF IN MICHIGAN...

I: Yeah when they would come through at Club Ponytail in Harbor Springs and in Ann Arbor at the Armory, I was generally the guy to call, so I played one-offs behind the Crystals, the Shangri-Las, the Four Tops, and the Contours.

J: AND WERE THEY JUST USING A DETROIT PICKUP BAND OR AN ANN ARBOR PICKUP BAND?

I: Yeah, well what they'd usually do, the Shangri-Las and the Crystals each had a guitarist who comes and then you and the bass player follow him. The Contours might'a had a couple guys. And the Four Tops, I can't remember, but they definitely had to have somebody 'cause those songs were sophisticated. But I was as close to Abdul Fakir's butt as I am to you right now, and what they were doing, they were doing the footwork, and he was the big guy that held it all together, and I was watching. The Crystals once said, "Hey, he looks like Phil [Spector]! Doesn't he look like Phil? Yeah, he looks like Phil." And then they'd laugh.

Right: The "fabulous" Iguanas opened for the Four Tops and the Shangri-Las in the same week at Club Ponytail in Harbor Springs. The club claimed the, "Largest Patio in Northern Michigan." Don Swickerath collection.

Club Ponytail

Teen & Collegiate Nite Club Harbor Springs

PRESENTS

The SHANGRI-LAS

Leader of
The Pack

Give Him A
Great Big Kiss

Give Us
Your Blessing

To Don
Best Wishes Always,
The Shangri-Jo
Mary Ann

ADMISSION $2.00

Plus THE FABULOUS IGUANAS

OPEN 7 NIGHTS
LARGEST PATIO IN NORTHERN MICHIGAN
Dance Under The Stars
Casual Dress Continuous Entertainment 8:00 p.m. — 1:00 a.m.

TUESDAY, AUGUST 10th

J: YOU WERE LIVING WITH YOUR PARENTS IN A MOBILE HOME THEN, RIGHT?

I: Yes. Finally, to compromise, they evacuated the master bedroom. Put my drums in that, I had the master bedroom, and they were sleeping in the kids' room. Father loaned me the money for the damn kit, etc., etc., etc. They taught me respect, and they had both been through rough upbringings. They were both people whose lives were destroyed by other people who were unfaithful and insolvent. In my father's case, the story was a woman booked passage, an English woman booked passage to the US, and had some sort of a fling with a sailor who split when he found out she was pregnant. She died in childbirth in Chicago, and one of the nurses in the area knew about it, and later adopted my dad. Her name was Ada Osterberg. She was a crazy old Swedish hippie, an avant hippie. I met her later. I loved her. She had braids and knee socks and she was one of those European kind of arty chicks. A little bit like the Serbian performance artist, Marina Abramovic. Because she was a registered nurse, she could adopt. She always had a job. She was single 'til the end of her life. The Depression hit, and she couldn't afford to keep her place in Chicago, so she took my father and they moved to a little cabin that had been their summer retreat in the Michigan woods. My mother was from a first generation Scandinavian hook-up.

JOHAN KUGELBERG: WHAT WAS HER MAIDEN NAME?

I: Christensen. The father was Harold Christensen from Copenhagen area. He was a cadet in the Danish Navy. I don't think he ever joined the Navy full on, but he might've done some merchant marine. But I have a picture of him as a cadet. And he married a girl from Oslo. And they emigrated to Chicago. He worked as a commercial fisherman on the Great Lakes and parlayed that with loans into a restaurant and a deli. And they lived in a nice section of Palatine which is a suburb going north west. And then the Depression wiped him out. He had an alcohol habit too, and liked other girls. And what they did those days was - I had an aunt, that not until my mom passed away did my dad let me know that my aunt was an illegitimate half-sister - and what they'd do at the time was you'd bring them in. And she'd had a troubled life. But my mother's family also lost everything in Chicago and had to move to their summer home in Michigan, and the two summer homes were adjacent. And that's how they met in the woods near Muskegon.

J: SO BACK TO THE IGUANAS. YOU MADE A RECORD, DIDN'T YOU?

I: The Iguanas made this record at United Sound in Detroit. We pressed up our own copies. Again, Swisher knew that some publishing existed, which is more than we knew. We decided we were going to get more professional equipment but at a discount, so we made a trip, all of us together in a van, to Midtown in New York City, and we went to the Brill building. And we met an old guy...It was just like Sam Spade's old office [1] except it said Arc Music. And we said, "We're a high school band..."

J: ARC MUSIC WAS CHESS RECORDS' PUBLISHING COMPANY...

I: Yeah, yeah. Bo Diddley, Chuck Berry. "...We wanna put out this record and we don't know what sort of..." He looked and he said, "Gimme two-hundred bucks." So something like that that we just gave him some money. "Get outta here. Don't worry about it." And then we went across the street over to Manny's (a famous musical instrument store) and then we went home. And we put these out and some of them have my song, "Again and Again," on the flip-side, I think. Maybe not?

J: NO, IT'S "I DON'T KNOW WHY." ACCORDING TO JIM MCLAUGHLIN, IT WAS GOING TO BE THE B-SIDE OF THE SECOND PRESSING, BUT YOU LEFT THE BAND BEFORE IT HAPPENED.

I: I was pushing for it, but they were like, "No, no. We need a nice song." I gotta get out of this group.

1) Dashiell Hammett's fictional detective in *The Maltese Falcon*, memorably filmed in 1941 by John Huston with Humphrey Bogart, Mary Astor and Peter Lorre in the starring roles. The Brill Building still stands at 1619 Broadway on 49th Street, New York.

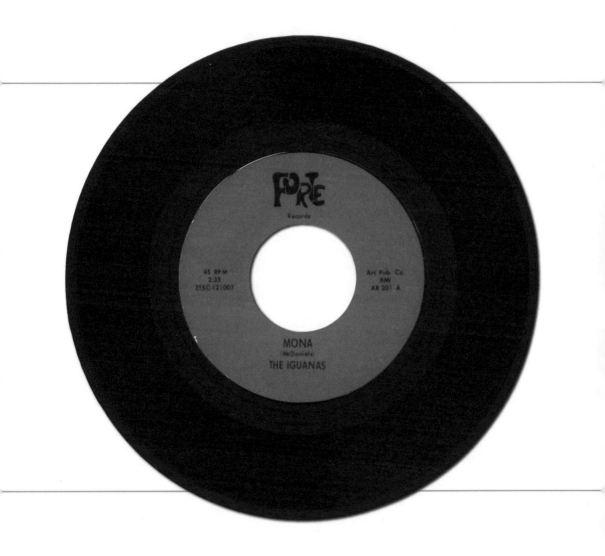

Above: In 1965, The Iguanas self-released their single, a cover of Bo Diddley's "Mona," backed with "I Don't Know Why" on Forte Records. Jeff Gold collection.

J: SO THEN YOU LEAVE THE IGUANAS AND THEN JOIN THE PRIME MOVERS.

I: Prime Movers here. We're Prime Movers. This is an older group of guys. Michael Erlewine [vocals, harmonica], who founded and still runs AllMusic.com. That's me on drums, his brother Danny [guitar] is a top luthier working out of Austin, the wonderful Robert Sheff on keyboards, who now has the artistic career as "Blue" Gene Tyranny. Puts out very, very nice music which you can get on the internet.

J: HE WAS IN THE STOOGES FOR A SECOND.

I: Yes, he was 'cause I always admired and loved him, and he's a very intelligent keyboard player. And that's me, and that must be Jack. That's Jack Dawson [bass] kneeling down. I love the little girls watching. This is also taken on State Street, Ann Arbor just off the corner of East Liberty Street.

Top Right: The Prime Movers, with "Iggy" Osterberg on drums. Iggy and guitarist Dan Erlewine lived in a building next to this lot on Ann Arbor's State Street, sharing the abandoned ladies' powder room of a French restaurant. Photo: Andy Sacks. **Bottom Right:** The band with a nun on the University of Michigan campus. Iggy in white suit. Photo: Andy Sacks.

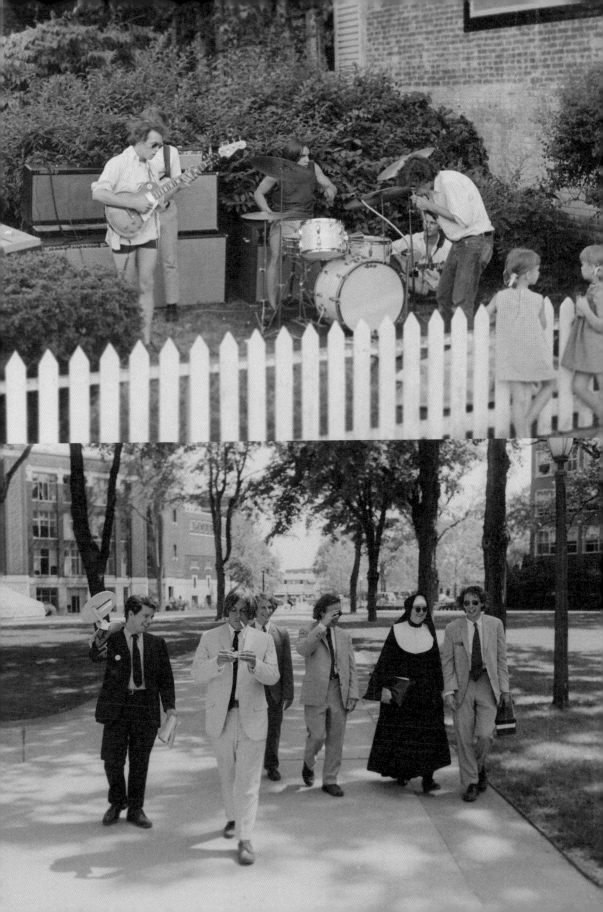

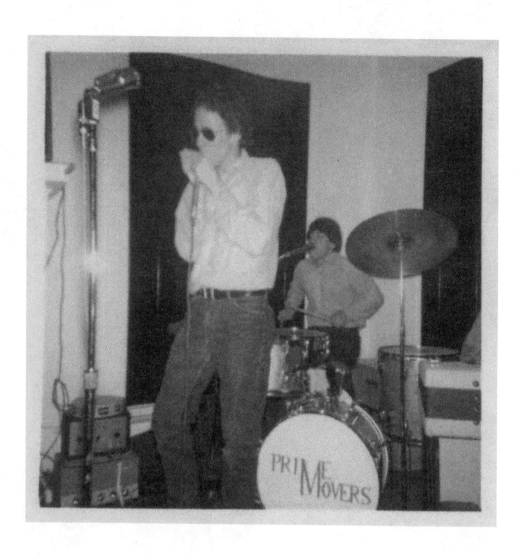

Above: Mike Erlewine and Iggy Osterberg. Michael Erlewine collection.

J: DID YOU LIVE IN THE PRIME MOVERS' HOUSE—YOU REFERENCED IT AT SOME POINT.

I: I had two residences as a Prime Mover, but no I never lived in the house. My residences as a Prime Mover were just like—remember that guy Navin in *The Jerk*? Steve Martin. Did you ever see *The Jerk*?

J: NO...

I: Well, in *The Jerk* Steve Martin gets a job at a gas station and the guys says, "I won't pay you any money but you can live here in the john," [laughs] and he's going, "This is great! I'll put in some curtains and there will be like, there's a flow and feng shui." So basically, I was living over a French restaurant called Vieux Carré in what had been their lady's powder room upstairs that had been abandoned. It had a large area to powder your nose and relax, and a smaller area with three bathroom stalls. And it was right next to the little yard where you see the picture of me playing with the Prime Movers. It was the building next to that yard, Herb David, who was a luthier, and the guy who had the only serious music store in Ann Arbor, had rented out the whole second floor and he had his guitar store up there, his music store, and he had this extra space so he rented it to Dan Erlewine and me, and we got a little piece of picket fence, just like the picket fence in that little picture, and we put a little piece of picket fence down the middle of the powder room and the left was my part and the right was his part and then we had our pick of the bathroom stalls. And that's how we lived and that was on State Street, which was about four blocks over to the Prime Movers' house. And there was a room on the very top of that house, up like three or four floors, steep I would say probably third floor and it was an attic room and that's where we rehearsed. And my drums were kept there, so I would go over there every day and just play and play and play. And try to work out what I was doing and I had access to the kitchen in the house. At that time and all my life, my big advantage in my career—considering that I'm not Aretha Franklin or Sammy Davis—is that I'm entirely portable, and it's not only on stage that I'm completely ready to do anything. I'll do anything. I just don't even think about it. Day and night during those months I lived on only peanut butter and jelly on white bread. I would go to the band house. Mike Erlewine had much nicer digs, y'know. He kept all the money, and I'd go there, eat PB&J, and practice all day. I never had any money, I never thought about it 'til later.

J: YEAH YOU GUYS HAD SOME SUCCESS.

I: Well yeah, and so he had a van and he would drive the van and it was fine, but I never lived there. Mike Erlewine lived there, Bob Sheff lived there sometimes.

J: AND YOU GUYS WERE A SUBSTANTIAL DRAW LIVE, RIGHT?

I: We were getting known. We were getting up there, yeah. We were playing imitations of Chicago blues and it wasn't bad at all, and so we were a good bar and university band. And once in a while after I got in the band, we started having a little teen appeal, and we would actually get hired at teen-type dances. But that never went too far.

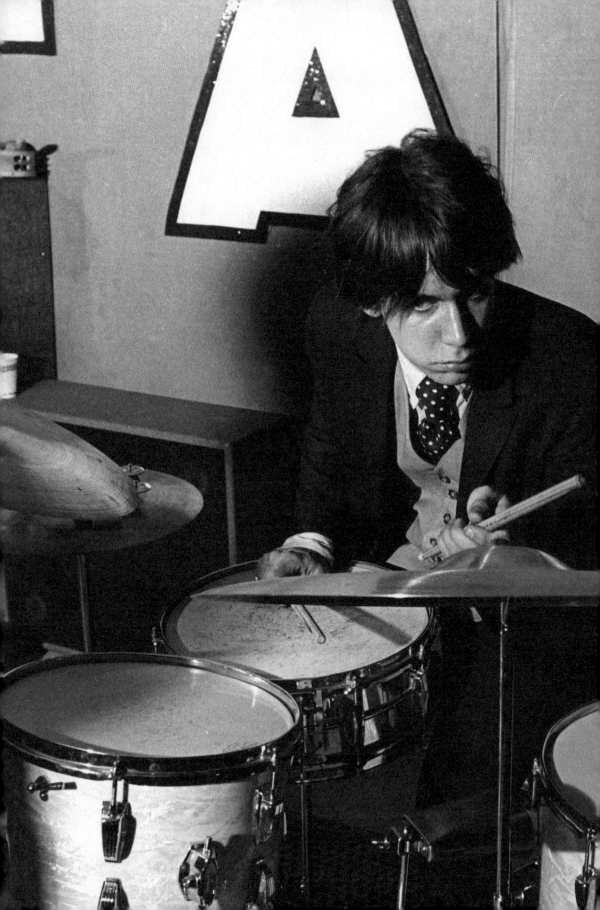

Iggy in his thrift store suit, pounding the skins at a WTAC Radio, Flint Michigan dance party. Photo: Andy Sacks.

J: AT THIS POINT, ARE YOU STARTING TO STAND OUT AS A PERSONALITY IN THE BAND?

I: Yeah, I'm afraid so, and I sorta blocked that out 'til other people remind me. The Prime Movers at one point, we played a gig and I decided I wanted to appear. I wanted to slide down the rope with a Superman cape on. Things like that. You've probably heard the record I sing, "I'm a Man," as "I'm a Wheelbarrow." Yeah, a little bit. And the clothing! The suit I wore in that other photo was from a thrift store, and I wanted to look like Charlie Watts. I'd see those Savile Rowe suits, and I didn't know what Savile Row was so I went to these thrifts shops...

J: AND HOW ABOUT THIS PHOTO?

I: That's Jack Dawson, who replaced [future Stooges guitarist] Ron Asheton's brief stay in the Prime Movers, and Jack was very sensible, the only true full-time university student that was ever in the band, and may have been a music major. He was extremely good, but I though he was kinda not really very bluesy. A very quiet, nice guy. And this may have been a mandated style choice 'cause the guys had these Garrison belts. The two Erlewine brothers.

J: AND DURING THIS TIME YOU MADE A PILGRIMAGE TO CHICAGO...

I: When I was in the Prime Movers, Mike Bloomfield and Paul Butterfield[2] came through a Detroit coffee house. We went to play for them to see if they could help us get connected. [Legendary blues drummer] Sam Lay had been replaced in the group at that time: he was playing with James Cotton. And I said to Bloomfield, "I would really like to go to Chicago and meet Sam," so Bloomfield gave me his address. So I went to Chicago with my drums, and I had this address, and I ended up deep in the West side, and it looked exactly like...I've been to Mombasa since. It looked like Mombasa! I loved it!

I didn't know places that beautiful existed. Pink, blue, yellow, braids, African stuff, super fly people, and all of it packed in tight and teeming with life. There was an old brownstone with some apartments in it, and I rang the bell, and this very lovely and dignified woman who was, is still with him. I can't remember her first name. She came to the door, and I explained who I was, and she just said, "Well, Sam's not here right now." But apparently, I didn't remember this part.

What I remembered was that she gave me some really delicious fried chicken and that she kind of in a panic called Bob Koester. "I've got this white boy here." But apparently his son says that I slept on the floor of his room. His son was about six years old. He remembers me sleeping on the floor there for a few nights. They were kind to me, and I have a picture here. I have my picture with Sam.

2) Formed in 1964, the Butterfield Blues Band was the foremost blues revival group in the US by 1965. Featuring Paul Butterfield (b 1942) on vocals and harmonica, Mike Bloomfield (b 1943 - d 1981) and Elvin Bishop (b 1942) on guitars, and Sam Lay on drums, they recorded the groundbreaking *The Paul Butterfield Blues Band* in 1965. 1966's *East-West* was a formative mix of blues, soul pop and modal Indian music. Sam Lay (b 1935) is an African America drummer and vocalist. He has played with Howlin' Wolf, John Lee Hooker, Bo Diddley, Magic Sam, Muddy Waters, the Butterfield Blues Band and Bob Dylan. James Cotton (b 1935) is an African American blues harmonica player, singer and songwriter who recorded for Sun Records in Memphis before joining Muddy Waters' band and striking out on his own in 1966. Bob Koester (b 1932) is the owner and founder of Delmark Records, the oldest independent jazz and blues record label in the US. His artists included Magic Sam, Buddy Guy, Junior Wells and the Art Ensemble of Chicago.

Top: Prime Movers bassist Jack Dawson and Iggy Osterberg on tambourine. Michael Erlewine collection. **Bottom:** Iggy with blues legend Sam Lay on the first night of his trip to Chicago; top row L-R, Charlotte Wolter, Barbara Kramer and Vivian Shevitz, Ann Arbor friends who accompanied him on the trip. Barbara Kramer collection.

J: FROM THEN?

I: Yes. He was playing with James Cotton at a place called the Curly's Club, and the three girls who worked at Discount Records, who had bankrolled me and drove me to Chicago came to the club with me. So he posed for a picture, and he was very dignified. I never had a drum lesson or anything, but during that time, I got to see good practitioners doing it for real, and a very fine drummer who was around quite a bit then was Odie Payne.[3] I watched him play a lot, and I'd walk up to watch Sam play.

I did play one little gig with Big Walter Horton and Johnny Young because they'd gotten a gig at like an Episcopalian church. "Let's look at the blues people," type. Unitarian. And so Bob Koester said, "Come on. You can play, and we'll give you ten bucks." And I remember sitting in the car on the way there in the front seat with Big Walter, and he took out a switchblade and he waved it at my face laughing, and he said, "You better be able to play some drums, white boy." So that was my one little gig. Other than that I just hung around, absorbed a lot of great records, and all those great films from the war. During the war when they couldn't make the records, everybody made a film, so I saw Fats Waller and Sinatra and Ellington.

J: AND SOMETIME IN 1966, YOU HAVE YOUR ENCOUNTER WITH THE DRAFT BOARD...

I: Yeah, well that was a big problem for all of us, everybody had a different way of getting out of it. My way was I got a nice crew cut, fairly similar to the haircut I had on the debate team. I had some clothes that my mom had bought for me; she was always trying to get me some nice clothes to wear like your mother would buy for you, right, when I was in the group. So I remember it was a sort of kind of a mock turtleneck En Rouge shirt and some nice gray slacks. And I just stayed up all night—that's what most people do, they thought you'd look crazier. And I went down there and I did the mental tests, I sat in the room with the multiple choice or whatever it was and did that and then you had to strip down to your undies and stand in a line to start the physical examination. I never wore undies anyway, you know so it may have been on purpose or just a stroke of luck, so I just stripped off my pants and I stood there butt naked with my little clipboard and some guy said, "what's up with this?" And I may have tried to exhibit a ruse, but I really don't remember. But basically, I was looking for somebody to give me a psychiatric examination and then I went in a room alone, a very small room with a guy at a desk who looked kinda like Arthur Godfrey or, he looked like Paul Giamatti in *Straight Outta Compton*. He looked just like that and so he asked me if I knew what a queen was and I did, and he asked me if I was gay and I said I was, and he jotted something down and they let me go.

J: AMAZING.

I: He gave me a 1-Y,[4] that was about it, yeah.

3) African American blues drummer (b 1926 - d 1989) who played with Jimmy Rogers, Muddy Waters, Memphis Minnie, Chuck Berry, Buddy Guy, Elmore James and Otis Rush among many others. Big influence on Sam Lay. 4) A Vietnam era draft board classification; 1-Y was, "registrant available for military service, but qualified for military only in the event of war or national emergency."

2. THE PSYCHEDELIC STOOGES

J: ALRIGHT, SO WE'RE GOING TO MOVE ON TO THE STOOGES. SO IT STARTS, I'VE READ, IN THESE MID-'67 REHEARSALS AS A THREE-PIECE WITH SCOTT [ASHETON] ON VOCALS AND YOU ON DRUMS.

I: I was on keyboard.

J: SO TELL US ABOUT HOW THAT STARTS. IT SEEMS LIKE YOU PESTERED THESE GUYS TO...

I: Yeah, I called them up. They weren't doing anything. They were hanging around. Ron Asheton would hang around and occasionally play with Scott Richardson,[5] who had a band called the Chosen Few that James Williamson had been in and out of, playing high school type events as a cover band and sorta wannabe Stones. And Scott Asheton had been pestering me to teach him drums. He was just a beautiful kid who looked athletic and would stare at me and say, "Would you teach me to play some drums?" And I was augmenting my life in the Prime Movers working at Discount Records[6] and learning everything about music from these older guys. Classical musicians, avant musicians, Dionne Warwick fans. Every kind of person worked there.

JK: AND DETROIT WAS REALLY DEEP IN AVANT-GARDE TOO.

I: Yes, Ann Arbor was. Ann Arbor more. Wayne State (a nearby university) a little bit, but then Ann Arbor very deep. These people would come through town. Andy Warhol, Karlheinz Stockhausen or whatever. I knew about John Cage. Harry Partch[7] I learned about at the record store.

So anyway we started out with me on keyboards, and I slowly realized little by little that my ideas were raucous enough. There were some raucous things you had to adhere to get anywhere, but I also knew that if you got too raucous you were just gonna end up like every other band in the area. It was just gonna be an imitation of something, and then they'd get to be twenty-two-years-old and just have to grow up and get a job or whatever. So little by little, I went from the keyboard to the over-amplified twenty-five dollar Hawaiian guitar tuned to E. That didn't quite get there either. We were practicing. To practice, I'd walk a half hour to a bus stop from my trailer, forty-five minute bus ride to the other side of town fifteen more minutes on foot to the Ashetons' house, and then I'd throw things at their house and ring the doorbell until they'd wake up. And then after they woke up, I'd have to get them stoned because it was understood right off, "You know, we don't do anything unless we're stoned, man. That's where it's at."

J: ARE YOU GUYS OUT OF HIGH SCHOOL AT THIS POINT?

I: We're out of high school, I've been to Chicago, and been through that. And we started, it was Ron on bass, Scott on drums, me on keyboards. Then it went to the Hawaiian thing.

5) Later to front the SRC (Scot Richard Case) who recorded three albums for Capitol Records in the late sixties. 6) Situated at 300 S State Street near Central Campus in Ann Arbor, managed by Jeep Holland (later to form A-Square Records— the MC5, SRC, The Rationals). Iggy worked there as a stock boy. 7) American folk/avant-garde theorist who made his own instruments and composed using just intonation. He released records on his own Gate 5 label. His works include, *U.S. Highball*, *The Bewitched*, *Revelation in The Courthouse Park*, and *On the Seventh Day Petals Fell in Petaluma*.

JK: WERE THE TWO BROTHERS REALLY CLOSE AT THIS POINT?

I: No, not particularly. They were more like typical music group brothers. Sorta like that great affection that couldn't stand or understand the way the others were. Very different personalities.

JK: RON ASHETON SAID A WONDERFUL THING IN AN OLD INTERVIEW THAT I WILL ALWAYS REMEMBER WHERE HE SAYS THAT SCOTT WAS A STONED PUNK AND THAT HE, RON, WAS ALWAYS THE WEIRD GUY. AND THE DYNAMIC OF THE WEIRD GUY AND THE STONED PUNK BROUGHT SOMETHING TO THE STOOGES.

I: I would say that's very true. That's very accurate. Scott would hang around with other young semi-toughs.

J: AND IS SCOTT SINGING INITIALLY?

I: No, Scott has never opened his mouth and sung. Okay I gotta be entirely factual. When the band was disintegrating between the exit of Dave [Alexander, the original Stooges bassist] and the entrance of Williamson, Scott did write two songs on the guitar. One was called "Out on the Range," and the lyric was, "I'm out on the range where things are strange." And then he lists everything he's ingested to get him out on the range, right? And I had a similar song we used to do live called "Heavy Score", and I would list a bunch of things and then I'd say, "It's a heavy score, baby." Then he had another one that was also funny, and I can't remember what it is. So he had the two, and y'know, he would laugh. And you know I tried to take all ideas seriously, so I thought, "Well, comedy. I mean we already do some comedy. I wonder if this would go." Nah...So no, he's never sung.

J: DIDN'T SOME OF THE GUYS TRAVEL TO THE UK [IN 1965] TO BUY CLOTHES AND TRY TO FIND THE BEATLES?

I: That was Dave and Ron. Well, probably the big thing was it gave them a first hand look at a different world. They did apparently go to a Who gig. That must have been a wonderful thing. They ended up basically hanging around Liverpool a lot and staying in bed and breakfasts. But they did learn that there was a different world out there it probably made them even hungrier to touch it. Now Ron said the trip, "gave us the backbone to say no." Okay, Ron, backbone is what you need. After the "no" is the "yes." It gave us the slouch to say no, but whatever. That is important to make that stand where you go, "I'm out of this system. I'm out."

J: AND YOU HAD THAT ALREADY BECAUSE YOU HAD CHICAGO AND YOU HAD THE RECORD STORE...

I: I had already decided and right around that time, I dropped out. I did go to college for a semester.

JK: WHAT DID YOU STUDY?

I: Asian Studies, Social Anthropology 101, which was big for the group 'cause I was like, "This is rock and roll! This is great!" And I had a library card. Spanish, at which I failed miserably, and I don't remember the fourth subject. I got a D, two C's , and a B. It wasn't bad.

J: SO AT WHAT POINT DO YOU BECOME THE PSYCHEDELIC STOOGES?

I: It went like this. First we were just rehearsing in Ron's basement with a little string of Christmas lights, when and if I could get the guys going. Never for more than twenty minutes because by the time we had just got going, their mother would come home from work. She worked for the school. She got off early, and the first thing she'd do, she'd walk in the door and yell, "STOP THAT NOISE! I'M HOME!" And then Ron would be going, "Don't disturb my mom!" So that was all that. And then the next step was we hooked up with a manager who had managed the Chosen Few, and this man's name was Ron Richardson. He was a licensed drug experimenter for the University of Michigan, and before he ever met me, he liked to give drugs to the Ashetons and other boys to see what happened.

JK: SO DID HE COME OUT OF THE LSD EXPERIMENTS OF THE EARLY '60S?

I: LSD, DMT, all that stuff. So at first, he was coming over. We all took jobs, which we all failed at miserably, to buy a band house, the three of us. Not to buy, to rent a band house on campus, and we were going to have rehearsals. And then we let Dave live there because he had a car. And any time we'd made one little bit of noise, the police would immediately come. Ron and Scott were supposed to be working at a psychedelic shop. A head shop.

JK: WHAT WAS THE HEAD SHOP CALLED?

I: I can't remember the name of the head shop, but it was closer to downtown where the rents were cheaper in Ann Arbor. I was working both at Discount Records but also across the street at a restaurant called The Virginian run by an old Greek bald guy. And when I'd be on, like it was all the teeny boppers, and I'd sell them cokes and fries and they'd all giggle and stuff. And everything went okay there 'til I started smoking dope and then I screwed up all the orders and I got fired. So that was that, and Ron Richardson would come over to our house with these big bongs and either DMT or LSD and also very strong marijuana. Eventually, this led to this private gig where I played that guitar in 1967, and that was at Ron Richardson's home, which was in front of a junkyard out on State Street on the edge of the campus about a mile past Yost Field House. And in the junkyard was all this shit that I went looney cross-eyed and made it into different sorts of created instruments. Harry Partch [an avant garde composer who built his own instruments] was someone we listened to. I listened to it in the (band) house on Forest Court[8] there for ideas. And I actually built...he had one instrument called something like the Cloud something...

J: CLOUD CHAMBER BOWLS...

I: They were bottles.

8) The Stooges first band house was at 1324 Forest Court in Ann Arbor.

J: YES, IT WAS MADE OUT OF BOTTLES.

I: Okay, I tried to make the thing suspend from a pole with huge and progressively smaller spring water bottles. And I put a little different bits of water in each one, and I would hit each one and it would go blum, blum, blum. But it fell apart. I'm not a professional. It fell apart right there in the living room, soaked the rug. There was mold. So I went to the next step. I got a Waring blender and I put this much water in it. Mic'ed it up. Sounded like you were in the most wonderful waterfall, y'know.

JK: THERE WAS A HARRY PARTCH RECORD IN THE MID-'60S THAT HAD A BOOKLET WITH PHOTOGRAPHS.

I: Yeah, yeah. I saw the photos. It was the big record. You're damn right. I saw the photos. I nicked it from Discount. I was also listening to Tuareg medicine chants.

J: HOW LUCKY WERE YOU TO BE WORKING THERE!

I: Yeah, I know. Well Ann Arbor had a culture. These kids were what they called townies. I was not really a university guy. I was a half-townie-half, but y'know I could swing both ways. I could see both viewpoints. But we were role-playing. We were taking drugs and role-playing, and we became named in that house because I kept saying, "Let's get back to the band." And they're off, y'know, life is a holiday. "What are we going to name the band?" And we'd been up all night on acid and Ron said, "Well, we'll just be like the (Three) Stooges except psychedelic. We'll be the Psychedelic Stooges!" And I thought that had a ring. That was good. But we did things in that house...I was trying to reinvent myself. I was beginning to realize that I didn't have what it took to be an instrumental front man and that I had serious holes in my songwriting abilities, but other places that I thought I could be good.

JK: DID YOU KNOW THAT YOU HAD A BEAUTIFUL VOICE AT THIS TIME?

I: No. I had no idea whether I could sing or not. I didn't even think about that, but I was trying to learn. But I didn't think about it as something that would be an asset yet.

JK: HOW DID YOU FIGURE THAT OUT?

I: It went little by little and basically the main thing was somebody had to do it, and basically I realized, "Oh my God. There's gonna have to be a singer."

JK: DID IT TAKE TIME FOR YOU TO FIND YOUR VOCAL RANGE AND HOW YOU PROJECTED YOUR VOICE?

I: No because my effective range when we started was only about three notes. And still if I'm gonna do rock and roll, I'm still most comfortable singing in E or A. And if we're in E, I sing an E, I sing a G, and I can reach for a B, but it's better an E, a G, and a D. And if you're in A, it's a C, an A, and a G. Listen, "1969 okay." Two notes. "All across the USA." There's the low one. See, that's the D.

JK: YOU MUST HAVE LOVED BO DIDDLEY AND HOWLIN' WOLF.

I: Yeah! Because they were so great and they were also accessible, and then there was so much detail in the meld of the rhythmics.

JK: BUT THEY'RE DOING LIKE OPEN E TUNINGS, AND THERE'S VERY FEW CHORDS.

J: SO TELL ME ABOUT THAT FIRST GIG, ON HALLOWEEN 1967. IT WAS VERY EXPERIMENTAL...YOU PLAYED A HAWAIIAN GUITAR. AT ONE POINT, YOU HELD A VACUUM CLEANER IN FRONT OF THE MICROPHONE?

I: It took place in Ron Richardson's rented house which was on State Road, which was a road that later turns in and goes from the farmland outside Ann Arbor straight into the heart of campus, and when it hits campus it becomes State Street. And his house was on the part of town where things go downhill as you leave the campus and it was an ugly little white-ish gray-ish frame bungalow style house with maybe one bedroom and a living room, and no furniture to speak of. And in the back of the house, the house adjoined a junkyard and it was a, sort of a disused junkyard. There was a bunch of junk and it wasn't like a working junkyard where you can go and buy spark plugs but it also wasn't just a dumping ground, I mean there were no old pop bottles or refuse there. It was just odd, an odd graveyard of useless metal-loid goods. And some of those goods I later used to make the instruments out of for our first gig. But on that particular show, Scott Asheton beat on an oil barrel that I pulled outta that junkyard and I wired it up with little dollar ninety-nine contact mics from Radio Shack and he was not playing a kit yet, he just had the oil drum standing there and I think I had gotten him what we call parade beaters. I don't believe he was actually hammering it with hammers, but he was using something called a parade beater which was basically a small club that was used often in marching bands—it's much harder hitting, makes a much bigger racket than a drum stick. So he had that that was his instrument, and Ron was playing a Gibson Firebird bass guitar, and they each had their own amp and my instrument was a twenty-five dollar Hawaiian guitar—I believe it may have been a National—it's in the [Rock and Roll] Hall of Fame somehow.

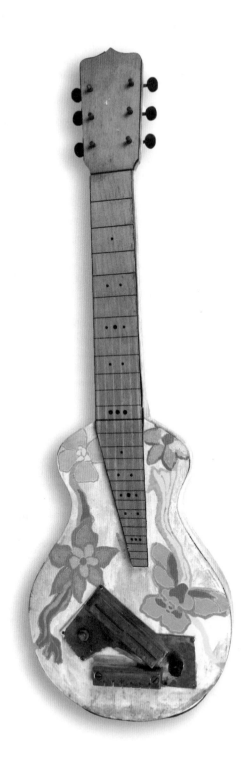

Above: Iggy played this $25 Hawaiian guitar at the first ever Psychedelic Stooges performance.

I: Yeah, this was the guitar that Dave later ruined [laughs] by painting it a floral pattern while he was on LSD and not realizing he painted over the pick-ups. I had that guitar and I had a Kustom amp that I bought because I was young and ignorant and it looked cool—it had tuck-n-roll naugahyde, Kustom, the early Doors used 'em for awhile too. And I had each string on the guitar, I was playing it with heavy guitar strings, each string was tuned to E, and I played it with a slide bar and it really did sound—it really sounded like an airplane was landing in the room. And so, the guy who ran that house, Ron Richardson, I always knew, he was always giving us lots of psychedelic drugs: DMT, DET, LSD, and he always had lots of weed, and had this big bong—and it was the biggest, ugliest, plastic tubing bong I've ever seen in my life [laughs] and we just smoked his bong and you couldn't help but wanna cough your guts out. So he invited a bunch of people over, all of whom who kinda knew us from various bands and wanted to be supportive and help us out in our fledgling career. There were about maybe, I would say, somewhere between 12 and 25 people came over. John Sinclair came, I think Wayne Kramer and people like that and their friends. Mostly guys, but there were also some ladies there as well—in the afternoon. It was not in the evening, it was in the afternoon, late afternoon/early evening like cocktail hour maybe. And that's what I remember anyway, that's how I remember it and I sat on the floor and I played the main composition, it was written like a lot like what the Melvins did later, many years later. It sounded like a Melvins tune. It was an E major going up and down, E to F, E to F, in a dirge like [makes sounds] while Scott beat on the fucking, hammered on this oil drum and Ron played the bass...

J: AND WERE YOU SINGING?

I: No, no there were no vocals, and I was cross-legged on the floor and the people were all smoking a lotta dope and hash, and one by one they escaped as we played. We cleared out the whole room. Everybody felt sorta like "oh dear," so that's what I remember about it: all our friends were embarrassed for us and walked out. And I felt ill after, so we tried to recuperate.

J: DID YOU GUYS SEE THIS AS A DEBUT FOR YOUR NEW BAND?

I: Yeah, it was like a debut to try to get support that would get us to the point where we could actually go out and do gigs and it was kinda like a "what do you think?" And I had already been through quite a time period of people who knew me feeling like I'd gone nuts and feeling sorry for me because I had been a viable, working drummer in the area and now I wanted to do this some sorta weird scheme that had been going on too long and had not resulted in any cover songs or anything. But I had thought this out as policy and it was just obvious to me, I could see the future for almost every group in the area and it wasn't pretty. They weren't going anywhere because they weren't what they were pretending to be, we needed to come up with something of our own so this was my initial foray into coming up with some of our own.

J: DID YOU GET ANY POSITIVE FEEDBACK?

I: No. Some people were kind. You're supposed to be kind to struggling artists. That was all, but we didn't give up. And then the next thing was that professor, Ron Richardson, got a house. It was just like something straight out of *In Cold Blood*. Out on, I think it was on Freeland Road.

No furniture, cold farm house with bent, deserted ex-corn fields. Just a weird place. And we were there and it was winter and we had failed in the Halloween recital. We were taking all his drugs, messing up his house, and we weren't bringing in any income, so one day he shut off the heat in the room.

J: DID THINGS CHANGE WHEN YOU STARTED PLAYING THE GRANDE BALLROOM IN DETROIT?

I: By the time we managed to land a job at the Grande Ballroom it hadn't changed that much from our first show. The first time at the Grande I was still on guitar and it wasn't that different except it was swingin' a little more. It wasn't that different and one big difference was when we played in Ron Richardson's room, we were playing for butch, rock-ist, jazz-ist, political key men and their babes. But when we played the Grande, we were playing for the youth and one of them happened to be a writer on the Michigan Daily, the college newspaper, and immediately we had press. We got a very, very large review so this kid was intrigued by what we were doing. So it was, a different setting helped.

And it was just around that time, I don't remember how this happened, but I realized, I said, "Ron, you take the guitar. You need to be the guitar player." It was actually after our first gig. Our first gig was still me on a guitar, and Dave ruined my thing. Dave was supposed to operate my inventions, and he got it wrong. And I realized I wasn't good enough on guitar and I fired myself from that position. Yeah, I fired myself, and I handed a guitar to Ron. And then we went in. I said, "We're gonna go rehearse anyway even if it's cold!" "Oh come on." "Yes we are! We've gotta do this!" And I just bullied them or hassled them. We were in parkas, freezing in this unheated antler room in early February Michigan, and all the sudden there was a little groove. Ron was playing something that was based on a Hendrix type riff. "Bam, bam, baa. De, doot-doot, daa. De, doot-doot, doo." Exactly how it went. And Scott's playing it, and all the sudden I heard the professor pull up. And I needed to score points with the group, and I needed to vent at this guy. And all the sudden I danced like a disturbed American Indian is how I would put it. It was like an American Indian kind of low down dancing, but it was a little bit weird and I made up this little song "Fuck You, Professor." And as soon as I started doing this slightly embarrassing thing, up went the energy from them. [Stooges producer John] Cale noticed this in the studio. He said, "They don't play good unless you jump around." And on that first record, all those takes were them instrumental and me out there exhausting myself, take after take jumping around, waving my arms, but not singing. And then I overdubbed all the vocals.

Above: An early show at the Ann Arbor Armory with Iggy in whiteface, and Ron and Dave playing conventional guitar and bass—but Scott still on the oil drum, April 1968. Photo: Steve Bober.

J: SOUNDS LIKE YOU WERE CLEARLY THE PRIME MOTIVATOR IN THIS BECOMING A BAND.

I: I was the one who kept saying, "We're gonna do this! We CAN do this." And there were various levels from the two string players of, "No. Couldn't be. Never will. Well, maybe I'll rejoin the Chosen Few. Maybe I'll just go home to my parents." But never Scott. Scott didn't say much. He wasn't positive, he wasn't negative. He was always ready to drum if you could get him out of bed.

J: AND I READ A COUPLE QUOTES FROM YOU WHERE YOU SAID YOU SAW THIS AS YOUR ESCAPE FROM THE LIFE THAT WAS LAID OUT FOR YOU.

I: Yeah, that's right. I didn't like high school. I didn't like it socially. I didn't feel well, and I didn't want to not feel well all my life. I just had this instinct. "I can't do this. I cannot do this." And I also thought I can write. I got a twenty-five dollar check my junior year in high school from Dell Publishing. They had a poetry contest in *Ingenue Magazine*, and one of my girlfriends who is now married to Danny Erlewine sent my poem in. Didn't tell me, and I won the prize.

J: DID YOU READ POETRY?

I: Not too much. I don't remember doing much reading. Like a lot of young assholes, I was just excited to get right out there and open my mouth.

J: NOT LIKE THE EVERGREEN REVIEW AND STUFF LIKE THAT?

I: No, I wasn't that. I was just a kid who was lucky that our high school had advanced placement programs, and we had a wonderful guy who I later realized was almost certainly a gay guy, sensitive gay guy, who had a doctorate in literature named Dr. Eastwood. Had taught at Tulane, and he was my English teacher in eleventh and twelfth grade. He pushed me. And I've always liked those types since. Academic old gentlemen who you can tell are like, "Hey, he's not like my parents," who were great people.

J: YOUR DAD WAS AN ENGLISH TEACHER, RIGHT?

I: Yeah, my dad was an English teacher.

J: SO YOU HAD SOME ELEMENT OF THAT TOO.

I: Oh, I was taught to verbalize and argue all the time like a lot of kids in the western canon who have diligent parents.

J: SO HOW ABOUT THIS PHOTOGRAPH OF THE BAND, AND YOU'RE IN WHITEFACE.

I: This is where we were still living in that *In Cold Blood* house that belonged to the professor, and this looks like one of our very first shows in which I started fronting. And I've given Ron the guitar. Barefoot. I had a perm gone wrong. I had long hair and I thought it would look more wild permed, but I didn't know that would shorten it. I had no eyebrows, which was a physical problem. And we had a little twenty minute set worked out.

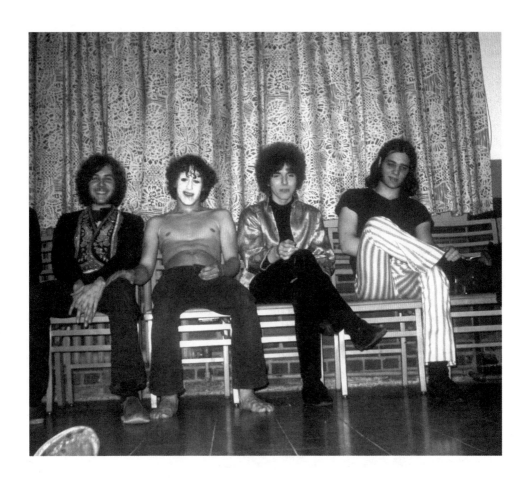

Above: Ron, Iggy, Dave and Scott; Ann Arbor Armory, April 1968. Photo: Steve Bober.

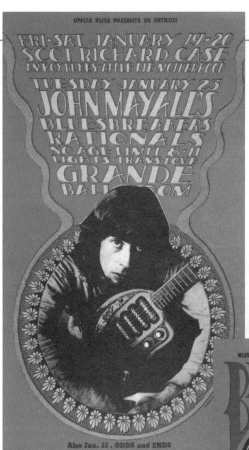

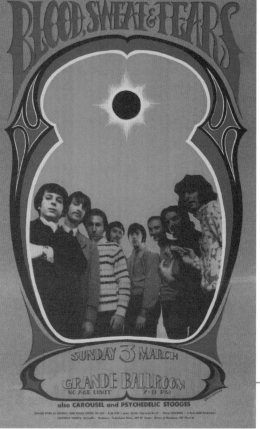

Above: While not listed in the advertising, the Psychedelic Stooges "professional" debut took place on January 20, 1968, replacing the Amboy Dukes at a show headlined by the Scot Richard Case. Michael Storeim/Classic Posters collection. **Right:** Six weeks later, the Psychedelic Stooges played their second professional show, opening for Blood, Sweat & Tears. This time their name made it on the poster. Jeff Gold collection.

JK: HAD YOU WRITTEN LYRICS FOR THE NEW SET?

I: I wrote titles and then I would ad-lib the lyrics. I'm quick that way. Y'know, I like words.

JK: DO YOU REMEMBER THE TITLES?

I: Yeah. "Dance and Romance," "Goodbye Bozos," "Asthma Attack," "I'm Sick." Those are four I can remember.

JK: WOULD YOU KEEP GREAT LYRIC LINES THAT YOU AD-LIBBED? WOULD YOU JOT THEM DOWN OR MEMORIZE THEM OR ANYTHING?

I: No. I just knew the title and then I'd make it up at the time and then I'd give a secret hand signal to end the riff and go to the next one. And then the idea was to never give the audience a chance not to applaud. That was a lot of it. Don't let them judge you! Never let them judge you if you're not gonna win. So then when we left the stage, I'd tell them, "Feedback the instruments. Go off one by one, and then I'll follow." That way they didn't have a chance not to applaud afterward.

J: IS THIS STUFF INSTRUMENTALLY AND VOCALLY IMPROVISED? THE STUFF WE READ IS THAT IT WAS JUST YOU GUYS GOING UP THERE MAKING NOISE.

I: No, no. Each one had a given motif. There was a motif and then I would sort of develop it vocally and when I stopped vocalizing, Ron would play some and they would play it in different ways. And when I decided to come back in and sing, I'd sing and sometimes they'd make way for me or as Jack White was quoted, he said, "I love in 'Fun House' when you say 'Take it down!' and they don't!" [laughs]

J: WERE YOU STILL USING THE BLENDER AND THE OIL DRUMS?

I: No, the oil drums now become the bass drums, but they were still the oil drums. Timbales instead of the normal tom toms. Parade mallets instead of normal sticks. The tap dancing is off. No, it was just white face, bare, clean, simple, strip it down.

J: SO THE FIRST GIG YOU PLAY IS AT THE GRANDE, THE FIRST PROFESSIONAL GIG. SUPPOSEDLY IT'S A LAST MINUTE SUBSTITUTION FOR THE AMBOY DUKES AT AN SRC SHOW.

I: I don't remember anything about that gig.

J: AND THE FIRST ADVERTISED ONE IS OPENING FOR BLOOD, SWEAT & TEARS.

I: That's the one I remember.

J: AND THAT'S THE FIRST GIG WITH DAVE ON BASS. SO WHAT DO YOU REMEMBER ABOUT THAT AND WHY DID YOU ADD A FOURTH MEMBER?

I: Well, because when I put Ron on the guitar, we had to have a bass. We were going to go a little more traditional. That was the answer. A little less with the other stuff. And also Dave was willing and it was nicer for him to play the bass than to just be throwing amplifier heads on the ground and operating a blender. That's not gonna get him anywhere with the chicks [laughs]. So what I remember from both of those gigs, it was interesting, (MC5 manager) John Sinclair[9] was up front and center paying a lot of attention and being very generous to us as a person. It was shortly after that that we switched managers and we got Jimmy Silver, who was a friend of John's. They probably knew each other because I think Jimmy was a big hash dealer and wanted to go straight like a lot of people. One thing I remember is nobody moved. From the first time that we ever did our first show, nobody got up for a drink. The heads didn't move at the back of the hall. That was always the scene.

J: THEY'D NEVER SEEN ANYTHING LIKE IT.

I: There weren't a lot of people. There was nobody approaching the stage or anything like that, but that was common for everybody. And the only big thing I remember is that after the Blood, Sweat, & Tears thing is where they stamped me with my name. I had been known derisively as Iggy (an Iguanas reference) at the record store. Jeep Holland[10] called me that to tease me and the Prime Movers called me that to humiliate me. And the Michigan Daily came out with a review the next day saying, "Blood, Sweat, & Tears: ho hum, nothing new here. But these Stooges!" And it said fronted by local area drummer Iggy Osterberg. It had already been by that time what seemed like a good year and a half trying to get this group together, and I had press. I hated being Iggy. I knew it was going to cause a lot of problems. I had been thinking about my stage name, and I thought, "Well maybe Jimmy James," is what I had thought. "Well that's not very creative, is it?" And suddenly it's Iggy Osterberg, so after I got over the initial "Oh no," I thought, "I've got press!" Hey, so I thought it didn't ring well with Osterberg, and over months I came up with Pop. And they mentioned all the instruments. He mentioned all the weird stuff we did.

J: AND WERE YOU FRIGHTENED TO BE PLAYING A PROFESSIONAL GIG WITH A NATIONAL ACT, OR WAS IT JUST LIKE "AHH, WHO CARES?"

I: Listen, frightened doesn't even start. The entire group always, all of us before every show for a long, long time were petrified into immobility. We would sit, all four of us, not even turning our heads in these tiny dressing rooms. Of course, the other guys all had hair problems. They had hair that they felt was too frizzy, so they would go to great lengths before the gigs to get their hair just right. We'd have to go with the windows up in the car, and especially Ron, he would turn his whole body. And you've got that picture you sent me of him under the hair blower. Me, you know I wanted to have good hair too. I was a little more confident about mine once I got rid of the perm.

9) MC5 manager from 1966 onwards: John Sinclair is a poet, activist and writer from Flint, Michigan. 10) Hugh "Jeep" Holland was the founder of the A-Square Record label in Ann Arbor in 1967, and consequently became an integral part of the southeast Michigan music scene in the late 1960s and early 1970s.

Right: Inside the band house. Robert Matheu collection.

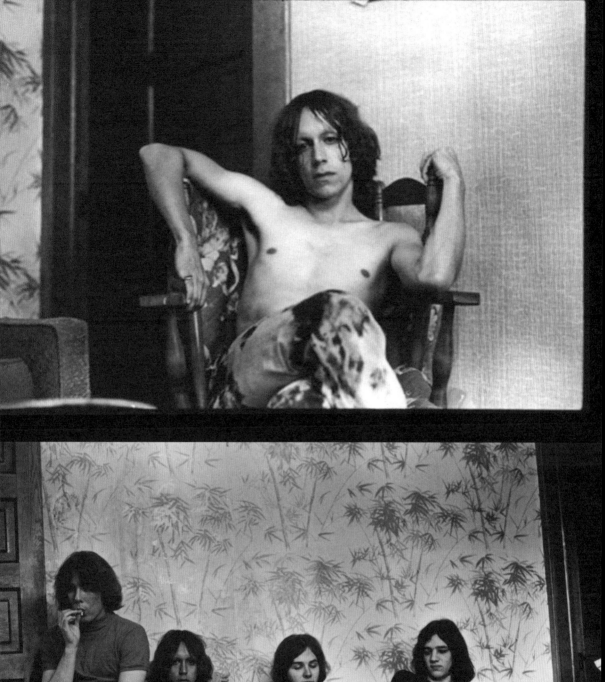
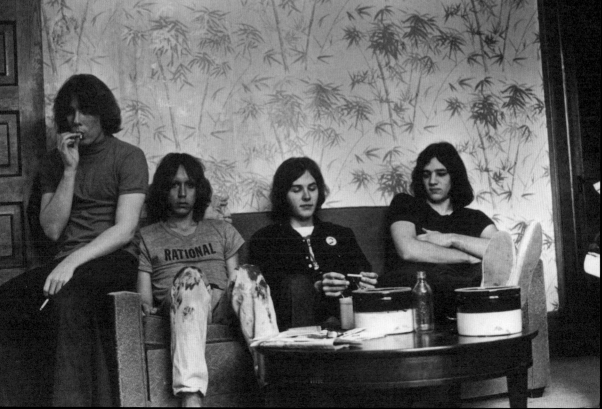

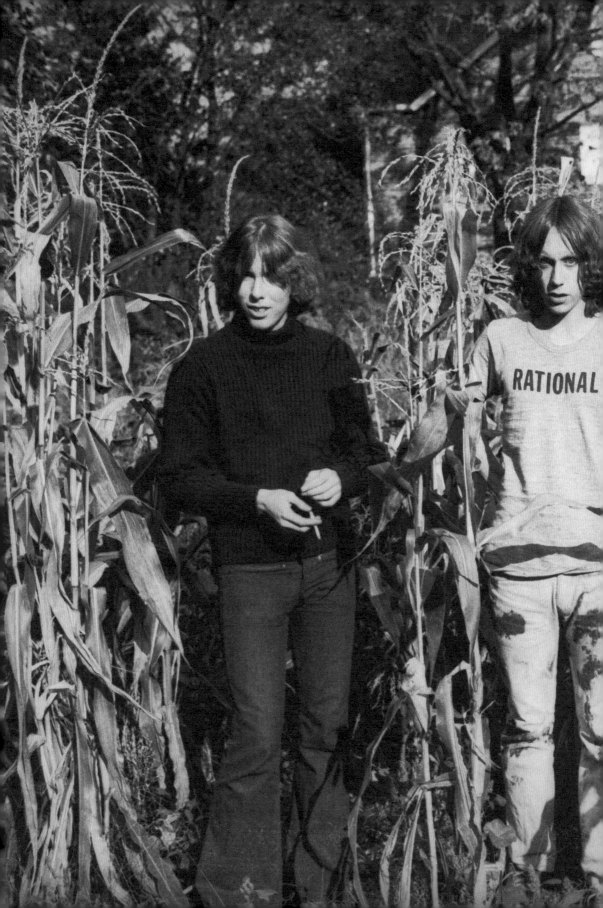

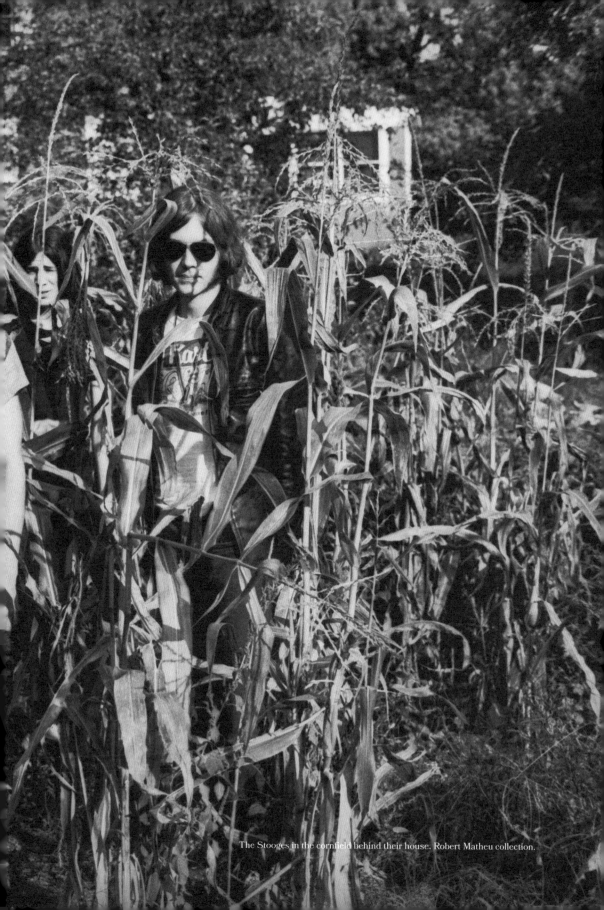

The Stooges in the cornfield behind their house. Robert Matheu collection.

J: BUT YOU QUICKLY GOT A LOOK TOGETHER, DIDN'T YOU?

I: Actually the entire visual of the band was pretty compelling. If you look at that picture of us in the corn, you know the one?

J: I DO.

I: Well, I don't know what you think, but that looks to me like Nirvana except it's 1968. It's the whole ethic, and not just the clothes but the whole attitude you know? And then the music—the music, the Asheton brothers—those two wonderful people lived their whole lives in a trance. It's true, and they were trance musicians, and some of the trance music they made they came up with themselves, and after I capeeshed to it, some of it, I was able to write for them. And none of it would ever sound interesting at all unless they played it, you know. I have trance tendencies—a lot of musicians do—but those two, they really had it you know, you get those Asheton guys locking in a certain way and it will put you into a kind of trance.

J: THERE WAS ALSO NO CONTEXT FOR WHAT YOU WERE DOING, SO AS A FAN, FROM MY PERSPECTIVE, THE VISUAL WAS UNUSUAL, YOUR DANCING WAS UNPRECEDENTED, THE MUSIC WAS UNPRECEDENTED, AND SO IT WAS A KIND OF SHOCK...

I: Yeah, a lot of people were interested in music at that time and in a certain way, a certain sense of the word "interested," they couldn't just get it, they couldn't sorta file us away in five minutes and get on with their night, you know, like "I get it, it's a Van Morrison thing..."

J: TALK ABOUT DAVE FOR A SECOND. I'VE GOT ANOTHER GREAT RON QUOTE WHERE HE SAYS, "IGGY WAS THE STRAIGHT-LACED FRAT, HIGH SCHOOL REGULAR DUDE. DAVE WAS THE TRUE REBEL WHO PLAYED A BIG PART IN PERVERTING US."

I: That's true. Dave was a tortured kid. He had a really, really bad skin problem. He couldn't get fucked. He couldn't get a date. Before he got in the group, he already had a pretty serious alcohol problem that would crop up. He was also—I was told but never saw it—a seriously fearless and vicious street fighter. I think his mom, who was a sweetheart, might've been an alcoholic, and his dad was a butcher, who was a stolid man like, "I'm tired. It's after work. Don't bother me." And they lived in a very sorta quiet, two-door house a couple blocks from the Ashetons. And I met Dave when I met Scott. You would never see Scott alone. He'd always be with Dave and their friend Roy. And he was a very, very intelligent and witty person if he felt like talking to you, and the flip-side was all the sudden he didn't feel good. He didn't feel like it. He'd say something to hurt your feelings or dismiss you in some way, and he got into the group, that carried over into a defeatist verbalization that drove me nuts because I wanted to get somewhere. I was not fucking around. So it would be, "Oh, listen to this great Hendrix record. We could never play like that. Listen to this great Love record. We could never play like that," sort of thing. And he was never, ever—well, none of them were—but Dave particularly was absolutely not approachable ever unless he was stoned on marijuana, and from time to time because he was the only guy with an allowance and a car and things like that, he would decide that, "I don't need those guys," or, "They're using me," or whatever and he'd disappear. As the band went on, he did some great work, and he was sorta the straight man for Ron. They'd stay up late all night and they would shoot jokes back and forth. The two of them were like a late night comedy team in their own minds, and Ron was pretty funny.

Here's a good illuminating thing about Dave. When we lived in the Forest Court house, Dave took his first acid trip with me, and it might have been my first acid trip. I think it was. And the two of us dropped the acid and after about forty minutes, we felt it going on. And so, "Hey, let's take a walk down the street." We walked down the little street and the trees were so beautiful, and we were looking at everything else. "Wow." And then Dave looked at me and he said—he shocked me with this, and that's maybe the difference between me and all the fellas—he looked at me and he said, "Things should be like this all the time."

J + JK: HEARTBREAKING...THAT'S SO SAD...

I: And immediately up went a red flag because somehow—I don't know how, if it's innate or by parents or somehow—but somehow I had, had an idea that that was unrealistic. But he was nice, and all these guys, look. These guys were the closest I've ever had to having what are traditionally called friendships in my life. A very wise man with a bigger career than me once said truthfully, "There are no friends in showbiz." You've been around. You know kind of once you get over to the serious performers, you know that's kind of true, but these guys were as close as I got.

J: YOU WENT THROUGH THE TRENCHES WITH THEM.

I: Yeah, and Dave was sometimes very nice to me, he'd sometime share his marijuana and an extra bedroom with me and play records together y'know and then he'd get mean. And as the group started going and I started getting attention for my performance style and at the same times started dealing with the agent, dealing with the manager, answering the phone, hassling everybody to make rehearsal, the two of them started resenting me a lot.

J: RON AND DAVE?

I: Yeah, and the jokes together all night became about me.

J: I WONDERED IF YOU HAD ANY THOUGHTS ON WHO MIGHT HAVE INSPIRED DAVE ALEXANDER OR THE ASHETONS.

I: Dave loved Love: he was the kinda guy who liked to listen to his music on headphones. I did not like to listen on headphones, I liked it out in the room. Ron was very, very much Jimi Hendrix—that was his number one. And he loved The Pretty Things and you could really hear that in the bass playing on *Raw Power*. I'm trying to remember, I don't want to get his name wrong, but there's a wonderful...the bass player in The Pretty Things [John Stax] did wonderful walking bass lines.

For guitar he loved Hendrix and you could also hear a lot of influence from Pete Townshend. But I got them to listen to The Velvets. We all went to the same party together and that first Velvet Underground album was playing, we all thought it was like creepy 'til we heard it the second time, you know and then WOW. So Ron was also influenced by that and the whole group was very interested in anything the Stones did. And you know Scott Asheton was more into the Rolling Stones and then later it became more like he veered over into more Funkadelic—which is very fine music. We knew those guys, so we would hang with them sometimes and they were nice to us. It was pretty much a narrower field for them and I was the guy bringing in the Coltrane, the Pharaoh Sanders, "listen to this, listen to this." They were not unreceptive to anything. I was bringing in Harry Partch, listen to this, and they listened to it and just had fun, they'd take it as comedy, you know? But they were being influenced. I put on Harry Partch and Ron would turn off all the lights in the house and dress up like a hunchback and run around the house. We did some role playing, you know while we were getting together we would get stoned together and role-play.

J: AND WHO WERE THE MORE TRADITIONAL INFLUENCES OF YOURS? THE MORE ROCK, I KNOW YOU SAID VAN MORRISON OR THEM AT ONE POINT.

I: Van Morrison was very big, The Doors had things to offer. All of us really listened closely to John Lee Hooker because it was simply good music, you did not have to change chords and that was big with us. We were aware of, you wouldn't call these artists you followed, but any time there was a good garage record, we were all very aware of it. In other words, if there was something like Bobby Fuller Four or "A Little Bit of Soul" by the Music Explosion—we were aware of those records. The MC5 might have had something to do with this, I started getting more and more interested in James Brown who was suddenly, he was getting on the white radio with "Papa's Got a Brand New Bag" and I thought, "Holy shit what the fuck is this," and you could hear that directly in *Fun House*, that's my attempt to do something a little bit like, a little bit urban blues but a lot of James Brown in there.

J: AND DID YOU SEE THE VELVETS EVER?

I: No I never saw the Velvet Underground, I went to a party with some of them but we missed their set, we went to see them playing the State Fairgrounds[11] and it was Velvet Underground, Exploding Plastic Inevitable, and with Gerard Malanga—who I later did that photo session with, and the Yardbirds. And, oh and I loved these guys, Sam the Sham and the Pharaohs all played as well. Oh man, and I'll tell you something: Sam looked like a guy who would sell you oregano joints or something but the band—the Pharaohs—they looked like three or four guys who had been alcoholics since their teenage years and had never been let out of a bar or into the light—they were the color of centipedes—but they all wore these matching satin stage shirts with big collars, kind of like pirates, and when the Yardbirds came out —it was

Keith Relf, Jimmy McCarty, Chris Dreja, Jeff Beck, and Jimmy Page, and they all had on very similar, they also had decided we'll wear satin shirts, and each one had a different colored satin shirt. But they looked cool and they sounded great and we missed the Velvets part, but Warhol and Gerard and a few people showed up in an after party we were at...he remembered later meeting me there, we met very briefly there.

JK: SO AT THAT STAGE DID YOU HAVE AN AGENT AS WELL AS A MANAGER?

I: Yes, DMA. Diversified Management Agency. Dave Leone,[12] who finally told me at the end, "Okay, I'm sending you two-hundred bucks and don't ever call me again!" Yeah, I'll tell you I've made every wrong move that anybody has ever said I've made. The only thing that bothers me is that how consistently the people who tell tales the most on that have never figured out their own wrong moves. They're all peerless, flawless, and blameless.

J: SO ALL THOSE WEIRDO INSTRUMENTS WERE BASICALLY JUST THE HALLOWEEN PARTY AND THE REHEARSALS AND BY APRIL YOU'RE GETTING INTO MORE BASIC INSTRUMENTATION?

I: It'd come back in little ways. For instance on the night when it was my 21st birthday, we were supposed to be opening for Cream. I decided, "Hey, let's do a really big oil drum." So with my manager's help, we got a two-hundred gallon oil drum and brought it to the Grande Ballroom in the afternoon and hoisted it all the way up these two, three flights of stairs and set it in front of the stage. And the idea was you had a contact mic in it and my manager was supposed to hit it with a giant mallet. He had no sense of time. Surely you can just count to four, but some people can't. And the other problem was something went wrong with the grounding in the electrical supply. Sometimes there's a technical thing that happens where the power cuts down. It's an ohm thing. The power wasn't there to make any more than like a little ukulele strum, so Ron came out and went, "DUMMM," and nothing came out. The sound was that of a very limp penis. Cream had canceled and the James Gang were playing instead, and my guess is a lot of people didn't know. The audience reaction was, and I quote, "Boo. We want the Cream. We want the Cream." So I stood on top of the oil drum shaking my fists. I was on Orange Sunshine acid and just stood there and endured and we played our little bit and then somebody else played. I think we were third on the bill. And I went home. That night was my 21st birthday and I went to Dave's, his mother cooked me a hamburger with one candle on it, and I thought, "This career is just about over." Y'know I was like really, really, really heartbroken.

11) November 17-20, 1966, Michigan State Fairgrounds Coliseum, Highland Park, Michigan. Dick Clark "Caravan of Stars" tour. Shortly afterwards, the Yardbirds began covering "I'm Waiting for the Man." 12) Dave Leone was the founder of the Hideout chain of teen clubs in Metro Detroit as well as the Hideout record label that released the likes of Bob Seger and the Last Heard, the Pleasure Seekers and the Underdogs.

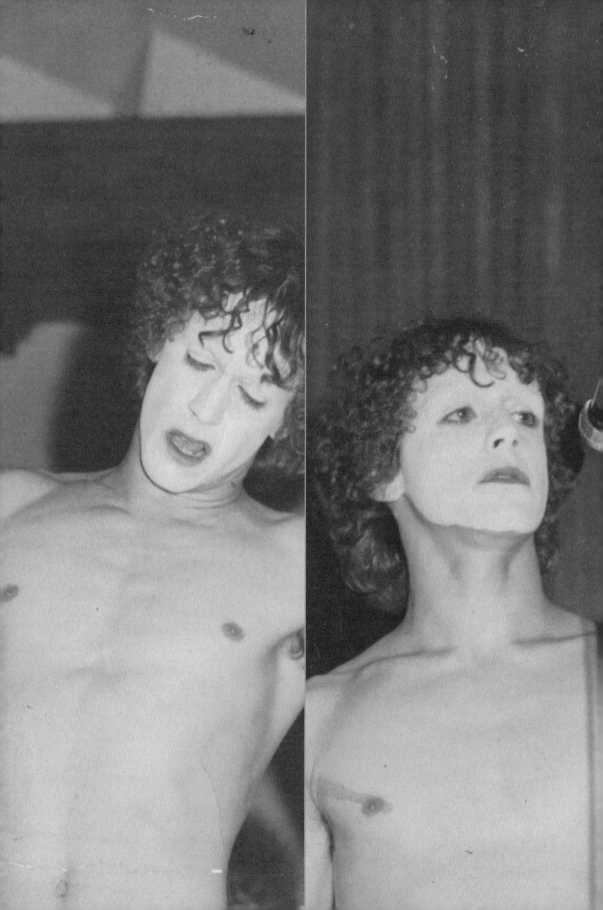

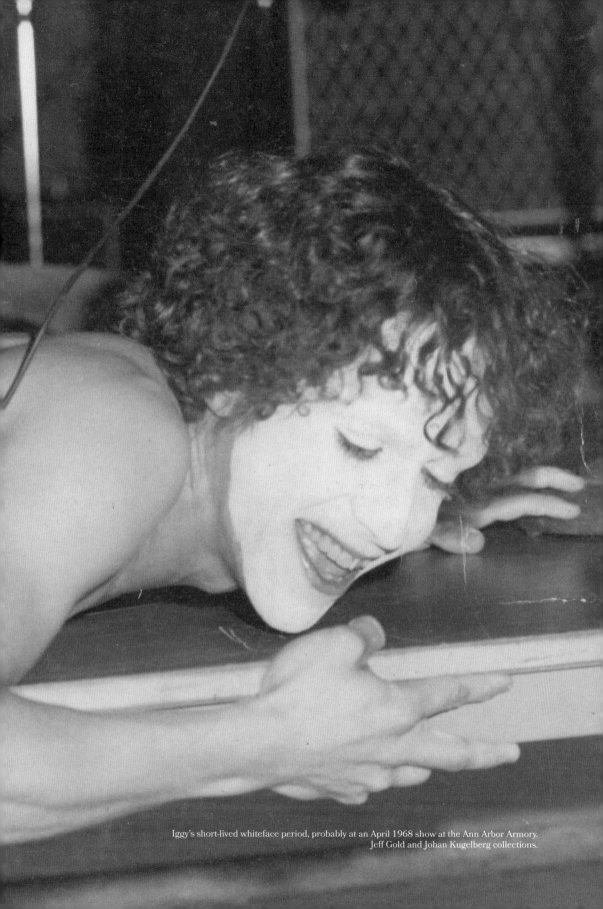

Iggy's short-lived whiteface period, probably at an April 1968 show at the Ann Arbor Armory.
Jeff Gold and Johan Kugelberg collections.

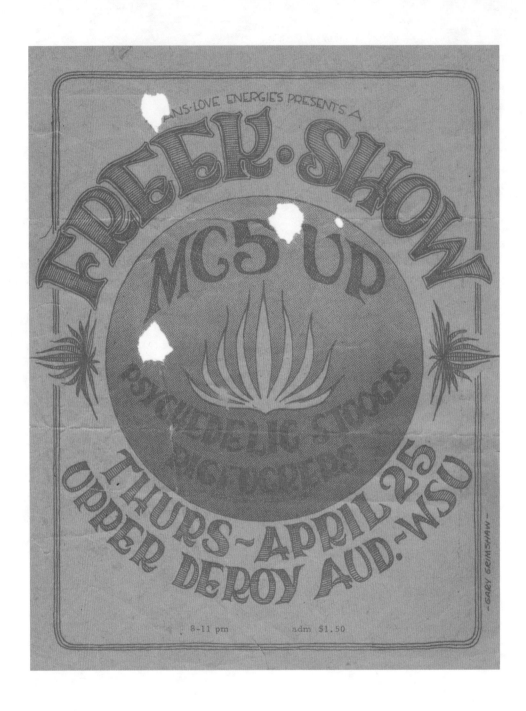

Above: A freek show indeed, headlined by Stooges "big brother band" MC5 and The UP, who lived with the 5 at White Panther Party founder John Sinclair's commune, April 1968. Grant McKinnon collection.

J: THAT'S INTERESTING BECAUSE I READ ABOUT YOU GUYS AT THE GRANDE EARLY ON WHERE YOU HAD ALL THESE CRAZY INSTRUMENTS AND STUFF, BUT IT SOUNDS LIKE IT'S EVOLVING INTO SONGS THAT ROCK EVEN AT THAT STAGE.

I: Yeah, it still wasn't songs in that sense, but there were still things that would come up like sometimes I'd blow a boat horn into the mic or sometimes I'd bring a pie. Once I brought a pie and threw it at the audience, stuff like that. Little odd things I could think of to make it a little different.

J: AND THE WHITE FACE, THE SAME THING?

I: Yeah. For a short time, the white face. Once my hair got long enough so that I looked acceptable then no more white face.

J: AND IT SEEMS LIKE A PIVOTAL THING IN YOUR PERFORMING WAS YOU GO SEE THIS MESS OF A SHOW BY THE DOORS AT MICHIGAN...

I: Yeah, because I realized how great what they were doing was from the records. I could also tell that the records had been doctored and overdubbed a lot, but when I saw them, I saw two things at the same time: one, how abjectly that level of creativity was bound to fail when you tried to fit it into a raucous mentality and two, how willing Jim Morrison was to bait the audience and do anything and look great doing it. I thought, I honestly thought if they can do this, I have no more excuse. It was really that.

J: THAT SHOW WAS OCTOBER 20TH, 1967. ELEVEN DAYS BEFORE HALLOWEEN.

I: I just knew that, "Okay, you have no more excuses." If there's this big a gap between—I saw how unpopular and unprofessional this top-selling kid group was in that particular venue on that particular night— then hey, we've already got something in common [laughs]! We're unpopular and unprofessional! Let's go! Later I saw them at Cobo Hall (in May 1970) and they had become thoroughly professional and Morrison, you could tell, was less happy with the confines of that.

JK: PAUL WILLIAMS FROM *CRAWDADDY* SAID THAT HE SAW THE DOORS NUMEROUS TIMES AND THAT SURPRISINGLY MUCH OF THE JIM MORRISON STAGE WILDNESS HAD CUES FOR WHEN IT SHOULD HAPPEN IN THE SHOW.

I: That it was planned? Yes. Of course. Absolutely. Here's what everybody does. In the same sense that I had little hand signals starting out and then I found out later James Brown had lots of hand signals but I didn't know that anyone would come to those sorts of conclusions. Once you're starting to do more gigs and you're getting paid more for them and you begin to realize that it's to your benefit to have people show up the next time, right, okay, then what happens is you start thinking about a little bit of consistency. So if you're good, you leave the things you're gonna do open, but you find certain spaces for them so that there will be an arc. And by the time I saw them the next time, there was an arc to the gig. It wasn't total chaos, and at one point he leapt gingerly off the stage and ran Pan-like. It was beautiful! Ran like Pan. He did sort of an Isadora Duncan the length of Cobo Hall then back, finished the song but the song was performed very impressively by these great musicians and his voice was fuckin' great! Great singer! And then he added a detail like what was more like what I used to do at the Grande, he hung out in the hallways of Cobo Hall as the public was exiting. He did the opposite of the British, "I've got to run! They're all after me!" No, he was hanging out! And Dave walked up to him, "Hey Jim." He said, "Hey man." Yeah, 'cause he wanted to be down. But you do. You do. Of course you do. You put some arcs, but you might put the wrong thing in there. Like the dick might come out or something, y'know [laughs].

J: YOU GUYS PLAYED THE GRANDE TWENTY-TWO TIMES IN '68 WITH ALL THESE NATIONAL ACTS. THE FUGS, SLY AND THE FAMILY STONE, CREAM, THE MOTHERS!

I: Yes, and I remember them all! Yes!

J: WERE YOU FLIPPING OUT AT SOME POINT OR THINKING, "WE'RE BECOMING A PROFESSIONAL BAND."

I: No, it was more just like it was Christmas. It was better than college. It was like here I got to see all these people on this small stage up close and even their dressing room would be just on the other side...

J: ARE YOU MEETING THEM AT ALL?

I: Yeah a little bit, but not too much because I've never been one of those people. Scott Richardson was one of those, "Hey, we've got a great place where you can stay." And other people were like that. Some people, the MC5 would be combative with them. Me, I wanted to peek at how they did things and watch what they did professionally, but I've never been the sort of person who's gonna go try to make a connection. But when somebody puts it out there, I'm gonna pick it up.

J: AND ARE ANY OF THEM SAYING, "HEY, WE SAW WHAT YOU DID. IT WAS CRAZY." WERE YOU GETTING ANY FEEDBACK?

I: No, no. Not at that time. We just opened for these people, often third on the bill, and we just always watched and I remember almost every single show that any of them did. And usually what I'd do is we'd play our show, I'd calm down, and then I'd walk around the Grande. The culture at the Grande was there was a lot people in the middle who would watch the show, but it was built, maybe as a Hispanic influence, it was built with a very long, columnated prome-

nade all the way around the auditorium. So you could do what people do in Spain or Mexico at night. You have a little pa-ra-de. And the boys are usually walking one way, and the girls are walking the other way. And you meet a chick or you meet a friend of yours and you talk...

JK: DID YOU GET A SENSE THAT IT WAS A LATE 19TH CENTURY STRUCTURE?

I: No. Hindsight, as I later learned more about the world around me, I would go, "Oh shit!" and I'd be in Mexico and see that at night, and I'd say, "That's just like the Grande."

J: THE GRANDE WAS RUN AS A COLLECTIVE, RIGHT? THE PEOPLE WHO RAN THE GRANDE?

I: It was a collective. Russ Gibb was Andy Warhol. In the same sense that Andy Warhol had a collective, which means if he liked you, you got this little piece of paper that said you could have a free hamburger and chickpeas at Max's Kansas City if you didn't use it too often. You could hang out. You weren't gonna get paid. You weren't gonna make any decisions. So Russ ran it.

J: IN THE INTERVIEW YOU DID FOR MY BOOK *101 ESSENTIAL ROCK RECORDS* YOU TALK ABOUT HOW SEEING THE MOTHERS WAS KIND OF A LIBERATING THING FOR YOU. AND I WOULD IMAGINE THE FUGS MAYBE TOO? ANYBODY ELSE?

I: Oh, The Fugs. And I always forget to credit The Fugs. A big thing about The Fugs was I saw them when I was still in the Prime Movers at the Ann Arbor Armory. Tuli Kupferberg comes out dressed in combat fatigues with a toy machine gun and they open with "Kill for Peace." But before they open the song, he drags a huge canvas bag, sets it on the stage, and during the set proceeds to strip one costume and reach in it for like a bow and arrow or a fireman's hat or whatever it is and did this theatre. Did this running theatre as they played, and boy did I pay attention to that. That was very, very big for me. The Mothers were big more on record because there was a key moment when Scott Richardson was gonna try to hire Ron away and destroy our group. I think he saw me coming as competition, that he had a band together who could do more. We could only play the Grande at this point. He could play the Grande and the Hideouts, which is where the normal teen bands played doing covers with real professional musicians. So he brought Ron over to the house to offer him a gig, and it would have broken up our band. But Dave and Scott and I tagged along. Ron couldn't say no, so Dave and Scott Asheton I think got together, especially Scott, and said, "Don't do this." And the guys that Scott Richardson had playing in the group were so po-faced. They just had no personality, I think. The Quackenbush brothers, y'know. Just a couple of wallies, and they offered Ron a wage and everything and he turned them down. What I was doing during that three hours of crisis hell was what I always do when the people around me start to let me down. I say, "Well, okay you put that over here to one side and find something musical to do to, and go forward." So I saw this Mothers of Invention record. I'd never heard the Mothers of Invention. I'd heard of them, so I listened to them and laughed and laughed and really enjoyed all the conceptuality of all of it. But seeing them live, the main effect was the fear I felt to open for them. I thought, "How do you open..." I wanted to make sure nobody forgot a Stooges gig, so I did my first stage dive.

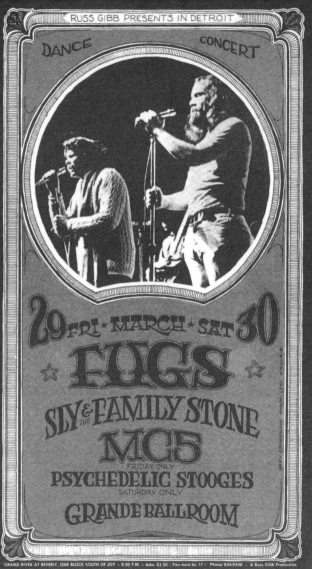

RUSS GIBB PRESENTS IN DETROIT

DANCE CONCERT

29 FRI ★ MARCH ★ SAT 30

FUGS

SLY & THE FAMILY STONE

MC5
FRIDAY ONLY

PSYCHEDELIC STOOGES
SATURDAY ONLY

GRANDE BALLROOM

GRAND RIVER AT BEVERLY, ONE BLOCK SOUTH OF JOY – 8:30 P.M. – Adm. $3.50 – You must be 17 – Phone 834-9348 – A Russ Gibb Production
ADVANCE TICKETS: Grinnell's – Hudson's – Trans-Love Store, 499 W. Forest – House of Mystique, 937 Plum St.
Sunday, March 31, 7:00 - 11:00, No Age Limit, Fugs, Sly and the Family Stone, MC5

RUSS GIBB

26 APRIL
RATIONAL
THYME
APPLE CORPS

SUN
APRIL
28

FIRST SHOW
PSYCHEDELIC STOOGES
CHARGING RHINOCEROS
OF SOUL

GRAND

Grand River at Beverly, one block south of Joy
Advance Tickets: Grinnell's, Hudson's, Trans-Love Store

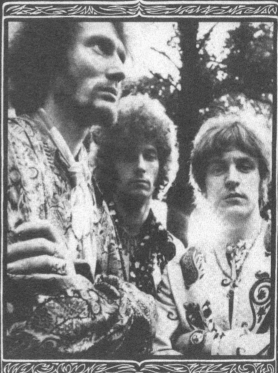

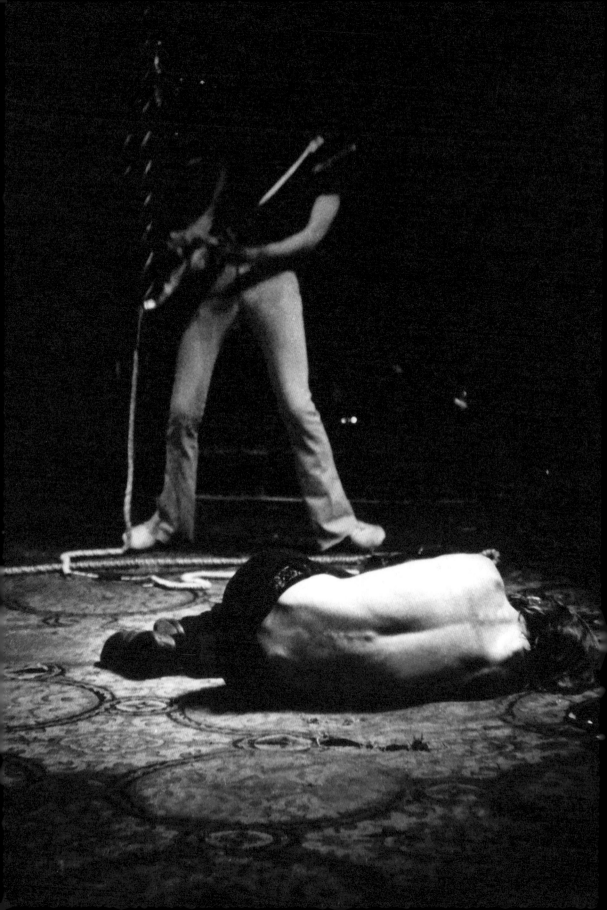

J: WHICH WAS PROBABLY THE FIRST STAGE DIVE.

I: Maybe. It was a stage fall where I just fell like a little kid, and two really big girls had approached the stage to watch. So I try to fall on them and they just moved. Blood everywhere, and that's that chipped tooth that is in all the photos.

J: AND DID THAT GET A RESPONSE?

I: Well no, nobody responded to anything I did for a long time until people started...Either it would be girls approaching the stage, men shaking their fists or giving me the finger, and then quietly other bands' roadies approaching us for positions because the reason to be a roadie in Michigan at that time was if you're not in a band and you wanted to get a sex life, the next best thing was to be a roadie.

J: AND DO YOU KEEP GETTING INVITED BACK TO THE GRANDE BECAUSE YOU'RE A DRAW? BECAUSE (PROMOTER) RUSS GIBB LIKES YOU?

I: I think a little bit of each, and I think the key thing was—and I saw this was gonna be necessary—was that we became protégés of the MC5.

Left: Performing "Asthma Attack" at the Grande, early '69. Photo: Robert Matheu.

J: SO ON AUGUST 11, '68 YOU PLAY A GIG AT A VENUE CALLED MOTHERS, AND YOUR ZIPPER BREAKS AND YOU GET BUSTED.

I: The other group, Jagged Edge had a singer named Stoney[13] and in some of the posters you gave me you'll notice that sometimes, we were billed over them, but other times earlier they were billed over us. So I thought, "I've gotta knock off Stoney." And Nico was with us at the time making me crazier and crazier.

JK: YOU MET HER IN NEW YORK...

I: Yeah, and she said, "I will come and live with you for some time." So I was learning to drink red wine, which helped me with the jitters you get when you take too much LSD too often, and I was taking a lot of it and it was usually cut with something horrible. Some sort of speed. So I was drinking more and basically we went to this gig, and I remembered, "Shit, that Stoney's pretty fuckin' good. How am I gonna follow this?" And I go out on stage, and it was a kind of mic I'd never worked before. An Electro-Voice stationary mic that I didn't realize had an on and off switch, so I thought it didn't work because I forgot to turn it on. So I was really uptight, so I went into these crazy dance moves and basically what happened was my zipper split on these unbelievable low-ride rubber pants that the MC5's wives had made for me. I wiggled off stage, took them off, and didn't have anything else I thought was right to put on, so I took a towel and did a strip tease. That's the truth. I did an it's on, it's off thing and finally went right out into the crowd and made sure I got a fucking reaction. I laid on the floor buck naked and writhed around like a tortured worm or a cavorting cat. Take your pick, right? So at that point, a huge circle of onlookers literally followed me like an amoeba around the floor, and I thought, "I'm getting a reaction. I'm getting away with this!" So I leapt back up on the stage, and jumped into the wings, and tried to make a getaway and it didn't work out.

J: AND YOUR DAD HAD TO COME BAIL YOU OUT OF THAT?

I: Yes, what they did was to punish me, rather than take me to the post they took me to state prison and luckily by the time I got there it was daytime, and it took them a while to book me and all that. So they transferred me to state on a higher charge and I called my dad or some-body did and said, "Jim's in state prison in Jackson." But as I got in there, all the guys were really nice to me. I was put in a cell-block with a bunch of heavy guys, and what was gonna happen was one of them was gonna be my husband when the sun went down. And on my way up to be put in the cell-block in my rubber pants with a busted zipper and a t-shirt and my perm—I weighed about a hundred-and-fifteen at the time—and I had sneakers just like those that were red, the guard sang this song I'd never heard. The words were, "Old King Cole's a merry old soul with a buckskin belly and a rubber asshole." So my dad came and got me and took me to the Dairy Queen and he was real quiet about it. He was not too pleased. He tried to give me some good advice, but was not screaming. Didn't say, "Oh I'm so embarrassed."

13) Dave "Stoney" Mazur fronted this group whose recordings would go unreleased until 2014.

Right: The zipper on Iggy's rubber pants split during this show, leading to his first "wardrobe malfunction" and first arrest. Psychedelic Stooges Concert Poster, Library and Archives, Rock and Roll Hall of Fame and Museum.

IN CONCERT

SUN.
AUG. 11
$2⁰⁰ 7:30-
$2⁰⁰ 11:30

A
SHOW
YOU WILL
NOT FORGET!
THE
PSYCHEDELIC
STOOGES AND
THE JAGGED
EDGE

MOTHER'S
DANCE-CONCERTS
LOCATED IN ROMEO-
15 MINUTES NORTH OF UTICA
ON VAN DYKE

LIGHT
SHOW BY
B-S ELECTRONICS

PHONE 752-
9206

J: LUCKY YOU.

I: I mean as you pointed out in your book [*101 Essential Rock Records*], there was "recessive artisans working in the dark alone" quality to the music the guys made in the group or even that I was capable of making. Somebody had to engage the public. Y'know what I'm saying?

J: TOTALLY!

I: On the other hand, the way in which I engaged the public was only possible because of a mysterious force that was the absolute exclusive possession of these three people. As simple as it was, they already had a way of locking with each other and listening with each other and there was what William S. Burroughs used to call a third mind between those three people. I could never really enter it. I was always the opposing thumb.

J: THAT'S INTERESTING. YOU ALWAYS FELT LIKE THE OPPOSING THUMB?

I: Yes, always. And it was always, "Hey, come on. Let's do a practice! Hey, that's a great riff! Let me try to put it..." It was always me coming in.

J: YOU WILLED IT INTO EXISTENCE WITHOUT BEING A PART OF IT.

I: Exactly, yes. That's right. I willed it into existence without being a part, and then of course what happened was that the manager is going to talk to me a little more 'cause I'm up earlier in the house and I will talk about problem things. I'm gonna take on all the tasks.

J: YOU'RE THE ADULT.

I: Yeah, but I was also the wacky personality. I was doing both at once.

J: BUT IT SEEMS LIKE THE DIVIDE BETWEEN JIM AND IGGY...

I: Was terrible. It was very hard to maintain.

J: JIM IS THE GUY RUNNING EVERYTHING AND IGGY'S THE GUY UP ON STAGE. IS THAT RIGHT?

I: Yeah, I was running things, but in a deferential way. But I was doing the work. Yeah, it would be like, "We can't play until we're full and stoned." I'd be the guy who actually scored the marijuana and went and picked up the food usually. But not totally. Ron was somewhat responsible. It went me, Ron, Scott, and Dave in the order of responsibility, I would say.

JK: AND ARE THE FELLAS AT THIS POINT STARTING TO NOTICE HOW GOOD YOU GUYS ARE GETTING? ARE SCOTT AND RON AND DAVE GOING LIKE, "DAMN," ONCE IN A WHILE?

I: Not exactly that, but we knew. We knew this was really something, but it was hard for them. It was harder for them than for me in the sense that—I always tell it like it is—at that point, I was the only guy that could get fucked after the gig.

JK: NOT EVEN SCOTT, HANDSOME DEVIL THAT HE WAS?

I: As handsome and beautiful a guy he is, Scott was painfully shy with women. Painfully shy. Like really shy. But as things went forward that started to change a little bit.

J: SO YOU GUYS HAVE BEEN TOGETHER NOT LONG, DANNY FIELDS (ELEKTRA RECORDS "HOUSE HIPPY") HEARS ABOUT YOU FROM JOHN SINCLAIR AND COMES TO ANN ARBOR TO CHECK OUT THE STOOGES AND THE MC5.

I: Here's what you had to do. I figured to make it at that time regionally, you had to play the Grande a lot, you had to be able to play the Hideout, which we were just getting to the point where we could do that, but that was not until we got the record contract actually but hadn't had the record out yet. That was more like late '68/early '69, and I thought it was key to ally with the MC5, who made a constant practice of playing free benefits all over the area. So we were playing the basement of the Unitarian Church,[14] Wayne State University Ping Pong Arena, every fuckin' weird place you could imagine free with the MC5.

J: JUST TO SPREAD THE WORD AND GET TO OTHER GIGS TO PLAY?

I: Yes, and also because they were the best reference for us. In other words, "Okay, this is sort of in the vein of..." I knew enough to not try to be one of those nine thousand groups that's gonna imitate the Stones or something, but it was good to have a local reference and a local ally and plus we thought they were really a cool band. And I was able to effect some of that through getting Jimmy Silver but also Fred ("Sonic" Smith, MC5 guitarist), who was the real backbone of that group, had been dating Kathy Asheton years before. She's a couple years younger than Scotty. She's the youngest kid. Through Kathy they met Ron and Scott and they liked Ron and Scott. Particularly Scotty had been friendly with Wayne (Kramer, MC5 guitarist) and Fred, so that helped too, and those people were very, very generous to us. Very generous, and I think it was good for them to have a group with a little life in it to spread their communal trip. So it worked out both ways y'know?

J: SO THE STOOGES AS THE "LITTLE BROTHER BAND" TO THE MC5 THING IS REAL...

I: Oh absolutely we were. During and up to the time we got signed, where you see that Leni Sinclair (John Sinclair's wife) picture of everybody together, that was at their house. But y'know whenever I'd run out of money to literally even buy anything to eat, I would walk into town, and I'd just go in the back of their house and I'd go to their kitchen and make myself a peanut butter and jelly sandwich. I had to just eat it, y'know? And I would just wander around. I was like "Cousin Ig," y'know?

14) Located at 4605 Cass Avenue, the First Unitarian Church has long been a community gathering spot in the Cass Corridor. The Dialog '68 Concerts featuring the MC5 and the Stooges took place there.

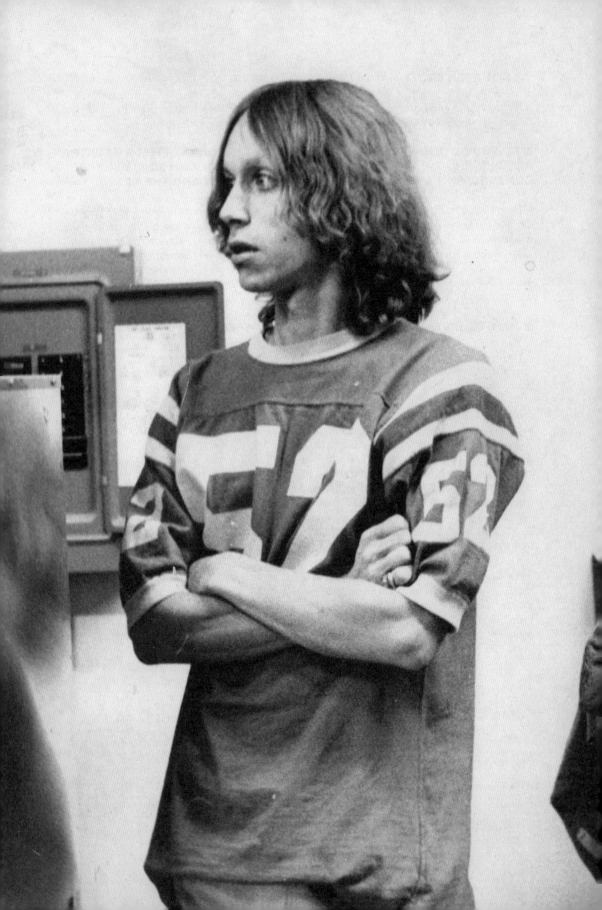

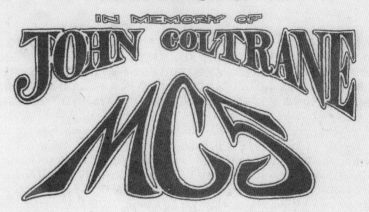

MONDAY ≈ SEPT. 23

IN MEMORY OF

JOHN COLTRANE

MC5

♥

UNION BALLROOM

ROCK CONCERT

LIGHTS ~ TRANS-LOVE

★ MC5 ★

★ STOOGES ★

★ UP ★

9 P.M. ~ MIDNIGHT

~ 1 DOLLAR ~

BENEFIT FOR MC5 & CHILDREN'S COMMUNITY SCHOOL

POSTER ~ ROBIN SOMMERS

Left: Iggy in a football shirt, probably at the Grande Ballroom, September 1968. Photo: Leni Sinclair. **Above:** Elektra's Danny Fields first saw the no longer psychedelic Stooges at a benefit for the Ann Arbor Children's Community School. The show paid tribute to an inspiration of the band, the late jazz saxophonist, John Coltrane.

3. ELEKTRA COMES TO DETROIT

J: SO DANNY FIELDS COMES TO THIS UNIVERSITY OF MICHIGAN GIG ON THE 23RD OF SEPTEMBER AND SEES YOU AND THE MC5 AND EVIDENTLY, THE ACCOUNT I READ SAID YOU SHOOED THE BAND OFF, THE AMPS ARE FEEDING BACK, YOU'RE WANDERING AROUND IN A MATERNITY DRESS AND WHITE FACE, SPITTING ON PEOPLE, AND DANNY SAYS, "YOU'RE A STAR!"

I: That's what I remember. I don't know if I was still wearing the white face and the dress at the time. I might have been just a little more raucous, but I definitely was working the crowd. You're talking about a beautiful old ballroom, lovely old wooden ballroom of moderate size, a few hundred kids sitting cross-legged enjoying, I hope, a concert by a band on a stage about ye high—about twenty-four inches, thirty inches high—and playing so loud in this oaken room that's made to amplify the sound of a solo violin because it's Belle Époque mentality.

J: IT'S A BALLROOM.

I: Yeah, and I do remember it as, "You're a star and I work for Elektra Records." I'm like, "Yeah right, he looks like a hustler to me." But I guess he really did, and Ron tells that he said, "You guys are stars." That could be too. I don't really know, but I think I remember him saying to me, "You are a star."

J: SO AT WHAT POINT DO YOU START TO SAY TO YOURSELF, HEY COULD THIS BE REAL?

I: Later that afternoon he got to our address. I think I said somehow, "Look, talk to my manager" [laughs].

JK: WAS THE REASON THAT YOU GUYS DIDN'T GO INTO A STUDIO BEFORE FEBRUARY '69 THAT YOU GUYS WERE BROKE OR WAS IT NEVER DISCUSSED?

I: No, you just didn't do that at the time. The corporate group was god. Acceptance by a record company made you a demigod in that the working person intuited at that time that the power was with the corporate group and most people are going to be worked into death and boredom by the corporate group, but that others apparently could be anointed and touched by the hand of the gods as artistes. So at the time, the first question anyone would ask you in the area—man, woman, boy, girl, didn't matter—as soon as you let it slip or it came up that you were going to make a record or you're making a record, "What label you with?" Now who gives a fuckin' fine fuck, right? And the new corporate tie and the new patronage is of course with film and commercials and TV. Through the licensing.

J: SO YOU GUYS HADN'T BEEN AT IT THAT LONG WHEN YOU CONSIDER THAT MANY DUES PAYING GROUPS WERE AROUND. HOW DID YOU FEEL THAT THIS WAS A GUY FROM ELEKTRA WHO APPARENTLY WANTED TO SIGN YOU AND...

I: I immediately went into terror. He said, "I'm going to bring the heads of the company out in a month to see you." So we arranged a gig in Ann Arbor in a converted bowling alley called the Fifth Dimension and I went into a panic of illness. I wanted to make sure I was so—just all

the things you're supposed to be at that time—skinny, androgynous, provocative, etc. I just laid on the floor in that room that you've got the wonderful pictures of. I wouldn't eat. I shit on the floor. I wanted to violate all conventions. I had already started this sort of thing in the Forest Court house when I used to hear James Brown say, "Get down." Get down, that's a good point. Let's get rid of the furniture. So I took all the furniture then in my room and set it on end. The bed was on end. The chairs were on end. The dresser was on end. Just screw everything up. Let's juggle. Let's have a new deal here. So I got very, very ill and crazy. And I was like 112 pounds by the time we did that gig. I remember that.

J: DO YOU REMEMBER ANYTHING ABOUT—

I: The Fifth Dimension was next to the bus station, very near, within two hundred yards of the bridge where a couple years later Scott tried to drive a ten or twelve foot truck under the nine foot bridge.[15] I saw Hendrix in that room!

J: WHAT DO YOU REMEMBER ABOUT THE GIG?

I: Just that I was very, very, very nervous because we didn't have a done deal yet. We did a three-song set for (Elektra founder and president) Jac Holzman and (Elektra vice president) Bill Harvey. [Laughs] Came out and we did "I'm Sick," "Asthma Attack," and it was "Goodbye Bozos" or "Dance and Romance." Then "I'm Sick" was a bolero, which later became the ending to "Ann." I wrote that on a Wurlitzer piano and the guys played it, so that was that. It started with this bolero and I flopped around on the stage going, "I'm sick! I'm siiiick! I'm sick! Blah!" And "Asthma Attack" was a descending chord change that I'd wrote—not the "Asthma Attack" as a freak out that's on bootleg, but it was a structured piece of repetitive descending chording that sounded a lot like "Interstellar Overdrive." I'd written two of the three, and it was B, A, G, E. Like a Who thing, and then I would wheeze and say, "asthma attack." And then the third, "Dance and Romance" sometimes called "Goodbye Bozos," was like "Little Doll." It was a Diddley jam and then you'd get the whole thing that would peak the energy. And they signed us. (Elektra signed both the MC5 and the Stooges on the same day, October 8, 1968, the MC5 got an advance of $15,000 and the Stooges $5,000.)

15) According to *Please Kill Me: The Uncensored History of Punk* (Grove Press, 2006) in 1971 Scott Asheton was driving The Stooges' equipment van home from a gig with two roadies, when the top of the van failed to clear the underside of Ann Arbor's Washington Street Bridge. All three occupants were injured and sent to the hospital.

Kokaine Karma

BY BOB RUDNICK/DENNIS FRAWLEY

EVO October 4, 1968

Elektra records has just signed the MC-5 and the Psychedelic Stooges(two rock groups that are by products of the multi-media community, Trans Love Energies. Their music is audience-involving, capturing the listener in a primitive frenzy of emotion unlike the arty, overproduced groups being hyped by all the record companies. It was rock 'n' roll that originally captured our adolescent hearts, sending stirring thrills to our feet and triggering romantic notions in the brain. These Michigan groups project the essence of rock—it's excitement. The MC-5 fuse their sound with avant-garde riffs and a physical involvement that is second in total theatre only to the Psychedelic Stooges who carry their burlesque and music right into the audience.

It is to Elektra's credit (especially the psychic awareness of Danny Fields) that they are opening the money vaults and recording the beginnings of a new era of American guerrilla rock bands. At last in this country the passion of revolution and the passion of music are united. But not in an atonal panorama of boring stilted images; instead their sound leaps in the joy of being free crashing down the walls of the established order the exuberant cries of freshly fucked teenagers and spaced out commando freaks shooting down frigidity with rapid fire orgiastic guitar runs as Iggy of the Stooges pisses his way to the White House.

The only group whose concept approaches the MC-5 is The Rolling Stones while the spirits of W. C. Fields, The Marx Brothers, Elvis Presley and The 3 Stooges are reborn in the psychedelic vagabonds from the Midwest.

J: AND DO YOU REMEMBER ANYTHING ABOUT THE ELEKTRA GUYS—WHAT WAS YOUR IMPRESSION OF JAC AND BILL HARVEY? WERE THESE GUYS STRAIGHT GUYS OR KIND OF HIP IN JAC'S CASE?

I: We liked them a lot, I was very interested in them. I remember that Holzman always had kind of a cute West Village, swinging, Austin Powers-art guy costume on. He would wear these little corduroy Levi-type jackets, and pants with the discreet flaring, wear these little newsboy caps you know. And they were just like, "Ok, great guys! Uh yeah, nice to meet ya!" I knew right off that it was obvious that Jac was intelligent and I could sense that he might probably be informed about a whole lot of things. From working the record store, I knew a lot about the records he'd put out, which included (Elektra's classical imprint) Nonesuch. Fuckin' Nonesuch. So here's the guy who has the label when I first heard Balinese gamelan for instance, so I knew that Jac was no goombah bimbo. My point is I usually think they're bimbos first. When I see the suit, I'm like, "Beep beep." Not Holzman. You know he'd go to like Paul Sergeant's on West 4th Street in the Village where they had Carnaby type clothes, right? So he'd wear a little corduroy cap and a little two-fer and I thought, "Oh, I could swing with this guy." He was cool. He was smart.

J: AND BILL HARVEY, WHO I NEVER MET, SEEMED LIKE A HARD GUY, BUT BOY, DID HE DESIGN GREAT ALBUM COVERS.

I: Yes, he did a good job for them. Absolutely. He was just a real gruff, no nonsense businessman. Of course he's gonna be grumpy dealing with fuckin' weird people. He was more the kinda guy who people hired to be a general manager of a business, you know. But he would wear a red and green tie because I think he was an art minor in school, in college. So he was like that. A tough guy with an art minor, ya know. Like he could get a job at CNN, know what I mean?

Left: This East Village Other column announced Elektra Records' signing of the MC5 and Stooges. *Kokaine Karma* was written by Bob Rudnick and Dennis Frawley, also hosts of a show on the Upsala College's radio station, WFMU. On a trip to New York, MC5 manager John Sinclair brought them a copy of the band's second independently released 45, "Looking at You/Borderline." The duo introduced Sinclair to Elektra "house hippie" Danny Fields who also hosted a show on the station. Fields soon travelled to Ann Arbor to see the MC5, and was introduced to The Stooges. **Right:** Elektra head Jac Holzman and vice president Bill Harvey first saw the MC5 and Stooges at this show. As the Stooges' Elektra contract is dated the same day, October 8, 1968, the decision to go ahead with the signings must have been made beforehand.

J: IT WAS AROUND THIS TIME, AT THE END OF 1968, THAT YOU MOVED FROM FOREST COURT TO A NEW BAND HOUSE ON PACKARD ROAD ON THE OUTSKIRTS OF TOWN; I'VE SEEN IT CALLED EITHER THE "FUN HOUSE" OR "STOOGE MANOR."

I: Well, I think Fun House is appropriate.[16] We didn't know it was when we moved in, but we knew it by the time we moved out. It was a very generously sized old farmhouse with a fairly—it wasn't stately—but a long driveway with a large green lawn and very mature trees like a humble Midwest version of a plantation, and it had been the center of a huge plantation, a very large farm that belonged to a man named Baylis. And then Mr. Baylis as he got older and had more relatives who wanted more money, they sold off bits of his farm to different subdivisions and finally to a parkway that was put through there. And it was wonderful and I have to give credit again, in key times, I couldn't have found us that house because I didn't know anybody culturally appropriate to help this group. I knew some rich kids I went to school with, poor kids from the trailer camp, and a bunch of odd art people, but it was the Ashetons' mother who found it through some people at school. So if it wasn't for the Ashetons, we never would have had the chance to rent that place. We rented for, I want to say it was a little under three-hundred bucks a month, and it had a downstairs, it had a living room, a family room, a kitchen, and a parlor, all of moderate size, and then also downstairs, two full bedrooms. So that's like six rooms. Upstairs there were two complete apartments, separate apartments with a landing and separate doors. One of them was kitchen, bedroom, and bathroom, and the other one was kitchen, bedroom, and bathroom with an extra living area. A very nice apartment, and then there was an attic. That was where I was, "I wanna be in the attic," but really it was because I always tried to serve the group. I think I have a little personal manager in me. So I wanted them to be happy and comfortable, and I deferred. But also, up there it was the treetops, and the trailer, my parents did the right thing to live in that trailer. It was all synthetic materials. It was wood paneling up there. I loved it. I felt so good, and the sleigh bed I liked the best.

J: WHAT KIND OF SHAPE WAS IT IN WHEN YOU GUYS MOVED IN?

I: Well it was just this, exactly like [the photo] but without all that stuff laying around. That's the only difference.

J: AND THE OWNER, FARMER BAYLIS, WAS HE OK WITH YOU GUYS?

I: No, he would come over. He was such a nice guy and it was so sad, and Ron would call him the Bear because he still felt proprietorial about the property. He built it with his hands, and when he wanted to see what was going on, we weren't very forthcoming. And the big thing with us, it was a conundrum because we didn't want to be mean to him. Ron had a kind, sensitive side particularly for folk. They're half Ukrainian, the family, which explains a lot: suspicious of outsiders, clannish, like their booze, y'know. The mother's Ukrainian, the father was not. The Asheton was the other side. So the conundrum was we didn't want to hurt his feelings, but we were smoking dope, and at that time, as you know...

16) Also known as Stooge Manor, the house at 2666 Packard Road was home to not only the band and its gear, but also manager Jimmy Silver and his wife and child, as well as various roadies and insiders. Iggy's first wife, Wendy Weissburg, moved in during their short 1968 union and, later, singer and model Nico lived here briefly. The video for Nico's song "Evening of Light," was recorded in the cornfields behind the house. The Fun House was eventually torn down.

Top Right: The Fun House, aka Stooge Manor. Jeff Gold collection. **Bottom Right:** A flyer for the Iguanas taped to a wall in the Fun House. Jeff Gold collection.

J: IT WAS REALLY ILLEGAL. TWO JOINTS FOR JOHN SINCLAIR AND GOODBYE, HE'S IN PRISON FOR TWO YEARS![17]

I: Exactly. We didn't want him to find out about that, y'know, so that was the thing. We put up the egg crates in the larger room, and the smaller room...You've got a picture. I don't know if it's from that room or not. It includes me and the Iguanas on a wall.

J: SUPPOSEDLY THAT WAS THE KITCHEN IN THE STOOGE MANOR.

I: Maybe it was the kitchen. I don't know.

J: AND THESE "DISASTER AREA" PHOTOS OF YOUR ROOM...ARE THEY REPRESENTATIVE OF...

I: Yeah! That's how it always was because that's how I wanted it to be. The main point was that...

J: I MEAN IT'S KIND OF LIKE YOUR STAGE ACT.

I: Between *The Stooges* and *Fun House*, I did get married briefly, and a girl came up there, very nice girl from a good family, and tried to clean it up. She tried to clean it up and put furniture in there, and she even brought a car with her. It was a hell of a dowry. I had a Firebird convertible, baby, but I just hated it. I couldn't take it because to me the idea was, for the person I was gonna be, I saw the order of life as a threat to the order of my music. That's what I thought 'cause I'm a fucking lunatic maybe or something, but that was what I thought.

17) In 1969, John Sinclair was sentenced ten years for giving an undercover narcotics officer two joints. He ultimately served two years after the Michigan Supreme Court ruled the state's marijuana laws unconstitutional.

Above: Iggy's bedroom in the Fun House. Jeff Gold and Johan Kugelberg collections.

Left and Right: Iggy's bedroom in the Fun House. Jeff Gold and Johan Kugelberg collections.

J: WAS THIS HAIR DRYER IN THE HOUSE?

I: That's in the house. That's Ron's. Ron had a room for a while off Jim Silver's. It was the extra room next to the apartment. That's where he kept the hair dryer and slept, and sometimes I'd use it too. No, like we'd take turns, one after another, before the gigs.

J: AND I DON'T KNOW IF THIS PHOTO OF (ROCK CRITIC) LESTER BANGS[18] AND DANNY FIELDS WAS TAKEN INSIDE THE HOUSE, BUT IT SEEMED TO MATCH SOME OF THE OTHERS.

I: I don't know where that is. It could have been the house, but that's a great pic of Lester.

J: DO YOU HAVE ANY RECOLLECTIONS OF HIM? I MEAN HE WAS SUCH A VOCAL EARLY SUPPORTER.

I: The big recollection of Lester, it's not good. Scott and I had this habit we would do when we knew somebody had some drugs and we wanted them, is we would just tail the person from about eight inches and lurk. And we used to do it to Lester, and it would drive him nuts, and he'd say, "Stop that! What are you doing?" "Come on Lester. We know you got some." That was about it really. Other than that, just that he always made sure to be a little grumpy. You know what I mean? He was already like some grandpa in some strange theatre piece or something. Always made sure he was a little bit grumpy.

18) Lester Bangs (b 1948 - d 1982) was an important and influential rock critic, who wrote for *Creem* and *Rolling Stone*. He was an early and enthusiastic supporter of The Stooges.

Top Right: Ron Asheton under his hairdryer in the Fun House. Iggy said, "The other guys all had hair problems...they would go to great lengths before the gigs to get their hair just right." Jeff Gold collection. **Bottom Right:** Legendary rock critic and major Stooges supporter, Lester Bangs, with Elektra "house hippie" Danny Fields, photographed by Ron Asheton. Jeff Gold collection.

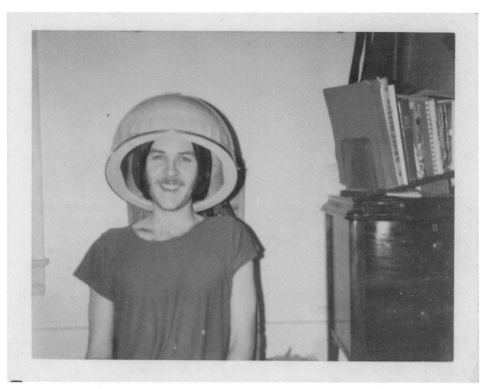

JK: ONE THING I WONDERED ABOUT IS THIS FIFTH ESTATE ARTICLE, WHERE IT TALKS ABOUT JIMMY SILVER AND JOHN SINCLAIR PLAYING TAPES AND FILMS OF THE BANDS FOR HOLZMAN.

I: Who said what?

J: IT SAYS JIMMY SILVER CAME TO NEW YORK TO MEET WITH HOLZMAN AND PLAY HIM TAPES AND FILMS.

I: That would probably be Leni Sinclair's films. You've seen them. The silent super-8s that are around. Leni started filming us right off I think. There's film around of me like doing the Indian dances and all that. There's black and white as well as color.

Elektra buys 5

In a lightning move, Elektra Records signed the MC5 and the Stooges to long-term recording contracts in New York September 26.

The move was engineered by Elektra's publicity director, Danny Fields, who flew out to hear the bands last weekend at the Grande Ballroom in Detroit and the Union Ballroom in Ann Arbor, where the 5 and the Stooges were playing a benefit for the Children's Community School.

Fields returned to New York on Tuesday morning and sent for John Sinclair and Jimmy Silver of Trans-Love Energies the next day. The two young rock and roll magnates conferred with Elektra president Jac Holzmann, played tapes and films of the groups, and quickly reached agreement with the company.

The MC5's first album will be recorded live at the Grande Ballroom late this month or early in November, as soon as Elektra can get an engineer out to Detroit. The recording will be produced by Holzmann himself and coordinated by Trans-Love Energies.

After the live tape is recorded Elektra will fly the 5 to Los Angeles to mix the tapes and do some studio recording in Elektra's new west coast studios.

A single release is tentatively scheduled for early December, with the album itself due around Christmas or early January. A 16-mm color film of the 5 will be produced by Trans-Love Energies for release with the single, which will probably be "Kick Out the Jams"/"Rocket Reducer No. 62."

The Stooges will be recording in Los Angeles in late winter, with their initial album release tentatively scheduled for Spring 1969.

The MC5 recording session will be held on a Wednesday and Thursday night at the Grande Ballroom and will be open to all the band's friends and neighbors -- free! Details will be released in the next issue of the Fifth Estate.

Elektra also plans to introduce the two Ann Arbor groups to their New York audience around Christmas-time in a dual concert, as soon as they can arrange the proper facilities in the city. The MC5 are planning a road tour to coincide with the release of their first Elektra single and will be in the Detroit-Ann Arbor area until then.

Above: An article in Ann Arbor's underground newspaper, *The Fifth Estate*, announces Elektra's signing of hometown heroes the MC5 and Stooges. Jeff Gold collection.

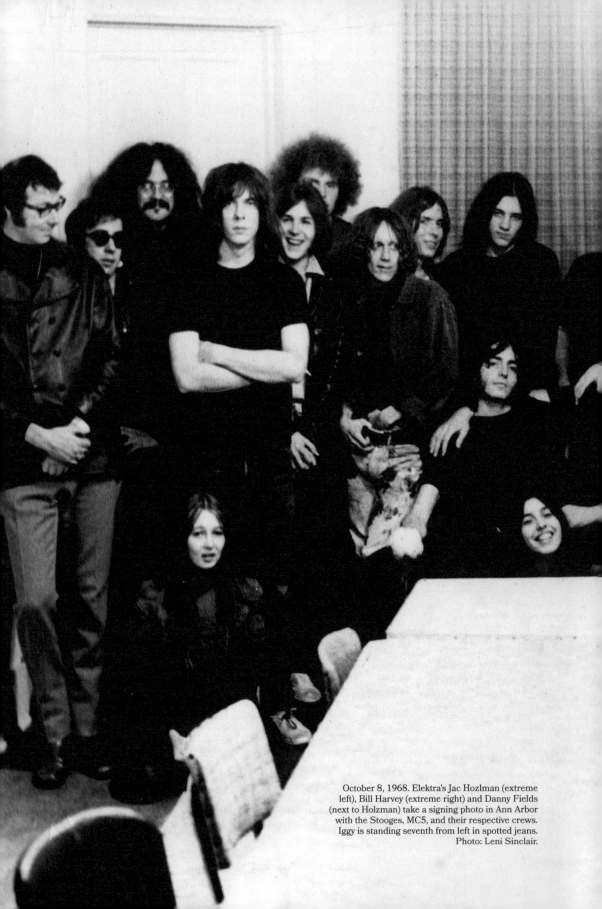

October 8, 1968. Elektra's Jac Hozlman (extreme left), Bill Harvey (extreme right) and Danny Fields (next to Holzman) take a signing photo in Ann Arbor with the Stooges, MC5, and their respective crews. Iggy is standing seventh from left in spotted jeans. Photo: Leni Sinclair.

J: SO YOU SIGNED A DEAL WITH ELEKTRA, AT THE SAME TIME AS THE MC5 DID. WERE YOU ON CLOUD NINE?

I: I can't remember. We never really talked much to each other, but I felt that we needed some real songs. What happened was the pressure was to come up with real articulated songs, and the guy who really stepped up at that point was Ron Asheton, who came up with two riffs that you could start staking a career on. I knew that at the time when I heard "Dog" and "Fun," and I think what he did was he mixed a little Velvets, a little Ravi Shankar, a little Who, and just a dab of Hendrix to get those. I know which Hendrix song he was fooling around with before he hit the riff on "Dog," but I am not gonna go there. No, it's okay. "Highway Chile." It's the same chords [hums the chords]. But then he started playing it like the Who, but with the opens, he had like a Velvets or a Raga record. I had been playing him a lot of raga. We both loved the Velvets, and he let the amp talk.

So he came up with those two. For a long time as we were getting ready to record, we'd go out and play and develop the material live and we'd just play the riff over and over. And I thought they needed to be articulated, so I bought a cheap wooden guitar in a plastic bag for thirty-two dollars with nylon strings. You know the type. In a clear plastic bag. They still sell them. And I learned cheater chords, just anything you could do with one finger. I started putting wrinkles in them. So when you hear the little rhythmic change for the chorus, that's me. And then you hear the changes [hums the riff]. That's me, and the idea was...I'd heard in R&B different devices they use to depart from a motif, from a funk riff, and then bring it back and make it sound twice as heavy.

JK: THE J.B.'S OR FUNKADELIC.

I: Exactly, so in the beginning, the false start to "'69," that was my idea and that was from the J.B.'s. That was from where it goes to the bridge and it floats and then when it ends it's like, "Wow." The change on "Dog" is Eddie Floyd. To me, it's "Knock On Wood" [hums "Knock On Wood"]. So we had [hums "Dog"] to go to the D and just lay on the E and it does come back in a much more powerful way I thought, and also gave it more articulation to make it more like a song. But the main contribution was the riff and the words and the same in "No Fun."

"1969" we ripped off from an interlude on a Byrds album. They were more folky, but one song ("Tribal Gathering")—we'd heard it back in Freeland Road in the professor's house—had a wicked solo: all of the sudden, they'd break for eight, twelve bars on that riff and they didn't do anything with it. And we thought, "Whoa, we..." And I don't know, Ron says it was his idea. I thought it was mine. It doesn't matter.

J: HOW ABOUT "WE WILL FALL?" IS THAT A BUTTERFIELD "EAST-WEST" KINDA THING?

I: "We Will Fall"...the idea was to give Dave a song. Dave didn't write, so Ron said, "Listen, we should have a song that he writes." He brokered it to me. Dave would always be the one that would be into the Eastern religion or he was the one like with the Timothy Leary "tune in, drop out." He was a dreamy type of a guy. Dave had liked this chant, "Om shri ram jai ram jai jai ram." I think it might have been me that put the actual melody as such as it was, but that's not so important. Everything I ever did in the group as far as melodic ideas or changes, it's very simple songwriting, pedestrian 101, but not everybody can do it and none of them ever learned to do it ever. Tension release, that sorta thing.

J: AND SO IT SOUNDS LIKE AT THIS TIME YOU'RE KIND OF THE SHOT-CALLER WHO'S TAKING EVERYBODY'S IDEAS, INTEGRATING THEM, FIGURING OUT WHAT IS ACTUALLY GOING TO HAPPEN...

I: Yes, but I'm not any more important as a talent as anyone else in the group. Somebody had to put it all together and herd everybody. And everybody played wonderfully. Dave liked to practice less than anybody else. If you listen closely to the longer versions of "No Fun," there will be times where you can hear his fingers get tired toward the end [laughs]. But on the other hand he makes up for it: he'll do these improvisations where he's just looking at the strings and going, "I think I'll just go over here and see what happens." A real musician will never do that. They'll always play something more obvious. And so you can hear him having fun and amusing himself and it makes the music special.

JK: WAS THERE A JOHNNY CASH CONNECTION TO "NO FUN?"

I: Yeah, well the change from "I Walk the Line." Yeah, that was my idea, but Ron had the riff. I mean honestly—other songs not withstanding—the riff to "I Wanna Be Your Dog" is the one instantly recognizable and memorable message in the entire history of this group, and ever since then whatever incarnation of the band it was, once people did start to get to know us... boy, start that riff and everybody knows and everybody feels like they're gonna have a good time [laughs].

October 4 , 19 68

Messrs. James Osterberg Jr., Ronald Asheton, Scott
 Asheton and David Alexander (PKA "THE STOOGES")
2666 Packard
Ann Arbor, Michigan

Dear Sirs:

 This will set forth all of the terms of the agreement under which we have engaged
you and you have agreed to render your unique artistic and professional services for
the purpose of making phonograph records.

 1. This agreement shall commence on October 8, 1968 and shall continue in
effect for a term which shall consist of an initial period of one year fr
such date, and the additional period or periods, if any, by which such term may be
extended through our exercise of the options granted to us herein.

 2. During the term of this agreement you will render your services at recording
sessions at studios, times and places to be designated by us, for the purpose of making
phonograph records. The musical compositions to be recorded shall be determined by
mutual agreement, but in the event of failure of such agreement, they shall be deter-
mined by us. You agree to repeat any work hereunder until the master recordings are
deemed by us to be satisfactory for the manufacture and sale of phonograph records.
During each period of the term hereof, you will perform for the recording of satis-
factory master recordings which shall constitute a minimum of __twenty-eight__
78 rpm record sides, or their equivalent. Additional master recordings shall be
performed by you and recorded by us at our election.

 3. As sole and exclusive compensation for your agreement to provide your
services to us, for all of the services to be rendered hereunder, and for all of the rig
granted to us herein, we agree to pay you a non-returnable advance against royalties of
__FIVE THOUSAND ($5,000.00) DOLLARS*__
for each set of __fourteen__ 78 rpm records, or the equivalent thereof,
recorded hereunder, which sum shall be payable within fourteen (14) days of the satis-
factory conclusion of the recording sessions embodying all of the performances to be
included in the said recordings. Any payments in connection with your services here-
under made to the A.F. of M., AGVA, AFTRA, or other unions, shall be a credit against
and deducted from the non-returnable payment set forth above and shall also consti-
tute an advance against royalties.

 4. (a) We will pay you, as more fully set forth elsewhere herein, the applicabl
royalty set forth below in respect of 90% of the average wholesale price (less all
taxes and the cost of the container) in respect of 100% of all phonograph records emb
ing on both sides thereof only compositions performed by you and recorded hereunder
manufactured and sold by us for distribution in the United States of America, and
for which we are paid. We shall have the right to deduct returns and credits in com-
puting the number of records manufactured and sold hereunder.

 APPLICABLE ROYALTY RATES:

 In respect of "pop singles" and "EPs": 10 %

 In respect of all phonograph records
 other than "pop singles" and "EPs": 10 %

*Artists acknowledge that ONE THOUSAND ($1,000.00) DOLLARS of
figure has already been paid to them.

- 1 -

18. If we have exercised the option granted in paragraph 17 hereof, we shall have another option to extend the term of this agreement for a second additional period from October 8, 1970 to October 8, 1971 upon all the terms and conditions herein contained.

19. If we have exercised the option granted in paragraph 18 hereof, we shall have another option to extend the term of this agreement for a third additional period from October 8, 1971 to October 8, 1972 upon all the terms and conditions contained herein.

20. If we have exercised the option granted in paragraph 19 hereof, we shall have another option to extend the term of this agreement for a fourth additional period from October 8, 1972 to October 8, 1973 upon all the terms and conditions herein contained.

21. This agreement sets forth the entire understanding between the parties with respect to the subject matter hereof, and no modification, amendment, waiver, termination or discharge of this agreement or any provision thereof shall be binding upon us unless confirmed by a written instrument signed by an authorized representative of our company. No waiver of any provision of or default under this agreement shall affect our right thereafter to enforce such provision or to exercise any right or remedy in the event of any other default, whether or not similar. The validity, construction and effect of this agreement, and any and all extensions and/or modifications thereof, shall be governed by the laws of the State of New York. This agreement shall not be binding until signed by both you and us.

Very truly yours,

THE ELEKTRA CORPORATION

By _____

I hereby accept the terms of this agreement between THE ELEKTRA CORPORATION and myself and agree to be bound thereby.

Ronald F. Asheton

Social Security No.

Social Security No.

David Alexander

Social Security No.

Scott Asheton

Social Security No.

James Osterberg Jr.

Social Security No.

The first and last pages of The Stooges Elektra contract; they received a $5,000 advance. Their much more established "big brother band," the MC5, had released two singles independently and were signed for $15,000. Jeff Gold collection.

- 5 -

4. THE STOOGES

Above: The band records *The Stooges*. Photo: Glen Craig. **Right:** Stooges manager Jimmy Silver writes to Danny Fields expressing enthusiasm for Elektra's choice of John Cale to produce their first album, and "the cash has made all of the boys feel better." Though the band signed with Elektra as "The Stooges," Silver is still using "Psychedelic Stooges" stationery. Geoffrey Weiss collection.

Danny-

 Just got home and wrote to Jac to thank him for the money...
I also told him how much we like the idea of having John Cale produce
the boys...and we do. Jim super likes the stuff John did on the last
cut of the Nico album and Ron is really into the fact that we will
now have the a producer. A producer will make it so much easier for
us in so many ways, especially someone like John. I don't even know
him at all except to have talked to him for about five minutes in
your office, but I just know that we're all gonna do it just great.
I was thinking about the whole idea all the way home and the more I
thought about it the more enthusiastic I became.

 Jim is much healthier than when I left him but he is still very
flippy from being so sick and it's going to be a while before he's
really in top shape. He says he can put out a good performance next
week, though, and I have complete faith in him...the cash has made
all fm of the boys feel much better: concrete action is always the
best token of affection - it's so real. Three grand is like a drop
in the bucket but it's super good right now and the timing is right
in there.

 I'm so embarassed...I don't know what ever made me think the moon
was in Virgo the other day: the sun and moon were in conjunction in
Libra (my solar and lunar low point for the entire year, naturally),
and at just about the time that you asked me when the moon would enter
Scorpio - the moon was entering Scopio (new moon at that). Anyway,
so much for my Stellar Confusion.

 A favor before I go - could you have Tinker send us a couple of
those Eye reprints about the Doors? And...Michael Magic Marker said
that he'd get us a copy of the Group Image's record so we could get it
played for him out here, and I think he's going to give it to you to
bring with you next week. I also wrote to him and told him that I
didn't think we could swing it to bring him out here Halloween to hear
us, although he said he was into doing some nice things for us in NY
if he got the chance.

(over)

the elektra corporation 1855 broadway (corner of 61st street) new york city new york 10023 ju 2-7711

March 4, 1969

Mr. Jimmy Silver
2666 Packard
Ann Arbor, Michigan 48104

Dear Jimmy:

The recording dates are now set and confirmed, and I am listing
all details below:

 Studio: THE RECORD PLANT
 317 West 44th St., New York City
 Studio A

 Dates: March 17 - 1:00 PM to 7:00 PM
 March 18 - " " " "
 March 19 - " " " "
 March 20 - " " " "
 March 21 - " " " "

I am sending copies of this letter to all those involved.

Best wishes.

 Sincerely,

 Pearl Goodman
 Sec'y to Jac Holzman

cc: John Cale
 Danny Fields

cable address Folkmusic New York

Left: Jac Hozlman's secretary writes to Jimmy Silver with initial recording dates for the Stooges debut. Sessions were eventually pushed back a month, and the recording studio changed. Jeff Gold collection. **Below:** Ann Arbor, 1969. Photo: Glen Craig.

19) Jerry Ragovoy was an important American Record producer and songwriter; Bernard "Pretty" Purdie is a legendary American session drummer who bills himself as "The World's Most Recorded Drummer."

J: SO IN APRIL YOU GUYS RECORDED AT THE HIT FACTORY EVEN THOUGH THIS MEMO SAYS RECORD PLANT?

I: Yes. It was a little tiny room over a peep show run by Jerry Ragovoy, and Pretty Purdie's[19] drums were set up there. Said "Pretty Purdie" on the kit. And then when we wanted to play loud, they said, "ARRRRGGGHHH...Jerry Ragovoy...and 'Cry For Me' was made here." And I said, "I don't give fuck about fucking Jerry fucking all this fucking..." because I didn't have any respect and I was being threatened by people who didn't get it, y'know.

JK: DID YOU HAVE A RELATIONSHIP WITH (VELVET UNDERGROUND BASSIST/ VIOLIST) JOHN CALE PRIOR TO YOU GUYS STARTING TO WORK TOGETHER?

I: Yes, I liked him. When he was gonna produce us, he came out, and he and I talked. And when we went to New York, we came before the sessions, and I went and visited. He had an apartment with Betsey (Johnson, his fashion designer wife) just north of Houston around, say between Mercer and Bleecker where the student housing is, somewhere around there. At that time, I had never been anywhere like that, and I went down there and I was like, "You live here? Oh my God!" Because it was like this really nice modern building in the middle of a war zone, y'know. Just heavy, heavy area and he had a beautiful, beautiful pink Rickenbacker bass set up with a nice bass rig as art right in the middle of their room and I was already wearing her clothes. They had a Paraphernalia (Johnson's boutique) in Ann Arbor, and I didn't know who she was. I used to just go over there and buy the clothes.

J: HOW DID YOU GET ON WITH HIM IN THE STUDIO?

I: For a certain kind of artist when you want to make a good record, you're gonna make it a better record when the producer is a personality, not just some sort of technician. So we had John and then shortly thereafter it was John and Nico sitting there. And John wore to the sessions a Dracula cape that he owned and Nico would sit there in some weird European peasant shawl, knitting, and the two of them, it was really like the Munsters.

J: IT'S BEEN SAID THAT YOU CAME TO NEW YORK WITH WELL-REHEARSED VERSIONS OF "I WANNA BE YOUR DOG," "NO FUN," AND "1969."

I: One more maybe, and "Ann."

J: AND DID LONG, FREAK-OUT-Y VERSIONS AND JAC HEARD IT AND SAID THEY DIDN'T WORK.

I: He was right. I was really worried. As soon as I heard them back, I realized, "Oh my God." It would get to the outro solo, and Ron would play something fantastic for about up to thirty, forty seconds and then it wasn't. A little longer on, "No Fun." But eventually, I would be sitting there and I'd think, "Okay, this is not interesting to listen to. Maybe if I smoke another joint." So I'd try that. I've done this all my life. "Maybe if I go to Miami," or whatever. And it wasn't working, and it really took a good record guy...John would have let that pass because he would have an avant attitude, "Well, it just shows the way these delinquents run out of ideas, and that would be, for instance, very interesting in a music theatre." Y'know, blah blah blah, right? According to LaMonte Young or whatever, right? But Jac just came right in and said, "No. No, this is not..."

J: DID YOU PUSH BACK AGAINST IT?

I: Not at all. We just immediately said, "We've got more."

J: YOU KNEW THAT HOLZMAN WAS RIGHT WHEN HE SAID THAT YOU NEEDED TO WRITE SOME MORE SONGS AND GO BACK INTO THE STUDIO? THAT HE KNEW YOU HADN'T MADE A GREAT ALBUM YET?

I: Yeah, I know when people are right often. I still make lots of mistakes and I've fucked up so many different times in my career, but sometimes I know. Sometimes I know. So we wrote the other songs. I think we had three days until they were gonna put us in another studio. They put us in a different studio. It was ABC. It was a wonderful, modern studio. And I think the way it went was Ron had the riff for "Real Cool Time," which is so beautiful, and I did words, and I think Ron had the entire progression. Well, y'know there is no progression on "Real Cool Time." "Not Right," he wrote the whole thing and I did the words very quickly. We also had "We Will Fall," so three new ones. And "Little Doll" I believe I came up with just sitting in the lobby of the Chelsea [hotel] saying, "Well wait, we can use like the riff from 'Upper and Lower Egypt' cause we all liked Pharoah Sanders, and just sing this and that." And I saw one of these New York girls with a big cigarette, and I thought, "Yeah, I could sing like a Jerry Lee Lewis type of 'paean to a cheap chick.'" And the lyric, from Jerry Lee Lewis, at various times he would credit, "The soul of rock and roll is in the young girl." I think I just told those guys play it like that and then go to the change and out. Ron might have thought he wrote it and that's possible, but the main thing was again how he and Scott played it.

There's an interesting technical point that I want to bring up. Ron Asheton having been a bass player, never at this time played with a normal white guy blues asshole set of guitar strings. Most guys play with the lightest possible strings to make it easier to do all this shit, but Ron was used to big bass strings so when he started, he played with a set of super heavy strings.

JK: LIKE THE GUY IN BLACK SABBATH.

I: That makes sense because that makes a whole different sound, and it's easier to record somebody like that. So the initial album pressings were done by people who didn't get the band, a folk rock label, and didn't care and were very careful about the needles [and the potential for records to skip]. I noticed that when the CD revolution came in, of the three albums, this was the one that suddenly burst from the CD, seemed much more natural, musical, and louder. And that is a lot to do with because he played with the heavier strings, the compression, he had a more believable sound.

J: YOU KNOW THE OTHER INTERESTING THING IS I WAS LISTENING TO *METALLIC K.O.* A LOT LATELY, AND ON THAT RON PLAYED LEAD GUITAR ON BASS. A LOT OF THAT BASS PLAYING IS NOT CONVENTIONAL BASS PLAYING. IT'S FANTASTIC.

I: I know, I know, I know. Part of that, he always had that wonderful jumpy style as a bass player. Big influence was the guy from the Pretty Things and also Bill Wyman. But then after he played guitar for quite a while he became really fluent, so when he went back to bass...he would call me up late at night here, and he would say, "Okay, I've been listening to *Raw Power* and it's true. I am my own favorite bass player." [Laughs] And he'd hang up the phone.

J: I LOVE THAT LINE YOU HAD ABOUT "THERE MAY HAVE ONLY BEEN ONE HUNDRED WORDS ON THE FIRST STOOGES ALBUM, SO YOU MADE EACH ONE COUNT."

I: Yeah, try to keep it short. [Kid's TV host] Soupy Sales had that when I was a kid. "Now kids, write in your card to Soupy when it's your birthday, but keep the letters to twenty-five words or less." I never wanted to succumb to wannabe Dylanism. All these people writing these great huge piles of shit because Bob could, but they couldn't, so I tried to make it all decent.

Jimmy Silver said in that interview that I wrote some things down, so I guess I did do some writing too. Basically yeah, throw it out, throw it out, repeat it, repeat it, get it down, and just don't do anything that doesn't feel right. I was only aware of Soupy Sales and the idea, just the idea. It was also the way I dressed. Like what I liked to do, I liked to get a very good quality knitwear, a good English like a Pringle shirt, but I'd wear it with all the buttons unbuttoned, and I'd wear it for two months. So things like that, it was try to make a simple, beautiful style. I think I got that maybe from some of the richer prep kids, I watched how Ricky DuPont dressed, and my girlfriend at one time was, I can't remember her name now, but she was a Reynolds heiress from the aluminum company. I met her father. I was a house guest for a while with them. I learned about the finer things and also a certain taste for just really clean simplicity. It was there in, if you listen to like "Farmer John." She's the one with champagne eyes, y'know? And you wanna get that across nicely.

JK: AND GREAT R&B AND SOUL LYRICS ARE THE SAME THING.

I: Yeah, and a lot of it was advertising too. I was listening to a lot of advertising jingles.

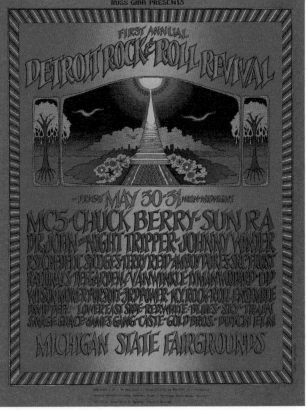

Left: Iggy, pictured for the first and only time on a Grande handbill, April 1969. Michael Storeim/Classic Posters collection. **Right:** Iggy's parents first saw the Stooges at the Detroit Rock & Roll Revival in May 1969. Michael Storeim/Classic Posters collection.

J: SO WERE YOU CONFIDENT GOING INTO THE STUDIO FOR THE FIRST TIME? WELL, THE SECOND TIME I GUESS?

I: We thought the songs were good and everything, but we really had a panic about the whole sound of the thing and we had less of a panic in the second go. Y'know we didn't have any cassette machine. Everything we learned to play, we just did it by memory. And we went home and it wasn't even April yet and the thing didn't come out until August.

J: THEN JUST AFTER YOU RECORDED THE ALBUM, YOUR PARENTS CAME TO SEE YOU PERFORM FOR THE FIRST TIME. I WONDERED WHAT THEIR REACTION WAS.

I: The first one I remember—I asked them to go—it was some sort of a festival and it was at the Detroit, some sort of racetrack there.

J: MICHIGAN STATE FAIRGROUNDS. IT WAS ON MAY 30, 1969.

I: That's it, and my father said after, he told me, "Well Jim, you remind me of a young pitcher I would work with as a baseball coach." He said, "It's a lot of flash, but you lack control." And my mom said, "Well your dad kept getting up and stretching to look to see what you were doing." [Laughs] She was trying to encourage me. He was aghast at one point. I played once right around that time in Dearborn (May 24, 1969) where he taught, and there was a review that came out, "Pop Goes the Bottle. Bring Back Elvis." What happened was I was a little drunk and there were these girls staring at me in the front row and I didn't know how to handle it yet and I wasn't sure what it meant and I felt like I wasn't connecting with the room. They had a big spot on me and I wasn't used to having a follow spot and I thought it would look great if I go over and take my wine bottle and smash it against the microphone and watch all the glass shatter in the light. So I did that and then after I did it, this young pretty girl in the front row who had been just staring at me, suddenly she held up her fists like this and her arm was covered in blood so she got cut slightly and she was a little miffed. I had these tendencies weaved in and out. Took me a while to become conventionally confident. So that upset him because he was like, "I work there in Dearborn. Should not be doing this to me." Much later there would be things like he might catch me with a girl when I would have these periods when I'd have to come back home when I'd be out of money. He'd say, "Well at least thank God you still have your natural drives," because I think one of his big fears was that I'd become a homosexual.

J: JUST BECAUSE OF SHOW BUSINESS AND YOUR ACT?

I: I think the way I looked and my act and the way I was dressing and the people I was associating with.

Dear Danny —

Just thought I'd write you about Saturday night's performance since you're just about the only people I know who would be interested. It's really about what I saw in it... maybe just what everybody sees... but it was the first time I really experienced what everybody seems to say about the sexual revolution in r'n'r and what you seem to see in the band.

We were in this dive (one Crow's Nest West) with about 100 kids, and the other band was fucked up (bass was broken), so they went on about 10 PM doing a drum-guitar duet, and after a while Jim starts singing with them and they start playing about 50 feet above their heads and the bass player steps up and starts playing 3 string bass and after a while they get really out there and Jim steps down and for about five minutes they played music like I'm sure they've never played or heard before.

Then we go on and play pretty good (borrowed fucked-equipment, etc.) and finish in about 35 minutes. (over)

Pretty soon the owner comes down to the dressing room
bitching, "too short", "½ the money" etc. etc... So Jim says
fuck I'll go do my flamenco dance, who wants to jam with me,
... and the band goes upstairs and John sets up the amps again
and they start playing. Soon Jim's shirt comes off and the
group start really working out, Scotty right in the middle
moving with the grace of some black-maned lion at the drums,
and Ron and Dave on either side, twisting and writhing
like madmen, insane music just blasting.... and Jim
half naked, perfectly erect, way up front of them, almost
stock still, bathed in this pale white light...

　　　Just like some crazed body, the band moving crazed
with Jim an erect hard white dick RIGHT THERE...
it was indescribable....perfect

　　　And that was it. Intellectually I always knew that
was it, but right then... IT WAS. Far out. Anyway,
it can't miss, it's the real thing.... I'm speechless. Not
by what the show was or is but by my own realization
of it. Just thought you'd appreciate it.

　　　　　　　　　　　　　　　　　　Jimmy

P.S: Heimall will have the pics for you at the end of the
week. See you in a couple of days.

Manager Jimmy Silver writes to Danny Fields about an extraordinary gig. May 27, 1969. Johan Kugelberg collection.

MC5!
STOOGES!

HELP ME KEEP
MY DADDY
OUT OF JAIL

all proceeds go to the
John Sinclair Defense Fund

TATE BLUES BAND!

Legal **S**elf **D**efense

Wednesday July 23rd 7-11 pm - $2.- Grande Ballroom/Det

IS ROCK and ROLL HERE TO STAY?

his is a rap all about rock and roll. But this special offer ever be repeated: I'm leavin here. By the time you read this, one year on the Barbary Coast, I'll be long gone, rockin down ad to Tijuana, and all them native dancin girls.)

by art johnson

IGGY AND THE STOOGES: A REVIEW

gy was the first rock and roll star I know to use raw hamburger act. He rubbed it all over his body and raw chest and then ate Wiggy Iggy is with The Stooges, yet another macabre feature seamy side of Detroit, my town. When I was there a months ago, I saw The s for the first time at the k Pop Festival.

festival itself blew my I had never been to one , I went with John Sinclair s wife, Lenny. John wanted n me on to the powerful hat was goin on, and it id. You heard about Wood- "Passive, polite and help- the tv commentator des- the half million hippies who

were there.

Well, Sagatuk was a far cry from Woodstock. Them half million hippies would have been stomped on, ground up, and eaten like Iggy's hamburger by the motor city crowd at Sagatuk. The night before we got there, there had been a minor war over possession of the hill behind the grandstand. Some farmer tried to hold off five motorcycle gangs with a shotgun.

Sagatuk was overrun with drunk and half crazed greasers and organized gangs. The Highwaymen, who are the MC5's favorite gang, got in free for guarding the outside fence. Me and this friend of mine, Danny, who quit as vice prez of God's Children to become the White Panther house mechanic, had a job keeping creeps and maniacs out of the fenced in backstage area.

What we did, we would let people in backstage to see the stars in exchange for a six pack (or some feelies) and got so fuckin blasted I barely remember John late that nite draggin me outa

IGGY

there as people started stompin each other into the ground.

But the Stooges, anyway, were truly macabre. Iggy, the lead singer, is very weird and very sick, and he sucks off the microphone when he sings, and does all kinds of contortions with his double jointed body as if he were a trapezoid.

The Stooges have a new record out with Electra, but you probably won't like them if you dig the Fillmore bands. You will really dig them if your idea of rock and roll never got any farther than Eddy Cochran singing Sum-

merume Blues.

GIVE US BARABUS!

The Red Mountain Tribe threw its first annual true life stomp down bring yer own rock and rabble dance party at the High School in Berkeley last Saturday night, and everybody was higher'n a kite. Free music was the name of the game, and a thousand of the most low down sorts you ever seen outside of the detention home walls bopped in off the streets.

Osceola, Backwater Rising, Commander Cody, and Wilderness all woulda busted the applauseometer if we had a battle of the bands. Backwater Rising led off with Matchbox and got funkier as they got drunkier. Commander Cody opened up with a Truck Drivin song and Blue Suede Shoes.

It was so nice to see all the people dancin for a change, instead of just sittin around. There were naked chicks doin the bop all over the place. Pussy lickin good!

If you dug the trip, keep your cards and letters comin, and we'll do it again soon.

Commander Cody, by the way, is leavin soon for a tour through Nashville and Detroit, but will be back out by the end of the year. Billy C tole me that it had been a long time since the band had such a high time.

You should know too, that see p. 17

Left: The Stooges played this July 1969 benefit for John Sinclair's defense fund; the MC5 manager had been busted for giving two joints to an undercover police officer. Iggy: "I thought it was key to ally with the MC5, who made a constant practice of playing free benefits all over the area." Grant McKinnon collection. **Top:** A September 1969 article in the underground newspaper *Berkeley Tribe*, basically a review of the band's performance at the July 1969 Saugatuck Pop Festival. Jeff Gold collection.

J: SO HOW ABOUT THE ALBUM COVER? YOU JUMPED IN THE AIR AND...

I: Again, it was me being an idiot like I have been so many times. They were gonna pose us, and I saw right away. "Oh God, they got [photographer] Joel Brodsky. They're gonna pose us just like the Doors." I was like, "This is bullshit! You don't understand! What this band is about is action! Now let me show YOU some action! Okay guys, line up here." And they're looking like, "Oh, ho ho." And then I took a run...there's a bare concrete floor. You know those mid-level cheap lofts in the '30s somewhere. And I took a running leap over the band and I hit chin first and there's blood everywhere and I was already pretty stoned on marijuana. So they actually, as I remember, what happened is they actually took me out, sewed me up, and sent me back the same day to finish the session.

J: IT LOOKS LIKE IT.

I: I believe so. And what they had to do was the original photo, the eyes looked like this because that's how stoned I was, so Harvey took this eye and just recreated it right? Then they just airbrushed out the stitches and put a little shadow on the chin.

J: Y'KNOW IT'S A RECORD COVER THAT I'VE STARED AT A THOUSAND TIMES AND I NEVER NOTICED THAT. THAT'S UNBELIEVABLE.

I: Yes, you can see the work there?

J: WAS THERE ANY TRUTH TO THE STORY THAT EITHER YOU OR RON CALLED (THREE STOOGES LEADER) MOE HOWARD TO GET PERMISSION TO CALL THE BAND THE STOOGES?

I: Ron. And in fact, Ron for quite a while visited (Stooge) Larry Fine, and he would bring Larry cigars and whiskey and stuff like that. Yeah.

J: AND MOE SAID, "FINE, DON'T BOTHER ME?"

I: Well, of course. I believe that that's a CBS matter by the way, but he said, "Yeah, as long as you don't have a comedy group or something."

J: SO YOU GUYS ARE THE PSYCHEDELIC STOOGES AND THEN THE ELEKTRA CONTRACT SAYS THE STOOGES.

I: Well I was thinking, "How do we tighten things up here?"

J: SO THAT WAS YOUR DECISION, NOT THEIRS?

I: I believe so. I was trying to clean things up...y'know, communicate.

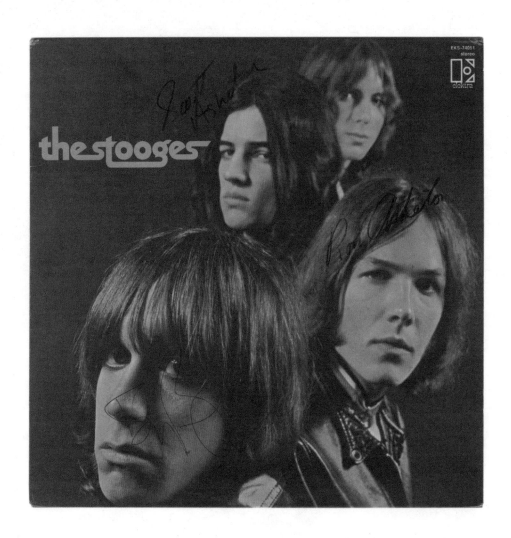

Above: The first Stooges album, signed by Iggy, Ron and Scott Asheton. Jeff Gold collection.

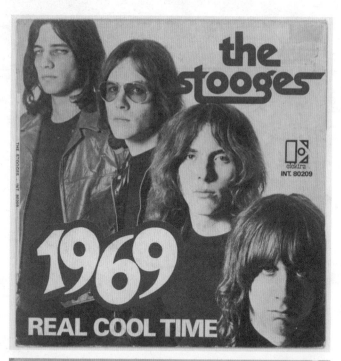

Top Left: The original French issue of "1969." Ben Blackwell collection. **Bottom Left:** *Creem* magazine enthusiastically supported The Stooges and Elektra reciprocated with this full page ad. Johan Kugelberg collection. **Right:** A record industry trade ad for the Stooges debut album. Jeff Gold collection.

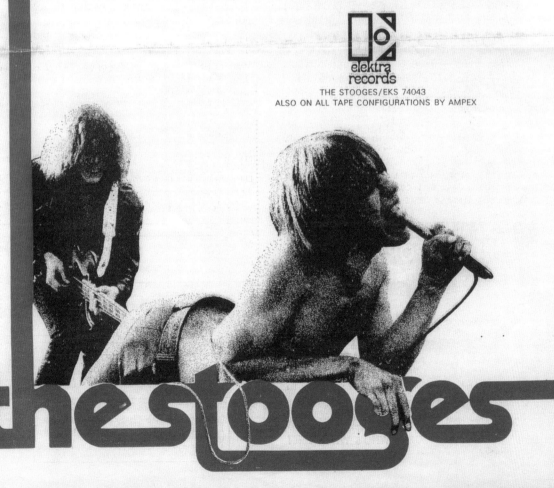

J: DID YOU FEEL ELEKTRA WAS INTO YOU? WERE THEY SUPPORTIVE?

I: Compared to different people in different ways, yeah. Especially Jac because when the album did finally get recorded, John Cale gave it this doom and gloom mix and I didn't want that. That wasn't ours. And I always thought Jac humored me so expertly that he took me up to their wonderful office in what was then the Gulf and Western Building, which is such a nice place to be, and he'd say, "Do you like it like this?" And he'd play me one and I'd go, "Yeah! That's exactly how I like it!" And then he'd say, "Do you like this one like this?" "Yeah!" And so for years after, I thought I'd remixed it because what do I know. And then later I found out that he'd called in Lew Merenstein.[20] But he spared me the angst. Anyway yeah, I felt Jac was as into us as he could reasonably be. There were two traumas I had. One was we'd keep saying, "When is the record coming out?" And they'd say, "Just shut up. It's gonna come out when it comes out." And so I would walk into town every Tuesday until it was August. That was one problem, and the other problem was when I looked at the record and [I was credited as] "IGGY STOOGE??" Oh I was just so...

J: THEY DID THAT?

I: They did that. Yeah, what they said first was there was some sort of discussion about, "Would you guys all change your name to Stooge?" And we all went, "AHH!!" Somebody brought that up, so they just did it to me. The other thing that happened in between was we thought, "Now to be the band that we really need to be, we need to have new clothes and new amplifiers." So we asked Jimmy Silver to work it out for us. We thought Elektra had given us more money, but what they really did was bought the publishing. To this day, I still have not paid attention to if they bought half the publishing or all of it, but it's Warner/Chappell Paradox. We did keep the writer's share and we might have even kept half the publishing. I sold that a long time ago. But then we did this trip to New York where certain things were already becoming evident. The guys wanted to stay downtown. I was tired of the Village. I was like, "Hey, Central Park! Hey, what's going on up here? I like these fancy people up here!" So I went to the Drake, and we bought clothes and amps and had a good old time for two weeks and have paid for it ever since.

20) Lewis Merenstein (b 1934) is a record producer who worked with Van Morrison, most notably on Astral Weeks. Jac Holzman hired him to remix the first Stooges album.

J: THE STOOGES FIRST ALBUM CAME OUT THE WEEK OF THE WOODSTOCK FESTIVAL, WHICH SEEMS SO BIZARRE TO ME. WHERE DID THE STOOGES FIT IN THAT WORLD OR THE WORLD OF ROCK?

I: The counterpoint. The counter to the counter-culture.

J: EXACTLY. BUT AT THE TIME DID YOU ASK YOURSELF "WHERE DO WE FIT HERE?" DID YOU HAVE A STRONG NOTION THAT YOU WERE THE COUNTERPOINT?

I: I was just vaguely aware. I was like, "Woodstock?" I don't remember what I felt except that I knew we were different and already realized that. I was sensing that, I was saying, "Well how are we going to fit into this would outside of Detroit?"

J: AT THE TIME YOU MADE YOUR FIRST ALBUM, YOU'D ONLY PLAYED IN MICHIGAN AND THE GRANDE IN CLEVELAND. I THINK YOU HAD DONE ONE GIG OUTSIDE OF MICHIGAN, WHICH IS KIND OF AMAZING.

I: That's probably true, yeah.

J: WHAT WERE ELEKTRA'S PLANS FOR THE BAND?

I: I mean there were different people with different levels of interest at Elektra. Harvey was wary, Jac was supportive in a very professional way and I think he liked me personally more than the group, but he wasn't thrilled I don't think. And I was aware that we were a little different than their groups, but I thought that was a good thing because I thought that the label had class. I wanted to be with a class label, and I think long term, that was a really good thing.

J: ELEKTRA'S FIRST BIO CALLS THE BAND, "FOUR BIZARRE GENIUSES WHO APPARENTLY WERE BORN TO WORK WITH ONE ANOTHER…TURNING OUT IN THE PROCESS SOME OF THE WEIRDEST AND MOST POWERFUL MUSIC HEARD ANYWHERE. WIDELY KNOWN FOR STAGE ANTICS. THEY CLIMAXED THEIR GIG AT THE DELTA COLLEGE POP FESTIVAL WITH IGGY CARRYING ONE OF THE WILLING FANS AWAY ON HIS SHOULDER; THE TEENAGER TURNED OUT TO BE THE DAUGHTER OF A HORRIFIED DEAN."

I: I don't think I even read that until you showed that to me.

J: WERE YOU GUYS OKAY WITH IT?

I: No! You're not okay with that. You cringe. I cringed at the Iggy Stooge and I cringed whenever any of them at Elektra opened their mouth about anything. But as long as they kept their mouth shut. The only one who was a very, very bright individual was Fields.

ELEKTRA RECORDS
1855 Broadway
New York City 10023

the stooges

A lot of bands have developed out of the wilderness of Ann Arbor, Michigan (an area which has been nominated as "the rock and roll sanctuary of the world"), and each seems to have its own peculiar brand of craziness and total mania.

Not even in Ann Arbor, however, is there any band that is as crazed as the incredible STOOGES, four bizarre geniuses who were apparently born to work with one another. Iggy, Dave Alexander, and the Asheton brothers Ron and Scott fell into each other's clutches in the summer of 1967 and stayed there, turning out in the process some of the weirdest and most powerful music to be heard anywhere.

Their backgrounds take in much of the history of the Ann Arbor rock scene: Iggy was drummer with the Prime Movers for some time and had played before that with the Iguanas. Ron Asheton also worked with the Prime Movers and with the Chosen Few, which was led by Scott Richardson of the SRC.

The STOOGES made their first public appearance on Halloween of 1967 at a private party in Ann Arbor, and played their first professional gig with the SRC at the

Grande in February, 1968. They blew down everything in their path, and became widely known and loved for their fabulous stage antics and strange music. They would arrive at a job and simply set up and jam out, blowing masses of minds in the process. To this day, every performance by the STOOGES is full of surprises. (They climaxed their gig at the Delta College Pop Festival with Iggy carrying one of the willing fans away on his shoulder; the ecstatic teenager turned out to be the daughter of a horrified dean. They are not called the STOOGES for nothing.)

The group lives on a commune in rural Ann Arbor with their manager Jimmy Silver and their staff.

The band was brought to Elektra Records last October by Danny Fields, who had heard them play at a benefit in the University of Michigan's Union Ballroom. Their first album for Elektra was produced by John Cale, formerly of the Velvet Underground, in the Spring of 1969. It speaks louder, by far, than anything more we could tell you about this extraordinary group.

- 2 -

(7/69)

To: Jac
From: Danny
Re: Stooges

Haven't communicated with you at all since the release of the Stooges
album, and I'd like to get down to you my analysis of the situation
at this point, what I think of what's been done and what we have
and what we're going to do next.

The best news, of course, is that we've got a great first album, a
truly great album, not perfect, but great. The reaction to it is
just fine, everyone is saying the right things, and it looks like
anyone who becomes aware of it is turned on to the potency of the
record and potential of the group. So let us congratulate ourselves,
but let us not be smug. There is much work to be done.

I think there are two ways the album can go. With some acceptance
in the progressive rock media, some word of mouth, some print publici
and some advertising, it is a 100,000 selling album; not a bad
potential, and not really hard to come by, since the record is so
good, and Steve is doing such a good job, and so am I, and so is the
band. But I think the album also has, without any question, gold
record potential, and, again without any question, this is what
the band and I have in mind, this is what we're talking about,
nothing less, because it is possible, though not inevitable.

It all comes back to getting the group a hit single, an exploi-
tation single, if you will, and with that done, we're off. With
that not done, all my publicity and all your advertising and all
fm airplay and whatever, we will sell 100,000. Now 1969 is it, as
I thought originally, as people have been telling me, as you see it,
as the band sees it: 1969 is a hit and it's got to be made into one.
By any means necessary, at any cost.

It is going to cost money to hold back money atthis point, and I
cannot help but get the impression that even up to this point, Elektr
has been holding back. For example, I had asked for a poster of the
band to be packaged with the album, not an extraordinary request for
a band which is so visually compelling, and was told that the cost
was prohibitive. Now I am told that trade ads are going to appear in
Billboard and Record World, but not in Cashbox; meanwhile, over at
Cashbox is Bruce Harris, our biggest friend in any of the trades, who
mentions the Stooges in practically each column he writes, who
is called upon by his bosses to explain this incredible enthusiasm
each time he puts in a hype about the band, and is now going to be
in a rather awkward position when the Cashbox people see they didn't
get the ad, but more than that, it just doesn't make sense not
to blanket the trades, it is simply an impressive gesture of faith
on the part of the record company, and people notice when an ad
appears in all three trades, it takes on another dimension. It
feels like something is really happening, and that is, I hope,the
feeling that Elektra is trying to get across. It's the difference

2

between a small-time look and a big-time look. This is a big-time
band, and if you're not going to reinforce that idea you're just
risking holding everything back. For example, I would suggest
that two weeks following the current trade ad for the album, that
another trade ad appear in all the trades for 1969, the big new
single from the big new album. I mean, Jac, let's just pull out
the stops, just this once, let us go all the way, and let Elektra
promote this single as it had promoted Light My Fire, even much
more, more than anything. Let's get all our energy behind it,
let us behave as if there is no album, just this single, let
Steve switch his energies from promoting the album to promoting
the single, and let us hire extra promo men if and where they can
be helpful, let us really get into that "by any means necessary"
consciousness on this project and see what happens. I would
rather see, if it must come to achoice, the money that would be
spent advertising the album via print and radio spent on promoting
this single. Of course, I really believe we should have both,
but I think the potential gains of a hit single dictate the
priority of this course of action.

Soon after the August 1969 release of *The Stooges*, Danny Fields wrote this memo to Jac Holzman, advocating for a hit single "by any means necessary." Jeff Gold collection.

the stooges
mini-minded musicians
by John Mendelsohn

I don't for a minute suppose it's very sagacious of me to make my FM & FINE ARTS debut raving amuck about an album which invariably repels almost everyone on first listening. But that, dearies, is precisely what I'm going to do, if for no other reason than this: THE STOOGES (Elektra EKS 74051) completely amazes me, endlessly amuses me, has me drinking a lot of Pepsi, and generally knocks me out.

Don't worry: my tastes aren't that anarchic. I mean, I *loathed* this record without the slightest qualification the first time I heard it. I couldn't have been more disgusted by the maddening excess of guitar effects and by Iggy Stooge's seemingly anti-musical belching/singing, which BILLBOARD, always good for a laugh, described as "inventive." Nor could I have been more contemptuous of The Stooges' harmonic stupidity and infantile lyrics. All of which, I suddenly and inexplicably discovered during a recent listening, are what makes Stooge music the magnificent pimply rubbish-rock that it is.

With few exceptions, we rock-and-roll people have gotten disastrously hung-up in a tangle of basically-irrelevant aesthetic considerations. Since about the time of The Beatles' RUBBER SOUL (1965), the Richard Goldstein school has told us in glowing polysyllables that Rock Is Art, as if rock- and-roll were some horribly fragile Pharoah's turd, freshly-unearthed. And we've taken to believing them.

Now, I neither know nor care what "Rock" is. (How pompous that word sounds coming from the mouths and pens of those who one can't help but suspect would rather turn in their MA diplomas than add "and-roll" to the end.) But I sure do have some idea what rock-*and-roll* is. Rock-and-roll is sexual and tough and a little belligerent, a nasty and defiant assertion of youth, whose adrenalin flow is expressed by the music. It's music that can inspire you to slice up a theater seat with a razor blade, trade punches with Rent-a-Cops, make hot passionate love to the first miniskirted chickie you can get your hands on, and stand up on your seat and shout for sheer animal joy. The best rock-and-roll takes you right back, regardless of your age, to the most boisterous and defiant days of your adolescence, an' you're not takin' no jive from *anybody*. Rock-and-roll is fun, Art be screwed.

Rest assured, The Stooges aren't all *that*. (The closest I've seen anybody come to it is The Who, particularly on *Summertime Blues*, in live concerts.) But The Stooges come close.

First, off, let's look at Iggy, the lead "singer," who, according to legend, enlivens the group's live performances by simulating a variety of fun/sex things with his microphone stand or by urinating on the first few rows of his audiences. I tend to suspect that, offstage, Iggy must be one of the biggest jerks imaginable, and I'm entirely convinced that technically he's the worst singer I've ever heard.

And he's just perfect. He's probably the world's Number One singing street punk of all time — the Elvis-Jagger-Morrison tradition gone completely berserk. The most ridiculously unmusical sounds come from him in a garbled blur from somewhere between the underside of his thick snakey tongue and the remotest corner of his snot-stuffed sinuses. Occasionally — in fact, on every song — he runs out of words halfway through and just stands around screaming, grunting, retching, and wheezing things like "a-com-own," or, in moments of true inspiration, "a-com-own an' shake!" I can listen to Iggy for hours and siever for a moment cease to be amazed.

And the band! Guitarist Ron Asheton, who's gorgeous, displays every bit as much musical insensitivity as did Blue Cheer's Leigh Stevens. Remarkable. On *every* song he manages to completely destroy any semblance of clarity or precision on the instrumental track. He's completely dependent on hopelessly garbled, eardrum-puncturing fuzztone and/or wah-wah. And most of the time he just plays the same chords over and over and over and over; his solos are immune to such adjectives as "talented," "original" or "tasteful." He's a guitarist to watch, certainly.

The rhythm section has gorgeous

COAST FM & FINE ARTS
NOV: 1969

drummer Scott Asheton and bassist Dave Alexander, whose nipple-length tangles of hair, Neander-thal features and acne lend him the sort of look Max Rafferty and colleagues must have in mind when they deliver their "dirty long-haired punk" harangues. They sort of clunk along stupidly in a vague Bo Diddley side-man manner, only quite marvelously awful. (I must repeat: musical proficiency, even competence, is hardly prerequisite for making good rock-and-roll; several of rock-and-roll's finest moments have come during blasts of objectionable musicianship — and even flat singing.)

As for the songs themselves: what incredibly delightful teen-aged tripe! The Stooges are the American counterpart of the none-too-articulate, dumb, nasty, defiant mod kid Pete Townshend showed us in *My Generation*. They've got vocabularies of roughly 212 words; they're probably drop-outs; they're baffled and a little bit edgy, and their horniness is equalled only by their boredom. Mostly what they do is call up girls and invite themselves over to ball — as in *Real Cool Time*, where Iggy sings:

Can I come over tonight?
Can I come over tonight?
You know what I wanna do —
That's right . . .

Or else they just sort of stand around and complain in the most adolescent terms:

Well it's 1969, Okay.
All across the U.S.A.
It's another year for me and you,
Another year with nothin' to do.
Well last year I was twenty-one
I didn't have a lot of fun.
Now I'm gonna be twenty-two.
I say "Oh my" and a "Boo-hoo".

It used to be that older people — non-rock-and-roll people, like parents and members of the clergy — would hold their hands over their ears, stick out their tongues, and spew contemptuous invectives at the sound of rock-and-roll. Yet, ever since Paul McCartney sang "Til There Was You" on the Ed Sullivan Show, they have tried to placate us with inanities like "It has a catchy beat," or "My, what a pretty melody!" But there aint *nobody* gonna be patronisingly charitable with The Stooges.

Which, I think, is sort of nice.☐

Top: John Mendelsohn of *Coast Magazine* loves *the Stooges* after hating it. The review includes a very early "punk" reference. Ben Blackwell collection. **Bottom:** Not all the alternative press embraced the Stooges; the New Haven Rock Press saw them as "copies of the Stones and the MC5 made by a broken Xerox machine." Johan Kugelberg collection. **Right:** Elektra sent this glamour shot of Iggy to *16 Magazine*. Jeff Gold collection.

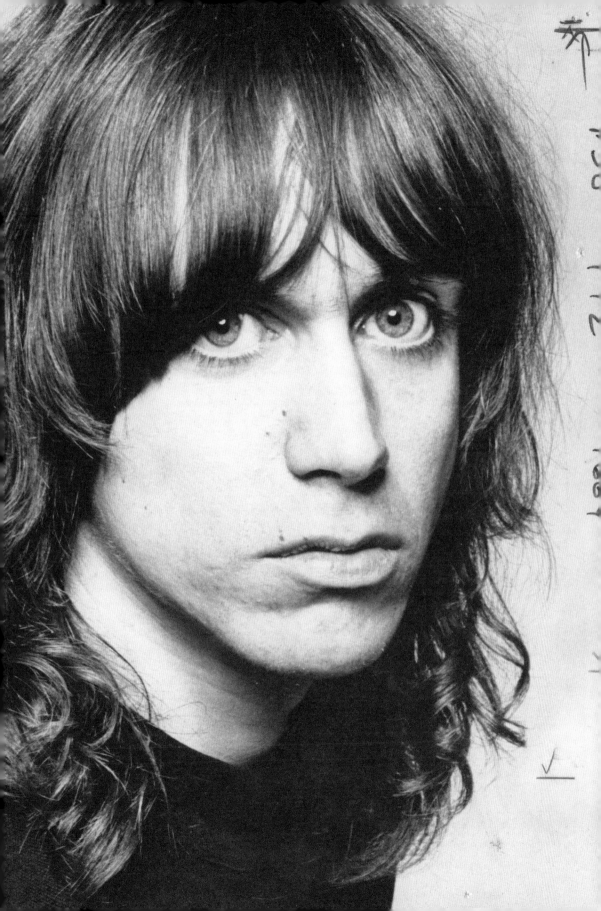

WILSON MOWER PURSUIT
STOOGES AMBOY DUKES
MC 5 GOLD BROTHERS UP
SAVAGE GRACE KRAACK
LYMAM WOODARD
TATE BLUES

PRESENT A

FESTIVAL of LIFE

SUNDAY 17 AUGUST 12~10

ANN ARBOR

I94 → DETROIT

N
W←↕→E
S

US 23

TUTTLE HILL
X

DAY

PLANK

(3 MILES PAST MILAN DRAGSTRIP)

$2.00 DONATION
BRING YOUR THINGS TO SHARE
FREE TAXI FROM ANN ARBOR
761-8314

Top: Michigan's finest play another John Sinclair benefit, August 1969. Johan Kugelberg collection. **Right:** The Stooges return to Ann Arbor as hometown heroes, headlining the Grande Ballroom for two nights, two weeks after the release of their debut album. Grant McKinnon collection.

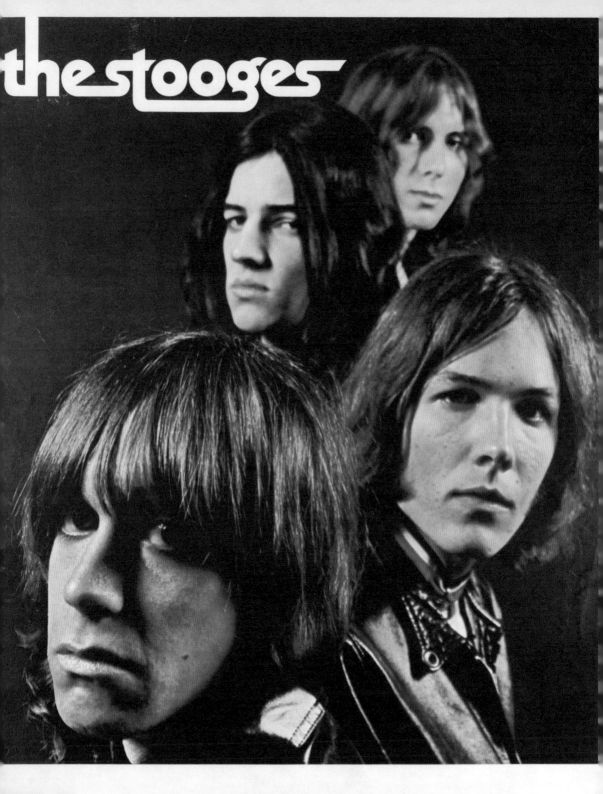

thestooges

The Grande Ballroom
August 22nd & 23rd

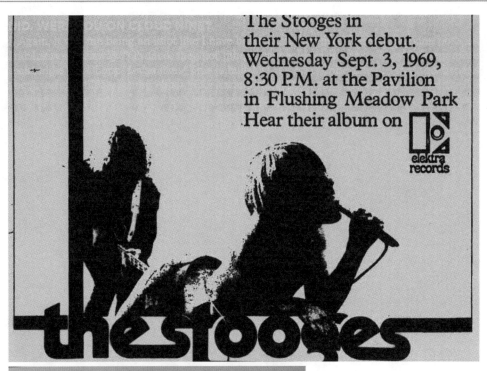

Above: Iggy cut himself with a broken drumstick to "up the ante" at their first New York show. **Left:** The Stooges played Boston for the first time in September 1969. Iggy: "Basically they just sat there and stared at us. They weren't going for it." David Swartz collection.

5. HIT THE ROAD

J: VERY SOON AFTER THAT, THE FIRST WEEK OF SEPTEMBER '69, YOU DO A SHOW AT THE NEW YORK WORLD'S FAIR PAVILION WITH THE MC5 AND DAVID PEEL AND MOLOCH. IT'S YOUR FIRST NEW YORK GIG, YOUR FIRST BIG CITY GIG OUTSIDE OF DETROIT AND CINCINNATI. SUPPOSEDLY ON THE FIRST NIGHT YOU CUT YOURSELF WITH A BROKEN DRUM STICK.

I: That's true. It was little cuts.

J: WERE YOU UPPING THE ANTE BECAUSE IT WAS NEW YORK?

I: Sure, I was upping the ante, so I was gonna do wild running stage dives, I was wearing short shorts, I wanted to get noticed. I was nervous because it's New York City. You're in the capital city, New York's the capital of America, not Washington. So it was a big deal to me, and I was upping the ante. What I remember most of all, I just remember how far I dove a couple times. Other than that, the big impression I'll always carry with me was after the gig, I was out watching the other groups and Jimmy Silver in my presence introduced me to Frank Barsalona, and Frank looked like the mafia. He looked absolutely ready for the Sopranos. He was ready for any Scorsese movie. He was a silver-haired, beautifully quaffed, not unattractive Italian man about seventy-five pounds overweight in a very nice knit Polo-type shirt with some very nice casual East Egg slacks and a pair of boat loafers. He ran something called Premier Talent. That was the most hardcore booking agency. All the English groups: Who, Led Zeppelin, Stevie Marriott, Frampton. So Jimmy was trying to explain to him why he should book us and introduce us, and Frank stood right there and he looked at Jimmy and he looked at me and he said, "I think that someday in the future, you are going to be very important, but I can't help you right now." I tried to listen to the good part, but I did get the turn-down.

J: SO YOU'RE GOING FROM JUST PLAYING MICHIGAN, TO NEW YORK, THE BOSTON TEA PARTY (SEPTEMBER 9-11), THEN YOU PLAY PHILADELPHIA (SEPTEMBER 19-20), AND I FOUND A QUOTE...YOU TALK ABOUT FLINGING YOURSELF ON THE FLOOR, DRAWING BLOOD, CUTTING YOURSELF, TAUNTING, WALKING INTO THE AUDIENCE. "FINALLY TWELVE PEOPLE APPLAUD. START TALKING TO THE REST OF THE AUDIENCE. YOU REFUSE TO BE IGNORED. IF YOU WEREN'T GOING TO GET A POSITIVE REACTION, YOU DAMN WELL WERE GONNA GET ONE THAT WOULDN'T LET THEM SLEEP AT NIGHT."

I: That's it, yeah. The Tea Party gig particularly. We were supporting Ten Years After. That club was under Fenway Park. It was very large. It had probably just been a basement storage space. It had a really low ceiling. It was dank. The dressing rooms were lousy. It was a packed audience sitting cross-legged waiting for this horrible, boring British band, but with the really cute, nice ruffled shirt and a really cute guy with a great haircut. We had to open and basically they just sat there and stared at us. They weren't going for it. The thing I would always remember the best was when we went back from the end of the set, we had to walk back through the crowd, and we get to our little section of the dressing room and Ten Years After's groupies were sitting in our places and they didn't want to get up. We were even out-ragged by their groupies. At that show, we looked like representatives of the teen culture from 1995. This is the thing. We were about almost thirty years ahead of our time. We had the go-kart t-shirts and the little slim pants. Everything, and we looked like kids, but nobody wanted that. They wanted these other guys.

J: NOW YOU'RE PLAYING THESE MAJOR MARKETS WHERE YOU'RE UNKNOWN. HAVING COME FROM A SCENE WHERE YOU WERE PRETTY WELL KNOWN AND HAD AN AUDIENCE, WHAT WAS YOUR REACTION TO THAT?

I: My reaction was just I remember I was always on the lookout for anybody who was gonna support the group. So I wanted to get to know and cultivate those people and work for them. And it could be anybody from teen stoners to if we went to New York City, Donald Lyons for instance. Taylor Mead would come to a gig and seem to not hate it. There were a lot of big city intellectuals that liked us. [21]

So I was looking for support step by step. The other thing I was trying to do at the time was I was starting to realize little by little that we were going to have to get out of Detroit to make it because we weren't Bob Seger. If you're Bob Seger, if you have a certain kind of chops, you could stay in Detroit, keep working on your ability to do a mass-market thing, and you could hit and stay there all your life and work the system. We weren't like that. We were gonna need a cultural petri dish. Detroit had done all it could do for us. Ann Arbor had done all it could do.

But what happened was every time I would broach the subject, Ron was a real homebody and would go crazy, and every time I would try to go spend time in the big city, I would make a big mess and fail abysmally to harness the positive possibilities. So I was always looking for support.

21) Donald Lyon (b 1938 - d 2011): film and theatre critic, Factory denizen - appeared in "Chelsea Girls." Taylor Mead (b 1924 - d 2013) was a poet and performer, openly gay, who transcended the Beat period to become one of Warhol's first superstars.

Left: Ironically titled, "A Day of Peace," this concert was reportedly canceled as a result of riots two weeks earlier at the same venue. Grant McKinnon collection. **Right:** The Stooges and Up play at a Ann Arbor junior high school, November 1969. Johan Kugelberg collection.

Live From Detroi

Some people will tell you that San Francisco is the music capitol of the world, while others will swear it's New York, and then when you're almost convinced, some bloke will come along and say it's foggy old London town. Well, they're all washed up because it's Ann Arbor, Michigan, and if it needs to be proven then the latest Ann Arbor group, four guys called the Stooges is all you have to hear. From the state which made headlines by putting out ugly American cars and Motown muck (recently), the old roads are rapidly changing. Having already given birth to the MC5 and now the Stooges, Detroit and Ann Arbor are rapidly establishing sounds of their own which evidently also seem to be the sounds of the people.

Where should we kick out the jams to? To the streets, man! To the streets! Give it to the Stooges! So just when you thought things were going to get quiet and mellow again with country and folk music, look what happens. Yeah, here come the crazies, with a sound so hard and grinding, so full of sex that one walks around totally resurrected. Iggy Stooge, Dave Alexander, the Asheton brothers, Ron and Scott, are producing some of the most powerful rock ever seen or heard anywhere. With a reputation for being crazy, and all the faculties and abilities to live up to it, they have caused furor and

IGGY STOOGE

fervor whenever and wherever they'
played.

Iggy, lead singer and head crazy,
a recent Ann Arbor concert, smeare
chopmeat all over his body, and whe
sufficiently greased and ready
squirm, leaped head first off the stag
into a swarming, swelling group of hu
gry, fanatic girls. Yeah. If that's n
enough, at the Delta College Pop Fe
tival, Iggy climaxed the show by carry
ing one of the eager beaver fans awa
on his shoulder. The girl later turne
out to be the daughter of a horrifie
dean. Yeah, yeah. They exercise powe
and control on stage as if it were righ
fully theirs; and as much as rock 'n' ro
is the guidepost for young and ol
boppers, the Stooges are paving new
paths for rock 'n' roll.

*Catapulting himself to the new
sex symbol of rock.*

Wiggy Iggy And The Stooges

The group lives on a commune in
ral Ann Arbor, with their manager,
mmy Smith and the rest of the fam-
. They were brought to Elektra Rec-
ds under the intuitive genius of Dan-
Fields, who heard them play at a
nefit in the University of Michigan's
ion Ballroom, and who calls them
e "epitome of uni-sexuality." Their
st album was produced by John Cale,
merly with the Velvet Underground
the Spring of 69'. The record is
rd rock in its most pure, raw, un-
cise form.

When forming the group, Ron was
ked to play lead guitar. He didn't
ve one, so Iggy, Scott and Dave
pped in and bought one under the
ndition that he learn all their ma-
ial and play on stage with them in
ee days. That's the way things went
the beginning, and that's the way
y go now. Nobody ever claimed
y were superb musicians, especially
y; they just do it as best they
ow how, not caring much about criti-
m and caring less about the people
t equipped to dig what they're do-

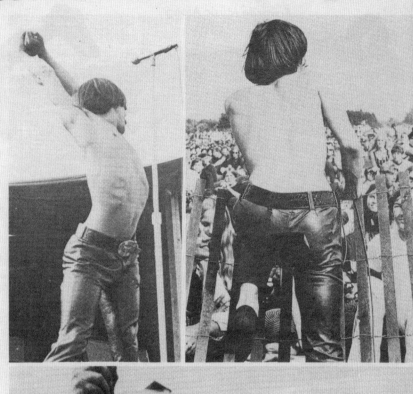

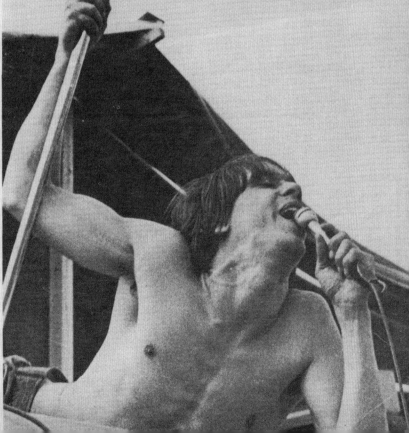

The album is long and rangy, musi-
lly average, but emotionally as in-
nse as, well . . . why don't you sup-
y the analogy? Buy the record. It's
e one on which a guy looks identical
Grace Slick, but with a touch of
orrison in his face; that's Iggy.
hey're the Stooges.

Wild shows and crazy antics.

ktra

1855 Broadway, New York, N.Y. 10023 212 JUdson 2-7711

ROYALTY STATEMENT

THE STOOGES
2666 PACKARD
ANN ARBOR, MICHIGAN 48104

	FOR PERIOD ENDING	CODE
	1 12/31/69	4130

		QUAN. SOLD	RATE	TOTAL
54	THE STOOGES	1219	.0591	72
51	THE STOOGES	33738	.2714	9156
51	THE STOOGES	1299	.2714	352
51	THE STOOGES	515	.2714	139
	SUB-TOTAL			9720
	DEDUCT:			
	ADVANCES AGAINST ALBUM #74051		36858.66	
	7/13/69 - 50 E 74051 @ $1.00		50.00	36908
	BALANCE OWING ELEKTRA			27187

FEB 1 5 1970

ADVANCE ON 74051 36, 858 66
LESS CASH ADVANCE 26, 000 —
 10, 858 66
EARNINGS 9, 720 85
 1, 137 81

TOTAL

J: SO THIS IS A ROYALTY STATEMENT FOR YOU GUYS FROM YOUR FIRST YEAR ON ELEKTRA.

I: Yeah, would you explain something to me? On my new statements, the old albums are at the five percent royalty. The Chubby Checker rate because, as Jac's always said, "Well that's what everybody was paying!" Now the new configurations you get about a fifteen percent royalty. But if that seems to be the figure they told me, why is this rate .27?

J: A QUARTER. YOU'RE GETTING TWENTY-SEVEN CENTS PER ALBUM.

I: Wait, it wasn't bad.

J: THE ALBUMS ARE PROBABLY A $4.98 LIST PRICE, SO YEAH. IT'S PROBABLY ABOUT A FIVE PERCENT ROYALTY. HERE YOU'RE GETTING SIX CENTS. THAT MUST BE SOME INTERNATIONAL SCAM WHERE THEY SOLD TWELVE HUNDRED INTERNATIONALLY AND THEY CUT THE ROYALTY DOWN FOR INTERNATIONAL SALES. BUT IN THE US, THE ALBUM SOLD THIRTY-SIX THOUSAND RECORDS IN FOUR MONTHS, WHICH WAS NOT BAD!

I: That's what they said and I always wondered, until you showed me that I always wondered if they were lying.

J: IN FOUR MONTHS, THIRTY-SIX THOUSAND. NOT TERRIBLE AT THE TIME. WERE YOU PAYING ATTENTION AT THE TIME TO RECORD SALES OR ROYALTIES?

I: Here's what I thought. I always said to myself right when we got the deal and I thought about the whole thing, I didn't know about the sales and how much it cost, but, "What is the potential number of people that could be interested in this band," and in my mind I came up with fifty thousand. I thought fifty thousand people, so we got most of the way there.

J: FAST!

I: But I wasn't thinking about sales. Not at all. We never expected to get any money from a record because a record company and a record to us, or at least to me, was just something you did because it was prestigious and wonderful.

J: IT HELPED YOU PLAY LIVE.

I: Yeah, all that.

Left: The Stooges ended 1969 owing Elektra $27,000 in un-recouped recording costs and advances; not unusual for a new band. Jeff Gold Collection.

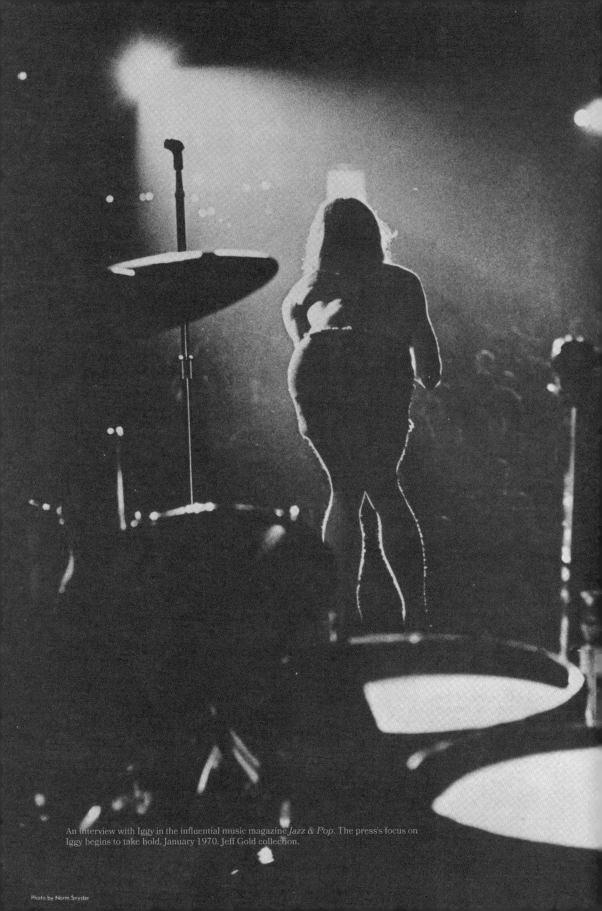

An interview with Iggy in the influential music magazine *Jazz & Pop*. The press's focus on Iggy begins to take hold, January 1970. Jeff Gold collection.

Iggy Stooge

interview by David Walley

Iggy: You know, half the people think that I'm trying to say, "I hate you," that I'm trying to make a sex parade. And I don't give a fuck about the specific bullshit in the audience, you know —

David: Right. But that's part of it, rock and roll is about balling —

Iggy: Sex in itself, really. That's right — this is for the teenyboppers. Rock — rock — take the Juilliard String Quartet, for example — radicals.

David: Your favorite contemporary artist?

Iggy: Yes. I like the Velvet Underground and I'm one of those very few people who really, really like Nico's music. I love her last album and when I come into New York I make it a point to try to see her.

David: If you listen to too many bands, you just get into —

Iggy: I'd probably get tired of my own. You know, maybe I don't listen to a lot of the bands because they're better than my own. We played the Ann Arbor scene for ten years, as I started to say. I started to say, I started in Ann Arbor and ended up in Chicago with one of the black soul bands. Like Johnnie Young and Pete Wallingford and all these guys, you know, good musicians but a little too old to keep their minds together — Like children, complete children, playing — the most fantastic thing that ever happened, because it's just playing with a bunch of ten-year-olds who've got knives and guns and things.

David: What do you want to see your music get into? I mean, what further things would you like to do to disabuse the audience of misconceptions they might have about your performance?

Iggy: Well, I never know what I want in advance really, to tell you the truth. I really never know what I want in advance from the audience, and I don't know what I want in advance from the band either. It's very hard to describe how our music is put together, because it's left largely to chance, because it's more fun that way, I guess. I play a lot of instruments myself, write all the lyrics and a lot of the music, and together we gain command of the same language, so you can't really tell when one starts and the other leaves off. The reason I started was I realized that the only thing that was going to make my life worth having, in my mind, had nothing to do with good times or happiness or friendliness or anything. It just had to do with a struggle, a struggle for me — I have to be able to create something myself, which I can then turn around and appreciate, and it can make me feel what I have felt when I heard other people's music that I really liked.

You know how you feel when you hear music that you *really* like. When I felt that way years ago, I said that I had to be able to do that myself, you see, and that's my whole struggle — to be able to excite myself. That's why sometimes I'll do things — when I get upset, too upset because all this tremendous rush, just like bubbles, comes up from my organs right up through my stomach and just lights there in my head and I'll start to cry or scream or something like that, and that's when a lot of things happen on stage.

I have found in the last couple of years, since I started trying in my music — to be able to feed myself, and as much as possible, and I've become ruthless about it. I'll do it with music. I'll do it if I have to cut myself, if I have to kill myself, if I have to go barefoot, I don't know what, but whatever

J: AND AROUND THIS TIME, THE MC5 GET DROPPED AND THEN DANNY GETS FIRED BECAUSE HE GETS IN AN ARGUMENT WITH BILL HARVEY. THE STORY IS THAT THE HUDSON'S DEPARTMENT STORE CHAIN [IN MICHIGAN] WOULDN'T CARRY THE MC5'S ALBUM, BECAUSE IT HAD THE WORD "MOTHERFUCKERS" ON IT, SO JOHN SINCLAIR TOOK A FULL PAGE AD FOR THE ALBUM IN THE LOCAL UNDERGROUND NEWSPAPERS, WHICH LOOKED LIKE AN ELEKTRA AD, AND SAID "KICK IN THE DOOR IF THE STORE WON'T SELL YOU THE ALBUM" AND "FUCK HUDSON'S." THIS CAUSES HUDSON'S TO SAY, "WE'RE NOT CARRYING ANY ELEKTRA RECORDS, EVER. NO NONESUCH." AND SO JAC DROPPED THEM. SO THAT DIDN'T AFFECT YOUR WORLD?

I: Not really exactly. Indirectly it did.

J: THERE WAS SOME THOUGHT ACTUALLY THAT IT MIGHT HAVE BENEFITED YOU GUYS IN THE SENSE THAT, "WE MADE THIS BIG INVESTMENT IN THESE TWO DETROIT BANDS AND NOW WE ONLY HAVE ONE."

I: I never thought about that. That's interesting. I didn't think about those things at the time.

Right: The "FUCK HUDSON'S!" ad. The retail chain responded by pulling all Elektra albums from their shelves, which eventually led to the label dropping the band, and eventually Danny Fields being fired. Ben Blackwell collection.

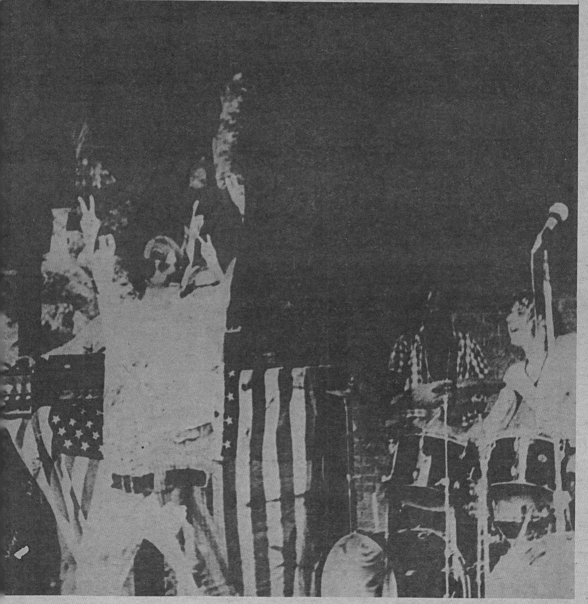

KICK OUT THE JAMS, MOTHERFUCKER!

and kick in the door if the store won't sell you the album

• **FUCK HUDSON'S!** on

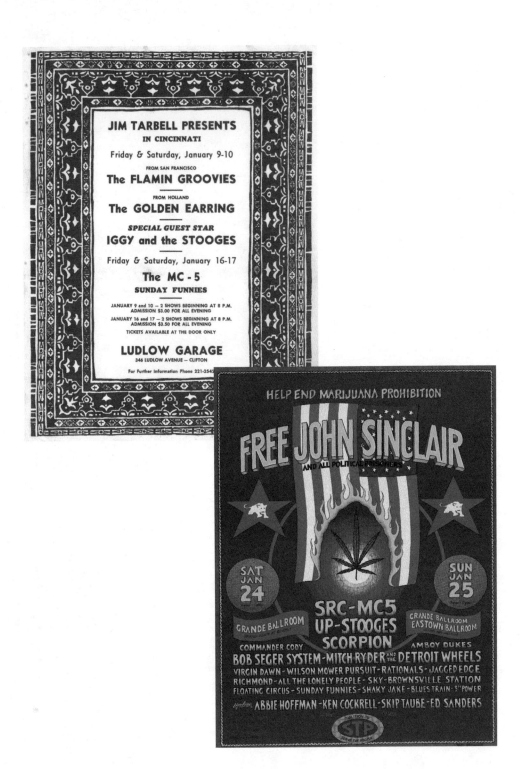

Above Left: In Cincinnati, the Stooges are billed as "special guest stars," January 1970. Grant McKinnon collection.
Above Right: Detroit's top bands rally to help John Sinclair, January 1970. Michael Storeim/Classic Posters collection.
Right: Grande Ballroom, Detroit. Photo: Robert Matheu.

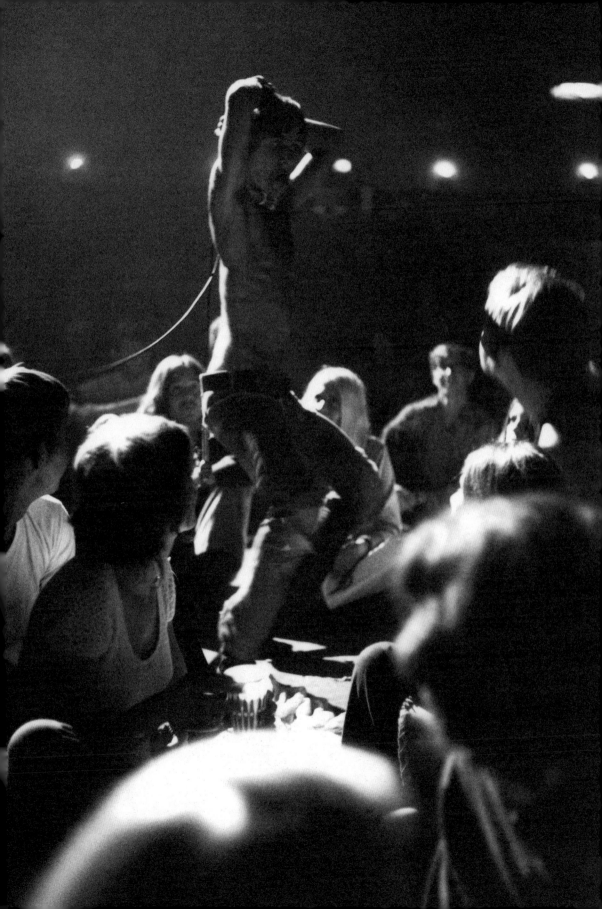

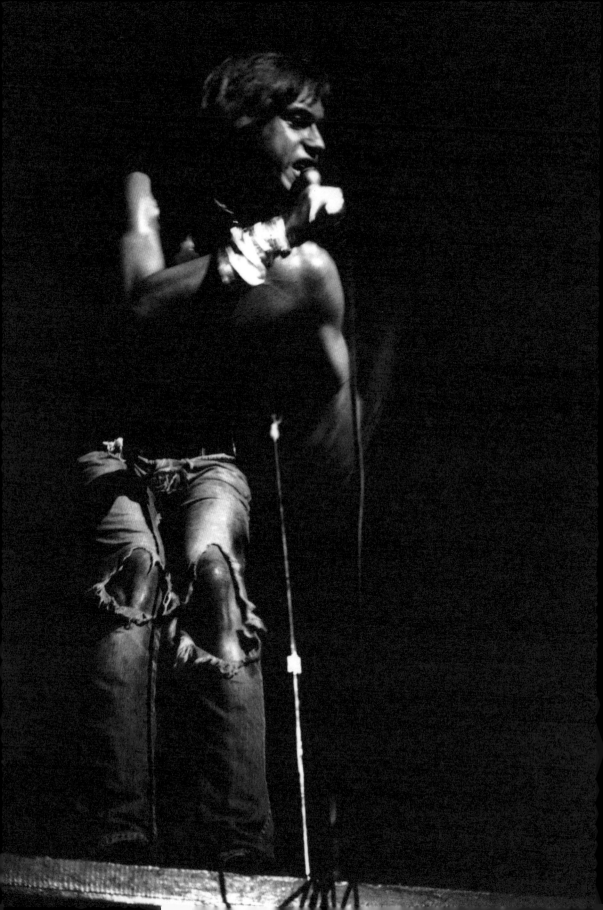

J: NOBODY IN MUSIC HAD EVER LOOKED LIKE YOU DID ON STAGE. I HEARD YOU READ SOME STORY ABOUT THE PHARAOHS GOING SHIRTLESS AND THAT MIGHT'VE...

I: When we were living on Forest Court and we couldn't rehearse, but we were role-playing and all that, I still had my library card to the [University's] underground library. It was only four blocks up the road and I would go to the library and I would dig up basically Soc Anth books. It was Soc Anth and Asian studies. I liked those courses and I thought, "There's stuff in here that's just..." It just interested me, all this shit. So I was going to the library and thinking, "What about a look? What about an approach?" And I saw the pharaohs and I saw the depictions of the pharaohs with no shirts and I thought, "It just looks so classic." And I thought, "I have a long torso. I could do that." It just seemed like that was gonna help. I don't know. It's not like I thought, "I'm the best looking guy," or anything like that, but it was gonna be expressive.

I also was aware of Living Theatre.[22] And John Cage and Charlotte Moorman and Nam June Paik. I was vaguely aware of all this stuff. All that shit was around and I was informed of that and that probably is why. There was a key person. Anne Wehrer.[23] Anne Opie Wehrer, married to Joe Wehrer, a professor, and she ran a kind of salon for the people that came through. I had always had a crush on both her daughters and then I got to know one of them later when I was starting the group and they took me to the house, introduced me to Anne, who had only a leg and a half. But she was one of these Americans I'd never been, where the blood went straight back to Jamestown and she knew how to wear a sweater and a country club outfit a certain way but she wasn't one of those women. And she liked me and later I had an affair with her. That was much later but she did turn me on to a lot of this stuff and she would talk to me about my ideas. Robert Ashley was another guy that was nice to me.

22) Founded in 1947 by Judith Malina (b 1926 - d 2015) and Julian Beck (b 1925 - d 1985), the Living Theatre were THE experimental theatre group in the US, with a sequence of productions that merged political / avant-garde texts with settings that exploded theatrical conventions and merged the performers with the audience. Their productions included plays and pieces by Bertolt Brecht, Pablo Picasso, Jean Cocteau, and Antonin Artaud. They were frequently arrested and harassed by the authorities. In a rock context, they are best known for informing Jim Morrison's confrontational piece of performance art at the Doors' chaotic March 1, 1969 show at the Dinner Key Auditorium in Florida. 23) Anne Wehrer (b 1929 - d 2007) is the co-writer of Iggy's 1982 autobiography, *I Need More*. Robert Ashley (b 1930 - d 2014), born in Ann Arbor, was a composer of avant-garde, electronic operas and other theatrical works.

Left: Eastown Theater, Detroit. Photo: Robert Matheu.

J: SO GOING FROM THE HIGHFALUTIN TO THE LOWFALUTIN, I GOT THIS RECENTLY, THIS POSTER FOR A SHOW BY THE STOOGES AND CHUBBY CHECKER (FEBRUARY 13, 1970) THAT HAS TO BE ONE OF THE WEIRDEST BILLS OF ALL TIME.

I: Well not only was it a weird bill, but what happened there was...I gotta tell you that this is one of the nicest people ever born. Chubby Checker was, at the time, trying to reinvent himself as a psychedelic guy, so he cruised me and I couldn't get out of it. People started saying, "Chubby wants to meet you. Chubby wants to talk to you." So we were staying in this little inn. That town, it's like a Norman Rockwell town, Springfield, Massachusetts. So beautiful with the little church and everything in order and I thought, "My God, people live like this. How wonderful." And we were in this inn and Chubby wanted to come up to my room, so Chubby comes up. Chubby's wearing a two-piece velour sky blue leisure suit with a great big medallion on a gold chain, right, and he had his hair in a very neat afro and he wanted to smoke dope with me and talk and you know what? He was just so nice. I liked him so much. There were just these odd things at the time. Nobody knew quite what to do with us.

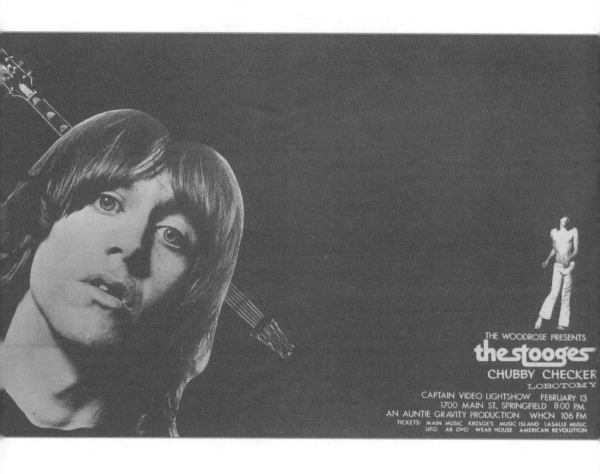

THE WOODROSE PRESENTS

the stooges

CHUBBY CHECKER

LOBOTOMY

CAPTAIN VIDEO LIGHTSHOW FEBRUARY 13
1700 MAIN ST, SPRINGFIELD 8:00 PM.
AN AUNTIE GRAVITY PRODUCTION WHCN 106 FM
TICKETS: MAIN MUSIC KRESGE'S MUSIC ISLAND LASALLE MUSIC
U.F.O. AB OVO WEAR HOUSE AMERICAN REVOLUTION

Above: The Stooges played with Chubby Checker in one of the strangest bills ever. Springfield, Massachusetts, February 1970. Jeff Gold collection.

IGGY: A Plutonian Prince

PLUTO ROCK

a good band smells

and a

bad band stinks

Three people sit quietly in the lavish public relations office of a major record company listening to a record. The name of the record is *A Salty Dog*, a slow, momentous dirge played by the famous rock group, Procol Harum. Yep, no doubt about it, Procol Harum with their constant self-sacrifice in the face of every adversity (slow public acceptance, low selling records, etc.) continue to grind out those sad, sometimes slightly hopeful, melancholic odes to the sea with an ardor that can only be described as messianic. They are Neptunians. "The hell with the pain, let's carry on." The atmosphere in the room matches the record. Everybody is in a state of reflective languor, no one intrudes, there is a total human power vacuum. Then, suddenly, with an almost careless force, the door flies open and Iggy Stooge, born James Jewell Osterburgh, washes into the room and its universe is totally transformed.

Large, gap-toothed grin, round magnetic eyes which sweep the room in search of a target. Pointing at one of the publicity ladies with all the imperiousness inherent in a true Plutonian, he says (in a low sinister whisper) "Hey, you wanna twist?"

Well, besides the initial impact-shock of Iggy's Plutonian presence, three important things were changed irrevocably. 1. No one in that room would ever think of Procol Harum in the same way again. Neptunian humility was deflated. 2. Nor would they forget that moment, their personal inter-relationships were changed indefinitely. 3. A super-galactic force had been exerted and all three would be held in its grip forever.

Iggy Stooge, more than most of his "rock music" counterparts, is perhaps the most perfect example of the dark, totally powerful Plutonian force.

Or, as some syphilitic French poet once put it: "le pouvoir du neant." The power of nothingness. Iggy and the Stooges (his three cruel, quiet cohorts in evil) don't "make music". They create a high intensity musical laser beam, continuously regenerative, which envelopes the mind of their audience (followers). Using the beam as a conductor, they transmit raw power units which put everything in the the vicinity under a total aura of subjugation. It's easy enough to see this force reflected in the faces of the spectators, you don't have to take my word for it. Glazed, fearful eyes, gaping mouths drooling spittle, fear-stricken wincing faces cringing in anticipation of a direct physical assault from Iggy, Plutonian incarnate. Essentially, the Stooges are "power conductors" who channel and re-define the awesome force which emanates from the dark side of the universe.

You can hear it on their records, after every human effort has been made at vinylizing and filtering it down to "easy listening music". Catch the expression on someone's face when they hear the first few measures of one of their records. A double-take, slow look of disbelief which dissolves into one of genuine concern. They are beginning to feel the Plutonian power tentacles reaching out at them. Their safe existence is threatened. But that's the whole point. While other Plutonian groups like Alice Cooper, the Mothers(to an extent), Mick Jagger and the Velvet Underground are slowly consuming themselves because of their inability to hold onto IT, the Stooges stand out, cold, hard and sinister — razor edged against the world as the true Plutonian envoys to this testing area some call the earth. Make no mistake about it, they are the ONES. Confront them. Then just try and deny it. You'll see

Above: The Stooges, and Iggy in particular, were embraced by many unconventional publications; here, *Pluto: An Occult Magazine For the Devil's Country*, 1970. Jeff Gold collection. **Right:** In February 1970, The Stooges appeared in *Screw*, a pornographic tabloid that according to the statement on the cover offered "Jerk-Off Entertainment for Men." Johan Kugelberg collection.

ROCK 'N RAUNCH

DOWNTOWN STOOGES BALL

by HANK ARLECCHINO

Yes, The Doors did come to town. Donovan brought out the Flower Children; the Rolling Stones brought out the Beautiful People; and the Doors brought out the Astoria trash. I knew it was going to be one of those grim evenings when I watched the monstrously ugly, dirty-necked, waxy-eared crowd push its way through a glass door at the Felt Forum and walk over two bloodied victims in order to get into the theatre. The Doors were never known for gentleness and the arena was packed with savages to prove it. Once upon a time, their lead singer was a sex symbol. Now Jim Morrison can hardly stand up. He's got spastic tick of the jaw. His hands hung uncontrollably from his sides. In order to get himself together, he'd need a free course at Slenderella, a hair transplant, and a huge down to repress his twitches. For no reason at all, Jim would either scream into the microphone or he would jump around the stage, reminding me of my favorite Buster Crabbe movie, *Nabonga the Ape*. The weirdest thing about the whole event was that the music sounded great. The Doors do have a great sound. It's just that Jim has made them disgusting to look at. The star is also again going through his "poet" phase. His Lizard King nonsense has been underscored with pretentious sound effects and we were unnecessarily tortured with a recital of it. Jim Morrison gets SCREW'S BEST IMITATION OF DAME EDITH SITWELL AWARD and The Doors get our heartiest wishes for a new image. Their audience, who seemed to be having the time of their lives, is entitled to one of Al Goldstein's bottled farts. Send Al five dollars immediately.

FROM BETWEEN MY BUNS

Santana is a Top Ten band. The group is pretty good but not terribly innovative. However, a hysterical cult has built up around this group. Santana fans are schmucks. Any good Latin dance band plays the same music—only better. It's just that Santana's fans are too inexperienced to know this and too stupid to realize that just because they are hearing something for the first time, it doesn't mean that the world is enjoying the same virgin experience Regine, the middle-aged French chanteuse came to Carnegie Hall for a one-night stand. It was more than enough. These "Mademoiselle de Paris" type ladies always give me diarrhea anyway. Where sex is concerned, the French are blue-balled deaf and dumb creeps. They think *A Man and a Woman* is a heavy movie and that the song, "Je T'Aime" is a definitive fuck song. I ask you, could you ball anyone named Jane Birkin? At any rate, Regine's audience was a hoot. I've never seen a wilder collection of fashion freaks. It's a shame that only nonsense brings them out. Backstage, the singer was a totally different creature—tough, attractive, honest, gracious. If Regine promises not to sing, I promise to eat her Rado and Ragni's new RCA record "DisinHAIRited," a collection of songs that were written for but left out of *Hair*, is a cheap, vulgar, crass, crude way to make money. Shame on you, you greedy denizens of the Age of Aquarius. You suck! The medical name of my all-cured rectal ailment is condyloma. If you contract it, I hope you get it on your tongue.

DANNY BOY

Atlantic Records' Danny Fields knows more about Rock and sex than anyone.

Therefore, I threw him a few questions about the nature of the rock experience. FIELDS: The best rock concerts are Cluster Fucks. The audience engages in a communal ball. It balls each other and it knows it's possible because it has seen fucking on the stage. In some bands, you'll see two of the players acting out a fucking situation and neither necessarily is the man or the woman. They are just two lives who are fucking. This is one of the rituals of the future—one of the religious things that's coming and it has to do with living. The acid knowledge has taught us that the most wonderful and greatest miracle is life itself. Sex is life and sex is wonderful and young and beautiful. It's an art, the art of the sense of touch. Why isn't that art as great as any other art, as great as a symphony or a painting?
SCREW: Describe the best Cluster Fuck concert you've ever been to.
FIELDS: An MC-5 concert in Ann Arbor. There was an incredible thumping in the room. Everybody was right on it. The audience was fucking in time. The music was coming out of the floor and walls and everything. Everyone was smelling and doing things and their muscles were in action. Their whole forces came together and were spent together. The audience formed, for some incredible reason, the shape of a heart, a beating heart, with its point coming right out of the stage. It was a spontaneous Valentine, a silly, old, beautiful symbol.
SCREW: Would you like to see naked rock concerts in the future with real fucking going on?
FIELDS: Yes, I'd like to see some test runs of that. It sounds like a good idea. People are going to go home and fuck anyway. The rock concert is part of the fucking ritual. The music charges everyone up sexually and fucking is the nicest way to end the evening. Rock has more to do with that than a day at the factory. Rock concerts are a form of pre-arousal. They make you a little horny. But the concert itself is not a sexual fantasy. I don't think you can get off by sitting in a seat at the Fillmore. The more performers contribute to pre-arousal, the more I'm interested in them. Jim Morrison, Iggy, Mick Jagger all projected a new kind of sexuality, an auto-sexuality, a pan-sexuality, a trans-sexuality, a poly-sexuality as does Janis, the only woman in a large, male band.
SCREW: What is the nicest sex event you can think of?
FIELDS: I'd like to see one of these concerts we spoke about before.
SCREW: So would I, Danny.

FUCK YOU TOO

A lady whom I've never heard of named Freah Litz wrote a letter to the *Village Voice* to describe her association with SCREW. No one around here ever heard of Freah and I've been here from the beginning. The *Village Voice* will print any bullshit just to discredit SCREW. They are really running scared! They have a new twirp writing over there named Jim Nash. Jim has one small grape-shaped testicle and it hangs from his left nostril. The Doors' party was not grotesque, Jim. You are. We were also criticized in *Brat*, a teen-aged radical newspaper with a circulation of three. This week *Brat* features an article about female masturbation. *Brat* hates us because we're into fucking and they're still jerking off. This summer when the law was after Buckley and Goldstein, did they panic and hide? They bought three hundred bucks worth of baseball equipment and took us all to Central Park where we played against the company of *Hair* and all our horny readers came out to see the game. Now, I ask you: whose team would you rather be on—Buckley and Goldstein's or Freah Litz's? Yes, you got it. Get ready for the first pitch!

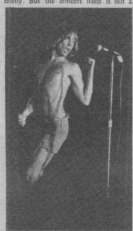

J: SO AFTER THAT, YOU PLAY UNGANO'S IN NEW YORK CITY (FEBRUARY 21-24, 1970) FOR THE FIRST TIME AND THERE'S THIS RIDICULOUS BILLBOARD REVIEW WHERE THIS GUY USES "EROTIC" THREE TIMES. "DANCED, GYRATED, LEAPED, AND SPRAWLED IN A MULTI-SEX STYLE."

I: I don't remember. Is that when I went on the pipes and they all fell out?

J: THAT'S THE SECOND TIME YOU PLAYED THERE.

I: Okay, I don't remember the first time.

Right: *Billboard* reported that during The Stooges February 1970 shows at Unganos in New York, "Iggy, one of the most erotic performers around, performed in multi-sex style." Jeff Gold collection.

STOOGES
LIQUID SMOKE

Ungano's, New York

The Stooges, fronted by Iggy, gave an active, erotic set at Ungano's, Feb. 24, They were preceded and followed by Liquid Smoke, a good blues rock quintet. Iggy, who uses Stooge as his last name, danced, gyrated, leaped and sprawled on front tables and floor while singing and shouting lyrics.

Iggy also used microphone and microphone stand and, in one number, even lead guitarist Ron Asheton, for erotic effects. Even persons sitting at front tables were not spared. The unusual act curiously worked as the large weekday crowd tried to anticipate Iggy's next move.

The strong support received from Asheton, bass guitarist Dave Alexander and drummer Scott Asheton almost were lost sight of as Iggy, one of the most erotic of performers around, performed in multi-sex style. Elektra Records has quite an act here!

Sandy Pantaleo was in fine form as Liquid Smoke's vocal lead with the closing "It's a Man's World" a standout. This Avco Embassy Records group, originally from North Carolina, proved together and promising. Organist Benny Ninmann and lead guitarist Vince Fersak had good instrumental sections, while the support of drum-

(Continued on page 28)

MARCH 7, 1970, BILLBOARD

Touch

A Monthly Newsletter From The ELEKTRA RECORDS Publicity Department

Touch
Supergroup
Superscoop
See Page 3

Number 1

BETWEEN THE LINERS

News from the Front: it gives me great pleasure to announce that a Friends of the Bizzaro Zone fashion plate award goes to that dashing young Rock photographer/journalist about town, JOHN BELLISSIMO, for his consistent ensemble of Washington D.C. policeman's coat, white and baby blue track shoes, Yale teeshirt, ochre maxi scarf and black bowler. Good for you, John! I don't know how much of a secret this is (if indeed any), but those two local black sheeps amongst the pop critics fold, LENNY KAYE and RICHARD ROBINSON—that old Messalina's darling himself—have been mantling a band of their own, working mostly in the laboratory during nocturnal electrical storms, I understand. It's tentatively baptized "Manray" and one of its imminent projects is a 20 minute version of "96 Tears".

Messalina's darling

. I have absolutely no comment on any of those rumors about HENRY EDWARDS of SCREW magazine and myself—especially the one about an insane illegitimate son living in the catacombs beneath the Fillmore East who can be heard playing a spectral organ after the last late show. It's all superstitious nonsense. Just in passing, JOHN SEBASTIAN was named Beautiful Person of the Year by a newspaper in East Orange, New Jersey...

Congratulations to ALBERT GOLDMAN, NEW YORK TIMES and LIFE pop music correspondent, who by day is disguised as a mild-mannered professor at Columbia University here in New York, for wheedling a 3 credit course on Rock into the curriculum. Will he really get to call it "Kontemporary Kulchrre"? . . . the new DAVID PEEL AND THE LOWER EAST SIDE album, "The American Revolution" will undoubtedly end up in the time capsule as a classic example of mid-twentieth century folklore, along with its stroke of genius companion poster. . . .

Anybody convinced that chivalry is dead had best check out RENAISSANCE'S prize, KEITH RELF because he is in his body the personification of King Arthur.

And then there was the one about the record company executive who said, "That was no rock idol . . . that was our mail boy!" Seriously, folks, as an innocent bystander and whiz kid, I am always interested in the sociological sidelines of the phenomena of this industry; I tell the world that a lot of what I've been

seeing lately stuffing envelopes measures up I've been seeing stuffing auditoriums. My own pick hit for this month is Michael who w JERRY ROSS PRODUCTIONS—our 7th flo bor here at 1855 Broadway. I happened to deserted elevator with Michael one morning sneaking in late, and I can still taste the di ment I felt when he did not accompany n office, revealing himself in the process to be gral part of some supergroup we had just si did not speak, but I knew by the Holy Gra over his head and the Forest Primeval loc eyes that he could be one of "Them". Rare career have I ever encountered such an i magnetism—not to mention bone structure if only ANTONIONI had come to ME for a s for the lead in "Zabriskie Point". So a word to all you Leaders of Show Biz asking "Whe stars of tomorrow?": check out the happi may lie right in your own back yards!

While I'm on the subject of taste sensation west coasters would do well to trot your pala to BILLY JAMES' THE BLACK RABBIT or for a treat of good eating and an atmos good living.

As you all know THE DOORS are riding of their fifth amazing album, "Morrison H milestone, you say? A million-seller, you fabulous smash, you say? Well, all that may enough . . . but how many of you are aw HENRY DILTZ (alias Tad Diltz), photogr said album is none other but the same man once with TAJ MAHAL'S band, THE RISIN AND the MODERN FOLK QUARTET, standing his epic friendship with the star-cro YANOVSKY and his notorious photograph on mailboxes and fireplugs . . . and who shall get him on the '67 MONKEES tour—that s

And now Lust Fans (ears prick), it's that the column that you've all been waiting for stomping, whistles, applause, panting, slaverin ing, sounds of writhing on the floor and asse varying degrees of coronaries) run and get your and spirits of ammonia because in just about ond now I'm going to give you this month's ASHETON Sex Fantasy (fanfare consisting of wolves and thunder crashing over the Hil

AND THE SCOTT ASHETON SEX FA FOR THIS MONTH IS:

STEEL GIRDERS!!!!!

Those of you who missed out on this mon tasy, don't feel bad! There'll be another one ne and you have all that time to research the (fact and myth) surrounding the awesome ST drummer.

Well, I see by the old clock on the wall second mail pick up is just about due, whic it's time for me to stuff my pocketbook full late bars and stalk out Michael in the eleva next time, remember, as Groucho said: "If a French picture I could do it."

Yours

Josephine

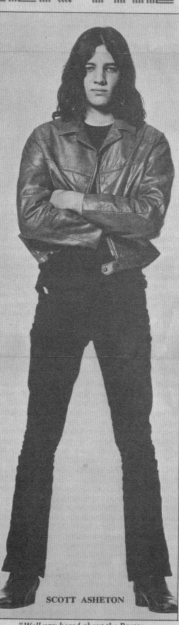

SCOTT ASHETON

*"Well you heard about the Boston. . . .
it's not one of those. . . ."*

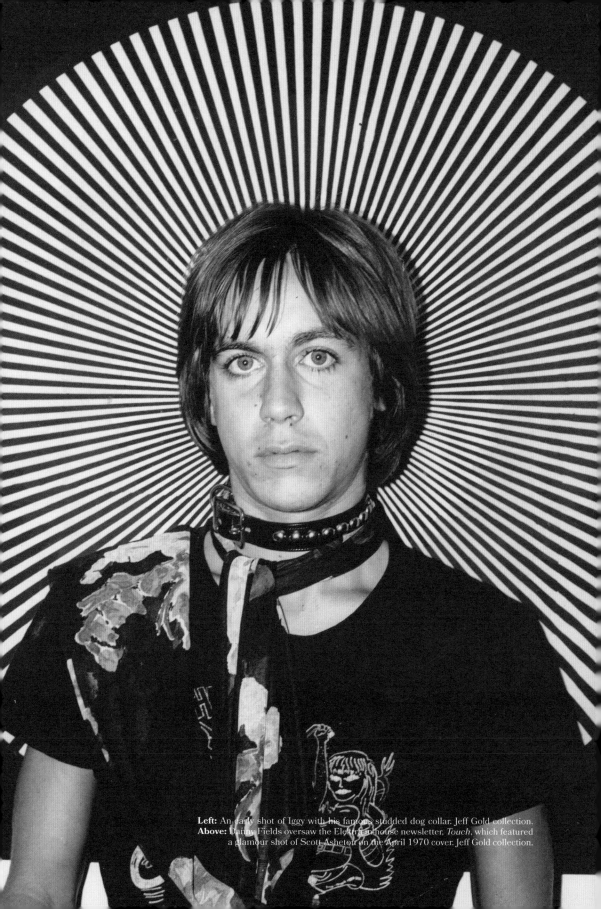

Left: An early shot of Iggy with his famous studded dog collar. Jeff Gold collection.
Above: Danny Fields oversaw the Elektra in-house newsletter, *Touch*, which featured a glamour shot of Scott Asheton on the April 1970 cover. Jeff Gold collection.

1855 Broadway, New York City, New York 10023 – 582-7711 / 962 No. La Cienega Blvd., Los Angeles, Calif. 90069 · 655-8280

elektra

DATE: June 15, 1970	ARTIST: STOOGES			
	TITLE:			
Side 1		SIDE 11		
1 LOOSE	3:33	8 1970		5:15
2 DOWN ON THE STREET	3:42	9 FUN HOUSE		7:46
3 T.V. EYE	4:17	10 L.A. BLUES		4:55
4 DIRT	7:00	11		
5		12		
6		13		
7		14		

REMARKS:

PRODUCER: Don Gallucci	STEREO	MONO	REEL	
ENGINEER: Ross/Myring	COPY	MASTER	OF	
	7½ IPS	15 IPS		

Above: Danny Fields' advance copy of the *Fun House* master tape. The band wanted the album to begin with "Loose," as it does here, but Elektra felt "Down on the Street" was a stronger opening track and changed the sequence. Jeff Gold collection.

6. FUN HOUSE

J: IN APRIL YOU GO TO LOS ANGELES TO RECORD *FUN HOUSE* WITH DON GALLUCCI, A STAFF PRODUCER FOR ELEKTRA, IN THEIR STUDIOS.

I: Yeah, they had just made him a staff producer. I thought, "This is okay because at least he played on 'Louie Louie.'" Don[24] remembers that he produced the album. I don't remember that. I just remember he was a babysitter and all the ideas were ours and he went along with it, but it doesn't really matter. A few things happened there. I wanted to get more aggressive. Scott wanted to get more aggressive.

J: IN TERMS OF?

I: Music, and more complex in terms of the information. The groups we liked were starting to do really sophisticated things. At the same time, whether it was my personality or the fact that he was now getting laid regularly, or a little bit the fact that everybody has their own rate of production and their own event horizon and Ron's was slow; somehow from my point of view, Ron went into a tunnel at that point, and I could not break him out. He came up with a few ideas that I thought sounded like our first album but not quite as good, and the one of them that was the best was, "TV Eye." So I got him to try an arrangement. He just had it as sort of a chord thing. I said, "How about if we get to that point, but start it out single string like a Booker T thing." He knew that reference and he tried it, but to do that, I had to camp outside his door night and day. Hassle him. And even then he wouldn't let me in, and I understand because you see how my room looked. The Iguanas even threw me out of the band: I'm thinking about certain things and other things...

J: TO THE EXCLUSION OF EVERYTHING ELSE.

I: Yes! That's how I am. I live in my head. Still have that problem. So most of the rest of the record, I wrote on a Mosrite guitar with a fifty watt Marshall amp up in my room and only Ron could have played it so wonderfully, but most of that, I wrote. Now Ron tells me later, he said that Dave did the riffs to "Dirt" and "Fun House." I would say I hope so, I'd like to think so, but I don't remember it that way. But without that one "TV Eye" riff and without hearing how great it sounded when he played it, the single string with the resonance and then build up, I would have had nothing to build on, so he was still the bedrock of that album. Now I often ask myself was I wrong? Could I maybe have not done *Fun House* and done stuff that was a little more like the first album and tried really hard to just maybe be cuter. I don't know.

So we developed it and he was still playing those heavy strings, which also makes it sound a certain way, and we brought in [saxophonist] Steve MacKay[25] to add depth and to add a build, and it just worked out.

24) Don Gallucci was the original keyboardist for The Kingsmen and played on "Louie Louie." He went on to form Don and the Goodtimes, Touch, and produce The Stooges. 25) Michigan Tenor saxophonist recruited by Iggy two days before the sessions began; he was working at Discount Records in Ann Arbor just before joining the band.

JK: IT'S ALL LIVE IN THE ROOM.

I: Well what it is, it's in the room with minimal overdubs, and as I remember it, we had our roadies come out with us and we brought in a van our stage equipment and set up our Electro-Voice theatre speakers, because I realized what we were doing on *Fun House* would not sound right if it was recorded dry and totally separated. That's how I remember it.

J: SO IT WAS YOUR IDEA TO DO IT LIVE.

I: I believe so. We came out and we were gonna do this our way and Don went along with it but we compromised in that they, for my vocal I believe they ran a double feed. To the board and to the other and mixed it. I believe so. The engineer was a charming, cultured British individual. I'd never met anybody like this and I was instantly charmed and reassured and I trusted him and I believed in him. His name was Brian Ross-Myring and I didn't know he did Barbara Streisand apparently, but he had an unflappable quality. Very nice quality about him, and I don't remember any problems with Don except early on somehow Don said, "Here's my album called Touch!" Have you seen his album?

J: NO.

I: It's some goombah redoing a Michelangelo. Yeah, it's really bad with the gatefold cover and everything and he thought because he was in Crabby Appleton and I didn't know what he was trying to get me to do, but I just remember like, "Oh, this guy!" But he was cool.

J: TO ME, THE GREAT PRODUCERS SOMETIMES WHEN THE ARTISTS HAVE VISION, THEY HAVE THE GOOD SENSE TO STEP BACK.

I: Yeah, he stood back and he let us do it and I think he was great about it. And the way it was done was we stayed at the Tropicana.[26] We would go in. It was literally just like Abbey Road where we had our guitars, drum sticks, and we would walk together from the Trop to the corner there of North La Cienega. Then half a block down La Cienega. I think it was Japanese-inspired architecture, that studio. Inside it was just this medium-sized very live, very organic room. What they used on the instruments was baffling only, so they did what they called these half baffles. They're about this long and about this high so that there's some meld but not too much. And each day would be the day of one song.

J: FROM WHAT I'VE READ, YOU WERE IN CHARGE PRETTY MUCH...

I: Yeah, I was in charge.

JK: SO YOU PICKED THE TAKES.

I: No, no, no. But there were some takes that were good where all of the vocal was not good, so there was some vocal overdubbing. I knew where I had to do that. There was some significant guitar overdubbing, but never as it's done now. What we would do, if he'd played a lead

26) The Tropicana Motel was at 8585 Santa Monica Boulevard in West Hollywood. It was just around the corner from the Elektra West Coast offices & recording studios at 962 La Cienega Boulevard.

like on *Fun House*, that's two leads, and on the chorus of "Dirt," he played it once straight picking it without any tricks really and then the second time through a Leslie to give it that quality. "LA Blues" is a complete double track. We freaked out once and finished and then picked the best freak out, but it just didn't sound freaky enough so, "Hey, we're in the studio!" Now a self-respecting free jazz musician is not going to freak double take, but we didn't have a problem, so we did it. We freaked out to our own freak out and then it became really like, "Whoa!!!"

J: WAS THAT ANYTHING LIKE THE EARLIEST VERSION OF THE STOOGES?

I: Very, very, very much like it. Yes. What it was, it sounded just how we would sound freaking out live because of the echo, and the second freak out—this is very interesting enough—was almost exactly like the first freak out. We could play with each other, and the people in the band, everybody had something to say and everybody really listened to each other.

J: AND WAS EVERYBODY OKAY THAT YOU WERE THE FINAL ARBITER?

I: I don't know how okay they were, but I think everybody just accepted it as long as I would leave them alone and they could get some dope to smoke and go watch...Do you remember those Ralph Williams Ford TV ads?[27]

J: ABSOLUTELY. I LOVED HIM.

I: Oh you know! Okay, Ron and Dave would go watch Ralph Williams all night.

J: SO *FUN HOUSE* TO ME IS WHERE IT ALL COMES TOGETHER. IT'S WHAT I IMAGINE THE STOOGES AT THE TIME WERE LIKE.

I: Yeah, I thought so. Didn't sell, did it? Later it did very nice business. It continues to sell steadily and it picked up all sorts of nice licenses. "TV Eye" and "Down On the Street."

JK: IT'S THE ONE THAT HIP-HOP DUDES CONNECT TO AS WELL.

I: Yeah, I would imagine so. That's been a gift, as my life got later, that black people like me [laughs].

JK: A COPY OF *FUN HOUSE* WAS IN AFRIKA BAMBAATAA'S RECORD COLLECTION. HE HAD A COPY OF *FUN HOUSE* AND IT WAS PLAYED. WHEN DID YOU START INTRODUCING *FUN HOUSE* SONGS INTO THE LIVE SET?

I: Right after. To echo, I can prove this through Johnny Ramone's complaint, "I went to see 'em and they didn't play any of the songs! They didn't even play the songs! That's how they cheat the audience! They don't care!" Because as soon as we got done with the first album, we just wanted to move right along. Let's write some new songs. Let's get going.

27) Ralph Williams was a Southern California car dealer who ran non-stop, hard sell late night television commercials starring himself, which were so idiosyncratic they gained a big cult following especially among stoned young people.

JK: WERE THERE TRANSITIONAL SONGS BETWEEN THE FIRST AND SECOND ALBUM THAT YOU DIDN'T RECORD OR THAT YOU DIDN'T DEVELOP?

I: There was one I wrote called "Private Parts." That was the only one that we didn't use. Everything else got used.

J: YOU TALKED TO [CRITIC] DAVE MARSH AT ONE POINT AND SAID YOU HAD NO INTEREST IN BEING A SONGWRITER OR LYRICIST. YOU JUST STOOD IN FRONT OF THE MIC AND THE WORDS STARTED FLYING AND YOU PICKED OUT THE ONES THAT SOUNDED BEAUTIFUL TOGETHER AND SEEMED TO HAVE SOME TRUTH.

I: That's absolutely true because as, I think Keith Richards had a version of that where he said, "Look you can write down some words and that sounds really good on the paper. You try to put it in the song, it's like putting an elephant in a rocking chair." Which is true. You have to find out how it sounds somehow to know if it's gonna ring true, so that's how I would do it and we would just rehearse over and over.

J: I'VE READ A LOT ABOUT DYSFUNCTIONAL STOOGES SHOWS. I WAS WONDERING IF YOU COULD THINK OF ONE OR TWO SHOWS WHERE YOU GUYS REALLY WERE FIRING ON ALL CYLINDERS AND YOU THOUGHT THE BAND REALLY CONNECTED?

I: Well, lots of them actually. God, most of our shows, we might go play a show in Jackson and we'd be great, but we were very, very good when we went out west to do *Fun House*—we played three or four shows: two at the Whisky and one or two at the Fillmore. And those were, we were very, very, very good. We played really well, we had that music down because you know we'd been playing it and developing it for a long time and then recording it. And we were shit hot.

J: SUPPOSEDLY WHEN YOU PLAYED THE WHISKY A GO-GO (MAY 7-8, 1970) FOR THE FIRST TIME, THE REACTION WAS NOT GOOD...

I: Well...there were a bunch of art people and they just moved back, afraid of us, and there's the few like extras from a go-go movie or a beach party movie. They would come up, little cute girls in hip huggers and all that sort of thing, and once we got going they were kinda like, "Oh this isn't like a fun band." And one girl, one surfer type girl, a very attractive girl in those hip-hugger bell bottoms came up and danced right in front of the stage while we worked and that was what prompted me, I jumped off the stage onto a cocktail table, grabbed the candle, and poured the hot wax on my chest to entertain her [laughs]. I didn't know what would happen, but I thought, "Well let's try this," and it doesn't hurt. Doesn't hurt. As soon as it hits your skin, it just goes cold and looks weird. I'm not sure why, but I wanted to make sure people didn't forget the gig in some sort of climax.

Right: While in Los Angeles to record *Fun House*, The Stooges played their first L.A. area shows at Hollywood's Whisky A Go-Go. There Iggy incorporated a table candle into the act. "I jumped off the stage onto a cocktail table and poured the hot wax on my chest...it doesn't hurt...As soon as it hits your skin, it just goes cold and looks weird." Photo: Ed Caraeff.

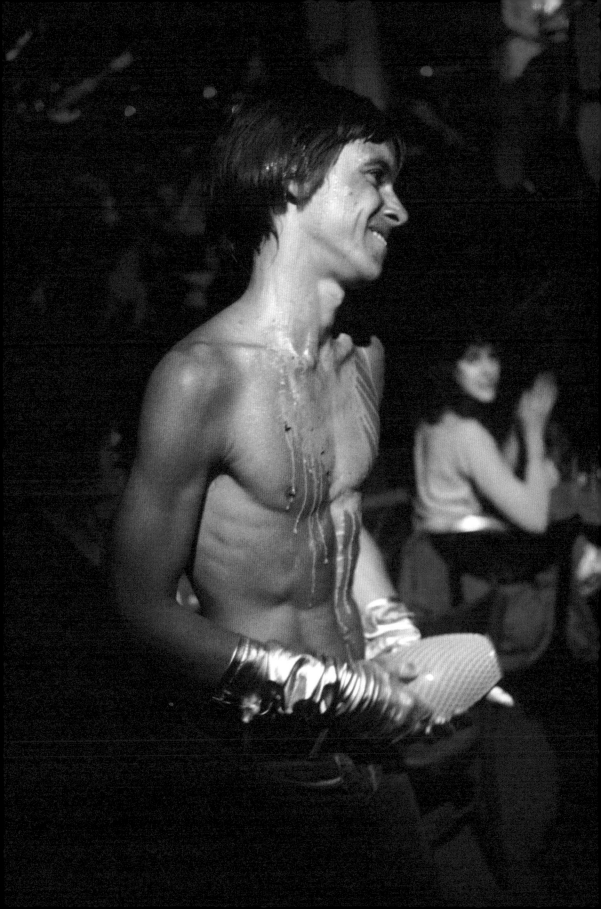

J: SO I DON'T KNOW IF OR HOW MUCH YOU WANT TO TALK ABOUT THIS, BUT SUPPOSEDLY THIS IS WHEN YOU TRY HEROIN FOR THE FIRST TIME.

I: Here's what happened. I tried coke for the first time on that trip. Danny Fields gave me some at the hotel and then I was one of those people. I'm so bad with drugs that I was like, "I don't feel anything! Blahlahlahlahlah." And I'm speed rapping and then, no, it did nothing to me and three days later— I'm a very agile person, or I was then—so I climbed in through the bathroom window of his suite, ransacked his room to find some more, and I stole his coke and he was so mad. "Man you stole my coke! Why would you do something like that?" That started it. There was a girl I fancied with the Cockettes. She was a dark Hispanic type. I go for darker girls. That's my favorite. And so I wanted to make some time with her. I met her at the gig and then I went up to San Francisco[28] later or maybe spent a couple extra days to visit her and at that time they were using that stuff.

JK: WAS SHE STAYING IN THE COCKETTES HOUSE?

I: She was staying in the Cockettes' house. She was a young girl. Tina something I think, and they were using it [heroin]. I did not, but I was really, "Oh my God. The creepiness of the vibe around that drug was very scary, and I'd never seen or experienced anything like that. I went back to Michigan, and what happened was the coke came in; and on the trip to LA with the Stooges Jimmy Silver had made connections at Erewhon (an early L.A. health food store), who still had that first store on Beverly. He was getting more interested in going that way and getting away from us, so he turned over management of the band to our roadie, who was his old friend who he had hired, and this guy had been living in the house with us.

His name was John Adams and he was a recovering heroin addict. The first thing he did was, "Well, got a lot of money now for this band." And he gave me my first heroin and gave Scott his first also in the backyard of the house. That's how it went, and then the heroin started coming in, not so much even as a high, but what was happening was I was using more stimulants to try to hype up the performances, to try to carry whatever I thought I was carrying, and it made me nervous like a lot of people who get into that.

J: DID YOU USE SPEED?

I: Yeah, often. I was using coke, speed, and LSD. Speed, not really ever knowingly, but that would be in everything. It's in the coke. It's in the acid. So I would use that [heroin] to calm me. You calm down much more effectively than marijuana, and all of the sudden I got hooked. I remember when the coke came into the Detroit area too and there was this dealer named Mique with a "q-u-e." Everyone knew her. "Mic-kay" or whatever, and she would hold these parties. And Ron could go to a party like that with his shades on and just do a little bit and have a few cocktails and have a great time and talk to everybody, but I would do it and I instantly wanted to think about stuff I could do. I was bored talking to people, and a little voice came in at her first coke party in my head and said, "You're not good at this. These other people can all do this, but you're no good at this. This is no good for you." But it didn't stop me from falling into it, and I became a complete drug maniac on and off from late 1970 through the end of '74. So five years, and then after that tailed off with relapses for another seven years.

28) May 15-16, 1970, for dates at the New Old Fillmore. The Cockettes were a radical, cosmic gender fuck theatre troupe who lived in a Haight Ashbury commune: inspired by the Living Theatre and the films of Jack Smith, they began putting on absurdist and camp productions that were indivisible from their chaotic lifestyle. Most of them were gay men but there were also women involved.

Above Left: Iggy in San Francisco with Tina, friend of The Cockettes. **Above Right:** At the New Old Fillmore. Photo: Robert Matheu.

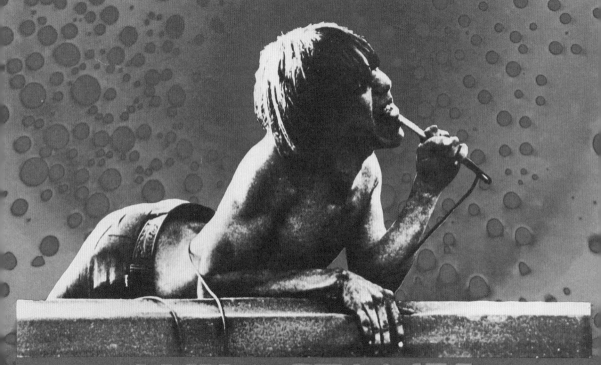

NEW OLD FILLMORE

IGGY AND THE STOOGES
THE FLAMIN GROOVIES
COMMANDER CODY PURPLE EARTHQUAKE
AND HEAVYWATER LIGHTSHOW
FRIDAY MAY 15·16 SATURDAY
FILLMORE & GEARY EIGHT-THIRTY P.M.
FRI $2.00 AT THE DOOR SAT $2.50
ALICE COOPER

J: SO YOU PLAY SAN FRANCISCO—AND I'M SURE THIS IS PROBABLY JUST A MISTAKE—BUT YOU'RE BILLED AS IGGY & THE STOOGES.

I: It was happening all the time in little ways, but I never noticed the bill. I tried to block that out. I found the whole thing embarrassing, and obviously it alienated the other guys in the group.

J: DO YOU REMEMBER ANYTHING IN PARTICULAR ABOUT PLAYING WITH ALICE COOPER AT THAT GIG?

I: Yeah, I remember how impressed I was with Alice Cooper's set and I thought that they had a terrifically swinging drummer and I liked the way they all wore the cheesy spandex suits together and I remember that they had a cheap but highly effective, completely self-contained lighting rig that Alice would control with his foot. He'd press a little thing with his foot and it would change to pink or whatever and it was very cool. And their best song at that time live I thought, it was a cover of a Australian song called, "Sun Arise" (a 1961 hit by Rolf Harris).

J: AND WERE YOU FRIENDLY WITH THEM AT THAT TIME?

I: No, not yet! I think they saw us and thought, "We've gotta get in on this shit!" That's what I think. I was competition. I felt competitive with them and I thought we did alright, but I thought, I may have thought, "Gee, I wish my group was as together and articulate as that." And they had an ease about it, it wasn't like they were working hard whereas I was working hard.

J: YOU HAD TO DO THE WHOLE SHOW.

I: Maybe that's it. That's what people say. And then I just remember that in San Francisco some of the Cockettes were in the front row and I was psychedelicized that night. More than several of the Cockettes were dressed up like Carmen Miranda gone wild and I was like, "what the hell is this"—and I loved it—"this is so cool and bananas and oranges and you know calico scarves and this whole thing." The other big thing I remember about it was, when we were—it was either during sound check or maybe somewhere during the gig when we weren't playing—this strange kind of cocky hippie with granny glasses approached me and he said "Hi, I'm Owsley Stanley,"[29] and he was real pleased, he was already pleased with himself, and he made some sort of comments, I can't remember what, but I did meet [LSD kingpin] Owsley and talk with him a little bit. I mean that's what you do if you go to San Francisco in 1970, you meet the Cockettes and at least one member of the Psychedelic Set—he had done the sound system that night. So that was his pride and joy doing sound systems.

29) Owsley "Bear" Stanley (b 1935 - d 2011) was the Grateful Dead's sound engineer and became legendary as the first private individual to manufacture mass quantities of LSD.

Left: The Stooges played San Francisco for the first time in May 1970, at the New Old Fillmore. Iggy: "Some of the Cockettes were in the front row and I was psychedelicized that night...they were dressed up like Carmen Miranda gone wild and I was like, "What the hell is this?" Jeff Gold collection.

Entertainment World

THE TRADE WEEKLY FOR ALL THE ENTERTAINMENT INDUSTRY

FIFTY CEN

MAY 29, 1970.

ON STAGE WITH THE STOOGES:
Songs From a Boy Named Iggy

DANCE FOR FILMS AND TV:
A Survey of Camera Choreographers

COMPOSER RANDY NEWMAN:
The Reluctant Troubadour

also...

ACTOR JAMES MASON:
Into the '70s and his 60's

DRUMMER BUDDY RICH:
"Jazz is Fire"

PRODUCER JOSEF SHAFTEL:
New Ideas for Film Financing

DON'T MISS WCFL'S

BIG TEN
SUMMER MUSIC FESTIVAL

SATURDAY JULY 18th
SOLDIER FIELD

SEE AND HEAR:

CHICAGO

ILLINOIS SPEED PRESS

ILLUSION

IT DOESN'T MATTER

HAPPY DAY

PIG IRON

STOOGES

DREAMS

LEON RUSSELL

MC-5

FUNKADELICS

JOE KELLEY BLUES BAND

MASON PROFFIT

BLOOMSBURY PEOPLE

BUSH

and More!

Beginning at Dawn with Giant
Orange Fireworks Display.

All Tickets $6.00

 278

FOLD ALONG THIS LINE

CLARK WEBER
6:00 am to 10:00 am
Monday through Saturday

Left: The May 1970 issue of *Entertainment World* saw The Stooges profiled alongside showbiz stalwarts James Mason and Buddy Rich! Johan Kugelberg collection. **Above:** An eclectic lineup for the July 1970 WCFL Chicago Summer Music Festival. Grant McKinnon collection.

J: WAS THERE ANY CALCULUS TO YOU GUYS HAVING A BETTER OR WORSE SHOW, MAYBE WITH YOU HAVING PEOPLE TO FEED OFF IN THE FRONT? YOU MENTIONED THAT GIRL IN LA OR THE COCKETTES IN SAN FRANCISCO?

I: Yes, it was always better when you had some activity in front, always. It's really hard without that, and sometimes we'd get, it ranged from violent activity to people thinking like "hey we get the joke" and come in with peanut butter or sometimes we'd have a lot of just female rock action - it just would depend really where we were. There never seemed to be a rhyme or reason to it, but the hardest was always when the people sort of hugged the back. The one thing that always gave me heart was I was very aware that we were the only group I knew of, or entity, that had absolute—I never saw any audience movement while we played for the first I'd say '68, '69 and '70 nobody like said, "Oh I'm gonna go check out the t-shirt stand," or, "I'm going to the bar," or "I'm gonna walk around and see if I can pick up some chicks or go get a whatever." No, uh-uh, everybody stayed in one place. So I knew we were onto something, you know?

J: CAN YOU TALK ABOUT THE IMPORTANCE OF YOUR FANS AND FAN CLUB? YOU HAD NATALIE STOOGELING DOING HER THING, "POPPED."

I: Well, Natalie[30] and those people were just these wonderful, strange people, lost people in a way. However, when they would come around, it was a warm feeling, so that was as far as it went I would say.

30) Natalie Stoogeling (nee Schlossman) was an enthusiastic Stooges supporter who befriended the band, founded their fan club, and published a series of six fan club newsletters between 1969 and 1971.

HAAAA STOOGE FANS EVERYWHERE!!!! This is our very first
Stooge newsletter titled POPPED (because Iggy did). I want to wel-
come all you elite to Stoogeland. It is a very fascinating and
bizarre place to be. (I know, because I have been floating there
for almost a year myself). Let me congratulate you on your good
taste. THE STOOGES ARE GREAT! Nothing like that good ole Rock and
Roll. "Come On--SHAKE"!

 I think I will start right in on all the DOIT and SCOOPAS.
All the stable info and reference notes will be included on the
individual bios (soon to follow) and the question and answer section
of the newsletter that will exist just as soon as I get some questions
from you people! (I have my own, but they don't make good copy in
mixed company. Besides, I blush easily and I promised myself when I
took this plunge to be the best Fan Club leader ever and to be dirty,
but not obscene).

 ON TO THE GOSSIP...

...Iggy Stooge gets airsick. When the Stooges arrived in New York

-1-

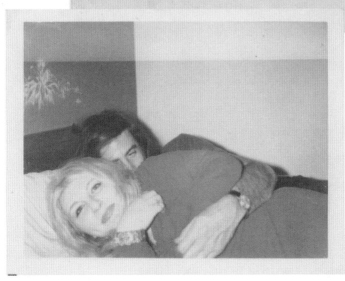

Above: The first issue of Popped, Natalie Stoogling's fan club newsletter. Johan Kugelberg collection. **Bottom:** Stooges fan club mastermind Natalie (Schlossman) Stoogeling with Danny Fields in a Chicago hotel room. Photo by Iggy Pop. Jeff Gold collection.

J: SO *FUN HOUSE* COMES OUT IN JULY 1970 AND YOU'RE CALLED IGGY POP ON THE ALBUM COVER.

I: Yeah, I told them, "Now, y'know, hey." Jim P-o-p-p was one of the delinquent friends of Ron and Dave and one of the people that hung out with that group. He had sniffed too much glue and lost a lot of his hair early. And he just had a great last name and one day I was in the Student Union sneaking some coffee and I thought about what a great name he had. He was laying there sleeping in one of the booths. Townies would go over there to get cheap food. Sneak into the Student Union and just hang. And later I thought, "Well, I don't know. I wanna be..." It was really even before the first album came out I started calling myself Iggy Pop, and then they just said Iggy Stooge. So yeah, I nicked it from Jim Popp.

Right: Elektra Records promotional poster for *Fun House*. Johan Kugelberg collection.

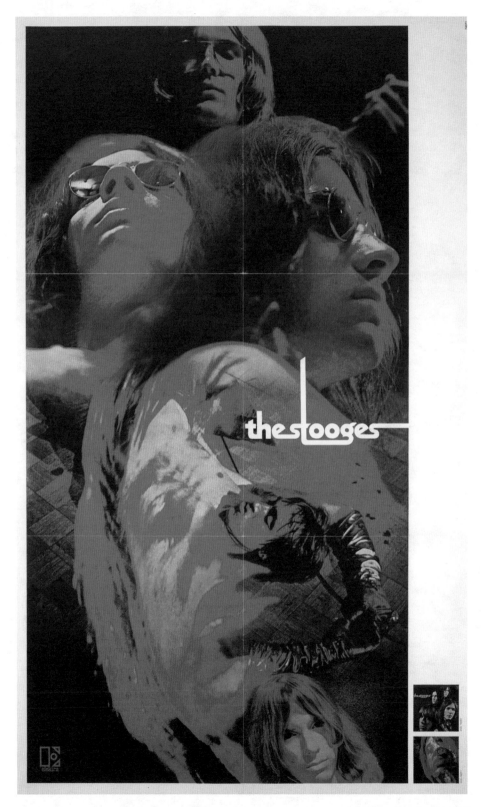

THE STOOGES "Fun House" (Elektra). Next to Grand Funk Railroad, this is the worst album I've heard this year. In truth it's a muddy load of sluggish, unimaginative rubbish heavily disguised by electricity and called American rock. I've heard a few tales about the Stooges. Singer Iggy Pop (that's daft enough) apparently spends evenings throwing himself into the midst of audiences and getting beaten up by the aforesaid tribes of poor people Well, maybe that's about the best thing you could do to the guy. Ron Asheton on lead guitar sounds as though he badly injured both hands. There's really no excuse for turning out such bloddy rotten stuff. I'm trying desperately to think of one good think about it — maybe the bass of Dave Alexander offers a little fluent power. But again, in truth, this album only goes to show up the gullible efforts of record companies, and the people who raise such groups to an absurd status. I'm willing to believe that the stage act is a gas to watch, but on record. EEeecchh! — **R.H.**

right/to want somethin'/to want
ethin'/tonight ..." Sitting around,
eraged, narcissistic, masochistic,
in gloom cuz we *could* have a real
time but I'm not right, whether
dope or day drudgery or just plain
otic donothing misanthropy, can't
through ("You don't know
Little Doll/And I don't know
...") – ah well, wait awhile, may-
ome fine rosy-fleshed little doll with
eyes will come along and marry you
then you'll get some. Until then,
gh, it shore ain't no fun, so swagger
your buddies, brag, leer at passing
whack your doodle at home at
gaping at polyethylene bunnies
ging teddy bears, go back the next
and dope out with the gang, grass,
d, reds, Romilar, who cares, some
bull's gonna buy us beer, and after
you go home and stare at the wall
cold and stupid inside and think,
the fuck, what the fuck. I hate
elf. Same damn thing last year, this
, on and on till I'm an old fart if I
that long. Shit. Think I'll rape my
k-fantasy cunt dog-style tonight.

retty depressing, eh? Sheer adoles-
drivel. Banal, too. Who needs music
a theme like that? What does it
to do with reality, with the new
al systems the Panthers and Yips are
kin' up, with the fact that I took
four days ago and since then every-
g is smooth with no hangups like it
ys is for about a week after a trip.
good, benevolent. So what the fuck
all that Holden Caulfield garbage
Stooge is always prattling about
to do with me? Or with art or rock
oll or anything? Sure, we all know
at adolescence, why belabor it, why
len "art" (or whatever the Stooges
n that caterwauling is) with some-
g better left in the recesses of
ature brains who'll eventually grow
of it themselves? And how, in the
e of all these obvious logical reali-
can any intelligent person take Iggy
age for anything but a blatant fool,
-eyed, sweaty and loud though he
be?

/ell, I'll tell ya why and how. I've
n building up through lots of
tions and postulations and fanta-
so not one dullard reading this and
ing a stack of dated, boring "rock"
ms but no Stooge music can fail to
prehend, at which time I will be
to get on to the business of describ-
the new Stooges album. So here
es the payload. Now, to answer the
question first, because the final con-
on of all Stooge-mockers is definite-
rue and central to the Stooges:
re goddam right Iggy Stooge is a
n fool. He does a lot better job of
ing a fool of himself on stage and
than almost any other performer
ever seen. That is one of his genius'
al facets.

hat we need are more rock "stars"
ng to make fools of themselves,
lutely jump off the deep end and
e the audience embarrassed for
if necessary, so long as they have
one shred of dignity or mythic
na left. Because then the whole
n pompous edifice of this supreme-
diculous rock 'n' roll industry, set
grab bucks by conning youth and
ouraging fantasies of a puissant
th culture," would collapse, and
it would collapse the careers of the
d talentless nonentities who breed
f it. Can you imagine Led Zeppelin
out Robert Plant conning the
nce: "I'm gonna give you every
of my love" – he really gives them

OF POP AND PIES
AND FUN
A Program For Mass Liberation in
the Form of a Stooges Review
Or, *Who's the Fool?*
by Lester Bangs

nothing, not even a good-natured grinful
"Howdy-do" – Or Jimmy Page's arch
scowl of super-musician ennui?

A friend and I were getting stoned
and watching the TV eye's broadcast of
the Cincinnatti Pop Festival the other
night, when a great (i.e., useless) idea
struck us. Most of the show was boring,
concentrating on groups like Grand
Funk (endless plodding version of
"Inside Looking Out" with lead singer
writhing and barking and making up
new lyrics like "Oh little honey I need
your love so *bad* ... c'mon, give it to
me ... oh little mama" etc.) and
Mountain (Felix Pappalardi spinning off
endless dull solos in a flat distillation of
the most overworked elements of
Cream's and Creedence's sounds, while
fat buckskinned Leslie West thumped
bass and reacted to Pappalardi's piddle
with broad, joyously-agonized mugging,
grimacing and grinning and nodding as if
each and every *note* out of Papa's guitar
was just blowing his mind like no music
he'd ever heard before). Well, I watched
all this monkey business with one eye
scanning the bookshelf for a likely
volume to pass the time till Iggy hit the
tube, and when he did it was fine – not
as good as watching Carlos Santana
squint and Cunt Joe spell out "FUCK"
in *Woodstock*, mind you, but a fine
video spread anyhoo – but the part of
the show that intrigued us the most
came in Alice Cooper's set (who, how-
ever gratingly shrill their amphetamine-
queen hysteria, certainly can't be
accused of taking themselves seriously –
come the revolution, they don't get
offed with Pappalardi and West and
George Harrison and all them other
cats), when Alice crouched, threw his
billowy cape over his stringy mop like a
monk's cowl, exposing his hormone-
plasticized torso, and crept duckwalking
like some Chuck Berry from a henbane
nightmare to the apron of the stage,
where he produced a pocketwatch, and
hypnotically in motion, and started
chanting in a calm conversational tone:

"Bodies ... need ... rest ..." – re-
peating it at same tempo till finally
some (genuinely wise) wiseacre a few
bodies into the crowd piped up, "So
what?" Good question. What if some-
body said "So what?" when Richie
Havens started into his righteous "Free-
dom" number? Of course, the question
is stupid since three dozen devout
Richie Havens fans would promptly
clobber the boorish loudmouth, if not
off him completely (in line with the
temper of the times, in which case he'd
be post-mortemed a pig). But nobody
gives a shit what anybody sez to A.C.
least of all A.C., who was probably dis-
appointed at not soliciting more razz-
berries from the peanut gallery, except
that a moment later he got his crowd
reaction in spades when some accom-
plished marksman in the mob lobbed a
whole *cake* (or maybe it was a pie –
yeah, let's say it was a pie just for the
sake of the fantasy I'm about to promul-
gate) which hit him square in the face.
So there he was: Alice Cooper, rock
star, crouched frontstage in the middle
of his act with a faceful of pie and
cream with clots dripping from his ears
and chin. So what did he do? How did
he recoup the sacred time-honored
dignity of the performing artist which
claims the stage as *his* magic force field
from which to bedazzle and *entertain*
the helpless audience? Well, he pulled a
handful of pie gook out of his face and
slapped it right back again, smearing it
into his pores and eyes and sneaking the
odd little fingerlicking taste. Again an-
again he repeated the gesture, smearing
it in good. The audience said not
another word.

The point of all this is not to elicit
sympathy for Alice Cooper, but rather
to point out that in a way Alice Cooper
is better than Richie Havens (even
though both make dull music) because
at least with Alice Cooper you have the
prerogative to express your reaction to
his show in a creative way. Most rock
stars have their audiences so cowed it's

nauseating. What blessed justice it
would be if *all* rock stars had to contend
with what A.C. elicits, if it became a
common practice and method of passing
judgment for audiences to regularly
fling pies in the faces of performers
whom they thought were coming on
with a load of bullshit. Beause the top
rockers have a mythic aura around
them, the "superstar," and that's a
basically unhealthy state of things, in
fact it's the very virus that's fucking up
rock, a subspecies of the virus I spoke of
earlier which infests "our" culture from
popstars to politics (imagine throwing a
pie in the face of Eldridge Cleaver! Joan
Baez!), and which the Stooges uncate-
gorically oppose as an advance platoon
in the nearing war to clear conned nar-
coleptic mindscreens of the earth, even-
tually liberating us all from basically un-
creative lifestyles in which people often
lacking half the talent or personality or
charisma of you or I are elevated into
godlike positions. Pure pomp and cir-
cumstance.

So now you see what I'm driving at,
why the Stooges are vital, aside from
being good musicians, which I'll prove
just as tangentially later. It takes
courage to make a fool of yourself, to
say, "See, this is all a sham, this whole
show and all its floodlit drug-jacked
realer-than-life trappings, and the fact
that you are out there and I am up here
means not the slightest thing." Because
it *doesn't*. The Stooges have that kind
of courage, but few other performers
do. Jim Morrison, of late – how in-
spiring to see the onetime atropine-eyed
Byronic S&M Lizard King come clean
stumbling around the stage with a Colt
45 in hand and finally wave his dong at
the teeny minions who came there to
see him hold both it and his gut in and
give them some more vivid production
which communicated nothing real but
suggested everything a fertile pube brain
could dredge up! Morrison def, does not
get a pie in the face! He 'fessed up! And
even old John Lennon, who for awhile
qualified for the first and biggest pie (to
drown him and Yoko both in slush as
ersatz as that which they originally ex-
creted on the entire Western world), has
set such a consistent record for absurd
self-parody above and beyond the needs
of the revolution (like saying "I gave
back the MBE also because 'Cold
Turkey' was slipping down the charts"
– a fine gesture. We won't forget it
later, either.) that he too qualifies for at
least a year's moratorium from the
creem guerillas. But then there's all
those *other people* – Delaney and
Bonnie (through no fault of their own –
after all, a man and his woman are
known by the company they keep) and
George Harrison (a giant pie stuffed
with the complete works of Manly P.
Hall) and that infernal snob McCartney
and those radical dilettante capitalist
pigs the Jefferson Airplane (it's all right
to be a honkey, in fact all the Marxists
are due for some pies in pronto priority,
but to wit on all that bread singin' bout
bein' an outlaw when yer most scur-
rilous illegal set is ripping off lyrics from
poor old A.A. Milne and struggling Sci-
Fi hacks, wa'al, the Creem Committee
don't cotton to that, neighbor.)

Similarly, Mick Jagger gets immedi-
ate pie-iority as a fake moneybags revo-
lutionary, and in general for acting
smarter and hipper and like more of a
cultural and fashion arbiter than he
really is. If Jesus had been at Altamont,
they would have crucified him, but if
Mick Jagger makes me wait 45 minutes
while he primps and stones up in his

ELEKTRA RECORDS
15 Columbus Circle
New York City 10023

the stooges

 The music and the legend of the STOOGES seem to be built
on the premise that <u>anything</u> can happen! The background, form-
ation, and ultimate unleashing of the STOOGES upon the world
suggest that the full force of their bizarre musical power rests
on that incalculable foundation.

 Iggy Stooge, The Human Explosion and World's Only Apoca-
lyptic Vocalist, burst forth upon the world on April 21, 1947 in
Ann Arbor, Michigan, "buzzing to ya' straight from hell," as he
explains it. His musical career began in high school where he
played drums for a rock & roll band known as "Iggy & The Iguanas,"
later joining a blues band called The Prime Movers. After trav-
eling to Chicago with them and getting to meet, play, and learn
from a number of musicians, he decided to "come home and make my
own music." Returning to Ann Arbor, Iggy sought out the other
STOOGES in a manner not unlike a wizard assembling his own battery
of charms, skills, and magic. It is no wonder that he thus
summoned the bedeviled talents of Ron, Scott, and Dave.

 Ron Asheton, the STOOGES lead guitarist and musical mav-
erick who plays his guitar with the deadly grace and skill of a
matador, was born on July 17, 1948 in Washington, D.C. After
moving to Ann Arbor, Ron worked with the Prime Movers for a while,

Left and Right: Elektra band biography for *Fun House*. Johan Kugelberg collection. **Center:** *Fun House* 8-Track tape. Mark Arevalo collection.

stooges
house]

ET 84071
SD

and played bass guitar with the Chosen Few before teaming up
with the other STOOGES.

Ron's brother, Scott, born August 16, 1949, is as stark
and ominous as the drums he beats. Iggy taught him most of the
basics of drumming, but Scott's powerful thunderblasts of per-
cussion are essentially results of his own unique style of energy.

Dave Alexander, bass guitarist, was born on June 3, 1947
in Ann Arbor. He is the throbbing pulsebeat of the group, whose
deep-toned vibrations are usually aimed below the belt.

Appropriately, the STOOGES made their first public appear-
ance on Halloween of 1967 at a private party in Ann Arbor, and
played their first professional gig at the Grande Ballroom in
Detroit in February of 1968. During these formative days, their
audiences were treated to some of the most bizarre and chaotic
performances imaginable. Iggy alternated playing such diverse
instruments as the Hawaiian guitar and a vacuum cleaner, singing
songs like "I'm Sick," and "Asthma Attack," and dancing wildly
like a free-form maniacal generator. All the while, Ron, Scott,
and Dave played like the musical extensions and feeders of Iggy's
amazing energy.

Today, their performances are still as amazing and unpre-
dictable, their music as incredible, and their sound as powerful
and terrifying as in the early days. And this is still only the
beginning.

GAY POWER

new york's first homosexual newspaper — metropolitan 35¢ national 50¢

GAY ACTIVISTS AT CITY HALL P.5
GAY LIBERATION: AN INSIDE VIEW P.8
IGGY STOOGE: THE MAGIC TOUCH P.10

VOLUME ONE

NO. 12

Gay Power: New York's First Homosexual Newspaper says Iggy has "The Magic Touch," 1970. Jeff Gold collection.

IGGY STOOGE-the magic touch.

Richard Nobile

JACKIE CURTIS TALKS WITH RITTA REDD

JACKIE CURTIS talks with RITTA REDD After Seeing Iggy & the Stooges at Ungano's

J: What did you want to say about Iggy Stooge?
I: He wasn't there for the audience's benefit; the audience was there for his benefit, and he told them so. He commanded the audience exactly like the Master would have done in an S & M situation.
J: That's gay.
R: I mean he grabbed a little hippie girl and dragged her across the stage while she was still in her chair; he dragged her across the floor by her FACE just waiting for her to respond, he wanted a reaction from HER and of course, he didn't get one as she fled back to her place in the "audience."

J: What do you mean he didn't get a response from her "of course?"
R: She fled in terror hon. And when the audience didn't come to Iggy, Iggy went to the audience, knocking plates down, glasses, standing on tables and telling people to get up and if they didn't get up he pulled them up out of their seats spilling drinks as well as girls' pocketbooks across the floor.
J: Did you see Geri Miller, superstar of "FLESH" and "TRASH" in the audience that night?
R: Yes.
J: How did she react?
R: She got up and left for a safe corner of the room away from the action. Maybe she won't like this, who cares? Well, that's what she did.
J: What else?
R: And then when he'd taken complete command of the audience he turned his back on them. He then proceeded to carry on with his guitar player.
J: What do you think Iggy's trying to say?
R: At the end he added insult to injury by proceeding to stand there for fifteen minutes while the people in the club just stared, their eyes were glued to Iggy. They were enthralled, by his torso, his silver lame gloves and his ripped jeans.
J: Do you think he is trying to say anything then?
R: I really don't know.
J: How did his carrying on affect you?
R: It was like Andrea Warhol's "Showtime" at Max's, you know, when you see it for the first time you flip out. It's fantastic, it's unreal, you just can't get over it. But I'd like to see the real conflict between Iggy and a person in the audience like say Andrea herself, I wanna be there because I think, even though Andrea is impossible to predict, however I'm sure it would be a memorable occasion.
J: Well what about other people in the audience, how do you think the male counterpart reacted?
R: Iggy was insulting their masculinity by throwing it in their faces reminding them of the role they play. Of course the world is full of masochists. I think Iggy's a great star.
J: Do you think Iggy's a masochist?
R: (Ritta pauses for a few moments and then) Well you really don't know what he's saying because he slaps himself in the face but I think he does that for the audience's reaction because you know I think he isn't really slapping himself but really slapping them and don't forget he's wearing those silver gloves and that's quite a different slap.
J: Was this the first time you saw Iggy performing LIVE?
R: Yes. He hypnotized me my dear, not only me, but the entire audience. One of the mood's he conveys is through physical effort, and that connects his karma with that of the audience.
J: What do you mean "Karma" my dear?
R: Karma? Uh, the whole mood of the audience was either antagonized by him or like a lot of them I noticed were rooting for him, egging him on. So there was a noticeable controversy which instantly creates an interest in what happens at the moment. The only thing wrong with this, if

you feel that way about it, is that you can't hear the words to any of the songs, but then who cares, all you really want to do is watch Iggy anyway.... and truthfully that's why they sell The Stooges records because if you're into hearing words and all the side effects you can listen to the albums later and get all that but I feel that if you're really up to taking what Iggy's handing out then you're gonna flip out when you catch him, but I don't think anyone will catch him because after he stood in front of the audience doing nothing with the red light glistening across his rippling body he walked off the stage and the audience roared, raved, screamed, stomped, yelled for "IGGY! IGGY!" to return for maybe an encore, Iggy never returned and I felt that people in the audience that were singled out for abuse were the ones who really dug it the most.
J: Did he abuse you?
R: No.
R: I was too far in the back goddamnit. I was standing with Leee Childers, and he couldn't stop snapping pictures of Iggy's contorting and posing, you know I kept saying, "Will you stop for a minute and just watch him?!"
J: What did you think of his appearance, his uniform?
R: Clothes are clothes.
J: What kind of personal vibrations did you get from him, if any?
R: More than the vibes it was pure energy, raw, the audience was turning on from his sheer force and that was a definite up.
J: Where do you think Rock is going?
R: I think Rock is gone. They're either going to have to find a new name for music today or stop using names at all.
J: Why?
R: Because it's all really part of the changes going on in life styles today and Iggy's performance is proof of it.
J: What life styles?
R: They're being developed as you're asking that. And besides it's much too early to predict what they'll be called, and I think if anybody starts giving them names, new or old, it'll just destroy any progress.
I feel within the next couple of years we're going to be hit with a barrage of new names that most people won't understand because that's what's wrong right now, half the world is going one way and the other half is headed right off a cliff because they're blinding themselves.
J: Which half?
R: Who knows? The only way to find that out is to wait and see who falls, who screams and what they find at the bottom.
J: What do you think Iggy would have done if the girl had responded to his advances?
R: Then we'll see what Iggy is really made of, I'd like to see how far a thing like this is going to go.
J: Did you think of his advances as sexual?
R: They were passed the sexual point, they were insulting.

(Continued on Page 19)

Cincinnati Summe
POP FESTI

JUNE 13 SAT.

16 acts
14 hours

gates open 10 a.m.
come early
bring blankets, pillows, watermelon,
incense, ozone rice, your old lady,
babies, and assorted other goodies
and do your own thing.

CROSLEY FIELD

Seating in the Stands,
and on the Grass,
or in the Ozone

SPECIAL
Festival P.A. System
the great white lite show in the sky

Camping Grounds
available nearby
ALL Camp sites
first come first served
Charter Buses *AVAILABLE from most cities see reverse side*

TRAFFI
10 YEARS AFTER

The Cincinnati Summer Pop Festival and resulting television special, *Midsummer Rock*, were pivotal for The Stooges. The band's first national television exposure featured Iggy's invention of crowd surfing, and the legendary peanut butter incident. Michael Storeim/Classic Posters collection.

J: SO NOW THE CINCINNATI POP FESTIVAL (IN JUNE 1970),[31] WHICH YOU GUYS DIDN'T KNOW WAS GOING TO BE TELEVISED?

I: No, we just went down there in a van, and somebody comes to you before you go on to say, "Sign this release. This is gonna be on television, and you need to sign this or you can't play." It was more like that, "Oh, okay!"

This was the first time in our entire career we went and we stayed in a clean motel. It was a Holiday Inn, and I flipped the fuck out. Again, like in *The Jerk*. Just like Steve Martin. "This is it. This is perfect. I have all my drugs in this room. I have TV and a clean bed and nothing's gonna happen. I could go to the bathroom. There are no associations. I could write things. I wanna live in a place like this all my life!" And then I was up all night. I had taken acid. "There's FOOD in this building! There's a restaurant, and I can go down and I have money and I can eat anything I want. I can have EGGS!" And I went and had eggs at the Holiday Inn, and that for me, man. "This is it. This is the life."

J: SO AT THAT POINT DO THE GEARS START TURNING IN YOUR HEAD TO FIGURE OUT WHAT YOU CAN DO TO MAXIMIZE THIS?

I: No, I had no expectation at all we were going to be on TV because I knew TV was for the other people in the show. I was shocked when they put us in. I just played the way I always played!

J: YOU MAY HAVE INVENTED CROWD-SURFING THAT DAY. HAD YOU EVER DONE THE STAGE WALK BEFORE?

I: No because I had never been on a high enough stage! It was the first time the stage was so high and the first time the people were so packed in that I could do it, so I thought, "This would be cool." And I kinda slipped down and I clambered up and somebody kinda intuited what I wanted to do and gave me a little help and I was on two hits of acid and I thought I was caroming from comedy to romance to egotism to messianic complex and the music, the riff they were doing, which was my invention at the end of "1970" is kind of a bolero. If you listen to the chords carefully, there's a little Spanish influence in there, and that's what opens things out. I mean, I don't think I would've done that to "Hang On Sloopy." So yeah, it went like that.

J: AND SO HOW LONG WERE YOU OUT THERE? AND HOW DO YOU COME TO SPREAD PEANUT BUTTER ALL OVER YOURSELF?

I: I don't know. It's not that long. Somebody just stuck up a jar of peanut butter and I thought, "Well..." And part of it is you're gauging what to do to entertain and how much of any one ingredient to dwell on before that's gonna go wrong.

31) The Cincinnati Summer Pop Festival, Crosley Field, Cincinnati. June 13, 1970. The Stooges set was filmed by NBC and two songs were broadcast in late August as part of a 90-minute television special, *Midsummer Rock*.

JK: THAT'S AMAZING. SO YOU'RE LITERALLY IN A WAY LIKE SINATRA AT THE SANDS THERE.

I: Exactly [laughs]. I love that album, by the way. That's a great album. So you're thinking. You're weighing it out, you're trying to do it and you're learning. I was learning at the time. You're learning to control the breaths, control your eagerness, control your nerves, and still sing the song but do movements. There's a lot going on.

J: AND ARE YOU AWARE THEY'RE FILMING YOU?

I: I think I probably was, yeah. But that didn't seem foremost, but there may have been a big part of my mind that went, "YOU. ARE. ON. FILM. THIS IS YOUR CHANCE, MOTHER-FUCKER." Very possible.

J: AND WAS THAT THE BIGGEST CROWD YOU'D PLAYED?

I: At that time, I believe so. Was that before or after Goose Lake?

J: BEFORE.

I: There were some other festivals around that time. There was one very disturbing one in Wisconsin[32] when I met Buffy Sainte-Marie on a small plane on the way there. She's so nice. I loved her. But at that one, that was a biker-run festival and when it cleared, someone was found tied to a pine tree with an ax through his heart. Yeah, it was heavy. So there were some bigger, but maybe not before. As I remember, it was bigger than anything y'know.

J: WHEN THE CINCINNATI FESTIVAL GOES ON TV IN AUGUST AND ALL THE SUDDEN PEOPLE SEE THIS INCREDIBLE MOMENT—NOBODY HAD SEEN ANYTHING LIKE THAT BEFORE. DID YOU START HEARING FROM PEOPLE? DID IT HAVE AN IMPACT YOU COULD FEEL? ON TICKET SALES?

I: I don't know about any sales, anything like that, but there was a just a little bit of a [surprised murmur] going on and I thought, "Well that's good that we got on TV." I was surprised. I just felt surprised. It was national syndicated Metro-Media. The hilarious part was the announcer was the same announcer I'd grown up watching on my parents' favorite TV show. He was Jack Lescoulie, Jackie Gleason's announcer, so it was great for me that it was Jack Lescoulie. At least I could impress my parents.

32) June 27, 1970: People's Fair, Stephens Point, Wisconsin.

DOWN ON THE STREET

MONO/STEREO

INT. 80252

the stooges

I FEEL ALRIGHT [1970]

Iggy Pop Has Becom
The Freak To Watc.

SOUNDS OF THE SEVEN
By MIKE JAHN

Iggy Pop—magnificent name, much better than Jim,
is really his name—is on national television. He is lead
in a group called the Stooges, who are living up to their
Iggy has just covered his chest with peanut butter and
in the audience, writhing and moaning and jumping on p
Now he disappears and is apparently on the ground, but a
viewers at home can see is a bunch of people looking dow
is chanting the lyrics to a song
called "1970." He is screaming:
"I'm all right!"
"I'm a-a-a-ll right!"
A girl looks down at him.
"Are you all right?" she asks.
This scene was broadcast in
a recent Metromedia television
special called "Midsummer
Rock," a 90-minute tape of a
rock festival held in Cincinnati.
The highlight of the program
for many people was the ap-
pearance of Iggy and the
Stooges. Previously known as
the Psychedelic Stooges, they
came out of Ann Arbor, Mich.,
and perhaps are rock music's
greatest contribution to that
fun-time sport called "Watch
the Freak." No doubts here,
Iggy has become the freak to
watch.

You never know what is go-
ing to happen at a Stooges con-
cert. They climaxed their per-
formance at a college rock fes-
tival with Iggy carrying one of
the fans away on his shoulder.
She turned out to be the daugh-
ter of a horrified dean. Says
Elektra Records, for whom they
record, "They are not called the
Stooges for nothing."

Wall of Sound

The group is more important
visually than musically. Musi-
cally, they fill up the room with
very loud sound and keep it
going while Iggy does his rou-
tine, whatever his routine hap-
pens to be on that particular
night. Musically, the image pre-
sented by the phrase "a wall of
sound" is appropriate. The
Stooges' music, for all practical
purposes, is one big noise that
throbs. The parts are at first
indistinguishable from each
other. The important thing
about their music is that it fills
the room and provides a con-
text for Iggy Pop, who is
watched by the audience with
intense fascination.

Peter Townshend of The Who
used to destroy guitars at the
end of a set. On those occa-
sions, the audience would be
drawn, transfixed, to the scene
of the destruction like the tra-
ditional moth to a flame. With
Iggy it is the same thing. He
writhes. He moans. He seems
totally self-involved. He rubs
his body, he contorts, bending
over backwards until his head
nearly touches the floor. He
rolls his tongue around. He

rooms, were just south o
Island. The audience was
on the floor, on top o
York State.

Into the Audience

Iggy did his normal w
then spotted a blonde si
Syracuse. He stared at
long moment, until a kid
her made an obscene ges
his direction. Iggy spra
the audience. He landed
fours and began crawli
ward the kid, slowly.
he reached him, the a
stood up. Much pushin
screaming for a few m
then Iggy crawled back
the audience. He crawle
the floor, mauled him fo
minutes, then let him g
Iggy disappeared behi
bank of amplifiers, emer
the other side a few m
later. He got to a racin
position, sprinted acros
and made a perfect he
racing dive into the a
knocking down about
ple in the vicinity of

Earlier in the show,
a drumstick and raked it
his chest until he sta
bleed. After another con
was heard to lament t
that he hadn't bled
While the previous rout
going on, the band neve
for a second on its
music. A full-color, fo
harmony version of this
is included in my just-pe
novel, "The Scene."

Watch the Freak! Sur
ly, the Stooges make
good records. Their

Above Left: Iggy invents crowd surfing at the Cincinnati Pop Festival, pictured on the French "Down On The Street" single. Ben Blackwell collection. **Above Right:** *The New York Times*, late-1970. Johan Kugelberg collection.

J: I LOVE THIS HEADLINE WRITTEN AFTER NBC AIRED THE *MIDSUMMER ROCK* PROGRAM, FROM MIKE JAHN'S *NEW YORK TIMES* SYNDICATED COLUMN, "IGGY POP HAS BECOME THE FREAK TO WATCH." HOW DID YOU FEEL ABOUT THIS KIND OF REACTION FROM THE PRESS?

I: I felt this way about all that different stuff. It was barely enabling the group to continue getting money for gigs because our records weren't selling that well, and it was really tiring me out too.

J: SO YOU GUYS ARE LIVING HAND-TO-MOUTH ESSENTIALLY.

I: Yeah, hand-to-mouth, but here's the hand-to-mouth trick. Hand-to-mouth only because it was a constant requirement to have drugs, and even marijuana and hashish, those things cost money. So I've heard it said "Well the band wasn't successful enough." The fact was that for a fledgling band, we had a long fledgling period during which we starved because the major single expenditure always had to be dope and even the marijuana was expensive. And the way I got even the first rehearsals in the Ashetons' home when I lived in the trailer, the way I got that done was I bought a marijuana plant for forty dollars from a guy, I put it in my day camp duffel bag, and I took it to the laundry center at the trailer camp to cure it.

J: IN THE CLOTHES DRYER?

I: Yeah, dryer. It works! Not knowing that the smell would go everywhere, and I ran away. It was quiet, that place, during the days. Everybody went after work, so nobody caught me and then I buried it in the corn field behind the trailer and every day before I went to their house...I'd dig it up. That was what they got up for. Jim's got some dope. So it was always a drug culture with that band from the get-go. Yeah, did I react most flamboyantly to it more than anybody else? Yeah.

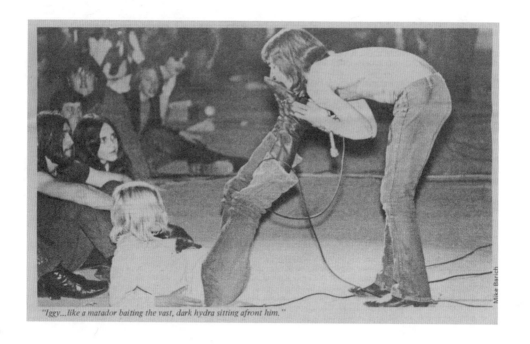

"Iggy...like a matador baiting the vast, dark hydra sitting afront him."

Mike Barich

Above: *Creem*, 1970. Jeff Gold collection. **Right:** At the Goose Lake Festival, Dave Alexander "froze" and didn't play his bass. Iggy fired him after the show. Jeff Gold collection.

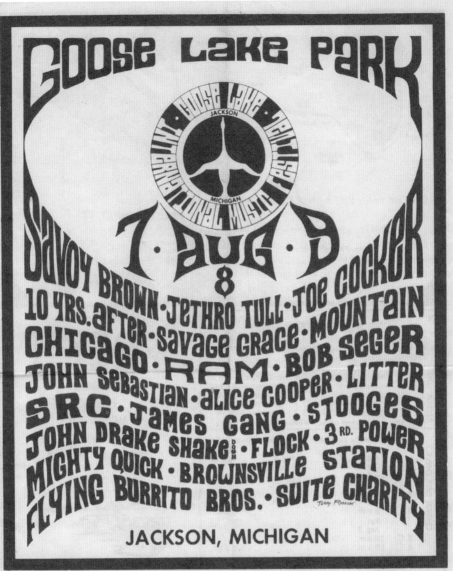

GOOSE LAKE PARK

7 · AUG · 8 · 9

SAVOY BROWN · JETHRO TULL · JOE COCKER
10 YRS. AFTER · SAVAGE GRACE · MOUNTAIN
CHICAGO · RAM · BOB SEGER
JOHN SEBASTIAN · ALICE COOPER · LITTER
SRC · JAMES GANG · STOOGES
JOHN DRAKE SHAKE · DON FLOCK · 3RD. POWER
MIGHTY QUICK · BROWNSVILLE STATION
FLYING BURRITO BROS. · SUITE CHARITY

JACKSON, MICHIGAN

ORDER YOUR FESTIVAL TICKETS NOW!

Admission at Goose Lake will be strictly limited to avoid congestion and allow complete enjoyment of the park for all.

TICKET PRICES:
Before July 3rd $15.00 After July 3rd $20.00

ADVANCE TICKETS ONLY

ABSOLUTELY NO GATE SALE. 3-DAY TICKETS ONLY. NO RE-ADMITTANCE WITHOUT NEW ADMISSION TICKET! Tickets available **now** by Mail: Send ticket order, along with large, stamped, self-addressed envelope to: **GOOSE LAKE PARK, INC.**, 30999 Ten Mile Road, Farmington, Mich. 48024 Tickets also available at all Hudson and Grinnell Stores throughout Michigan. Make check or money order payable to: Goose Lake Park, Inc. For further ticket information call (313) 831-1652.

J: AND RON WAS LESS INVOLVED IN IT?

I: Ron was always steadily involved in smoking marijuana and then later polite amounts of co-caine. Again starting after we made our first album, lots of really attractive girls would come by our house. Wanted to have sex with us, and we were always willing and very interested in that. And he was starting to get some of them, especially if they'd been through moi first. So he had one particularly quite nice girl that'd been through moi named Shelly and once he got with her, he didn't want to come out of his room. Dave was the same. Dave had a girl named Esther: she and the drunkenness was what got him to the point where finally when we played the Goose Lake Festival (August 8, 1970)[33] he could not play a note and I was mortified. But to be fair to him and to myself too, I became so unhinged on taking bad cocaine for a couple days in somebody's tent before that show that a few hours before, I experienced total amnesia and loss of self and I didn't know my name. I didn't know who I was. I didn't know why I was there.

JK: SOUNDS LIKE KETAMINE.

I: maybe that was it, but it was bad stuff. It wasn't real coke. And that's what's called Special K now? I've had everything before everybody else and that was like when the vertical's broken on your TV. That was going and just at the last minute, "There was some reason I'm here. I know there was some reason." And then it hit me. "You're a musician. You're gonna play." And it all started coming back, it came back. You can see from pictures of me I was messed up, but angst on my face was not from any of that. The angst was from there's no bass! We walked out and there was no bass.

J: DAVE JUST FROZE?

I: He froze. It's out on YouTube. You can hear it. It's guitar, drums, and vocal.

33) August 8, 1970: Goose Lake Park, Jackson, MI—Goose Lake International Music Festival. This was the largest crowd the Stooges had played to thus far, with approximately 100,000 attendees.

J: SO DURING THE SHOW, THE STORY IS YOU URGE PEOPLE TO RUSH THE BARRIERS, THEY DO, AND THEY TRY TO SHUT THE SHOW DOWN.

I: Yeah, yeah. True. The story was my roadies didn't let them (end the show) because we had vets at that time. Dave Dunlap, Bernie, and maybe Leo Beatty who is now working for Chrysler in Detroit, but we had three or four roadies who were capable of violence and more. I'm told that they prevented the organizers from shutting the show down. I don't know if that's really true.

J: AND YOU FIRED DAVE AFTER THE SHOW. WAS THAT THE STRAW THAT BROKE THE CAMEL'S BACK KINDA THING? IT HAD BEEN BREWING?

I: Yeah, I'd had enough. It had been brewing and he wouldn't show up to this. He wouldn't show up to that. But the main thing was at that point, okay look. I spent a year and a half trying to get these motherfuckers to rehearse, to get up in the morning, to be polite to me, to learn the fucking endings, to learn a song in less than a month when it only has three chords, and on and on and on. And now we've finally crossed the line of the definition of a gig. There has to be some definition. I'm afraid we're not in a position to justify someone not being able to play a note. We're not into some sort of strange performance art here yet. You know what I mean? I've had enough. No, I won't go there. Of course what happened immediately after that was when you change one thing in a group like that, it destabilizes everything.

J: DID THE ASHETONS GIVE YOU ANY BLOW-BACK FOR IT?

I: I don't believe so. I was a very determined, forceful person at the time, and I don't know. No, I don't remember any verbal blow-back whatsoever.

J: SO THIS PERIOD OF STABILITY ENDS. [ROADIE] ZEKE ZETTNER COMES IN ON BASS...

I: We made Zeke. He's cute, he's nice, he could play a little already, and we thought he could do it and he did it nicely for a while. [Roadie] Bill Cheatham[34] came in [on guitar] because I was like, "Look, we need to have more complexity of information here." That was what I thought, and Ron said, "Well if we're gonna have somebody else, then let's get Bill." And I thought, "Oh God...y'know Bill has not got the talent...but Bill's a nice guy."

JK: HOW FAR BACK DID BILL AND RON GO?

I: Oh, ancient. Way, way back. Again it was Ron's comfortable with old buddies, so Ron and Bill were old childhood friends. Bill was a great guy, and he had been doing some roadie stuff for the group. He played very, very well. He knew what not to play, and he played just fine. He could have recorded with the group had the group gotten that far. And he looked great.

J: AND THEN YOU BRING [SAXOPHONIST] STEVE MACKAY IN TOO.

I: Again it was because I thought some of the stuff he played on was key to our oeuvre and I thought we needed to make some lifts. I knew how great it was live when he started blowing.

JK: I'M CURIOUS ABOUT ONE OF THOSE MYTHICAL LOST SONGS CALLED "DOG FOOD"? WAS THAT A MACKAY SONG?

I: That's actually the other one. I forgot that one. I mentioned "Private Parts." There was also "Dog Food." No, I wrote that. I ripped off the riff [hums the riff]. That's a song called "I'm So Blue" by a chick group. "I'm so blue. I'm so blue. I'm so blue. Dum dum gone gone gone gone gone."[35] So yeah, there was that and that was one of mine and I rerecorded it for *Soldier*. It's on *Soldier*.

J: SO CHEATHAM AND ZETTNER JOIN TWO GIGS BEFORE YOUR SECOND BOOKING AT UNGANO'S (AUGUST 18-20, 1970), WHICH I WOULD IMAGINE IS AN IMPORTANT GIG BECAUSE IT'S ESSENTIALLY THE LAUNCH OF *FUN HOUSE*. WAS IT A SHOW YOU GUYS WERE THINKING ABOUT?

I: I was sure thinking about it. When we were going to play Ungano's that set, I'd never done four nights in the a row and I'd started taking coke. So I just went up to Bill Harvey's office and said, "Look Bill, what we've gotta do here now is we've gotta get me some coke to play these gigs. I need an advance." Actually telling them I need an advance for drug money! You're supposed to make up an excuse, but no. I was an honest kid, y'know.

J: AND HE ACTUALLY GAVE IT TO YOU, RIGHT?

I: He sure did. I took three tuinols after those gigs at Ungano's and went to sleep in the Chelsea Hotel for three days and I had to call my mom. They wouldn't let me go until I paid the bill. The band just left me.

34) Both Zeke Zettner (b 1943 - d 1978)) and Bill Cheatham (died late 1990s) were roadies for the band before coming in on bass and rhythm guitar respectively. Bill went to high school with Iggy and Ron Asheton, and before the Stooges had played with the Ashetons and Dave Alexander in the Dirty Shames. 35) The Ikettes, "I'm So Blue (The Gong-Gong Song)."

Right: A photo session with the short-lived Bill Cheatham/Zeke Zettner lineup, 1970. Photo: Peter Hujar.

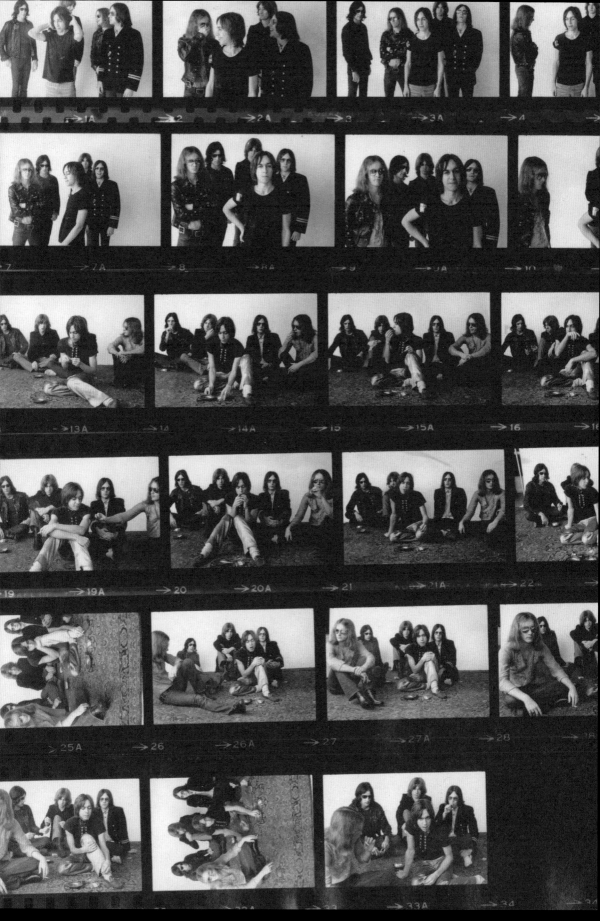

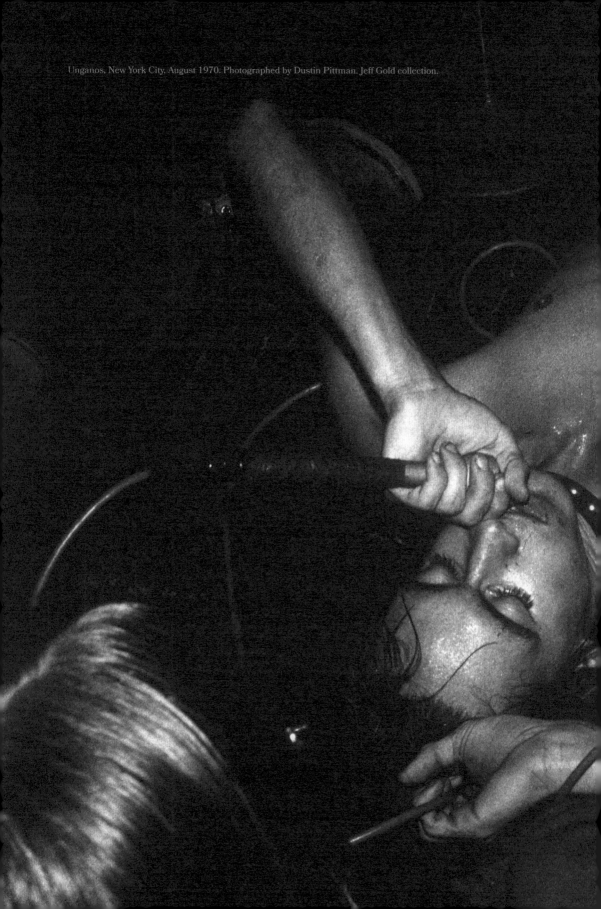

Unganos, New York City, August 1970. Photographed by Dustin Pittman. Jeff Gold collection.

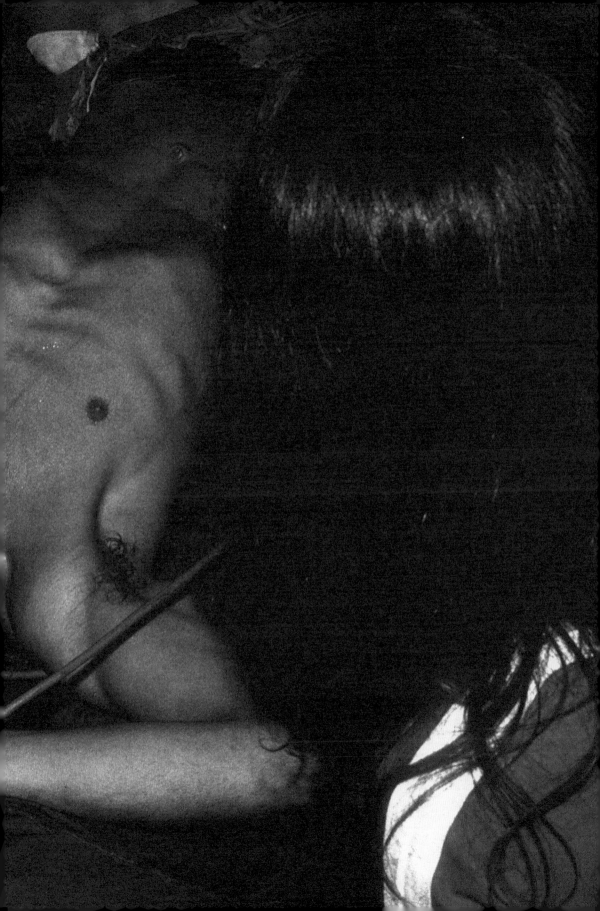

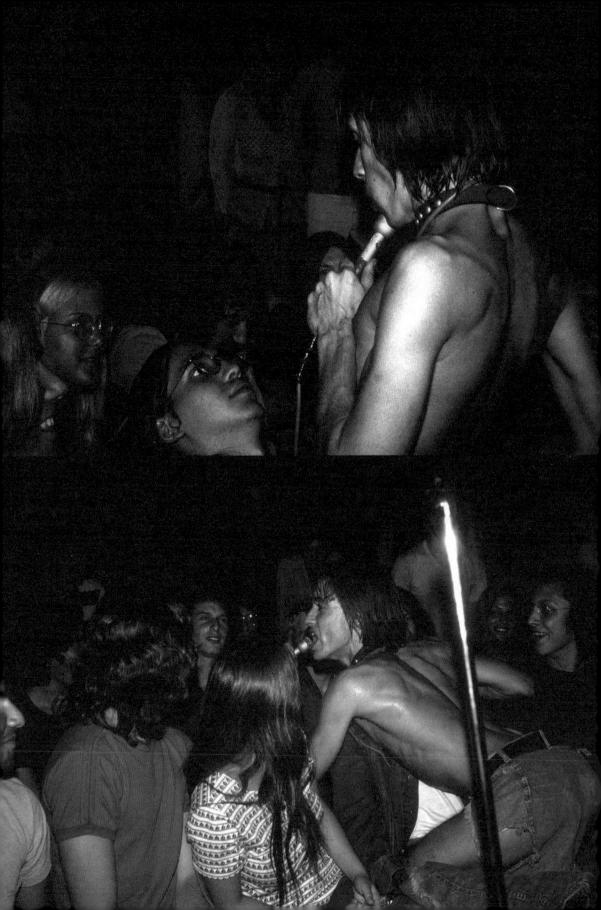

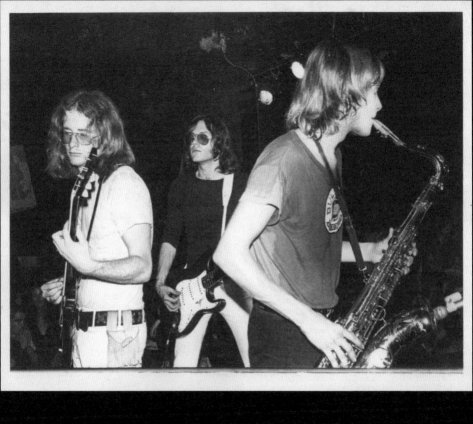

The Stooges

UNGANO'S, NYC — Elektra recording artists, The Stooges appeared at Unganos this past week, and performed each night to a sell out crowd of curious onlookers.

There have been, during the past year, dozens of articles written about the sensational Iggy Stooge. Rightfully so. Iggy is sensational—as a performer and as an acrobat—but he is supposedly a rock vocalist, and at that profession, he is anything but sensational.

Iggy Stooge is in a class by himself, and the other four Stooges—in another class. As a performer, Iggy is breathtaking. As an acrobat, he is as agile as a cat—but as a vocalist, he lacks in voice quality and frankly can't sing at all. His stage act is an exact copy of Jaggers, and as a result —Iggy also lacks originality.

The fact that the remaining four Stooges (they've added a saxophone) are seldom mentioned is understandable. They are a back up band and can hardly be called fine musicians. They remain on stage, stationary, while Iggy—dancing, screaming, and throwing himself atop the audience, steals the show. The Stooges, though, aren't all bad. They play loud, pulsating rock and roll music which, along with Iggy, is what the people pay to see.

The Stooges second Elektra LP, "Fun House," has just been released and should do very well considering you don't have to watch the group while you're hearing their music.

k.k

Above Left: Ungano's review from *Cashbox*, August 29, 1970: "As a performer, Iggy is breathtaking. As an acrobat, he is as agile as a cat—but as a vocalist he lacks in voice quality and frankly can't sing at all." Jeff Gold collection. **Above Right:** The guest list from Unganos; August 1970. Jeff Gold collection.

J: IN THE PHOTOS FROM UNGANOS, YOU SEE THE AUDIENCE IS BECOMING PART OF THE SHOW. THE AUDIENCE AND YOU ARE THE SHOW.

I: It was a small room. They had the choice to sit on the floor or to sit at a table or to be back away from us a little. They had choices, and they were interesting people. You notice it in the pictures. Almost all of them were either kinda strange people or informed people. It was not a kid crowd. These were very conscious people. I thought they were very attractive and I wanted to do a good job.

J: THIS IS THE GUEST LIST FROM UNGANOS...

I: Yeah, I saw this thing and there are some interesting people. So are these ones the ones who did come and these ones are the ones who didn't?

J: I THINK THIS IS JUST EVERYBODY.

I: Al Aronowitz! Al Goldstein! I'll bet Jon Landau didn't come.

JK: ED SANDERS.

J: FAMOUS TOBY MAMIS. STEVE PAUL. VINCE ALETTI. DANNY GOLDBERG. KARIN BERG. RICHARD AND LISA ROBINSON. ROBERT CHRISTGAU. ED SANDERS. LILLIAN ROXON. NAT HENTOFF.

I: This is the one I love. That's the one I flipped out. I wonder if he came. Wow, that would be so cool. Well I think that's really, really nice and great. Y'know Lisa Robinson was always trying to help me, so I'm sure it was her. Around that time, she rigged a *DownBeat* poll so that I would get best body [laughs]. Y'know when I was starting out as a kid learning to play drums, I'd subscribe to *DownBeat*, and I would read about Elvin Jones, Gretsch drums, all these people. So suddenly there I was in *DownBeat*. I took it much more seriously than I should have. "Hey, I'm in *DownBeat*."

J: WE'VE GOT THIS GREAT *CRAWDADDY!* **INTERVIEW BY JEAN-CHARLES COSTA, IN IT YOU SAY, "LAST NIGHT, WE WERE AT UNGANO'S, AND I WENT AND SAT ON WHAT'S-HIS-NAME, OH YEAH, FRED KIRBY'S LAP." HE WAS A** *BILLBOARD* **REVIEWER. "BUT I WASN'T THERE TO EMBARRASS HIM. IT WASN'T BECAUSE HE WAS THE GUY WITH THE SUIT AND TIE ON. WE WERE ALL FREAKS, AND WE WERE ALL FREAKS...WHEN I GET INTO MUSIC, I GET IN A STATE, AND WHEN I GET IN A STATE, I DO WHAT I WANT AND I FIGURE IT OUT LATER, RIGHT? I NEVER GET TO TOUCH A MAN LIKE THAT UP CLOSE, A MAN WHO LOOKS LIKE THAT YOU SEE, BUT NOW I DO." I KNOW THERE IS AN ELEMENT OF CALCULATION IN PERFORMANCE, BUT IS THERE ALSO AN ELEMENT OF JUST BEING IN THE MOMENT, LOSING IT, AND WHAT HAPPENS, HAPPENS?**

I: Yes. A lot of that, yeah. I wouldn't know how much of each. I wouldn't know.

JK: THE TITLE OF THE ARTICLE'S FANTASTIC TOO—"I AM THE AUDIENCE," WHICH IS REALLY POWERFUL.

I: At the end of *Fun House* on the record, I say the words over and over "I am." I'm trying to just, I wanna have an existence here, so I'm going to declare, "I am." You can't hear it on the record, but I think I maybe say the one word after, "I am you." But I don't know if I do or not, but later when we reunited the band, I would go out and I would add the "you."

Right: *Crawdaddy*, August 1970. Jeff Gold collection.

IGGY STOOGE
I Am The Audience

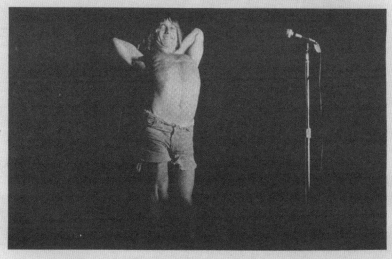

by Jean-Charles Costa

Anyway, so like I was...do you have that thing on?

Yeah —

I was in Chicago playing drums with these old blues dudes, like Walter Horton, John Young, and J.B. Hutto, dudes like that, and I found out that the music was just dripping off their fingers...sloosh...just dripping right off...and they knew they were real stars, because they are the real stars, and they had a sense of movement, of motion in their whole lives. Everything they did made me understand there's no such thing as sound. There is no such thing as sound, there's just motion and you think you can hear it, and that's music.

I started hearing motion late at night. I was almost twenty at the time, so I understood that I was about to immerse myself in a foreign language. Right? In a very watery sort of foreign language, so I wanted dudes to play with me who understood motion, who had a sense of comedy and frugality in music. I knew the Stooges, the other three Stooges, who were guys who lived together in a little suburb outside of Ann Arbor. They were sort of young hobos, high school drop-outs. They weren't musicians at the time, but you see I didn't want anyone who was a musician at the time.

They had constructed a tremendous comic fantasy which took place in their little houses just in their little suburb. I went and I picked up on it, and I said: "I can learn from these guys." So what happened was, we had a reason, a reason to play, and the reason to play is that we are four friends, and as we learn to play with each other, we learn how to like each other, to be with each other, we learn what people want to know, which is how to be *still* with other people. How to be *still* and still be with other people, so that fun is yours.

Ron (Asheton) and I literally developed everything we knew. We didn't know a chord, we didn't know nothin'. Nothin'! We didn't have no money, we didn't have no friends, we didn't have no nothin'. We were just *phbloahh* as far as anybody was concerned who had laid eyes on us.

It took us about a year of just shitting around. What we did, Ron and I had these little bizarre instruments, a little reed organ, I had a Hawaiian guitar for a while, Ron had a double bass — and we began just totally farout music together. It had no time structure at all or anything like that. It was influenced a lot by Indian music and a lot by some of the opera I used to listen to, but mainly by these poems of motion. The format grew, and Scotty was there, the drummer, and we had a beat, you see, a different kind of motion.

And then we had a bass all of a sudden, and it's grown from there. From the point where when we were on stage the first few times we literally played just two or three ultra-simplistic pieces, just a couple a chords, a simple riff, and I didn't use the English language at the time. I'd just say *wooob*...anything that came out that I *liiiked*...you know [Iggy smiles], which was pretty to me, beautiful, but only with the understanding that it was the best I could do, and still understanding that it's the best I can do, and that's all that it is.

Because as far as I'm concerned, 99 percent of all music in this society just stinks like shit, it's pure shit, and the music that isn't pure shit, the music that's good is 99 percent shit. So I'd put

it this way: a good band smells, and a bad band stinks, that's the way I look at it.

A good band is still 99 percent trash. The Rolling Stones are 99 percent trash, and it's not that there's a redeeming one percent. But they smell [Iggy screws up his nose and smiles]...that's a nice smell you know. So I always do what we're doing with the understanding that I'm just doing the best I can do, and it gets better 'cause there's a future. So we've never done another person's song.

No influences at all? I detected some traces of the WHO in your performance.

We're influenced by all rock and roll groups. Anything that came our way. Any way to put it together. We don't care — dig it, man.

Is there anyone you really like? Besides yourselves?

Ummm...you know...I dig the Stones, I dig the Velvets, I dig the DOORS at one time, I think my favorite group right now is the *Theater Of The Ridiculous*. Particularly when they do "Heaven Grand in Amber Orbit." Jackie Curtis is a fantastic talent, so is Ruby Lynn Rainer and a few others. But what we discovered anyway was that our format became lighter and lighter in touch. At first it was very *seeeerious* [Iggy frowns] and it's become lighter and lighter because that's what's beautiful.

Like on the first album, *No Fun*...*do-do-dit-do diddle-diddle-dit-do* [Iggy makes with vocal and hand percussion to illustrate]. You know what I mean? There's a lot of feeling in there that's *swooosh* [takes a deep breath] that runs through it like a nasty current...

One of the main impressions you convey during your live gigs is one of incredible hostility. You get a little frightening because you look so pissed off at the audience. Are you? Or is it part of what you're trying to communicate through the music.

I never see myself on stage of course, I don't know [grins]...

Do you ever feel really pissed off at them?

Not at all, not at all. The only times I ever feel any hostility, I could say towards myself — but what I mean is if the audience is not satisfying me or if the experience is not satisfying me, I consider it's my place and it's my joy as an artist to take that burden on myself.

And that's my joy you see, and if I ever *swooosh* [Iggy contorts his face into a fierce mask] or if I ever *schluurrp* [an even fiercer expression] it's to *me*. Like the last night we were there [UNGANO'S] and I went and sat on...what's his name's...oh yeah, Fred Kirby's lap, that wasn't to embarrass him. That wasn't because he was the guy with the suit and tie on, and we were all freaks so let's laugh at this old man. That was because when I get in the music, I get in a state, and when I get in a state I do what I want and I figure out what I mean later. Right?

I never get to touch a man like that up close, a man that looks like that, you see, but I do now [sly, knowing grin]. If I look hostile, I am, it's as simple as that.

I wouldn't try to deny it. Like some chick meets me after the gig or somethin' and I won't be falling around the floor [laughs]. I'll just be sittin', so then she'll have to make a decision.

Well, which one is the real you? What kind of shit is that? I'm alive and I'm gonna die, and I'm a man, I'm not a cat or a dog. There's a lot of cats and dogs runnin' around, and I'm a man and I'm

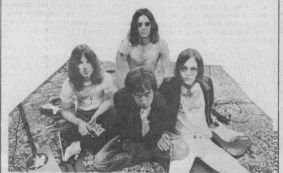

The Stooges

Above: *Changes*, late-1970. Jeff Gold collection. **Right:** *Zygote*, October 30, 1970. Jeff Gold collection.

Man Beast or Superman?

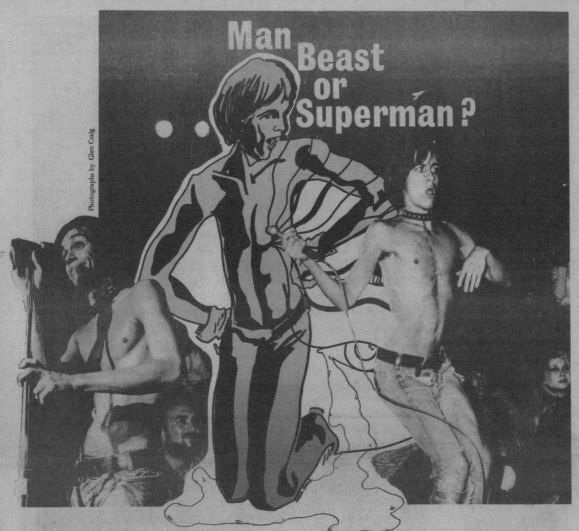

Photographs by Glen Craig

Iggy Stooge has easily become the Marat/Sade of rock music.

Iggy Stooge has involuntarily become the foremost leader of psychodrama in the rock medium.

Iggy Stooge has unknowingly revived the Elizabethan tradition of performer-audience participation for the lifeless theater.

Iggy Stooge has undoubtedly brought more sex and violence to the stage than Hitchcock did to the film industry with *Psycho*.

Iggy Stooge has taken over where Mick Jagger left off, and has taken trauma attacks farther than Jim Morrison would ever let his insanity reign.

Iggy Stooge has violated everything that is sacred, moralistic, and ethical—that's why everyone comes to see him. Iggy Stooge *is* what most are not, and what many yearn to be.

Before I had ever witnessed Iggy Stooge's psychotherapeutic act on stage, I could not understand why anyone would want to see him perform. The Beatles were a curious phenomenon of long hair and mod fashions, but at least they could play audible music. The Stones had proficient guitarists, a rebellious vocalist, and were wickedly naughty. Even Mr. Ed, the talking horse, amassed an audience due to his foresight, wit and verbal commentaries. But why would anyone want to see Iggy Stooge and the Stooges? At the most they are fifth-rate musicians, who, when they finally jam in unison, sound like the high school band you may have played with. Why would a person be attracted by utter noise, and someone taking psycotic fits? What can Iggy Stooge really mean to an audience of long-haired "hip freaks", such as those who assembled at Ungano's to observe him (Ungano's being the only club in the East with the nerve to let him play)?

An important part, and maybe even the most significant factor in understanding a liking for the "Stooge" character, can be found first in searching your own soul. A thorough investigation into heretofore unknown crevices of your conscious, and more likely your subconscious, would reveal startling answers to my query. Stooge's personality and actions can not be categorized without a forehand knowledge of your own characteristics. No one can assume that he is a beast because he stands attired in shredded jeans, a dog-collar, black boots, a bare chest, and chipped teeth. Nor can someone else view him as the epitome of the "most masculine male" because he dares to throw his sex at helpless girls in the audience. And the interpretation of him being Nietzsche's creative superman ("Man is something that has to be surpassed") can not become a truth because he smacks his face with the microphone, or dives into a bevy of spectators, or flips himself into a backward somersault. No, Iggy Stooge on stage is a tangible exhibition with whom you can compare your own inhibitions, moral definitions, and inner desires. He is a symbol of a goal that many would like to reach. He is the beast, the man, or the superman. It doesn't matter what you call him. He is the unknown. He is the unknown that you have not pioneered. The unknown that you may never pioneer. You've come to see what it is like to be the beast, or the man, or the superman. Iggy Stooge thus becomes more than the rock singer or crazed freak. Iggy Stooge becomes a representative of your own personality acting out your secret fantasies.

* * * *

Offstage, Iggy displays a much more reserved attitude. He is friendly and unintimidating. He smiles. He laughs. He talks openly. He is an amiable character. Sudden moments of

J: I JUST LOVE THIS, HARVARD UNIVERSITY'S *HARVARD CRIMSON* NEWSPAPER. THERE WAS GOING TO BE A ROCK FESTIVAL AT THEIR STADIUM AND YOU GUYS WERE THE BREAKING POINT WHERE HARVARD JUST WOULD NOT DO IT. IT WAS CANCELED BECAUSE OF THE STOOGES.

I: I love it. Yeah, I think that's great. I like the idea of Harvard.

J: THIS IS A GIG CONTRACT I THOUGHT WAS INTERESTING. YOU WERE MAKING $1,250 A NIGHT.

I: Where did we play and what time of the year?

J: AUGUST 29TH, 1970. SOMETHING CALLED SOUNDSTORM 2 AT THE BIG COUNTRY RANCH RESORT IN WEST FINLEY, PENNSYLVANIA.

I: Oh my God. I've gotta ask my wife. My wife's from Pittsburgh and I've gotta ask her where the hell Finley is. The only time I remember going to Pittsburgh or to Pennsylvania that I can remember was we played somewhere, and just literally almost nobody came. I don't remember the specific gig. I just remember that by that time we were up and running enough that we could get these various gigs, there was a DJ who indulged in a lot of payola. This was typical at the time. A big DJ in the DC area and he would call our manager. "Okay look, if you come and play my show for..." but it was like for a cheap rate, "'Down on the Street' is gonna be all over the radio." And suddenly there we were. We were top ten. That's the old school. That was one we went to then shit started happening. Like some big muscular guy had seen *Midsummer Rock* on TV, right, so he handed me a peanut butter and I took it and I threw it back at him and he wanted to beat me up and then I had to pretend I could beat back. I couldn't really, but I had to keep up a front. Almost got my ass kicked there.

The Harvard Crimson

The Weather
Storm Gne Unlikely

VOL. CL, NO. 104 CAMBRIDGE, MASS., FRIDAY, AUGUST 14, 1970 FIFTEEN CENTS

Stooges Shot Down by City And Harvard

CHARLES P. WHITLOCK

The Statue College Eagle Rock Festival failed to Harvard yesterday in a last ditch effort to find an acceptable site for the event, and holding area, went the way of Freshie Ridge. Efforts canceled.

I. Gard Wiggins administrative vice-president of Harvard, yesterday informed H.C. President Father Beaver Sapier that Harvard would not sponsor the concert for another rock concert this year week in the University gymnasium with full's plight.

Yesterday Wiggins met with Father Jarvis and gave him the bad news. Officially put ten of the students had be approved by the Harvard Corporation. Undeniably the University is hesitant to hold more rock concerts in the wake of rioting after rioting impromptu concerts stemming from disturbances following the Kennebunkup rock concerts.

Harvard's refusal shocked the students but the Eagle Rock festival, which has been an ill-organized affair over the last week.

The officer festival was originally scheduled for the Boston College stadium in Chestnut Hill subject to the approval of the city.

After the Chestnut Hill Association, a neighborhood group representing 184 families, objecting to the plan on the grounds that the event was not well enough supported, Boston Mayor Kevin White withdrew permission Wednesday. While in currently a gubernatorial candidate in the September Democratic primary.

"We do not have sufficient means to guarantee a festival without a high

(Continued on Page Five)

Dean Watson's departure as dean of Students will precipitate a major Administration shakeup in the fall, informed sources in the Administration said yesterday.

There was no information yesterday about possible replacements for Whitlock, who has performed the sensitive task of handling Harvard's relations with the state and federal governments on several years.

Watson and Perkins

So far just as chairman of the Ad Board, Whitlock will decide what punishment will be meted out to students who take any of the city authorities. Recent Ad Board cases have included violations being filed against four students who were accused of trashing

Ralph Nader gets a particularly welcome donation from his European packing cert.

Nader's invasion of privacy suit against General Motors was settled out of court yesterday for $425,000.

The suit was filed three years ago. Nader charged that GM had sent private detectives to spy on his private life after he published articles that GM's invasion-of-privacy suit. These fifth-company's private lives worse than usual.

Nader said the suit was for $1 million, the General Motors claimed it would cost them $16.7 million.

Nader said the money would be used to set up a "continuous legal monitoring of General Motors' enterprise on the safety, pollution and consumer protection

Whitlock, Epps to Assume Watson's Responsibilities

There may be information pointing about possible replacements for Whitlock.

The end of Ad Board chairman had traditionally been held by the dean of the College.

The current post that Whitlock and Epps would divide the duties currently held by the dean of students.

Official confirmation of the transfer of responsibility before the Fall semester was withheld by the University. The Corporation approved of the shift is thought to a matter of form.

a pay telephone to contact an extension into a strike headquarters

Announcements last year also indicated that the Ad Board would begin protecting academic counts identifying to the Corp.

In the year, Watson's office has handled serious housing, supervision of undergraduate organizations, and acts rules for Harvard's final clubs.

Dean Blue had slight declined to comment on the appointment pending official Corporation action. Dean Watson, Whitlock and Epps could not be reached for comment.

GM Settles Out of Court; To Award Nader $425,000

An additional 17 million punitive damages suit was filed but later dropped.

Nader's attorney said in a statement that the $425,000 settlement was "by far the largest amount ever paid in damages for invasion of privacy or in any similar type suit.

Harvard Senior Wins Summer Poetry Tilt

A senior at Harvard has won the Hoosier Island's Ninth Annual Poetry Festival.

The $25 first prize went to Charles G. Harkman for his poem "Firenze." The winning poem is printed on page 3.

Judges were C. L. Barber, dean of Humanities at the University of Calif.

Faubus in Fierce Fight

CONTRACT BLANK

AMERICAN FEDERATION OF MUSICIANS OF THE UNITED STATES AND CANADA
(HEREIN CALLED "FEDERATION") 002860

North Central Productions, Inc.

P. O. BOX 1812 — MADISON, WIS. 53701 — (608) 256-5588

License No. 3142

LOCAL NUMBER 277

THIS CONTRACT for the personal services of musicians on the engagement described below, made this 5 day of August 19 70 between the undersigned Purchaser of Music (herein called "Employer") and 4 musicians.* (including leader)

The musicians are engaged severally on the terms and conditions on the face hereof. The leader represents that the musicians already designated have agreed to be bound by said terms and conditions. Each musician yet to be chosen, upon acceptance, shall be bound by said terms and conditions. Each musician may enforce this agreement. The musicians severally agree to render services under the undersigned leader.

1. Name and Address of Place of Engagement **Sound Storm II, Big Country Ranch Resort, W. Finely, Pennsylvania.**

Print Name of Band or Group **Stooges**

2. Date(s), starting and finishing time of engagement **August 29, 1970. 9:00 –10:00 P.M. (Within 3 hours either way).**

3. Type of Engagement (specify whether dance, stage show, banquet, etc.) **Concert**

4. WAGE AGREED UPON **$1250.00 (One Thousand Two Hundred Fifty Dollars). $625.00 deposit by ~~July 11, 1970.~~ Aug** (Terms and Amount)

This wage includes expenses agreed to be reimbursed by the employer in accordance with the attached schedule, or a schedule to be furnished the Employer on or before the date of engagement.

5. Employer will make payments as follows: **To leader upon completion of engagement.** (Specify when payments are to be made)

Upon request by the Federation or the local in whose jurisdiction the musicians shall perform hereunder, Employer either shall make advance payment hereunder or shall post an appropriate bond.

If the engagement is subject to contribution to the A.F.M. & E.P.W. Pension Welfare Fund, the leader will collect same from the Employer and pay it to the Fund; and the Employer and leader agree to be bound by the Trust Indenture dated October 2, 1958, as amended, relating to services rendered hereunder in the U.S., and by the Agreement and Declaration of Trust dated April 3, 1962, as amended, relating to services rendered hereunder in Canada.

6. The Employer is hereby given an option to extend this agreement for a period of XXXXXXXXX weeks beyond the original term thereof. Said option can be exercised only by written notice from the Employer to the musicians, not later than days prior to the expiration of the original term, and a copy of said notice shall be filed with the Federation local in whose jurisdiction the engagement is to be played.

7. The Employer shall at all times have complete supervision, direction and control over the services of musicians on this engagement and expressly reserves the right to control the manner, means and details of the performance of services by the musicians including the leader as well as the ends to be accomplished. If any musicians have not been chosen upon the signing of this contract, the leader shall, as agent for the Employer and under his instructions, hire such persons and any replacements as are required.

8. In accordance with the Constitution, By-laws, Rules and Regulations of the Federation, the parties will submit every claim, dispute, controversy or difference involving the musical services arising out of or connected with this contract and the engagement covered thereby for determination by the International Executive Board of the Federation or a similar board of an appropriate local thereof and such determination shall be conclusive, final and binding upon the parties.

Additional Terms and Conditions

The leader shall, as agent of the Employer, enforce disciplinary measures for just cause, and carry out instructions as to selections and manner of performance. The agreement of the musicians to perform is subject to proven detention by sickness, accidents, riots, strikes, epidemics, acts of God, or any other legitimate conditions beyond their control. On behalf of the Employer the leader will distribute the amount received from the Employer to the musicians, including himself as indicated on the opposite side of this contract, or in place thereof on separate memoranda supplied to the Employer at or before the commencement of the employment hereunder and take and turn over to the Employer receipts therefor from each musician, including himself. The amount paid to the leader includes the cost of transportation, which will be reported by the leader to the Employer.

All employees covered by this agreement must be members in good standing of the Federation. However, if the employment provided for hereunder is subject to the Labor-Management Relations Act, 1947, all employees who are members of the Federation when their employment commences hereunder shall be continued in such employment only so long as they continue such membership in good standing. All other employees covered by this agreement, on or before the thirtieth day following the commencement of their employment, or the effective date of this agreement, whichever is later, shall become and continue to be members in good standing of the Federation. The provisions of this paragraph shall not become effective unless and until permitted by applicable law.

To the extent permitted by applicable law, nothing in this contract shall ever be construed so as to interfere with any duty owing by any musician performing hereunder to the Federation pursuant to its Constitution, By-laws, Rules, Regulations and Orders.

(Continued on reverse side)

Donald K. Bobo _(Print Employer's Name)_ Mr Iggy Stooge _(Print Leader's Name)_ Local No.

X _Donald K. Bobo_ (Signature of Employer) X (Signature of Leader)

c/o Big Country Resort 1843½ Mack (Street Address)

Route 2, W. Finely, Pennsylvania Detroit, Michigan 148
(City, State, Zip Code) (City, State, Zip Code)
(412) 428-9542
(Telephone) (Booking Agent)

*This contract does not conclusively determine the person liable to report and pay employment taxes and similar employer levies under rulings of the U.S. Internal Revenue Service and of some state agencies. FORM B-2B 10-66

WHMC RADIO
AND
FALLS CHURCH
COMMUNITY CENTER

PRESENT

SAT. SEPT. 12 AT 8:30 P.M

GENERAL ADMISSION $2.50

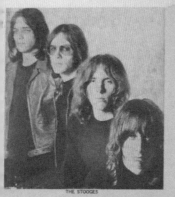

THE STOOGES

THE
STOOGES

PLUS

SUMMER

SAT. SEPT. 26 AT 8:30 P.M

GENERAL ADMISSION $2.00

BROWNSVILLE
STATION

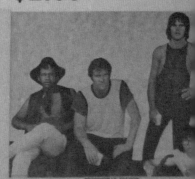

BROWNSVILLE STATION

Direction: DOMESTIC SOUND PRODUCTIONS
FOR MORE INFORMATION CALL 532-0227 or 532-2155

FUSION

42 OCTOBER 16 1970 35¢ 2A

The Stooges: Pro and Con
Interview: Jon Landau
Adam vs. Eve: Under
My Thumb Re-
visited

The Stooges are back to five pieces as
Steve McKay split, leaving the group
horn-less for the nonce. They still have
both Bill Cheatham and Ron Asheton
on guitar, Zeke Zettner on bass, Scott
Asheton on drums and their lead singer,
What's His Name.

Top Left: Iggy reads UK music paper *Disc*. He's wearing the same shrunken head shirt Ron wore at Unganos. Jeff Gold collection. **Top Right:** Taking a nap. *Earth* magazine, December 1970. Grant McKinnon collection. **Bottom Right:** Another incredibly strange bill. *Detroit Free Press*, November 1970. **Bottom Left:** *Creem*, November 1970. **Center Left:** *Fusion*, October 1970.

STOOGES

IGGY STOOGE -- Vocals	BILL CHEATHAM -- Bass
RON ASHETON -- Lead Guitar	SCOT ASHETON -- Drums

PRESENTING
THE WORLD'S FINEST
TALENT

GENERAL
ENTERTAINMENT

INDUSTRIAL
& CLUB
BOOKINGS

POP CONCERTS

PRODUCTIONS

Iggy and the boys set the world on its ass with their
incredible first record, The Stooges (Electra); Iggy
dances and sings the way you always wished you could,
a prancer, a rock and roll Nureyev without equal.
Lately, people have been relating his tactics to
"multisex" erotica though it really is just the
Detroit/Ann Arbor area's finest extension of the rock
and roll lead singer in the Jagger/Morrison tradition.
The band itself is super-involved with calisthenic
excercises in electro-guitar technology. The Stooges
have tightened up their stage show, and music in gener
in the last couple of months and people may soon begin
to see what happens when the world's most psychedelic
band meets Led Zeppelin. Or somethin' like that.
The Stooges have changed in the last year or so since
they cut the first album. And there's no way to expla
that except to say you shoulda seen 'em when they was
weird.

J: HERE IS ONE OF THE BEST THINGS JOHAN TURNED UP, A PRESS RELEASE FROM DIVERSIFIED MANAGEMENT AGENCY. THIS IS THE FOUR-PIECE BAND. IGGY STOOGE, RON ASHETON, BILL CHEATHAM ON BASS, AND SCOTT. I'M GOING TO READ THE FIRST HALF OF THIS BECAUSE IT'S SO GOOD. "IGGY AND THE BOYS SET THE WORLD ON ITS ASS WITH THEIR INCREDIBLE FIRST RECORD THE STOOGES. IGGY DANCES AND SINGS THE WAY YOU ALWAYS WISHED YOU COULD. A PRANCER, A ROCK AND ROLL NUREYEV WITHOUT EQUAL. LATELY PEOPLE HAVE BEEN RELATING HIS TACTICS TO MULTI-SEX EROTICA THOUGH REALLY IT IS JUST THE DETROIT/ANN ARBOR'S FINEST EXTENSION OF THE ROCK AND ROLL SINGER IN THE JAGGER/MORRISON TRADITION." THIS IS THE GREATEST LINE: "THE BAND ITSELF IS SUPER INVOLVED WITH CALISTHENIC EXERCISES IN ELECTRO GUITAR TECHNOLOGY."

I: Well, I'll tell you what. At the time, there was a nascent professional underground growing up, which was later gonna take over the industry. I understand this guy's position. Dave Leone was the guy there. They had to think of something to get people to come. They had to tell people something because you know how agents do. "I've got this act you won't believe. Now listen, the thing is." And so nobody knew what to make of us, so I would say listening to that, that would be the positive flow version of the general rap on us at the time.

JK: BUT HE'S ALSO PROBABLY HOPING TO GET IT SYNDICATED WITH THE UNDERGROUND PRESS SYNDICATE, WHICH AT THIS POINT IS SO POWERFUL. IT'S A HUNDRED AND EIGHTY UNDERGROUND NEWSPAPERS AT THIS POINT. THEY'RE SYNDICATING THEIR STORIES.

I: I never knew that at the time, but I'm starting to realize it now. I did notice at the time how the big faux pas with the MC5—what really destroyed that group—was when they came on a certain way and they halfway lived up to it and then there was the incident with the photo in Berkeley of the drummer and I'm not gonna say which guitarist. You can look it up, but having their way with a woman. All three naked, and she was not a counter culture angel and they did not look like love boys in the picture. And there were the three of them and it was sordid. It was like something right out of an old porn magazine, and that was what killed them. That finished them with that crowd because there's a deep Puritan strain in American culture.

Left: Booking agency press release touting The Stooges' involvement in "multi-sex erotica" and "calisthenic exercises in electro-guitar technology," 1970. Johan Kugelberg collection.

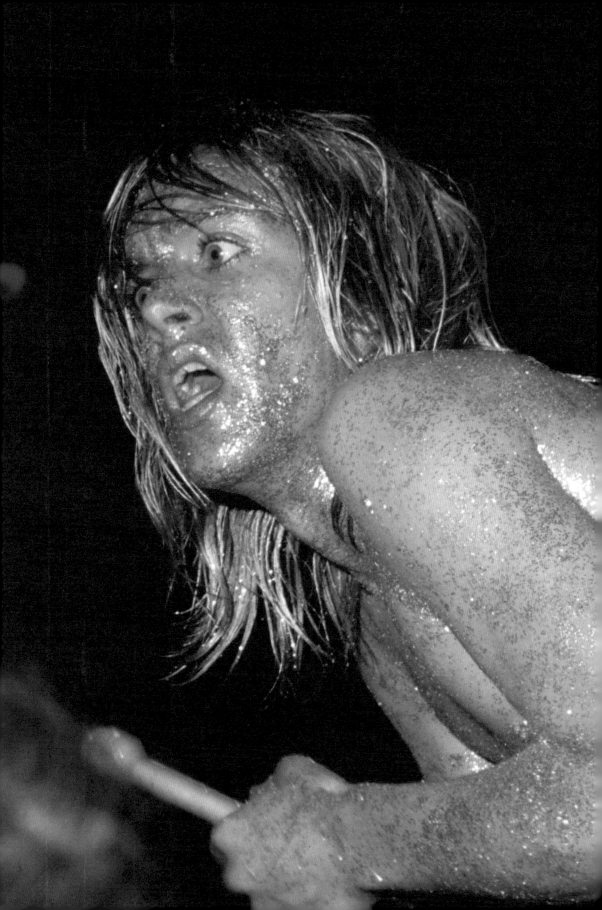

Electric Circus, Lisa Gottlieb.

J: SO IN OCTOBER 1970 YOU PLAY ELECTRIC CIRCUS IN NEW YORK CITY. YOU'RE COVERED IN GLITTER. I JUST LOVE THOSE PICTURES...

I: Yeah, at the time it's not only glitter but the hair is done over with something called Nestle Streaks 'n Tips, which was a spray instant hair color that came in an aerosol can and you used to be able to buy it at Walgreens. And it was used, I'd assume, mostly by prostitutes. I would use the silver. You spray it on, it instantly gives you more body than you had, and you're bright silver. But it drips on your neck, if you touch it, it's on your hands, and it takes days to come off so wherever I slept after for days would be covered in it. So I started using it at that time because I was using too much dope, I was not eating right, I'd switched from eating macrobiotic with lots of reefer to everyday try to get some heroin and straight to the Dairy Queen to get a sugar rush. Ice cream, ice cream. So I looked a bit off for what I wanted to do, so I'd take a small bottle of Johnson's baby oil, put it all over my body and my face then a small bottle of glitter. Pour that over that and then the Nestles. And that was a look! Lisa Robinson mentions it in one of her things, and from a distance, it looked pretty cool and it's cheap.

Photos by Gerard Malanga

Silver Streaked Iggy Returns to New York

The Stooges returned to New York triumphantly a short time ago and for two nights at the Electric Circus, the band excelled. Iggy seemed to have a little trouble adjusting to the Circus's unique audience the first night but by the second, he was in top form delivering the kind of legendary rock performance that he is famous for. The usually immobile Electric Circus audience demanded an encore and kept shouting out favorite tunes from the Stooges *Funhouse* album of last year. His face and hair sprayed with silver, Iggy had all new material however and it was more tuneful and striking than anything he's done before. The band was impeccable as it ground out the incredible high energy wall of sound rhythm that fits so well next to Iggy's singing. Both nights he walked on the audience's hands. In fact he spent almost half of the concert within grasp of the audience. The Stooges are going to Los Angeles to cut their third album soon—hopefully it will be out in August. Meanwhile, Steve McKay who played saxophone with the Stooges on their last album has amicably split from the band and has started his own group called Carnal Kitchen.

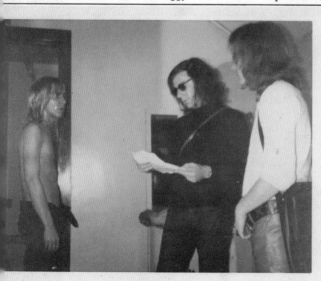

Top Right: *Circus*, Johan Kugelberg collection. Bottom **Left:** Backstage, with Danny Fields (center). Jeff Gold collection.
Bottom Right: Blue hair, courtesy Nestle Streaks 'n Tips. Photo: Natalie Stoogling.

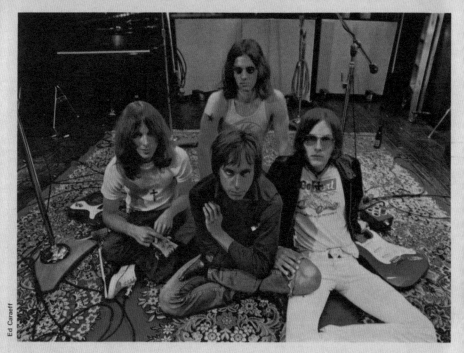

Ed Caraeff

Iggy and the Stooges Play in Fun House

BLIND DATE
with Maggie Bell

Maggie Bell settled down for Blind Date with a large glass of bourbon in front of her. The glass was emptied, and refilled on a couple of occasions and after first worries that she might not know any of the artists, she enjoyed "playing a nice game".

McGUINNESS Flint: "Lazy Afternoon", from the album "McGuiness Flint" (Capitol).

This sounds like the first album from a group with a hit record. Am I right? It's good this though, fine downhome stuff, and I love the way it's handled. But the fact remains that it's really n o t h i n g different, could be a number of groups, know what I mean? Play me another track, yes it's good, not a bad group, but why doesn't somebody come up with something distinctive?

Fuck 'em

THE STOOGES: "Down On The Street" from the album "Fun House" (Elektra).

Oh, no, I've certainly heard this voice before, it's those bloody Stooges. You know, we worked with them in the States, and they were terrible. The singer is absurd, he swears at the audience, and then throws himself into them. You know this sort of thing really annoys me. I work my guts out, and we all do to put over the best we've got, and then we share a bill with somebody like this. I hate it, horrible stuff.

THE EQUALS

would like to convey the Season's Greetings to all their fans, and at the same time thank them for putting

"BLACK SKIN BLUE-EYED BOYS"

into the charts



BEE GEES: "Lonely Days," from the album "2 Years On" (Polydor).

The Bee Gees! The beginning to this song is one of the most beautiful things I've heard in a long time. It's lovely, and deserves to be a hit. I don't like it when

it becomes too commercial. There are some much better tracks on this album. Listen to that piano though, they really have this distinctive piano sound, I mean, when you hear piano like that it couldn't be anyone else. Maurice can do some really funky things as well. Fabulous group really you know, and now they are into something completely new again, I wish them all the success possible.

ROBERT WYATT: "Las Vegas Tango" (Part One), from the album "The End of An Ear" (CBS).

Good voices here, a lot of people are really getting into free music. Oh yes, sounds like white energy music, and the percussion is fabulous. Must be someone like Aynsley Dunbar, but no, on second thoughts is it that guy with the Soft Machine? It must be him, nobody else could do this

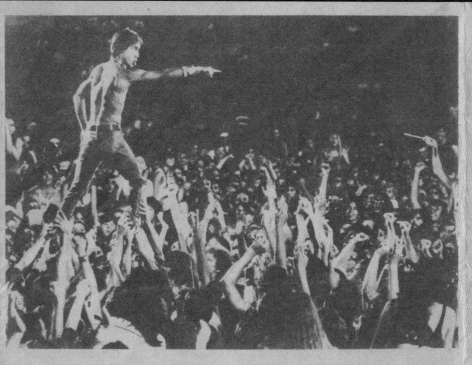

IGGY of the STOOGES has fun with his fans who just can't wait to get their hands on him. The Stooges LP is reviewed on this page.

THE STOOGES: FUN HOUSE (Elektra stereo 2410 009 29s 10).

The **Stooges** are a particularly American group — from the same bizarre traditions as Alice Cooper and the MC5 — who by way of Ann Arbor and Detroit, Michigan, have carved for themselves a semi-legendary little niche in US rock.

The gross **Iggy Stooge** is said to be a sexy little devil on stage, but not having seen the band perform and, going only on their records, it is hard to see their appeal. Pimply rubbish rock is how one American reviewer has described them in an appreciative article and I can recall another writer drooling over the tediousness of the material on their first LP.

If you can make virtue out of reasonably played rock tunes, sung by a tortured non-voice over repetitive riffs, then Fun House is for you. — **N.L.**

Titles: Down On The Street, Loose, TV Eye, Dirt, 1970, Fun House, LA Blues.

STUDIO DRIVE

MC5: BACK IN THE USA (Atlantic stereo SUPER 2400 016. 42s 6d).

The MC5 are a Detroit-based group which has not only built up a notorious reputation for their militant revolutionary beliefs but also for their repeated use of on-stage obscene shock tactics.

Unfortunately, this policy resulted in their musical prowess being completely overlooked. With this their second album (their first with Atlantic), they prove that they are a more than proficient outfit when it comes to rockin'-it-up with the best of the bunch.

Like the blues, rock 'n' roll music has always used such basic themes as teenage romance and sexual innuendos for its main inspiration. In an equally raw and exciting manner the MC5 have updated this tradition, bringing their sexual references more into line with to-

DELICIOUS DISCS AND DUBIOUS DISTINCTIONS

THE BEST AND WORST OF ROCK: 1970

BY JOHN MENDELSOHN

It's getting to the point where there's scarcely room for me in my modest but occasionally cozy domicile low in the glamorous Hollywood Hills because of the enormous mound of albums that ill-advised record companies have sent me in hopes that I will say a few nice words about them.

Where, in my early days as a writer about rock and roll, I'd be delighted senseless by the presence of a box of *gratis* music, I, today find myself grimacing painfully at the sight of more albums beneath the mailbox. For, try as I might, I know I'll never succeed in forcing myself to sit down with them for what a small voice within tells me is a "fair duration." And yet I feel just a bit like Jack the Ripper when I trade in even the least likely-looking candidate for my attention without giving it 40 minutes.

The result: albums go both un-listened-to and untraded-in for months, accumulating in huge piles that leave me barely enough room to recline languorously in.

I'm telling you this because I want you to be not absolutely enraged should I miss something decidedly killer every now and again, which is certainly inevitable.

What I usually wind up doing in desperation is stacking about

Iggy Stooge
Illustration by Diane MacDermott

14

Stooges concert. . .fun for a change

I went to Detroit and Chicago this past week to see the Stooges, as well as some other bands.....but mainly the Stooges. They haven't performed for quite a few months, and naturally everyone was really excited to see the new members of

LISA ROBINSON

band – guitarist James Williamson and bassist Jimmy Recca as well as to hear the new Stooge material.

The Vanity Theatre in Detroit on Tuesday night was full – a ballroom situation with no seats that certainly seems to work quite well out of New York City. Frut, the crazed rock and roll band that sounds like a bunch of great/lousy high school musicians, did their set – complete with "Running Bear and Little White Dove" and "Take Your Clothes Off And I'll Love You" and "I Love You Baby But You Don't Dress Cool"; followed by the Stooges.

Iggy was completely covered in glitter, all over his body, and his hair was frosted silver/white, with red feathers in it. From the back of the hall he looked like a golden fawn.....! I realized just how much I'd missed this band, as they went into their super loud, high energy set. All new material – and it sounded great. Two songs more that stood out especially were "1971" and "Black Like Me". One of those should be a single.....

The group plans to record in June, and Iggy was talking after the set about how this band (the two new members join original Stooges Ron and Scott Asheton) is the most musical he's played with. It was

even better in Chicago at the elegant and staid Chicago Opera House where the Stooges were on the bill with Alice Cooper. Iggy Pop jumped down into the orchestra pit and then climbed over that until he was halfway into the orchestra sets.

In the midst of the Midwest, these perfectly archetypical Midwestern punks were alive and well and outrageous.....and it was fun to go to a concert for a change.

Oh.....the MC5 also performed at the Vanity Theatre in Detroit, and really turned me off. I think they think they're getting into some far-

out, progressive music.....but I just found it sloppy and dull. The group started out their set with "Sister Anne", which could be rock and roll.....but then somehow managed to turn it all into some kind of rap that sounded vaguely like the Last Poets........ Also, Rob Tyner looks more and more like Charles Lloyd every day....

There sure is a lot of music going down in the Detroit area though. In addition to the Stooges, MC5 and Frut – Alice Cooper, J. Geils, Commander Cody, Pride of Women and UP, all played within a three day period!

RPM'S SEVEN YEAR OLD OPEN DOOR POLICY

BUSINESS HOURS – Tuesday to Friday, 9 AM to 5 PM.
CLOSED – Every Monday (Special appointments only).
PROMO MEN – Every Tuesday and Friday. Coffee is served all day (fresh). You are extremely welcome.
AD DEADLINE – Tuesday noon (11 days prior to issue date and 7 days prior to release date).
SPECIAL NUMBER – for ad reservations on Monday – (416) 489-2167
Editor & Publisher – Walt Grealis
Hypemaster – John Watts
Subscriptions – Sobina Rubins
Ad Consultant – Stan Klees (MusicAd&Art)
Telephone (416) 487-5812

Above Left: *Coast* magazine's John Mendelsohn chose *Fun House* as one of 1970's best albums. Jeff Gold collection.
Above Right: Major supporter Lisa Robinson on the short lived Ron Asheton/James Williamson two guitar lineup with Jimmy Recca on bass: "Iggy was completely covered in glitter...his hair was frosted silver/white, with red feathers in it. From the back of the hall he looked like a golden fawn," *RPM*. Jeff Gold collection. **Right:** A very rare poster for The Stooges first show with James Williamson; Farmington High School, near Detroit, December 5, 1970. Ben Blackwell collection.

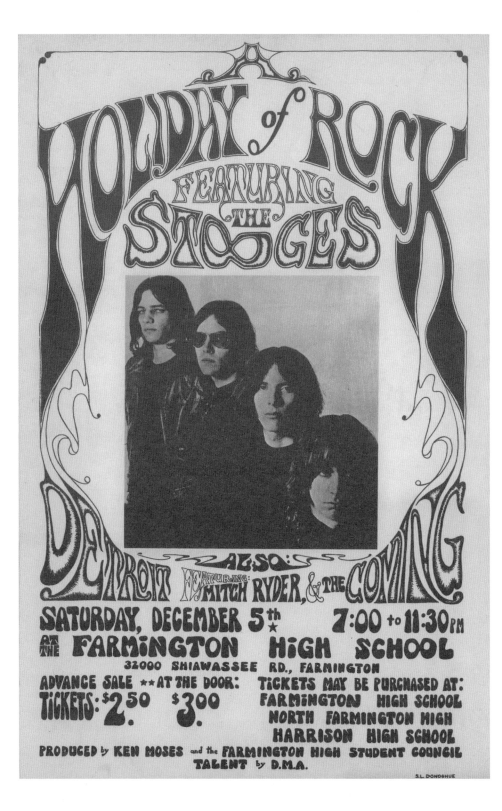

A HOLIDAY of ROCK FEATURING THE STOOGES

ALSO: FEATURING MITCH RYDER, & DETROIT THE COMING

SATURDAY, DECEMBER 5th ★ 7:00 to 11:30 PM
AT THE FARMINGTON HIGH SCHOOL
32000 SHIAWASSEE RD., FARMINGTON

ADVANCE SALE ★★ AT THE DOOR:
TICKETS: $2.50 $3.00

TICKETS MAY BE PURCHASED AT:
FARMINGTON HIGH SCHOOL
NORTH FARMINGTON HIGH
HARRISON HIGH SCHOOL

PRODUCED by KEN MOSES and the FARMINGTON HIGH STUDENT COUNCIL
TALENT by D.M.A.

S.L. DONOGHUE

Nov 13 - Detroit - East town $2000
14 - " " "
15 - Fremont, O. 1000 v. 50%
21 - U. Detroit 1750
22 - Frut Palace Mt. Clemens 600 v. 50%
23 - Dewey's Madison, Wisc 650 v. 50%
~~25 - Bermington, Palladium 1000~~
26 - Toledo, ~~Arena~~ 750
27 - Windsor, Ont.
28 - Gilligan's Buffalo 1300

Dec 4 - Rochester, Monroe Comm. College $1500
? 18 - Grand Rapids Mich —
19 - ~~Tentatively — Madison~~ Wisc
25-26 Miami, Pirates World $1500
27 - ~~Orlando, Fla.~~
? ~~29-30 Houston, Texas~~
? 29 - Atlanta — Mun. Auditorium $750
? 30 Orlando, Fla.

? 27 Jacksonville - Sead Aud $750
? 28 Coco Beech Blod Rock
29 Atlanta Municipal $750
? 30 - Orlando $750

5th. North Farmington H.S. $1200
12th - Palladium
31st . Chicago

8. WILLIAMSON IN, ELEKTRA OUT

J: SO SOON AFTER THE ELECTRIC CIRCUS, IN LATE NOVEMBER OR EARLY DECEMBER 1970, JAMES WILLIAMSON JOINS.

I: Is that when it was?

J: THE FIRST GIG WITH HIM WAS PROBABLY DECEMBER 5, 1970. FARMINGTON HIGH SCHOOL.

I: Oh my God.

J: AND HIS STEPFATHER HAD HIM IN REFORM SCHOOL, AND HE GOT OUT.

I: Well he makes it "reform school." If you wanna do due diligence, the name of the school was The Anderson School. I don't think it was a reform school. I think what happened was he was sent to a prep school because it was The Anderson School, and I believe if it wasn't in Connecticut, it was upstate New York.

J: AND WHY DID YOU GUYS RECRUIT HIM?

I: I was looking for somebody. Steve wanted to be a full member, and I felt that a saxophone needed to be a part-time side instrument. It didn't fit the template for a rock band of the kind we were trying to be, so we were still looking. I felt I was still looking for a second guitar, or something else. I was not getting what I wanted out of my relationship with Ron, but I was willing to say, "Well if we had a couple of guitars, that might..." Y'know at this time, the Doors were bringing in jazz musicians. The Rolling Stones had Billy Preston and the guy on slide: Mick Taylor. The Beatles had like whole orchestras, y'know?

So it was going around, that sort of thing, and I'd heard about, somebody, it may have been Scott Richardson again who said, "Well, there's this legendary guy James Williamson. He can really play." So I went to see him. I think he was at somebody else's gig in the basement of a frat house, and he played through this hyper thing—I guess he thought it was a composition—with a whole bunch of chords, and I thought, "Well he can certainly play a bunch of chords quickly, and if you could figure out what to do with that that would be somebody that could put more drive in the group."

I remember that somewhere during the process we had him come over, plug in, and actually jam with us, and my impressions then are pretty much what they are now. He plugged in, the first thing he played was a Jeff Beck riff from a Yardbirds record, and it was a lead passage that he had learned and I thought, "Very good attack. Very dirty sound. Not clear like Jeff Beck or even like Nugent, however, perfect for a dirty band. Doesn't matter." And then he played something that was like an early composition that never did get off the ground with us, but that became something called "Fresh Rag," which was where he played four block chords and I thought, "Okay, he's trying to write. He's not there yet."

Left: Danny Fields plots out a tour for late 1970. Third from the bottom, James Williamson's possible debut on December 5 debut. Jeff Gold collection.

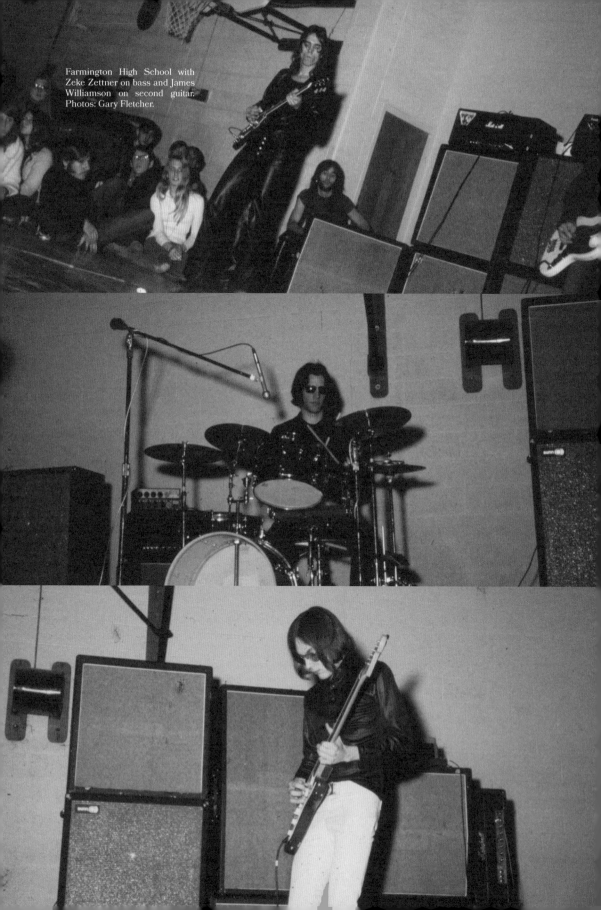

Farmington High School with Zeke Zettner on bass and James Williamson on second guitar. Photos: Gary Fletcher.

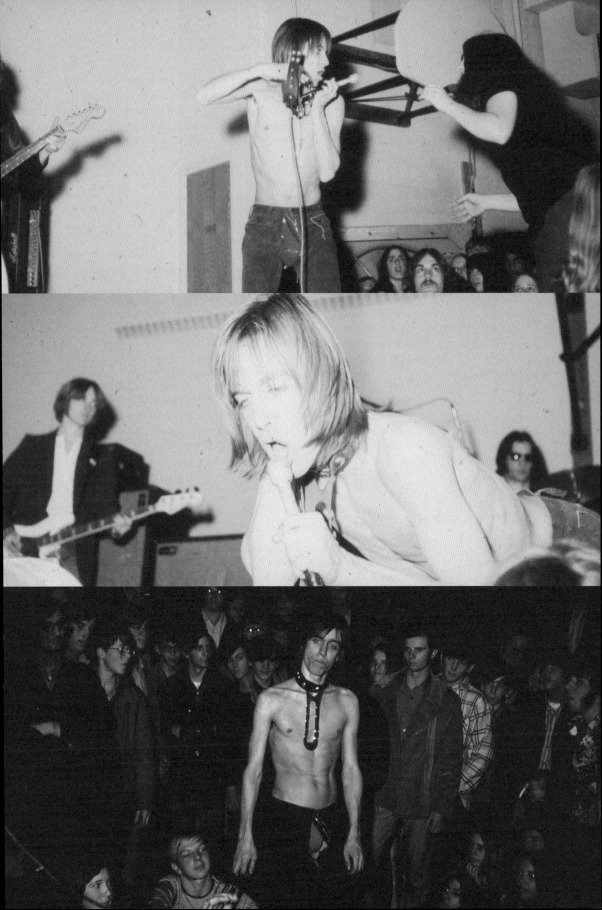

And from there we got him in. My first memory of it was that to me, the big shocker was right away he started wanting to cut his own deal, so it was like, "Hey, okay. You can move into the house." "No, I don't want to live in the house. You just give me my share of the money after the shows, and I'm gonna go live [somewhere else]." And he had this little place on Ann Street which is where it was easy to get that stuff. He was like, "Ew, a group of guys? Ew."

James first didn't want a room in the band house. Then he didn't want to room with me, which I can understand because I was not a cool junkie. I was, "Whew!" I was all over the map. But he did want to room with Scott, and Scott and him were gonna be this bad gang. And I guess they had a couple chicks who would come up. James always had this thing. Like, we would just have a chick come over and they'd kinda wanna just hang out and offer us, "Would you like to have some sex," and chat with me and stuff, and it was all very kinda innocent for a while. With James, the pattern would be that he'd get some chick, and then teach her how to clean, do his laundry, fetch him food, and after about a week, they'd get this beat-out look.

So there was this whole kind of apart thing with him, but I said ok. As the group blew up and disintegrated, I think he did end up in the Fun House in my old room or something. I don't remember how. But y'know my approach was always through a communal type of a thing, and this was very common. The Alice Cooper people did this. The Rolling Stones, everybody did this at one time. The Beatles. Before you make it, you pool, and that's where you get good. At one point, I remember when we all were already all on junk as much as possible and there was a very nice apartment house that we could suddenly afford because there was money coming in based on what we'd achieved a year ago. You know how there's a delay. I call it the pipe. The pipeline was still gushing from our old achievements, and I wanted to room with him. I said, "Look, we could room together and create." "Nah, I don't want to." Now, he had a point. That really hurt me, but he had a point later. I asked him about this later, and he said, "Well yeah, with your habit." Because it's true that when I did that stuff, I went crazy, but he was the kind of guy, he had it all on a schedule. He'd figure it out. A gentlemen junkie or a chippy or whatever. He had a little box that he kept his little, he used a binky for it.

J: WHAT'S A BINKY?

I: It's a homemade syringe. An eyedropper. So anyway he came in and we started writing the material you can hear on the Easy Action (UK record label) album *You Don't Want My Name*. And when you hear one on there that just sounds like simpler chords and more organized, those are mine. Like, "I Got a Right," and "You Don't Want My Name," and when you hear something that's very, very complicated, interesting riff but it doesn't seem to go anywhere, those are his.

J: SO I DON'T KNOW IF YOU WANT TO ADDRESS THIS, BUT I KEEP FINDING THESE QUOTES FROM PEOPLE LIKE NATALIE STOOGELING SUGGESTING THAT JAMES ACCELERATED THE DRUG USE, THE CRAZINESS, THE MAKE-UP, THE BIZARRE BEHAVIOR, AND DANNY SAYING HE WAS MALEVOLENT. I MEAN WAS HE KIND OF A DARK FORCE?

I: James tends to accelerate everything in my opinion. He has a terrible tendency still, but much worse back then, to speed up the songs on stage to the point where he's so manic and within himself that he leaves the drums behind. He started doing it again in our reunion, and as soon as you criticize him in any way, he flips out and either he has an excuse or just, "I don't agree! I disagree!" But back in the day it got to the point where there was an entire concert recorded for a live album by the fellow from Blue Oyster Cult. Sandy Pearlman?

J: RIGHT.

I: That couldn't be used.

J: IS THAT THE COLUMBIA ONE?

I: Yes. Every song fell apart after about two minutes. Did we have monitors? No. Would a guitarist in a good bar band have had that problem? No. On the other hand does Scott like to just get exasperated and give up? [Laughs] Yes. So that was it, on that particular concert.

But the key person to blame more than anything else, if you have to point a finger for the drug use was the guy John Adams who was living in our basement, who was a reformed junkie, who had been the scion of a railroad fortune. His father had been a big exec with one of the Southern, Southwestern railroads. John was just a no-good kid. We liked him, but he thought he was like [the gangster] Frank Nitti or something. So he was the one that was really getting it, bringing it in the house, and then saying, "Yeah, sure, you guys want some?" And then first it's free, and then it's a little money, and then he's dealing it to us, and then the next...

JK: ALMOST LIKE A TRUST FUND JUNKIE.

I: Yes, that's exactly what he was. He had been a trust fund junkie, he got off it, and Jimmy Silver had been the good influence in his life. As soon as Jimmy left, he got back on it, and he died of it later. He OD'd. I think he deserved what he got, but James was right there already. He was already doing that, but it's not right to blame the thing on him.

Going apeshit from St Marks to Staten Island with

Iggy and the Stooges

by Ed McCormack
photos by Leee Childers

Ed McCormack 1970

POP'S POP?!!

A series of secret communications and meetings conducted by an unnamed member of the T.T.T. (TOUCH TATTLETALE TEAM), with Doctor Hugo Frankenstein of Transylvania has revealed the possibility that Iggy Pop, high-voltage performer of The Stooges, may indeed be the Son of Frankenstein.

Dr. Frankenstein, who now resides in Ypsilanti, Michigan, is reported to have accidentally discovered Iggy while conducting experiments in his laboratory on his creation, The Frankenstein Monster. The Monster, who had complained only of slight acid indigestion, was placed behind an X-Ray machine and the Baby Iggy appeared screaming, "He got a T.V. Eye on me."

Dr. Frankenstein was disinclined to release many details of the child's life after birth, except to say that Iggy was confined until his 21st birthday to the attic of the Frankenstein Funhouse, where his only companions were a T.V. set and a jar of Chunky peanut-butter.

Left: *Changes*, December 1970. Jeff Gold collection. **Above:** Elektra's in-house newsletter, *Touch*, reveals Iggy was discovered by Dr. Frankenstein, February 1971. Jeff Gold collection.

the elektra corporation 15 columbus circle, new york city, new york 10023 (212) 582-7711

March 12, 1971

Messers James Williams and
Zek Zettner
c/o Mr. Danny Fields
Atlantic Records
1841 Broadway
New York, New York

Gentlemen:

Reference is hereby made to the agreement between us and Messers James Osterberg, Jr., Ronald Asheton, Scott Asheton and David Alexander dated October 4, 1968 (hereinafter including any and all extensions or modifications thereof, called the "Agreement"), copies of which are enclosed herewith. You agree to be bound by all of the terms and provisions thereof as fully as if you had signed such Agreement.

Please sign two copies of this letter and return them to us indicating your acceptance of the foregoing.

Very truly yours,

THE ELEKTRA CORPORATION

By _____

ACCEPTED AND AGREED TO:

James Williams _____

Zek Zettner _____

67 Brook Street
London W1Y 1YD

Telephone 01-629 9121
Cables Stigwood London W1
Telex 264267

Directors
R C Stigwood (Chairman)
D L Shaw FCA
R H Masters
B Vertue
K M Turner
R Gunnell
J Gunnell

The Robert Stigwood Organisation Ltd

Danny Fields, Esq.,
Atlantic Records,
1841 Broadway,
New York,
NY 10019. 12th January, 1971.

Dear Danny,

 IGGY & THE STOOGES

 Thank you for telephoning me yesterday about The Stooges, following your talk with Jac Holzman of Elektra Records.

 I think we can organise a four week tour in May or June, but I would only want to involve this company in handling such a tour if you use a top publicist to cover the event. I strongly recommend Mike Gill, who handles THE FACES (I think you know the group as The Small Faces), as he has the working capacity to handle the act for a period of 2-3 months, and I feel he can provide good coverage. He is due in New York at the beginning of February, and I am advising him to contact you so that you can discuss the project with him. You can, of course, check on things through Warner Reprise in London (this would be fairly simple, as they now handle the U.K. Elektra set-up).

 I am not sure at this stage what fees we could obtain for The Stooges, but would think between £1-200 per night, depending upon circumstances and the amount of support we get from Elektra. We would expect to book about 20 appearances in 28 days, but can possibly extend into the continent for a further week or so. As you will realise, a first tour would not be economically successful unless we have some 'hit' singles or albums, and the group could expect to make a loss, unless someone can be persuaded to pay for the air fares to and from America.

 I will discuss the matter with Clive Selwood (who is in America at the time of writing) to see what support Elektra here will give. In the meantime please indicate your agreement to a tour and suggest convenient starting dates.

Licensed annually by the City of Westminster

Above Left: Elektra contract amendment adding "James Williams" (James Williamson) and "Zek Zettner" (Zeke Zettner) to the band's recording contract, March 12, 1971. **Above Right:** Danny Fields tries to organize a Stooges UK tour for May or June 1971; unfortunately, the band broke up before it could happen. Jeff Gold collection. **Right:** The Stooges (L-R) Ron Asheton, James Williamson, Jimmy Recca, Iggy, Scott Asheton, 1971. Photo: Peter Hujar.

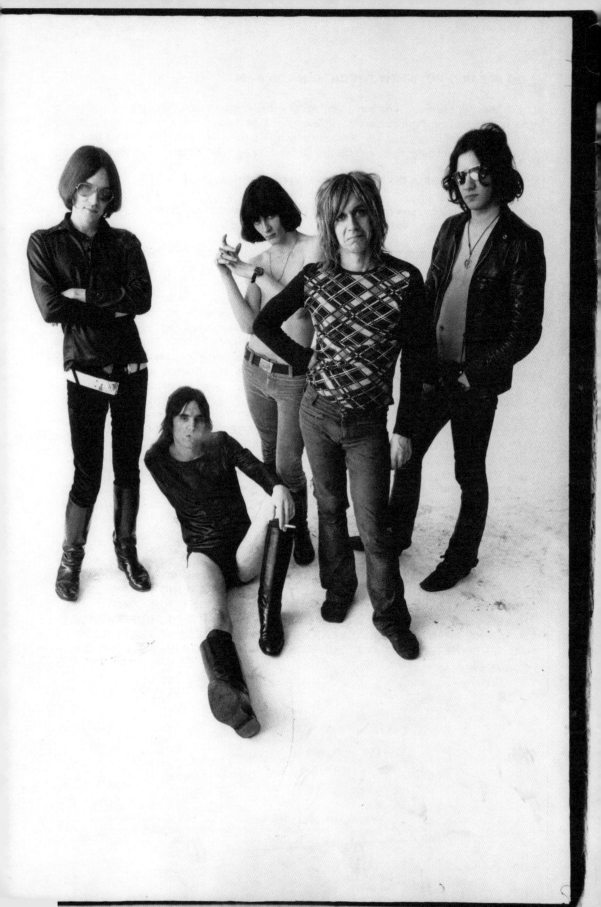

J: SO IN EARLY 1971 JIMMY RECCA JOINS ON BASS.[36]

I: Yeah, that came through somehow. I don't know if that was through Williamson, but suddenly he was there. I can't remember why, if Zeke wasn't good enough to keep up with the new riffs or what, but Jimmy could play a lot and play with a very good tone. I always felt that he looked good but not quite right with the group. I don't know what it was.

J: HE HAD KIND OF A LITTLE LORD FAUNTLEROY HAIRCUT.

I: Yeah, the Fauntleroy, and he would throw in these notes that were a little too nice sometimes, but still he was an awfully nice, agreeable person and he played well.

JK: HOW FAR DID *BIG TIME BUM* GO AS A CONCEPT FOR THE THIRD ELEKTRA ALBUM?

I: I can't remember. I just remember that it was a concept I had about myself and the group and an idea for a song, and then I think I wed that to one of James' power riffs. It's one of the songs we were trying to develop. The thing that happened very simply, all I remember about that third album encounter is that first of all, I don't even know why anybody decided to make our second album when they did, and I thought it might be something that you have secret knowledge of. Is there a pattern with these smart guys that own these companies that when they get a young group, there's like a tested formula? "Get as much out of them young as you can. It'll be valuable later. Don't wait 'til they're thirty!"

J: IT'S MORE OF THE ARC THAT YOU WANT TO SEE SOMEBODY DEVELOP, AND NOBODY EXPECTS THE FIRST ALBUM TO BE A BLOCKBUSTER. WHEN I WORKED AT WARNER BROTHERS AFTER I LEFT A&M, [WARNER'S CHAIRMAN] MO OSTIN WAS THE KING OF THAT. YOU JUST WANNA SEE FORWARD MOMENTUM.

I: And they always want you to give 'em something even if you didn't do well or if you did do well! "We want something else quick!"

J: WELL, I KNOW JAC AND I'M GONNA TRY TO PUT MYSELF INTO HIS PLACE. OKAY, THE FIRST ALBUM COMES OUT. THIS BAND'S DOING SOMETHING NOBODY ELSE IS DOING. THEY'RE AT LEAST GETTING A BUNCH OF PRESS ATTENTION. THEY SOLD CLOSE TO FORTY THOUSAND IN FOUR MONTHS. THERE'S SOMETHING HERE. WE HAVEN'T RELEASED THIS TO INDIFFERENCE. I'M MAKING AN INTELLECTUAL LEAP HERE, BUT I'M GUESSING THAT HE HAD NEVER MET A ROCK ACT, THE FRONTMAN OF WHICH WAS CULTURED

36) Jimmy Recca (b 1949) played bass in The Stooges from early 1971 through their first break up, in July 1971. Recca was later a member of The New Order with Ron Asheton and former MC5 drummer Dennis Thompson (b 1948).

AND INTELLIGENT LIKE YOU, WHO COULD TALK TO HIM ON THAT KIND OF A LEVEL, AND WHO HE COULD SAY, "HEY, THESE SONGS. YOU NEED MORE SONGS. THESE ARE TOO LONG," AND YOU GO, "YOU'RE RIGHT." ON ONE HAND HE'S GOT THIS ACT WHO'S THIS WILD MAN, AND ON THE OTHER HAND HE'S GOT THIS GUY HE CAN TALK TO. UNLIKE MAYBE THE MC5 OR JIM MORRISON, YOU'RE NOT OUT OF CONTROL. TO MAKE A SECOND ALBUM, ALL YOU WANT TO SEE IS FORWARD MOMENTUM. IF YOU PUT OUT A RECORD, IT'S GREETED WITH INDIFFERENCE, THE ACT ISN'T DOING ANYTHING ON THE ROAD, NOBODY'S WRITING ABOUT IT, MAYBE YOU DON'T MAKE THE SECOND RECORD. BUT PEOPLE ARE WRITING ABOUT THE STOOGES, PEOPLE ARE ASKING QUESTIONS, THE ACT IS MAKING SOME NOISE LIVE, THERE'S A VIBE IN DETROIT. NOW BY THE TIME THEY HAVE TO MAKE A DECISION ABOUT A THIRD ALBUM...

I: In general, people, these businessmen want action. At any rate, I believe they heard scuttle. Of course people are gonna chatter. I became a junkie mess, and I was doing all sorts of terrible things. Like in Farmington, I was shooting up in a stall of the boys room before the show. My first coke was given to me by Danny, and then the second coke was stolen from Danny as I told you [laughs]. It was just a little bit, and after that I was just getting it anywhere I could and still taking psilocybin and acid. Anyway, [for a potential third album] I just remember that we were trying to write these new songs. It was getting harder to organize the thoughts, harder to organize the rehearsals, and the stuff wasn't quite coalescing. It wasn't clear how Ron would relate to James as a guitarist. I told you James didn't wanna room with me, but the way I write with people is intense immersion. And he finally had to give up later and do it, and that's where he got his good songs on *Raw Power*, but at that time, he didn't want to do that. And somehow we'd gotten a little way into it, but things were getting worse and worse. I had scabs on my face. I had lice. I was getting picked up by the cops for things I didn't do. I used to frustrate police because I was one of these aimless guys you can't predict, whereas in LA later James got busted because he had a car with a license plate and a regular run he made to a known dealer, and they just waited to pick him up. But with me, I might be anywhere doing anything, taking anything, and nobody knew!

JK: SO THAT MEANS THAT THE DRAGNET GUYS ALSO CAN'T PREDICT YOUR NEXT MOVE.

I: Exactly. But what I was gonna say, I remember my terror when I heard that the company's coming out to hear some music, and the reason was simply I knew. I said, "Oh my God. They're gonna take one look at us. They're gonna see where we're at, they're gonna see what we are, and this is not gonna happen. That'll be the end of this."

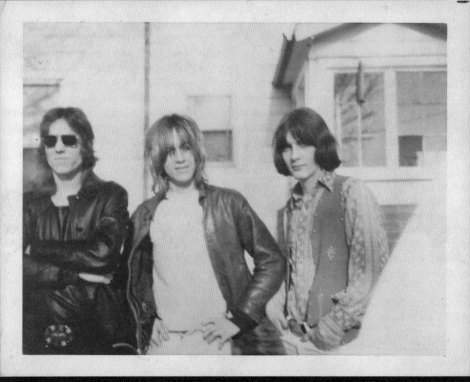

Above: James Williamson, Iggy and Jimmy Recca outside the Fun House. Jeff Gold collection. **Right:** The Stooges in a
Chicago hotel lobby with fans Mike and Carrie Shelton in first photo. Probably April 1971. Photos: Mike Shelton and
Natalie Stoogeling. Jeff Gold and Johan Kugelberg collection.

J: SO YOU KNEW WHEN ELEKTRA CAME OUT TO SEE YOU ABOUT THE THIRD ALBUM THAT IT WASN'T GOING TO HAPPEN.

I: Of course I knew. I was ashamed of what the group had become, and I couldn't pull out of it right then 'cause I was hooked. So came the day, we did try to pull together a rehearsal, and of course what you do if you're on dope is you can't do anything until you've got the dope. So we kept them waiting, a couple hours I believe, and different people showed up at different times and finally everybody was there and we played them the stuff. I've heard, "Oh, Don Gallucci didn't like Ron Asheton's weapons collection," and I've heard, "Oh, Bill Harvey says to Don, 'Do you hear anything?' 'Nah, I don't hear anything.' 'Nah, we don't hear anything.'" But I think the truth was they wanted to see how I was, and then they saw where I was at. If the rest of the band had suddenly counted to four and played "California Dreamin'," sounded just like the Mamas and Papas, they would've said, "Great. Get rid of Iggy, and let's make the record," but them being what they were, the way they sounded, and they were also seedy obviously and weird characters, also taking dope but not as crazed as me, I think they just realized, "Okay, this thing has hit a really bad turn."

And I suspect the reason for sending the producer was these business people like to cover their legal areas, and I think they wanted to be able to say, "Oh we did listen to the new [songs]," in case somebody else came in and said, "You didn't even listen to the music! There's no morals clause in the contract!" And from the letters you found, it's obvious that he referred to it, "I hope the problems YOU'VE had will blah blah blah, will cease," And they did two things. They tried to hold down the group, hoping they would sign these letters, they sent one to James Williamson, and later they tried to exercise a personal option on me.

J: LET ME ASK YOU A COUPLE OF QUESTIONS. I READ AN INTERVIEW WITH GALLUCCI ABOUT DROPPING YOU GUYS. I HAD A THEORY ABOUT THAT AND I DON'T KNOW IF IT RESONATES WITH YOU, BUT IT SEEMS LIKE BILL HARVEY AND DANNY ARE ENEMIES, SO I'M GUESSING BILL HARVEY IS LESS INTO THE STOOGES THAN JAC IS, SO HE GOES DOWN TO SEE YOU AND BRINGS GALLUCCI SO THE TWO OF THEM CAN TELL JAC THERE'S NOTHING HAPPENING AND IT'S NOT JUST HARVEY SAYING IT.

I: That's very possible too.

J: AND GALLUCCI SAYS THAT HE HATED DETROIT, THE WHOLE THING IS KIND OF AN ANATHEMA TO HIM, AND RON TAKES HIM ON A TOUR OF THE FUN HOUSE, WHICH FREAKS HIM OUT, AND THEN SHOWS HIM ALL OF HIS NAZI STUFF, AND HE'S REALLY HORRIFIED, AND GALLUCCI SAYS, "WHAT'S UP WITH THIS NAZI STUFF," AND RON STARTS MAKING NAZI JOKES THAT GALLUCCI SAYS AREN'T FUNNY, AND GALLUCCI SAYS THAT'S THE STRAW THAT BROKE THE CAMEL'S BACK. NOW HAVING BEEN IN SHOW BUSINESS, YOU AND I BOTH KNOW HAD THEY HEARD HITS, NONE OF THIS WOULD HAVE MATTERED.

I: I've heard that. I have not spoken to Don since we did that record, so I have no idea.

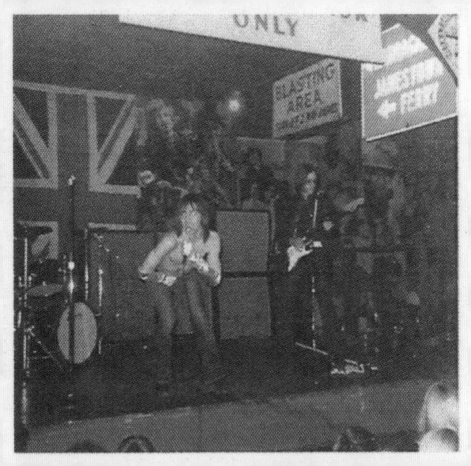

Today's Date __4-12-71__ ACT: __STOOGES__

DATE OF ENGAGEMENT __Sat. April 24 - 1971__ No. of Musicians __4__

PLACE OF ENGAGEMENT __Palladium__

ADDRESS __Brownell St.__

CITY AND STATE __Birmingham Mich__

ADDITIONS _____ PHONE: _____

SET UP TIME __6:00__ BETWEEN THE HOURS OF: __8__ TO __12__

SET TIME APPROX __11:00__ NO. OF SETS __1. 60 minute show__

WAGE AGREED UPON __$250 + 50% after $1250__ DEPOSIT: AMT __— 0 —__ DUE

CAPACITY _____ TICKET PRICE _____ ADVANCE _____

GROSS POTENTIAL _____

TYPE OF SHOW: DANCE __✓__ CONCERT ____ STATE ____ INDUSTRIAL ____

RIDER: GROUP ____ GENERAL ____ PICTURES: YES (NO) PROMO: YES (NO)

PAYMENT AS FOLLOWS: Prior to performance _____ Other __upon completion__

EMPLOYER: __Ed Andrews__ PHONE: HOME _____

COMPANY __Hideout Records__ CLUB _____

ADDRESS __124 S. Woodward__

CITY __Birmingham__ STATE __Mich__ ZIP _____

DATE MAILED TO EMPLOYER __4-12__ RET'D __✓__ BOND _____

DATE MAILED TO GROUP __✓__ RET'D __✓__

FINISHED CONTRACT TO EMPLOYER __✓__ UNION __✓__

NOTE: __I'll sign for both__

__DAVE__
AGENT

J: SO I HAVE THIS BOOKING SHEET FROM APRIL 24, 1971, THE PALLADIUM IN BIRMINGHAM, MICHIGAN. YOU'RE MAKING $250. AND FIFTY PERCENT OF THE GROSS AFTER $1250, SO IT'S GOTTEN PRETTY BAD.

I: Actually it was a thing where if we would play for the low guarantee, it was some sort of a thing they were trying, a venture. Is there a gig at the Vanity on there anywhere (April 13, 1971)? Because we played at the Vanity once, and I'm embarrassed to say we played for a briefcase full of heroin.

J: THAT'S A LOT OF HEROIN!

I: Well, no. It was these tiny little...the guy ripped us off. For a while we had a heroin dealer who wanted to be a promoter and said, "I'll promote gigs," at either the Vanity or the Cinderella, "with these guys." We were around a thousand-dollar band at that time. It was tailing off.

J: SO YOU KNOW YOU'RE BEING DROPPED BY ELEKTRA AT THIS POINT. THINGS HAVE GOTTEN DIRE. THE LAST GIG YOU AND WILLIAMSON PLAY TOGETHER IS THE STOOGES AND BOB SEGER AT THE TOLEDO SPORTS ARENA (MAY 29, 1971).

I: Oh my God, I was just gonna tell you! I remember that!

J: YOU AND WILLIAMSON QUIT AFTER THAT SHOW.

I: This gig in Toledo was one of two or three near the end of things. I remember being very cold and huddling by the electric heater in my room, trying to get it together to go onstage, couldn't do it, and finally took a bunch of downers just to kill the pain, and made a fool of myself and the gig. That's what I remember. I did a similar stunt at a gig I believe in Buffalo [37] where I kept everybody waiting and Danny lost some money, and many years later when Danny was ill, I paid him back by giving him—I think Danny Goldberg organized a collection—and I gave the amount of money that Danny lost on the group. And then there was another one that was really bad where I was literally, I was fucking a really nasty groupie on the floor of the men's room somewhere in Jersey while the band was playing. So this is where I'd gotten to.

J: AND WAS IT JUST LIKE, "ALRIGHT, I'M DONE," 'CAUSE THAT'S THE BREAKUP OF THE STOOGES.

I: Yeah, I think what happened finally, I think I might'a made a call to Ron and said, "I can't take it anymore. I can't do it. I'm sorry." You know.

37) Gilligan's, Buffalo, New York—likely December 1970.

Left: Stooges concert booking sheet, April 1971. Jeff Gold collection.

PEOPLE'S CONCERT
NO. ONE

FEATURING
THE STOOGES
AND
BOB SEEGER
...
SPECIAL GUESTS
SUNDAY FUNNIES
AND
FRUT
...

SAT. MAY 29
TOLEDO
SPORTS ARENA
8: PM

NO RESERVED
SEATS
...

ADVANCE
TICKETS
ONLY $2.00
($3.00 AT DOOR)

REDUCED ADMISSION
AN EXPERIMENT IN
CONCERT PRESENTATION
...
TALENT COURTESY OF
DIVERSIFIED MANAGEMENT AGENCY, DETROIT, MICH.

DENNIS LOPEZ PRESENTS

HOLLYWOOD BABYLON

COCKETTES • GTO'S
THE STOOGES
JOHN MENDELSOHN-SUPER STAR
SOUND BY TYCHOBRAHE

FRIDAY, JULY 16, 8:30
HOLLYWOOD
PALLADIUM

TICKETS ARE AVAILABLE
EVERYWHERE
$5.00

graphic design jeffrey mann mercuryfeast workshop

Left: A handbill for the final Stooges show of the Elektra era, May 21, 1971. Johan Kugelberg collection. **Right:** Poster for a show that never took place; The Stooges had broken up nearly two months earlier. Music critic John Mendelsohn, also on the bill, had been a Stooges supporter and was lead singer of the band Christopher Milk. Johan Kugelberg collection.

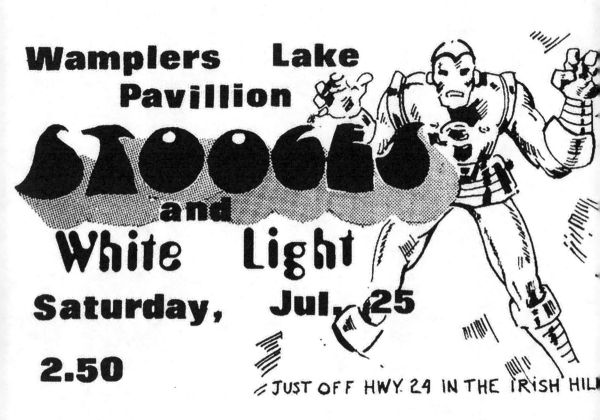

Above: A handbill for the only Stooges show without Iggy. He and James had left the band, but they had a contract for the show and Ron Asheton wanted the money. An audience member came onstage and sang a song, July 25, 1971.

J: AND THEN THERE'S ONE MORE CONTRACTUAL GIG AFTER THAT AT WAMPLERS LAKE PAVILION (JULY 25, 1971). YOU DIDN'T PLAY AND THEY PULLED A GUY OUT OF THE AUDIENCE TO SING A SONG.

I: That's where Ron had the guy, and there's a recording of it. "What You Gonna Do?" That's him. I used to hear it and thought, "I don't remember. I was pretty good!" and then I realized that was the guy.[38]

J: AND DID YOU KNOW THAT THEY WERE GONNA PLAY THIS GIG WITHOUT YOU GUYS.

I: Yes. I just said, "Well fuck it then. Go ahead. If that's what you're gonna do, Ron, if you think you can do that." Ron at some times would be just like a regular guy like, "Look, I don't care. I'm gonna go and get the money."

J: ACCORDING TO WHAT I'VE READ, YOU THEN MOVE IN WITH YOUR GIRLFRIEND BETSY, AND YOU SEND YOUR FRIEND HIAWATHA TO PICK UP YOUR STUFF FROM STOOGE MANOR.

I: That sounds accurate.

J: AND STOOGE MANOR IS SOON BULLDOZED.

I: When I was staying, going over to Betsy's house, I was reading *The Godfather* by Mario Puzo. I call that a self-help book. So that was my vision at the time.

J: A MANAGEMENT GUIDE!

I: Yeah, I'm gonna go out, and I'm gonna be the Godfather. And interestingly enough, that was one of the sobriquets I earned later in my career. But yes, I was reading *The Godfather*, and then later when I was in New York after they signed me up at MainMan, I waited 'til we signed up to tell them, "Uh, I'm on methadone. I need a little money." I would go to Clint Eastwood, I think it was *The Good, The Bad, and the Ugly* on Times Square. If I was down and out, "Oh, let's go to a Clint Eastwood movie and buck up here, buddy!"

38) Audience member and Stooges fan Steve Richards volunteered to sing with the otherwise instrumental lineup at this show.

June 21, 1971

Mr. Danny Fields
7 West 20th St.
New York, N.Y.

Dear Danny:

As of now, The Stooges owe Elektra some $10,875
which breaks down as per the attached memoranda.

These are the figures I promised I would get for
you.

Best regards,

Jac Holzman

JH/pg
Encl.

TO: BILL DATE: JUNE 14, 1971
 CC: JAC, HOWARD

FROM: JACK

REF: THE STOOGES

IN ADDITION TO THE STOOGES BEING UNEARNED IN EXCESS OF
$59,000 THERE IS A BALANCE DUE ELEKTRA ON NOTE OF
$5,800.

AT THIS POINT, I AM TOTALLY UNABLE TO COLLECT ANY MONEY
FROM DANNY FIELDS OR FROM THE STOOGES. WOULD YOU PLEASE
GIVE ME A SUGGESTION.

THANK YOU.

ADVANCES SINCE FUNHOUSE
+ OTHER COSTS

JR/JMM

the elektra corporation **15 columbus circle, new york city, new york 10023 (212) 582-771**

Dated _____

Messrs. James Osterberg, Jr.,
Ronald Asheton, Scott Asheton
and David Alexander (PKA"The Stooges")
c/o Mr. Danny Fields
Atlantic Records
1841 Broadway
New York, New York

Gentlemen:

Reference is hereby made to the recording agreement between each of you
and us dated October 4, 1968 and to the various modifications, amend-
ments, and/or extensions thereto (all of which are collectively referred
to herein as the "Agreement") and to the publishing agreements of the
same date between each of you and the Paradox Music Group (hereinafter
called the "Paradox Agreements").

In consideration of the mutual covenants herein contained and other good
and valuable consideration, receipt of which is hereby acknowledged, you
and we hereby agree as follows:

1. The Agreement is hereby terminated effective as of the date hereof
in accordance with and subject to the provisions as hereinafter set fort

2. You agree to pay us the sum of Five Thousand (\$5,000)Dollars upon
the signing of this instant agreement. This payment will be treated as
full reimbursement of the unrecouped advances due Elektra for the third
album to have been recorded by you under the Agreement, which album was
never so recorded.

3. (a)Reference is hereby made to the loan in the sum of \$7,000 made by
us, at your request, to Stooges, Inc. (hereinafter referred to as the
"loan") pursuant to a note dated August 19, 1970 (hereinafter referred
to as the "note"). As of the date hereof, Stooges, Inc. has repaid the
sum of \$1,200. toward the loan, leaving a balance of \$5,800 due and
outstanding. You and we hereby agree that until such time as Stooges,
Inc. has repaid the loan pursuant to the note, you shall also be obli-
gated to repay any sum still due and owing to us under the note with
all monies you shall receive, after the date hereof, from your personal
appearances, including, but not limited to, concerts, television and
motion pictures, and with any royalties due you under the Agreement
and with any monies due you under the Paradox Agreements and under the
agreement with Warner Brothers Publishing Company, Inc. referred to in
Paragraph 6 below (hereinafter referred to as the "Warner Brothers
Agreement").

Please Initial

cable address Noteworthy New York

J: SO THIS IS THE ELEKTRA TERMINATION AGREEMENT, WHICH I FOUND FASCINATING. I DON'T KNOW IF YOU LOOKED AT IT.

I: Some of it with the seven thousand dollar loan.

J: YEAH, YOU HAD TO PAY THEM BACK A $5,000 ADVANCE YOU GOT FOR THE THIRD ALBUM.

I: Yeah, and then also give them everything for the rest of our career basically!

J: YOU'VE PAID TWELVE HUNDRED BACK ON A SEVEN THOUSAND LOAN, SO YOU OWE FIFTY-EIGHT HUNDRED. BUT YOU—AND I'VE NEVER SEEN ANYTHING LIKE THIS—YOU'VE GOT TO NOTIFY THEM OF EVERY GIG YOU PLAY IN ADVANCE SO THEY CAN TAKE THE MONEY UNTIL THEY'RE PAID BACK AND THEY CAN NATIONALIZE YOUR ROYALTIES AND YOU'VE GOT TO PROMISE YOUR NEXT PUBLISHING AGREEMENT IS WITH WARNER'S PUBLISHING.

I: Well, all I've got to say is that's the silver lining to be a person who's very hard to track down.

Left: First page of the Stooges termination agreement with Elektra. The band paid Elektra $5,000 and agreed to repay an outstanding $7,000 loan from any future income. Jeff Gold collection.

the elektra corporation 15 columbus circle, new york city, new york 10023 (212) 582-

September 29, 1971

Mr. James Osterberg, Jr.
2666 Packard
Ann Arbor, Michigan

Dear Iggy:

We are pleased to advise you that, pursuant to our
agreement with you of October 4, 1968, we are exer-
cising our option to enter into a contract with you
for your individual services as a recording artist,
and we are hereby exercising our option for the first
year of such contract. We would appreciate seeing
you as soon as possible so that you can sign a new
formal agreement and so that we can plan your future
recording activities.

We hope that the problems which you had that resulted
in our not being able to release an album by The
Stooges during this past year can be overcome so that
your career can continue with the success we all expect

 Sincere regards,

 THE ELEKTRA CORPORATION

 By

Registered Mail--
Return Receipt Requested

the elektra corporation ▪ 15 columbus circle, new york city 10023 ▪ 582-7711

cable address Noteworthy New York

Above: In September 1971, after dropping The Stooges, Elektra attempted to exercise their right to sign Iggy as a solo
performer. Danny Fields, managing the band at that point, never mentioned it to Iggy, who first learned of this in 2003.
Jeff Gold collection

J: MANY YEARS LATER, DANNY FIELDS SOLD ME HIS MEMORABILIA. JUST BEFORE THE STOOGES PLAYED THEIR FIRST REUNION SHOW AT COACHELLA, I HAD LUNCH WITH YOUR MANAGER, ART COLLINS. AND I GAVE HIM COPIES OF THE STOOGES ELEKTRA CONTRACTS, WHICH DANNY HAD. BUT THE REAL SURPRISE WAS I FOUND LETTERS ELEKTRA HAD SENT DANNY, IN AN EFFORT TO PICK UP THEIR OPTION ON YOU AS A SOLO ARTIST, AFTER THE STOOGES BROKE UP. THEY HAD BEEN UNABLE TO FIND YOU, SO THEY SENT IT TO HIM. AND ART TOLD ME YOU DIDN'T KNOW ANYTHING ABOUT IT.

I: I didn't. I did hear at one point a murmur from Danny that, "The guys at Elektra say they would like to do like a David Cassidy kind of thing on you." That was the word that was used, and I understood where they would get the idea because originally when I was first taken around New York, one of the first places I was taken was to *16 Magazine* and to (*16* editor) Gloria Stavers' apartment.[39] They left me alone with Gloria, and I was thinking, "Is this, like, what I think this is?" And she was just very nice, but I think she woulda liked a little action.

J: SHE DID IT WITH JIM MORRISON.

I: Oh did she? Okay. So I wasn't going for that, and it didn't go farther than the one thing. But I liked her, and so I thought, "Oh, I see." I just intuited that that was the kiss of death. I'm probably about the most committed kind of artiste, especially for that first ten years, that I can think of, but I'm not sure how or why or that that's anything I personally achieved. It just kinda happened to me because logically I would think more like this. "David Cassidy? No, no, no, no. First of all, I don't have a stomach for that music, and secondly, look. There are a lot of better looking guys than me." I was not David Cassidy cute. I knew that too. So I didn't even entertain it.

J: THERE'S A DYLAN INTERVIEW WITH ED BRADLEY WHEN HIS *CHRONICLES* BOOK CAME OUT, AND ED BRADLEY GOES, "'TIMES THEY ARE A-CHANGIN', 'BLOWIN' IN THE WIND.' HOW DID YOU WRITE THOSE? COULD YOU STILL WRITE THOSE?" HE SAYS SOMETHING TO THE EFFECT OF "I DON'T KNOW HOW I WROTE THOSE. THEY CAME TO ME. I CAN'T DO THAT, BUT I CAN DO OTHER STUFF NOW." AND SO Y'KNOW, YOU MAY NOT HAVE BEEN FOLLOWING SOME LASER-LIKE FOCUS, BUT IT SURE ENDED UP FANTASTIC MUSICALLY.

I: Yeah, there was something I really wanted to be, and the equity that I wanted was a personal equity. I wanted equity. I wanted to own my personhood. Other people wanna own a house or they wanna get your publishing or something or they want some stock, but I just, I don't know why I wanted that. I think it was a very personal thing, a quest of personal identity.

J: YOU HAD A STRONG INTERNAL COMPASS IT SOUNDS LIKE.

I: And then later of course that became really valuable.

39) Gloria Stavers (b 1927 - d 1983) was the legendary editor of *16 Magazine,* where Danny Fields had worked before joining Elektra.

JK: DID THE SORT OF, THE TERROR OF '71 AND THE DRUGS, DID IT MESS UP YOUR SINGING VOICE, OR DID THE VOICE STAY INTACT?

I: Well the kind of voice I have, it just stayed about the same. Y'know I was pretty much just shouting that stuff. You can hear it on that. It's on that…

JK: YEAH, IT'S ON THAT LITTLE BOX [*YOU DON'T WANT MY NAME…YOU WANT MY ACTION*].

I: Yeah. I wasn't getting colds or anything. I was way beyond that. All that stuff didn't really catch up with me that I can remember, until my teeth went bad all at once during the '70s. It started with one that went bad much to the MainMan's fury, and it became legendary that Bowie wanted somebody for something, and [Bowie manager Tony] DeFries said, "Well, we've just had to pay for Iggy's new teeth," and Bowie went, "WHY…the new teeth…and the fucking…" But y'know it's the typical like you bought a horse with bad teeth, right? So '72, my teeth were starting to go, and by '74, '75, they all had to be replaced.

J: SO DANNY HAD THAT OPTION LETTER FROM ELEKTRA AND THEN A SECOND ATTEMPT SAYING, "DANNY, IF YOU KNOW WHERE IGGY IS, PLEASE GET HIM TO SIGN THIS." WAS HE DODGING IT ON YOUR BEHALF?

I: I think he must have been because he never pressured me.

J: AND YOU KNOW WHAT? IT'S ALL RIGHT AROUND THE TIME THAT YOU MEET BOWIE, AND SO THERE'S A PROSPECT THAT'S MUCH MORE PROMISING.

I: Yeah. I think Danny helped me dance around things in a way that was very intelligent, and then maybe also, was that around the time that he was fired by them or were they asking him as a friend??

J: NO, THEY WERE ASKING HIM AS YOUR MANAGER, WHICH HE WAS ESSENTIALLY. HE WAS LONG GONE FROM ELEKTRA.

I: Yeah, exactly. And he was, I didn't know it at the time. He and [club owner/manager] Steve Paul[40] had a really strange relationship.

J: I KNOW THEY WERE CLOSE.

I: They were close, and I just assumed all along that Danny was trying to steer me to Steve.

40) Steve Paul (b 1941 - d 2012) was the owner of the popular New York rock club The Scene (1964-7) and the manager of Johnny Winter and the McCoys.

J: WAS STEVE PAUL GAY?

I: I think looking back that he must have been, but he was like one of those mean butch gays. And he treated Danny a certain way, right, and he had this beautiful townhouse over in Gramercy Park, and we'd go over there, and he'd start. Y'know, and I thought, "This guy's too tough and mean. I'm not gonna survive this." And I just didn't wanna go with him, and I thought Danny was pushing me, and later when I went the other way, Danny looked at me and he said "If you had gone with Steve Paul, I never would have spoken to you again", or something to that effect, but he never said anything.

J: HOW DID YOU GET TO NEW YORK?

I: The coolest thing that Elektra did do: I got there on Jac Holzman's dime, and here's how. Jac Holzman brought me up to his office personally, and he gave me a choice of two very beautiful, expensive presents that I could have, and without using the words, I understood this was like the gold watch. This was the kiss-off, and so I said, "I'll take the Nikon camera."

J: I MEAN I'VE NEVER HEARD OF ANYBODY DOING THAT WHEN DROPPING AN ACT, SO THAT'S A REALLY THOUGHTFUL, GOOD THING. THAT'S REALLY UNUSUAL.

I: I know. So he gave me the Nikon camera, and I went and I pawned it, and I got enough money. What I did, at that time I was on a Valium and methadone treatment that my parents had arranged for me in Michigan. I pawned it, and I bought a ticket round trip: Detroit, Miami, New York, Detroit. An excursion ticket, and I booked some time. I had a little other money. I borrowed some money from DMA, the agency. They said, "Don't you ever call here again." And with the two together I booked a room at the Doral Golf Club, and I thought, "I'll do a Valium and golf cure." And at the end of that I was to meet Danny and Steve Paul at a concert by the Winter Brothers and possibly meet this guy from the McCoys (Steve Paul client Rick Derringer). That was one of the things being thrown around. And I got kicked out of the Doral. I did play golf for a couple days, and then one day I was so Valiumed out that I thought I'd lost my Valiums. So I called security, and that was that. They were like, "You're outta here," and I was in tears. I was like, "Someday, you'll wish you hadn't thrown me out. You'll be happy that I ever stayed here," but I did always like the place. And then I went to the show here, and I saw Miami and it blew my mind, and I was weary of Steve Paul and I did not want to sign with that person. I thought, "Oh, this is a heavy duty guy." So I went up to New York and I was sitting in Danny's apartment watching "Mr. Smith Goes To Washington."

Iggy Loses The Stooges

There's some question as to whether or not **Iggy Pop** has a group, or even a musical career any more. Elektra records had decided not to renew **Iggy's** contract, so he was taking his business elsewhere when the **Stooges** seemed to dissolve out from under him. Sources close to Iggy say that this does not mean he is finished. At last report he was on his way to New York to gather a new covey of musicians.

Crabby Appleton was also in trouble for awhile, but has gotten on their feet again. The problem (or is it the symptom?) seems to be that one of their associates had run off with their equipment.

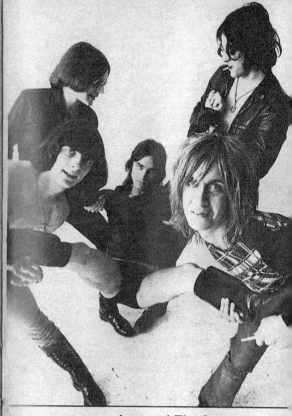

**Iggy and The Stooges:
No contract and no group.**

TALES OF THE TRAILER PARK STARRING IGGY STOOGE

guitar player of similar tastes and capabilities. After a five month layoff, the Stooges reappeared for a brief comeback with all new material from Iggy and Williamson, but Iggy was still not satisfied with the way the band, and especially himself, were going, so he decided in June that the best thing for him to do would be to split from the group.

Master Stooge had spent the summer reassessing his vision, golfing (no

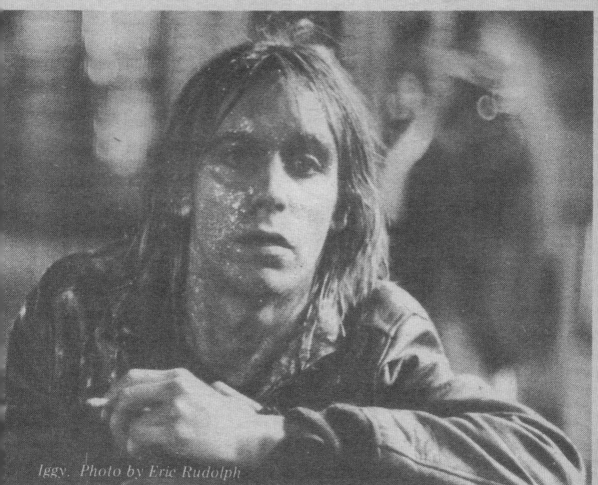

Iggy. Photo by Eric Rudolph

So Iggy has split from the Stooges. And the Ashetons are sitting at home, twiddling their thumbs, and the equipment's been repossessed, and Elektra hasn't picked up their option, and Iggy's back in the trailer park with his Mom and Dad and some notion to go to London to do a solo album. So

kidding), getting back in shape, and readying himself for the solo album he is about to record in London sometime around the end of October. After completing the album he will assemble a new stage band and do a tour of the major cities of Europe before returning here sometime next year. Right now he

world's best vocalist in the NME Musicians' Poll — yet maybe it is when one remembers that the lanky,

The description "non-singer" might seem uncharitable but it is surely Neil Young's other vocal qualities — the biting intensity of his delivery and, as

Yet it is true to say that with Neil Young the voice is the man; the voice the only vehicle that could convey with such insight and power the very special imagery

his own her wide open s cowboy, a chanelled th timeless song

We asked top vocalists to nan

HOW THE WORLD'S BEST PICKED THE WORLD'S BEST

TONY ASHTON
Ashton, Gardner and Dyke and Co

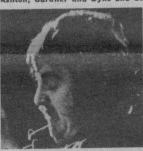

1. Joe Cocker
2. Roy Young
3. Ronnie Hawkins

DAVID BOWIE

1. Iggy Pop
2. Paul Rodgers
3. Christopher Milk

GRAHAM BELL
Arc

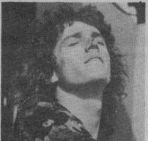

1. Eric Burdon
2. Robbie Robertson
3. Taj Mahal

EDGAR BROUGHTON

1. Neil Young
2. Mick Jagger
3. Jack Bruce

MARC BOLAN
T. Rex

1. Jim Morrison
2. Bessie Smith
3. Van Morrison

BOZ
King Crimson

1. Billie Holiday
2. Leon Thomas
3. John Lennon

9. BOWIE AND LONDON CALLING

J: SO I'VE HEARD TWO VERSIONS OF HOW YOU MET BOWIE. EITHER DANNY IS AT MAX'S KANSAS CITY AND CALLING YOU, OR (MUSIC WRITER) LISA ROBINSON IS CALLING YOU. BOWIE'S THERE AND WANTS TO MEET YOU (SEPTEMBER 7, 1971).

I: Danny's there and calling me.

G: AND YOU DON'T WANT TO GO?

I: Yeah, it's possible that first Lisa might have called Danny and Danny went down and I said, "Oh, I'll come later," or whatever and he might have called. But Danny definitely called at least twice. The first time, I'm saying "Look, I'm watching *It's A Wonderful Life* and he's so sincere! He's cleaning up! I don't wanna go down there!" And then he called back, he said, "Look, you could do yourself some good. These people could help you." He's just giving a sensible little nudge there, so I went down there.

J: SO PRIOR TO YOU MEETING BOWIE, IN *MELODY MAKER*, THEY'D ASKED A NUMBER OF ARTISTS FOR THEIR FAVORITE SINGERS AND HE'D PICKED YOU.

I: Yeah, that's what brought me down there. I'd heard about that that he'd mentioned that he liked what I did, and I thought, "Hey, that's unusual."

J: AND DID YOU KNOW WHO HE WAS?

I: No, I didn't know who he was.

J: BUT HE WAS SOME GUY OF SOME NOTE THAT DANNY WAS SAYING...

I: Oh by the time they got there, Danny had filled me in. "Look, this guy's got a, he's getting some action." I knew they had some sort of a thing going, and that they were doing business. That's all I knew, and then when I met them, I realized these are not business people. These are artists. That's good.

J: TELL US ABOUT GOING TO MAX'S AND WHAT THAT'S LIKE.

I: Well going there in general was like going to a very, very overcrowded, tiny little theatre that took place in an oval room in the back of the restaurant about the size of this tiki hut, full of booths along the sides, and then for the people who were less cool, some little tables in the middle, and on a typical night there would be three or four Warhol superstars, a couple of bored, hyper-cultural, over-sexed Jewish babes approaching middle age like Susan Blonde or Ultra Violet. I liked these babes a lot. Eve Babitz types, but not Eve. I met her during *Fun House*. She was groupie-ing me, her and the thin girl that passed away. Not Pamela Des Barres, the other girl. Lovely. Miss Christine.

Left: *Melody Maker*, May 1971, David Bowie picked Iggy as his favorite singer. Iggy had never heard of him. Jeff Gold collection.

So there would be a few babes. Glenn O'Brien would always be around. Leee Black Childers,[41] Eric Emerson. Donald Lyons and Taylor Mead would be back. So you'd have a couple of deranged academics, some publicity type people, some Warhol superstars, some edge-of-the-Warhol-superstar type people, and then you'd often have Lou Reed. I went, and everybody would sit there just kinda talking to each other and having these encounters and it was actually pretty fun and cool. And Taylor Mead especially was just very, what an entertaining guy, and Donald Lyons was my dad except he wasn't like my dad. "I didn't go to war." And you know Donald lived in one of these old, wonderful, yellowing apartments they used to have in New York where these old, yellowing men lived in the yellow apartments with the old, yellowing suit, and everything was fine. And they had the coffee in the Greek cup, and everything is fine. But he was on a block, 55th between 5th and 6th, very nice block. Nice restaurants, but upstairs was a dump but a nice place to be. So I was getting to know some of these people, but then if it was like me and Lou at a table then it would all get a bit...Y'know like Lou would say something like, "Well, little fella," or something...Y'know, he'd give me a little schtick.

J: IN MY ENCOUNTERS WITH HIM, LOU COULD BE A VERY GRUMPY GUY.

I: Yeah, he'd be grumpy, then I'd say, "Well, y'know I can move it on a stage." And then Lou would say, "I am the universe. I don't need to move." So there'd be these little encounters, and there was similar stuff with Bowie. More like both of us are kind of arch, but not so bad. And then y'know that night, [Bowie manager Tony] DeFries and a car dealer they had with them, who I think his name was Don Hunter. DeFries already was plotting to do some sort of business with this guy because there's a lot of flow in that business, and I believe they did probably work together after he quit show business. The original idea was to get me a backup band from England, and Bowie was recommending [English bands] World War Three and Edgar Broughton. Bowie would say one thing then DeFries would say something else. De-Fries would say, "Now, Don," or whatever, the American car dealer, "will manage you." And I said, "I do not want to be managed. This guy doesn't know music from a hole in the ground...I want you to manage me." So there was some of that jockeying.

J: WERE THERE NICETIES, OR DID THEY JUST LAUNCH INTO, "YOU GOTTA WORK WITH US?"

I: I think I probably launched into, "You gotta work with me!" [Laughs] Like I do! He kept going, "This ambitious man!" Well, yeah! I was like, "I'm ready! I'm ready. Let's go! Can I come up for breakfast or maybe whenever." And I was hungry too. I remember I ate one of those hotel stacks of toast because I was that hungry. I hadn't eaten well in a long time. So I don't remember exactly how that went, but the whole thing was like, "Yeah, yeah, yeah. Let's go." Any relationship with David was not spelled out or mentioned. It was that there was an organization [Bowie's management, MainMan], and the idea was that I would be signed as an artiste. I learned later [Lou Reed manager] Dennis Katz was telling Lou, "DON'T SIGN WITH THESE PEOPLE! Get produced, don't sign," but I didn't have anybody telling me, "Don't sign."

41) Leee Black Childers (b 1945 - d 2014)) was a photographer, Warhol acolyte and future MainMan vice president. In 1971 he stage managed Tony Ingrassia's production of Andy Warhols' *Pork*. Eric Emerson (b 1945 - d 1975) was a Warhol star at the age of 21, appearing in *Chelsea Girls* and *Lonesome Cowboys*. A large blow up photo of his head, projected as part of the Exploding Plastic Inevitable, was featured on early copies of *The Velvet Underground* and *Nico*.

J: SO BOWIE, OR DEFRIES SAYS, "YOU'RE COMING TO ENGLAND."

I: What they said was, "Go home and wait for us to call you."

J: RIGHT. YOU WERE CLEANING UP WHILE YOU...

I: Yeah, I went home and I got some help. My parents pulled off something, I had an illegal monitored professional methadone supply. America was a smaller place at the time. There was a family pharmacist in the area that they'd known for a long time. My dad walked into the pharmacy, and he said, "Bob...my son's duh duh dah...I don't want clinics and people like that duh duh dah..." And the guy said, "Don't worry about it. I'll buy a large bottle." It was something called Dolophine. It was a form of methadone. Cherry flavored. Much better than this Tang flavored crap that they had at the clinic. And that place was about a mile and a half from our house. And he bought it, and without a prescription, I went there everyday.

J: UNBELIEVABLE. WHAT A GREAT GUY.

I: Yeah, I know. They were really nice, and it started to stop the elephant. It was across from a Big Boy, so I'd go take my methadone, my Dolophine, and then I'd walk over to the Big Boy, and I'd have a coffee and challah bread or something and listen to the new records. You know, my mom would leave out usually two dollars and fifty cents every day as an allowance for me. So that got me by for a while. I would have little flare-ups and relapses. I had a drunk driving thing where I got a hold of some dope, and I was so drunk and stoned I crashed my car into a tree after I'd gone about seven blocks pursued by the cops on a one-way street the wrong way, but I didn't know it. And then when they kept going, "Get out of the car!" I was oblivious. So they opened the door and I fell out. They took me to the hospital, and they couldn't bust me because I had so much coke in my system it burned up the alcohol, so I was below the legal limit.

J: YOU WERE LIKE A CAT WITH NINE LIVES!

I: I've had many of these incidents. I'm not telling you all of them 'cause some of the worst ones get really bad. All those incidents kept popping up in my life right up until about '75, and then from '76 to '83, that seven-year period, less frequent, less severe, and then eventually after that I was gradually cool. But there would still be times: I'd written a song for *Repo Man* (1984), and there was something I didn't like about the bass line. So I came a second day, and the third morning, Steve Jones says to me, "You don't remember what you did yesterday, do you?" And of course I didn't. I was blacked out. It got to the point where any little thing I took...I can't smoke marijuana anymore. If I have one hit, I'll have to go hide under a chair or some place like that.

J: SO TELL US ABOUT GOING TO ENGLAND AND DECIDING TO WORK WITH JAMES.

I: Well basically I had checked out the World War Three records, and I didn't think they were as forward-looking as the Stooges already were. By the way I will say during this time when I was rounding up this deal, I did approach James to try to get him. The only reason we didn't both go around together and present everything as a group is that he had Hepatitis A. And so I went to see him, and he just looked at me like I was crazy and annoying him, and he said, "I'm sick, man. Don't bother me." He's always at some girl's house. This time it was his sister in a little flouncy bed, and I thought, "Well, okay. Fuck it." So I went myself and tried to get something going, and I understand. So I wanted to recruit him, but only if he had something, something to take it forward. 'Cause it hadn't happened in the last group. You've heard the songs on that album [*You Don't Want My Name, You Want My Action*; a compilation of live material with James Williamson from shows between *Fun House* and *Raw Power*].

The music on that album's kinda interesting, but there was nothing really, nothing coalesced. So that's where we were at, and I wanted to hear something. So later I tracked him down at his home in Birmingham with his mother, and I'll never forget my impression of what a sterile, utter cultural wasteland that neighborhood was. As I got near there, I had some sort of rental car or stolen. I don't know how I got there. I got there, right? Tracked down this reluctant rock star, and it was just one of these little American suburbs where every house is kinda nice, but all the trees are new and there's not one person on the sidewalk.

JK: DISNEY-FIED.

I: Yeah, like *Safe*. That Todd Haynes film.

JK: POST-WAR. LIKE POST-WAR COOKIE CUTTER SUBURBIA.

I: Exactly. Planned suburbia, not upper-class, just barely upper-middle. Like not the nicest part of Birmingham. So yeah, I thought, "God, what's here?" And I thought a lot about that later, and I realized how lucky the group was to be from Ann Arbor, which was my father's doing. My father wanted me to be somewhere where the school system was top drawer.

JK: ALSO IF YOU ARE IN THAT JUST SLIGHTLY ASPIRATIONAL MIDDLE CLASS PLACE IN A TOWN LIKE BIRMINGHAM GROWING UP, YOU'RE LOOKING AT THE RICH KIDS, AND YOU'RE LOOKING AT WHAT THEY HAVE EVERYDAY. WILLIAMSON MUST'VE HAD ENORMOUS HUNGER GROWING UP.

I: Yes, I think he did. I think he did, and he also had a problem because he'd lost his father. There's one thing I just wanna come out and say about the whole bunch of 'em and me too. There's a father going through this band, and it goes like this. If you ask—or God forbid, demand—of an Asheton brother to do anything, no matter what the words or action that comes out, the real statement is, "You're not my dad. You're not my dad. I don't care about you. You have no authority. I don't have to. You're not my dad." If you ask Williamson or tell him anything or fight any, "Fuck you. You're my stepfather. Fuck you. You're my step-dad."

J: RIGHT, THE COLONEL.

I: Right. With me it was, "I'm your dad. Hey. Hi. I'm you're fuckin' dad!" And that's what I was for this fucking group. Anyway Williamson nearly shit. So y'know, he was sorta unimpressed, but I sat down. Explained to him that I wanted to start a new band, and—are we good? And he played the riff to "Penetration," and I thought, "A-ha! There. Here we have detail. We have syncopation a la *Fun House*, but more sophisticated."

J: SO WHEN IS THIS?

I: I've already been signed by DeFries, but I'm back in the Detroit area waiting to get the call. So I saw that he had something that could be a direction just like "TV Eye" could be a direction for *Fun House*. I thought all the things that could be extrapolated from that, and that it had this moody, violent vibe. Of course that would appeal to a recovering junkie. So I told him, "Look, I've got this deal. This chance to go to London, and we could start a new band."

J: SO HE'S RECOVERED FROM HEPATITIS...

I: He was recovered, and I think he says that he was gonna start a new life with a girlfriend but then I intervened, and he called her up and said, "Sorry, I'm not coming to live with you." So then what I had to do was the tough part. From the wall phone in the tiny kitchen of our trailer, I called England to tell DeFries he had to bring two of us to which he said, "Oh. So now there are two of you?" And I was like, "Oh shit, I don't think he likes this." But I just took a deep breath, pinned him back down. I said, "Yeah, that's what we gotta do." I'm sure what happened was any time you asked him about anything that had to do with art personality, he just went straight to Bowie and said, "What should I do?"

J: WHICH IS SMART!

I: Yeah. Right. So there's a game going on here which I thought was very fun, and that's about it. I managed to survive myself for those few months in Detroit, in Ann Arbor just barely. We got on, I think it was a BOAC flight, and we went to Heathrow, and they said, "Well you're not getting in the fuckin' United Kingdom! Forget about it. Who are you fucking guys? You have no money. No jobs. What do you mean?" And they said, "Who do you know?" And we said, "Well we know this guy Tony DeFries." So I gave 'em a phone number, and they called him, and it took a few hours. During the few hours, they made a baffle. They had these temporary walls. They just put us in this little area. We sat there not knowing what was gonna happen, and he finally came down to Heathrow. "I'm an Englishman. I'll take charge of them." Little different than things today, right? I don't remember ever filling out a visa form or maybe he did that. Planes were really easy to get on. There's a wonderful book. I keep forgetting to tell the right film director about this book. There was a wonderful book: *The Skies Belong To Us: Love and Terror in The Golden Age of Hijacking* and they talk about how anybody could just get on the fuckin' airplane to any fuckin' place!

Iggy Popp: He'll try not to bloody himself up.

Page 10—MELODY MAKER, April 1, 1972

Lock up your daughters, Iggy

AS MARC BOLAN swung his hips for the benefit of Ring Starr's camerawork, did any of the 9,000 upturned faces notice the auburn-haired American fifth row from the front?

From his seat in Wembley's Empire Pool, Jim Osterberg, alias Iggy Pop, alias Iggy Stooge, was checking out an aspect of the English scene as from one phenomenon to another, and that singer he couldn't believe! "Kinda chipmunky," he was to say later. Iggy is sort of, uh, more extrovert.

He sings a bit but he likes to express himself in other ways as well. You know, bash his head against the stage, pound his teeth with the microphone, draw a little blood. Anything can happen at an Iggy Stooge concert. Everything does.

It was unfortunate that time he played with the Stooges in St Louis. The time that the mike stand broke, and he was rhythmically smashing the jagged edge on the stage, and he never saw the chick climbing towards him until he felt the metal slam into her head. When he pulled it out there was, ugh! all this blood everywhere. Nasty business. But, like I say, funny things go on when he's stooging around.

Iggy is living in England right now. He says he'll be making some appearances next month. All you British mums have been warned.

An Iggy Stooge performance is the physical, visual culmination of that long line of bumps and grinds that has distinguished rock and roll since Presley put lead piping down his pants. Iggy has gone further than any of them along the road of audience participation. A feature of his act has been to jump from the stage into the arms of his fans and invite them to beat him up a little. It sounds like the the fulfillment or sado masochistic fantasies. It probably is. Iggy just says it's impromptu. Whatever happens, Que sera, sera, rock and roll style.

Before Iggy's band disintegrated, the act would go something like this: The other three Stooges would arrive on stage, plug in, and proceed to play with the total immobility that's associated with Bill Wyman. Far out. But then, who is this bare-chested kid with the bug eyes and the flapping arms and the bashed-up two front teeth lashing? See him flop like an obscene jelly beside the guitarist before springing out over the spotlights on to the heads of the groupies. And Jesus, is that really hot wax he's pouring over his torso? Ladies and gentlemen, is Iggy Stooge your kind of meat?

BUT tell me, Iggy, is everything they say about you true? "Yeaaah, pretty much. Maybe it gets a little distorted. Like, if I was sitting on

some guy's lap it comes out that I was —— him, and if someone gets hurt they say I'm into injuring spectators. But that's cool.

"Let me tell you a story. One time on stage I did this windmill thing with a wine bottle, bashing it on my chest until it broke. I can't tell you how beautiful it was, to see the glass shattering and the lights reflecting it. And then I looked down and there's this chick, who's been telling me she loves me, holding up her arm and it's covered in blood. She's saying, 'I hate you.' The cops cordoned the place off. I just about got away."

Iggy, or Jim as he refers to himself offstage, snickers gleefully. He's wearing a wide-brimmed black hat over a face coarsened with excessive living. He sits in the London office of his new manager, puffing cigarettes and spitting out anecdotes with the smoke.

People have egged him on, he says. The Stooges once played this open air festival, and the organisers kept telling him not to incite the kids to bust down the perimeter fence else it was going to be his ass that was on the line. Naturally, he recalled, by the time he went on that was just what he intended to do.

"So I made these little gestures, pointing to the wall, and then they tried to revolve me off the revolving stage they had. But our equipment guys beat up on them. It was beautiful. You could feel the electricity. "I've seen him do so many far-out things, now let's see him kill himself."

"I tried to fail so I'd just fade away, but they wouldn't let me. We just kept getting bigger crowds. So I quit. 'Goodbye, world, —— off.' I bombed out for six months."

IGGY and The Stooges attained national prominence in the summer

of 1970 when they played a festival held at the Cincinatti Redlegs Baseball Stadium. Traffic, Mott The Hoople and Alice Cooper were also on the bill, but it was Iggy who made the headlines.

Pictures of him leaping, tongue flicking like . . . an iguana, and the people handing him round on their shoulders, were syndicated throughout the States. He was bound for glory, however spurious. Less than a year later the Stooges were all washed up.

There were lots of problems within the group. Musical ones. And: "I got a real man-size habit, and then I didn't want to be onstage anymore 'cause I knew I couldn't do my best under those circumstances

Interview by Michael Watts

— I always try to do my best for my music. So I started trying to get out of playing, but what with managers and audiences that's more easily said than done. It got to the point where I'd get on stage and then puke. The people didn't care. Their attitude would be, "I've seen him do so many far-out things, now let's see him kill himself."

"I tried to fail so I'd just fade away, but they wouldn't let me. We just kept getting bigger crowds. So I quit. 'Goodbye, world, —— off.' I bombed out for six months."

Iggy is clean now. He didn't go to any clinic, he took himself off the hook. It was sheer, schizoid, hell, he recalls, but he dropped the habit. And for that, he says, he has largely his parents to thank.

IGGY grew up in a trailer park. He was a caravan kid.

He was brought up in Ann Arbor, Michigan, and at high school there he joined his first rock and roll group, "Iggy And The Iguanas," as a drummer.

Later, playing in Detroit with a blues band called The Prime Movers, he met Mike Bloomfield, then with Paul Butterfield. Bloomfield liked him, he says and gave him Sam Lay's address in Chicago, so off he went to the Windy City and bummed off Lay for a while, picking up tips on playing. There followed a number of one-night stands with most of the black bluesmen there, such as Walter Horton and J. B. Hutto. About his drumming, Iggy ain't modest.

He never played more than one or two nights with these bands, but they got him out-rate. The more he hung around the Chicago bluesmen the more contempt he got from all the white guys trying to play the blues. They had no personal presence which was what he was looking for. He wanted to play music that dripped right off his fingers, like these black guys. He headed back to Detroit.

It was here in '68 that he formed the Stooges with three friends. These were the two Asheton brothers — Ron on lead guitar and Scott in drums — and Dave Alexander the bassist.

Musicians was a pretty high-flown word to use in connection with them. They'd had virtually no previous musical experience. Iggy had to teach the drummer the rudiments, and the bassist learned by himself. Iggy wanted people who were untutored. All the guys who could actually play, he recalls, were "stupid and unbeautiful."

They went out on the road as the Psychedelic Stooges, a name vaguely connected with the Three Stooges, and for a time were involved with the MC5 (also from Detroit) in John Sinclair's multi-media community, Trans Love Energies. The Stooges did a couple of benefits for the community concerned but it wasn't their scene. They never got paid and he didn't like the people who were involved. "I'm waiting for the day when I meet someone who's never heard of John Sinclair," he says.

THEN, in late '68, the band was signed by Elektra Records. Danny Fields, possibly the most famous rock and roll publicist of all time, went to Ann Arbor for Elektra to look over the MC5.

At this time, says Iggy, The Stooges were real bad, not just bad. For a start, they had hardly any equipment. At the end of their set, however, the band left the stage with the amps feeding back and Iggy was wandering around the audience being Iggy. Fields came by, told him who he was, and talked about signing them.

Iggy thought it was a put-in: "I believed he was an office boy, who just wanted

to meet me and impres He didn't look like w thought a record con executive should look He was dressed like jeans and a jacket."

He was finally conv of Fields' serious inten n o t long after Elektra's co-owners, Holzman and Bill Ha came to see the band performance they gave not exactly smooth. "W really sick. I had a perature of 104, bruises on my head I'd had a kind of a fit my one ear was gon was at this time th wrote 'I Am Sick' 'Asthma Attack.' Bef went on I was sitting in blanket, shivering, and when we appeared I falling down. It was macabre. I was in believable pain and thought, 'this guy's int They were so te freaked they thought should sign us."

The first of their albums for Elektra, was simply called John Cale. "It was really strange band, Elektra thought they strange producer," he "We were still livin Ann Arbor and John out. I really liked him just let us have our t His job was to protec mad ideas from ou influences." Iggy snic again.

"We did that album four days. We'd played a note at that and the band hadn't w any songs before, wrote the songs in days and then we reco They were all ten minutes long."

The album was cut a Hit Factory, which is

Top: *Circus*, May 1972. Richard Morton Jack collection. **Bottom:** *Melody Maker*, April 1972. Richard Morton Jack collection.

‹238›

ggy Is Back !

y is back! Yes, **Iggy Popp**, mas-
f shattered microphones, torn
(hiw own), and peanut-butter-
glitter-smeared stage shows.
shed the Stooges, slipped out
e hammer lock of some nasty
ts ("He's clean," manager Don
ter has reportedly said, kicked
ltra-violent stage routine that
to send him bleeding to the
ital, and shown up in London
t up a residence and start all
again. Does this mean that
y's going to give up the
mutilation that once rocketed
from anonymity in Michigan
ternational prominence? Well,
exactly. He'll still be "wild,"
his manager, but he'll try not
rt himself.

ere

s Square in New York.
Ragavoy was on the
ons. Iggy remembers
well, if not with any
ness: "It was an R and
udio, and they thought
were horrid little creat-

Then Holzman heard it
said, 'I don't hear any-
g but three chords,' so I
if you don't like it we
lots more material, let
o in again. He set it up
the day after tomorrow.
were at the Chelsea and
was there we wrote the
r half of the songs.
tle Doll' I wrote in the
y. All it is is '1969'
ged around."

second time around, he
. Holzman liked it, but
haven't remained the
of friends. Iggy is now
lising a deal with CBS.
idn't work out too well
Cale, either. Iggy
nd up mixing the tapes
self:

John's got a real genius
arrangements, like on
rble index,' but that
's too shiny for a rock
roll band. When I got
tapes they came out
nding like 'Marble
x' again. In general, he
n't have a feel for the
lity and dynamics of
and roll — or at least,
like to play it. He's got
lassical background and
made him stiff."

Weird

he second album. "Fun
use," made at Elektra's
lio in Los Angeles, was
duced this time by Don
lucci, who had recorded
Kingsmen's "Louie
ie" when he was 17.
xtra gave them a practice
dio to rehearse in. It
n't work out that way:
We were all pretty
rd by this time, and in-
d of working we picked

up these instruments like a
tuba and a saxophone and
marched around doing 'Old
Joe Clark.' We refused to do
anything but set up our
instruments and record.

Eventually, the sound we
got was so ridiculous that it
was physically impossible
for anyone else to like us."
Yes, it was weirdness and
more weirdness all the way.

BY now Our Hero, hat
pulled low over his
forehead, is slumped in
his chair with his feet
stuck on the windowsill.

His voice comes out in a
slurry drawl, like a looser
version of James Stewart.
Under the shadow of that
hat he seems no more

than a kid.

Young Jim Osterberg is
explaining why he's Iggy
Stooge. He will, he says, do
anything to get himself off.
It's absolutely necessary for

him to have kicks, to move
his mind, and if people are
upset, well, he's sorry, but
right from the word go he's
been used to offending
them.

People who "orient them-
selves into art" are always
telling him he's so abstract.
He's not anti-social, not
unless it's cops or charac-
ters with no brains. And
then, someone will look into
his face and see . . . bene-
ath the brim his eyes take
on that psychotic look.
Don't look at him, kids. It's
not nice.

Minds are alive, he ex-
plains. They see pictures
and make up stories. He
sees big pictures and makes
big stories; his audience
sees little pictures and
invents big stories. A per-
formance is a whole mixture
of these pictures, and
dreams. You should have
the guts to let the dream
flow.

Lucky

Iggy says he's had a lot
of luck in his life, too: "I've
always been lucky. I've
wanted everything in the
world. I've wanted it all.
I'm as dishonest as the next
guy, y'see. I'm greedy,
crooked and vain, and I like
to profile. Everybody has a
shadow and I like to project
a big one.

"When I met my present
manager I was on the bum
with no plans and no food,
and all of a sudden I met
this dude, said 'I trust him'
and signed with him.

"The next thing I know
I'm talking to the president
of Columbia and he's saying
'yeah and now I'm in Eng-
land. That's awful good for-
tune for a poor boy!

Iggy switched on TV the
other night, just in time to
catch Judee Sill saying she
preferred to play without a
rock and roll band, who are
so "young, loud and
snotty," or something like
that. Iggy has written a
tune about it, he was so
creased. Because, as he
says, that's the way it is
when you're having fun.

He'll be coming your way
soon. Have fun.

J: SO WHEN YOU'RE IN LONDON PRIOR TO THE ASHETONS COMING OVER, ARE YOU WRITING SONGS EVERY DAY OR TRYING TO?

I: No, no. He wouldn't give me the time of day. James didn't start a group and go through any of that stuff. He just got onto a platform that we had created then the platform fell apart, and when I persuaded him again, the only way he even gave me the one half time of day for one afternoon was because I said, "I've got a new platform." See, you've gotta have something.

So anyway there we were. We got to the UK. We had four different places we had lived, and I had five. And this was the progression: The Portobello Hotel, or that might have been second. I think it went like this: Portobello Hotel to Saint John's Wood to a home, and I'll get the circumstance of each, to the Bridal Suite at the Royal Gardens, which I think was an in-joke that it took me forty years to catch on to, then to Seymour Walk in Fulham.

I think what we actually did was we started out in Saint John's Wood in a very nice home that belonged to [Bowie management executive] Lawrence Meyers. They had a gym, and I remember that I used to go for walks by the Lord's Cricket Ground. And I'd walk around the cricket ground, "This is very nice around here! It's a little dead!" Y'know, there's nothing. Nowhere to eat. There are no people, and there was a Revox tape machine [in the house]. James was trying to tape one of his worst songs left over from the old Stooge period, and I was getting nervous 'cause when I heard this number played clean on a Revox without volume, I started realizing, "Oh my God. Y'know there's not a lot of musicality to this guy. It's mostly riffs and pushy, that pushy amp sound." He sounds great with an amp.

So I was getting worried. After we'd been there a while, they took us from there one afternoon and signed me to this GEM [management] contract; and somebody coming downstairs, which had full, wall-to-wall shag carpet everywhere, beige of course, somebody—I wanna say it was James—spilled an entire bowl of cornflakes and milk and did not properly clean it up. So we were out of there in about forty-eight hours, and they put us in the Portobello. And I think the hope was that we would join the ongoing salon artiste that still probably exists in the Portobello from about 11PM on, but we weren't like that! And this is when we first discovered British plumbing. They had good plumbing in Saint John's Wood, and that's rare over there.

J: I WAS GONNA SAY WATER PRESSURE'S NOT A GIVEN THERE.

I: Well in the Portobello we were in these little tiny basement rooms. Do you know in Europe when a room has no plumbing, they have these converters where there's no hot water. So they had these things. You're supposed to put some money into it then screw it in a certain direction, wait fifteen minutes, and take a shower. Well we are from fuckin' America, and we've never! I think it's Michel Houellebecq who points out in one of his recent novels, he said, "No Renaissance monarch ever enjoyed the choices of the average American at the mall."

So we were like, "I ain't stayin' here very long!" And we stayed there a little while, and we didn't hang out, but we walked around a lot and again there was no life. So they put us in the Bridal Suite at the Royal Garden, and we go up there and there's only one bed and it's got ruffles. So I said, "Fuck it. I'll sleep on the couch. You can have the bedroom." And I didn't realize of course the joke, and it was a beautiful suite. Boy it was a big, big, deep tub like a Joan Collins number, right? Well this one calibrated to exactly what temperature I wanted the water. All mirrors, so I could look at myself, which is great. Well it was part of my job, I was gonna front the band, y'know, so you have to be narcissistically prepared.

And the only thing was like, "Where am I gonna sleep?" And I kept looking around the room,

and I realized it had a murphy bed. So I stayed in the murphy in the living room and we lived there a while, and we didn't hang together much because he was starting to get uncomfortable, James. He just didn't like the people, he didn't like the setup, he didn't like Bowie, he didn't like anything, and he didn't like the idea. When Edgar Broughton was out they were positing, "Well what about this guy named Twink?" But Twink had been in a band called the Pink Fairies. James did not want to hear about pink fairies. I objected to it on different grounds. I was aware of the Pink Fairies, and I thought, "Oh no, it's just a fuckin' English John Sinclair all over again." That's the wrong association. Hip, leftist politics is the wrong crowd. No.

So there were no auditions ever. [If I had to] I would have taken a deep breath, and for the first time in my life, feeling bad about it, held auditions. I never held an audition in my career until 1990 when I really had to make sure. I'd had the hit, and I couldn't afford a fancy band. I had to make sure. The drummer better be good, so I had an audition. I had never been able to do that up to then. I thought it was disgusting. That's what plastic people do. That's what professionals do. Yuck, you know?

We went to a Bowie gig where Bowie was practicing walking on people, but there weren't enough people and he fell down, and they all were dressed up in all the Ziggy stuff. And they could play five or six songs together, and then maybe on the seventh song by halfway through they were on different parts because they hadn't worked it out yet. And it would be like a thousand, an old ballroom for twelve hundred people. There would be like a hundred and fifty people, but they were starting them out. And we saw that, and James hated it. I was interested in it, but he hated it.

He has this thing, James, that I call the smear, and what the smear is, I've only ever seen it on one other person, and that's Phil Spector, and I crossed Phil Spector. I crossed swords with him one day. And that's when somebody sneers at you with a smile. It's a smiling sneer. And the smile is to show you, "I'm not even bothered about this, and what I'm about to do is totally self-evident, but I'm gonna get you, fucker." And so he said, "These guys wear funny clothes."

J: POT CALLING THE KETTLE BLACK IN THE FUTURE.

I: I know because later he ended up looking exactly...

J: MR. GLAM!

I: Mr. Glam.

J: HOW DID THE BROTHERS GET INVOLVED?

I: Williamson says, "Let's get Scott Asheton."

J: JUST SCOTT.

I: Yes. I heard later from him in reference to other people that he wanted to work with, such as the Sales Brothers, he has this theory about, "Now if you get brothers, they'll gang up on you." He's a backroom politician. He's Lyndon Johnson. Anyway, so I said, "Well if we're gonna get Scott, might as well get Ron," and he didn't argue. He said, "Okay." So that's how that came up. And this is what's worn me down in that band ever since the first day. I'm selling it to the manager. I'm selling it to the crowd. I'm selling it to myself 'cause y'know the public isn't really helping much, and then I'm selling it to anybody they throw at me from the record company, the press, the promoters. They all want, so it gets tiring. And then I'm trying to do the actual work, and it's not like...Am I Burt Bacharach here? Come on. Let's get real. I know there are certain limitations there.

J: SO I READ THIS QUOTE OF RON'S. HE SAYS HE'S AT A PARTY AND SEES YOU AND JAMES AND EVENTUALLY FINDS OUT YOU'RE GOING TO ENGLAND AND HE'S NOT.

I: Yeah, I don't remember that.

J: AND HE'S CRESTFALLEN, SO WHAT'S THE REACTION WHEN YOU CALL HIM UP AND SAY, "HEY, GUESS WHAT."

I: I don't remember. My sins in the group: like yeah, is James malevolent? I think so. Are the Asheton fellas slow rolling sorta individuals? Yeah. The way I fuck people up is I just focus on what I want to focus on and then I forget about 'em. That's my little sin area. I forget about this, I forget about that, I don't remember who feels what about this or that.

J: SO RON AND SCOTT COME OVER AND...

I: By that time, we were out of the Royal Gardens. At the Royal Gardens, my typical days would be like...It's right on Kensington High Street. I'd go to Kensington Market and go look at all the cool clothes, and that's where I got that jacket [Iggy's legendary cheetah jacket, seen on back of *Raw Power*]. And I liked to go to the hairdresser in the Royal Gardens and have my hair done. And I would go to dinner all by myself in the Royal Gardens Bar, I would have a giant Texas T-bone steak.

J: AND YOU'RE ON A STIPEND FOR MAINMAN?

I: Yeah. Port wine and a Churchill cigar. I started smokin' Churchill cigars! Y'know I didn't have any money, but I was doing great and basically developing in my mind the next phase. And then we all moved into this house on Seymour Walk in Fulham, which was wonderful. There was a place called Small's Café where you could go in the afternoon and see some cool people, and we used to go have tea with Bowie there. Seymour Walk had Chagall prints on the wall, and I didn't know what they were. "Get this shit outta here!" [Laughs] And we threw it in the back room on the floor. Again it was a beautiful old English, typical English row town-house on a very, very nice cul-de-sac street with the classic white painted front and the proper door, kitchen below, big kitchen with a large dining table, living room on the group floor, and two stories of bedrooms, but because it was a rental, barely furnished. Not what we were used

to in America, but good enough. I slept in a kids bed. Everybody had a bed. Everybody had a chair. The thing that drove the Ashetons craziest was the English TV. At that time, after 10PM you could get darts or billiards, and that just drove them...

J: NO RALPH WILLIAMS!

I: Yeah, no Ralph Williams, no Broderick Crawford, no Gilligan's Island.

JK: WAS IT COMFORTABLE WHEN THEY SHOWED UP? DID YOU GUYS GET COMFORTABLE WITH EACH OTHER?

I: I don't know! Yeah, sure. I've never been comfortable with those people. I know them. They know me. It's on, y'know?

J: AND RON ACCEPTED HIS FATE BEING DEMOTED TO PLAYING BASS?

I: Ron hated me and hated James but not openly. Scott hated James and hated Ron sometimes in like a brotherly way. Everybody was just sullen and crappy, and I was the one. Now I had more power than before 'cause I had the money.

J: YOU WERE THE SIGNEE [MAINMAN HAD SIGNED ONLY IGGY FOR MANAGEMENT].

I: Yes. So I made them practice a lot, and they got tighter than they'd ever been. In the Royal Gardens, James wouldn't write with me because he wasn't comfortable, so I sat down. I had already had "I Got a Right," which we recorded in London from those days, but I wrote "I'm Sick of You!" all alone because the I way I am is if somebody douches me like that, I have self respect, so I'll say, "Okay Mr. Great Guitar Player, I may not come up with something as good as you, but I have self respect. I'm gonna come up with the best thing I can."

I worked day and night on that thing, and years later it became real popular. And when suddenly there was a lot of money sitting there for those two songs that had never been collected, our publisher calls me up and says, "James claims he co-wrote both these song." I flipped out and said, "He did not." So we compromised to get the money, which couldn't be collected until he and I came to an agreement. He admitted that "I Got a Right" was mine, took his name off it, which he had put on the bootlegs, but with "I'm Sick of You!" he still claims to this day that he wrote the connecting riff. But it's not his, and he wrote out a little affidavit to the effect of "I was doing some elementary riffing," but you can hear it. It's not his style. It's too simple, and too melodic. Hilariously I called him out about this many years later and we argued about who actually wrote the hard rock riff—I said I based it on The Yardbirds and he claimed he stole it from the 13th Floor Elevators, which I think is pretty funny. At any rate the melody and chord changes are mine.[42]

JK: IT'S TOO FUNKY TOO.

I: Yeah, it's different, y'know? James has no funk. So that happened, but in the new house we started writing things that all sounded like "Gimme Some Skin," and it included that one. It was very complicated, heavy, heavy stuff, and it was that stuff together with "I'm Sick of You!" and "I Got a Right" that we ended up playing at the...

42) These songs were released as 45's in 1977. "I Got A Right!" by Siamese Records in April, and "I'm Sick of You!" by BOMP Records late in the year. Iggy's claim of inspiration from The Yardbirds' "Happening Ten Years Time Ago" is clearly true.

J: THAT FAMOUS SHOW, AT THE KING'S CROSS CINEMA. FROM WHAT I'VE READ, YOU GUYS WANTED TO PLAY, BUT TONY DEFRIES DIDN'T WANT YOU TO GIG AND ONLY LET YOU DO THIS ONE SHOWCASE.

I: I think that may be true. I don't remember myself exactly pounding the walls to do a tour, but it was odd. On the other hand, the mentality of the other fellas in the group is such that again and again if you look at their careers individually, without me, you'll see that they just go out mindlessly and gig themselves to death until nobody wants to see 'em. Because yeah, do I know a thing or two about when to put yourself forward and when to pull back and where to show your face and where not too and with whom and how? Yeah, y'know that's what I do. Maybe some other people know a little more.

I was really here to learn, but these guys, to them part of the gig is, "Hey, that's where we're gonna meet this girl. That's where we're gonna meet the dealers. We're gonna get a little money. We have some action. I'm bored. Blah, blah, blah." So I don't think any of these guys have a very good sense of presentation.

J: AND IT'S CLEAR YOU DO.

I: I do think that each of the other fellas have at times, the Ashetons consistently and James intermittently, displayed a great sense of personal style. Some of the pictures of me with Ron playing together and of Ron himself? Wonderful, wonderful, very interesting dresser, interesting choice of the way he handled the instrument, nice posture on stage, good eyewear, very, very cool. And the brothers, even cooler. They had the look. Williamson started out with a kinda decent leather boy look. Y'know, the leather boy look in Detroit. It was a pretty good look. And then he kinda lost his way a little bit in England with the pancake and the three-quarter stance and everything, but then once he was on the dirt of Hollywood, that guy was in his element, and I suspect that what fueled his renaissance there had a lot to do with all sorts of illicit favors from illicit friends that he was really good at making.

J: WHAT WAS THAT KING'S CROSS SHOW LIKE?

I: Yeah, well I remember there was not an insignificant, but not a full amount of people there, there were probably 125, less than 200 people for sure. Everybody who claims they were there is lyin'. [Laughs] And they were all kicked back in the seats, in the proper theater seats, and there was a bar, like you have in old theaters, there was a kind of barrier—you can see it on the back of the album—they climbed on, posing a lot of the time. Then down where the screen used to be the people from MainMan built us—they had a good sense of drama—a stage, it's exactly like the one Elvis worked in, in Vegas, in Elvis' later years. They built us a boxing ring with no ropes. And very theatrical, purpose built for the thing: MainMan were doing their own gig and they had all the American junket journalists out seeing David Bowie [who played in Aylesbury that night.]

And so we got whoever, anybody who would be curious about this group of Stooges who had been around awhile, you know, and I remember when we rehearsed for the gig we did the rehearsals at a club for adults, very fancy club I believe it was called Talk of the Town. It was a fancy club in Mayfair that was being renovated. And so somehow we ended up rehearsing afternoons while this crew of British workmen were banging, ya know tearing shit down or renovating the place and we were playing like "Gimme Some Skin" and they called me, the second day they would come in and start taking the piss [laughs] and they would call me Bugs Bunny because of how my voice sounded, they'd say "Oh, here comes Bugs Bunny!"

Above: Though billed on this extremely rare poster as "Iggy Pop, Ex Iggy and the Stooges," this show at London's King's Cross Cinema was actually The Stooges' European debut. Johan Kugelberg collection.

And we rehearsed there and then on the night of the show, I just remember James Williamson came with some girlfriend he had and she had brought him a box of makeup that he intended to use—for whatever reason. He said it was his commentary on that, you know, the glam thing going on was like clowning so he was gonna wear clown makeup. May have had something to do with his complexion, I don't really know. So anyway he brought a box of makeup and I think he suggested, I had my own silver hairspray that I mentioned, Nestle Streaks-n-Tips, popular with street walkers and lower income ladies. So I had that in my hair and his girlfriend had some black eye shadow so I nicked some of that and put it on my lips and I think Ron, I can't remember who was wearing who's...I think there was an argument over who would get to wear my other, I had silver leather pants and black leather. One of them, either Ron or James, got to wear my leather pants (it was Ron).

And we went out and I just remember that I had a strange work ethic at the time, I would just go like crazy on something just compulsively and then I would just stop dead. And this is how I was on stage and I remember often we would do a song and it would be so exhausting I'd just fall down at the end of the song and just lay there on the stage and catch my breath. I did that a lot. The big thing I remember about the gig was there was a girl who I thought was quite attractive—she was from Peckham—and she had come to the show and I'd been trying to make this girl for a long time and I wasn't getting anywhere but I told her I was a guy who's in a band and that I was really cool [laughs]. And she came to the show and when I saw her in the crowd, I went over the bar and I went down in the middle of one of the songs and I grabbed her by her hair and pulled her head back and sang into her face for awhile and then after the show she liked me. I got over her that way so I ended up receiving some love.

That's pretty much what I remember about the gig other than it was very, very important to me to really, really go for it. I know we played "Gimme Some Skin," and "I Got a Right," and we were playing other stuff that probably, some of the stuff that we brought over from Detroit that was on *You Don't Want My Name*, that particular bootleg, some of that material. It was all very, very riffy, very, very fast, there are absolutely no, the closest thing to a chorus was maybe "I Got a Right"—everything else was just a total assault, you know.

J: DO YOU REMEMBER THE CROWD'S REACTION?

I: Yeah, I remember that—this was not unusual for crowds that we played for at that time—they very much paid attention, and they were very non-committal, I don't remember if they even applauded at all, but nobody booed. And I remember that they were definitely paying attention, and sort of trying to be as cool about the whole thing as they could. It was the London crowd.

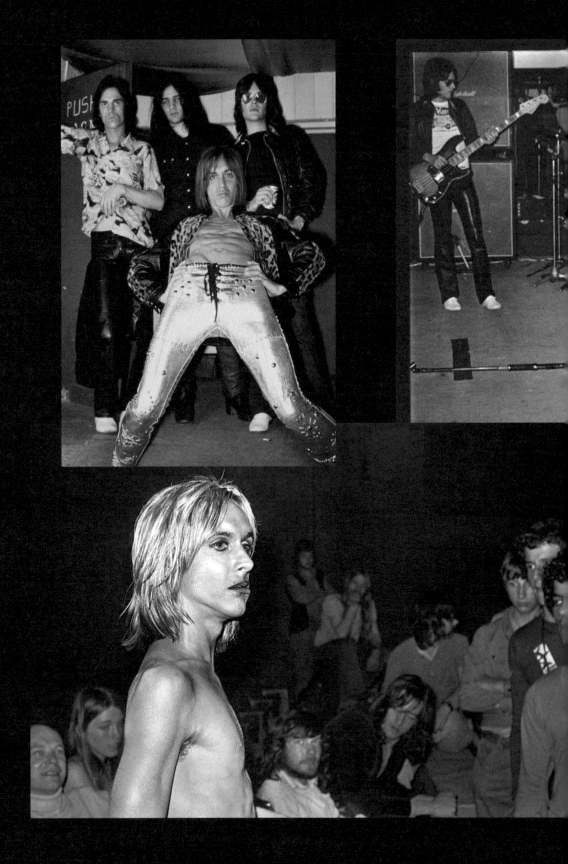

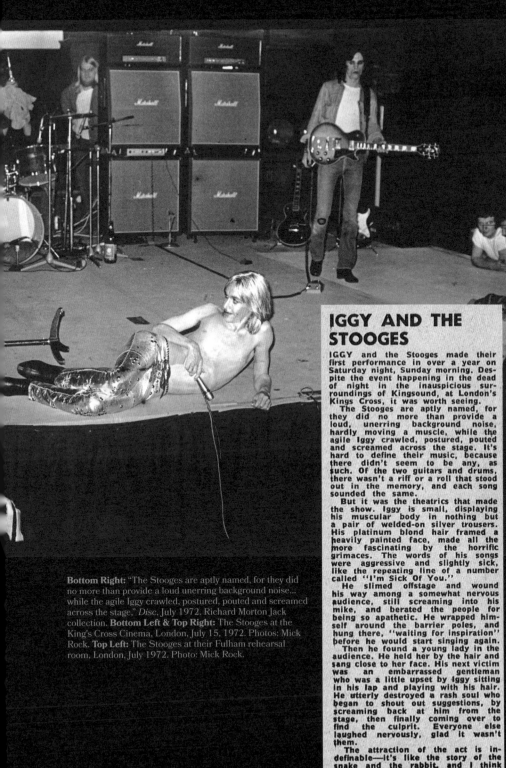

IGGY AND THE STOOGES

IGGY and the Stooges made their first performance in over a year on Saturday night, Sunday morning. Despite the event happening in the dead of night in the inauspicious surroundings of Kingsound, at London's Kings Cross, it was worth seeing.

The Stooges are aptly named, for they did no more than provide a loud, unerring background noise, hardly moving a muscle, while the agile Iggy crawled, postured, pouted and screamed across the stage. It's hard to define their music, because there didn't seem to be any, as such. Of the two guitars and drums, there wasn't a riff or a roll that stood out in the memory, and each song sounded the same.

But it was the theatrics that made the show. Iggy is small, displaying his muscular body in nothing but a pair of welded-on silver trousers. His platinum blond hair framed a heavily painted face, made all the more fascinating by the horrific grimaces. The words of his songs were aggressive and slightly sick, like the repeating line of a number called "I'm Sick Of You."

He slimed offstage and wound his way among a somewhat nervous audience, still screaming into his mike, and berated the people for being so apathetic. He wrapped himself around the barrier poles, and hung there, "waiting for inspiration" before he would start singing again.

Then he found a young lady in the audience. He held her by the hair and sang close to her face. His next victim was an embarrassed gentleman who was a little upset by Iggy sitting in his lap and playing with his hair. He utterly destroyed a rash soul who began to shout out suggestions, by screaming back at him from the stage, then finally coming over to find the culprit. Everyone else laughed nervously, glad it wasn't them.

The attraction of the act is indefinable—it's like the story of the snake and the rabbit, and I think Iggy was more than disgusted that his "rabbits" didn't put up a better fight.—ROSALIND RUSSELL

Bottom Right: "The Stooges are aptly named, for they did no more than provide a loud unerring background noise... while the agile Iggy crawled, postured, pouted and screamed across the stage," *Disc*, July 1972. Richard Morton Jack collection. **Bottom Left & Top Right:** The Stooges at the King's Cross Cinema, London, July 15, 1972. Photos: Mick Rock. **Top Left:** The Stooges at their Fulham rehearsal room, London, July 1972. Photo: Mick Rock.

10. RAW POWER

J: SO WHAT HAPPENED WITH THOSE FIRST SONGS YOU RECORDED?

I: "Gimme Some Skin" was rejected. We did some eight tracks of it, and even a sixteen track of "I Got a Right" with Keith Harwood, the Stones' engineer, at Olympic. But anyway we were writing that stuff, and I took it to DeFries and played it for him, and he just sat there. And again I had to be the one always to go over. It was horrible. By that point I had met a girl who had been on the cover of something called *For Men Only*. She was a centerfold chick. Very, very pretty girl, and through her I met people who could give me drugs. But I would take just a little bit of Ritalin or a little snort of coke at that point. A couple of Valium, but I was probably acting a little wacky when I went over to the management. So again I think probably he waited a little while, while he called Bowie who comes in, "He could do better than that." Someone, maybe the manager, maybe DeFries said, "Why don't you try a classic rock album with a ballad, an up-tempo rocker, and two medium."

So I do remember hearing that, and the other great thing that happened was somewhere along that time, T. Rex played Wembley [March 18, 1972]. Now this may have been even before the other two came over, but James and I went to see T. Rex. We listened to T. Rex in their heyday, listened to a lot of that. Especially with the song "Raw Power." You get a little T. Rex, a little soupçon of earlier Stones, and that first Zep album was out then, the no-nonsense one with "Communication Breakdown." That kinda was his vocabulary, the origins, and he would hate this, the modalities of the original band because "Gimme Danger" is just a fancy way of playing "I Wanna Be Your Dog" [hums the guitar line to "Gimme Danger"]. It's just stretched out more, and he put some filigrees in.

JK: IT'S A STONES-IER TAKE ON...

I: Yeah. So anyway we were doing that. Yeah, nobody was wonderful to me, and then James went, "We need a cook, man!" And then so okay, great. So we hired this cook, and within two meals, James is fucking the cook. And suddenly it's like James has a girlfriend in the house, and the rest of us don't. Everybody noticed. And Bowie would come over and visit us and like y'know..."Let's see what you do if I French kiss." Y'know, just stuff like English boys do, and he and I would go off and have tea at Small's and talk.

J: IS HE LISTENING TO SONGS OR CRITIQUING ANYTHING?

I: No. Earlier when we were at the Royal Gardens, he came over and offered. They said, "David wants to get together." I said, "Well, why not? We'll get together in the coffee shop." So we got together in the coffee shop in the afternoon, and I think I had tea with honey and he sat there eating sugar cubes. And he asked, he said point blank, "So do you want me to produce this album?" And I said, "No thanks because I already have my own vision for it." And he said, "Okay, fine." Just very clean, very cool, and we carried on. At any rate, we started developing this other material, and honestly, we had all the tools we needed to make our art. As usual of course, the business is an entire other thing. I mean this happens to everybody. The Stones

and the Beatles had to call their manager. "I'd like a car." Nobody knew about those things. Nobody knew that you should have an accountant, now that people handle your money, or that you shouldn't sign the first thing you see without legal counsel.

So that was it. I said to Tony or somebody, I said, "I've gotta get outta this house to write the words." I had to get away from the group and their surly ways, so I went to Blake's. I was under pressure. And that was when, between going to the Royal Gardens, sitting under the trees, and sitting in my room at Blake's, usually stoned on something, I finished all the lyrics.

J: CAN YOU TELL ME A LITTLE ABOUT YOUR LYRIC INSPIRATION? WHERE DO THINGS LIKE "I'M A STREET WALKING CHEETAH WITH A HEART FULL OF NAPALM" COME FROM?

I: Well that one was I had a cheetah jacket that I bought, I was staying at the Royal Gardens Hotel with Williamson. And I went down to Kensington Market and I spotted this jacket with a cheetah on the back, and I thought that was perfect for me so I bought it. What I used to do for kicks, I'd never seen such a nice park as Hyde Park. After I started the Stooges, I always walked long distances almost every day because it would give me a rhythm for my thoughts and ideas, but also because it was practice for what I do for fronting a group. You should be good on your feet to do that job. So I was walking around Hyde Park with my cheetah jacket on and my leather pants, and I was kinda cute you know, and it didn't take me long to notice that you know a certain kind of Jaguar saloon cars and Rolls Royces were slowing down as they passed me. So I thought, "oh yeah I get it they think I'm, you know..." So that was kinda where that came from. And the napalm meant anger and also, danger, you know danger to people who hang out with me 'cause I had figured that out that I was like, what do they say? "Mad, bad, and dangerous to know" something like that, you know. So that was the idea and then I'd always liked the song, "Heart Full of Soul," by The Yardbirds.

J: ME TOO.

I: I love to use rock and blues lyrics and certain pieces of American literature as building blocks in lyrics, I've always done that cause it roots the song to common experience if you change it enough you know.

NARCOTICS

Search and Destroy—The War on Drugs

AT a third-floor window of a Lower Manhattan hospital, a team of federal agents huddled behind a battery of cameras. Below them, other agents strolled along the sidewalks, or cruised down Gold Street in unmarked cars. One group waited in a windowless minibus parked across the street. Not far away, another group, posing as an emergency crew, sat under a yellow canvas work tent over the open manhole in which they had set up a communications center. Precisely at 8:40 p.m., two undercover agents drove up Gold Street in a green 1970 Cadillac. They pulled to a stop in the No Parking zone in front of the hospital—and waited.

Minutes later the hidden agents —there were 40 in all—got the word over their short-wave radios: "Suspects are proceeding down Spruce Street, headed for Gold." In the third-floor observation post, one agent cracked to TIME Correspondent James Willwerth, "The Chinese are very punctual." So they were—right on time for the most important narcotics bust this summer.

At 9 p.m., two wary men walked up to the green Cadillac: Kenneth Kankit Huie, 60, self-styled "unofficial mayor of Chinatown," and Tim Lok, 35, known to federal agents as "the General" for his ramrod-stiff posture. The four men—two undercover narcotics agents, and the two "connections" whom they had been trying to nail for four months—wasted no time. The agents opened the trunk of the Cadillac and showed the Chinese the contents of an olive-drab attaché case inside: $200,000 in $50 and $100 bills.

UNDERCOVER AGENTS SHOW HUIE & LOK $200,000 IN TRUNK
In hollowed-out heels, false-bottomed suitcases, cars, girdles and boa constrictors.

Then the General led one of the agents off on a meandering excursion that ended up in a Chinatown sportswear shop. There it was the agent's turn to inspect the wares: a cardboard box packed with 14 plastic bags containing 20 lbs. of pure No. 4 white heroin from Southeast Asia. Street value: $10 million.

The agent and the General then went back toward Gold Street in a taxi, followed in a gray Dodge station wagon by a third Chinese, Guan Chowtok, bringing the heroin. But Guan, owner of the sportswear shop, doubled

back and dropped the heroin in a v[a]cant lot, arriving empty-handed. H[e] seemed worried about police. The age[nt] and Guan argued in the street in fro[nt] of Beekman Hospital for several mi[n]utes, and finally the hesitant Chine[se] agreed to make the deal. The four m[en] piled into the green Cadillac and fo[l]lowed the gray Dodge station wagon [to] a dark, deserted street, under the sha[d]ow of the Brooklyn Bridge. Followi[ng] the General's directions, one undercov[er] agent walked through waist-hi[gh] grass into the vacant lot. Suddenly, [he] knelt down and said loudly: "This is t[he] package; this is the package."

On that signal, the night fairly e[x]ploded with armed men and flashi[ng] lights. Two unmarked cars squealed [to] a stop at opposite ends of the stre[et] blocking the escape routes. Agents wa[v]ing pistols and shotguns sprinted out [of] the shadows from all directions. Hu[ie,] the General and a fourth Chinese acco[m]plice surrendered immediately. Gu[an] jumped into his gray Dodge—and fou[nd] himself staring into the muzzle of a .[45] automatic in the hands of an agent wh[o] was leaning through an open window.

Though last week's Chinatown bu[st] was motion-picture perfect, to U.S. na[r]cotics experts it was another bittersw[eet] element in an increasingly frustratin[g,] not to say disastrous situation. True, t[he] raid was the latest in a number of su[c]cessful skirmishes in what Preside[nt] Nixon describes, more and more pla[u]sibly, as a global "war on drugs." [In] Montreal and Saigon, narcotics office[rs] have recently nabbed some of the b[ig]ger wholesalers. Washington, mea[n-]

DRUGS FOR THE U.S.

CANADA

Montreal

New York

U.S.

San Antonio

Nuevo Laredo

Miami

Haiti

MEXICO

Jamaica

Martinique

PANAMA
(Staging and storage area)

Bogotá

COLOMBIA

Cocaine producers

ECUADOR

BRAZIL

Mau Mau pilots

PERU BOLIVIA

PARAGUAY
Asunción

CHILE

URUGUAY
Montevideo

Buenos Aires

New HQ — U.S. Bureau of Narcotics in South America

ARGENTINA

WEST GERMANY
Munich
FRANCE

ITALY

TURKEY
(Opium producer)

Marseille
(Opium converted to heroin)

Opium and morphine base

SOUTHEAST ASIAN SOURCE

BURMA, LAOS & THAILAND
(Opium producers)

Hong Kong

Bangkok

Singapore

to Panama

U.S.

Pacific Ocean

TIME Map by V. Puglisi

J: AND THE MAGAZINE STORY THAT YOU SAW ABOUT THE WAR ON DRUGS, WITH THE HEADLINE "SEARCH AND DESTROY."

I: Yeah, *Time Magazine*. Yeah, and "Raw Power." I didn't want to tell the story that was in Time Magazine, but you need some connection. How do you connect to other people? And there's a lot to communication. You need the right platform, you need the right position, you need the right influences. You listen to that inchoate sludge of which we were capable in Detroit after *Fun House*, and then you listen to what we were able to come up with in the center of world civilization and rock and roll at the time, and blues even, because y'know we killed our, we ruined our best artists here [in America], and it's evident what happened. It had a lot to do with where we were.

J: DO YOU HAVE ANY TECHNIQUES—I KNOW BOWIE USED WILLIAM BURROUGHS' CUT-UP TECHNIQUE—DO YOU HAVE ANY LYRIC WRITING TECHNIQUES OR DOES IT JUST FLOW INTO YOU?

I: It pops into my brain usually as twisted versions of things that I've loved. Except in the use of one writer, and that's William Burroughs. For some reason his, I think it was Martin Amis who was trying to have a dig with him and said, "other great writers can write a story but Burroughs is a writer of bits—but what bits!" Wow. And so those bits are perfect to put into punky-rock songs, so at certain points in the *Raw Power* era I was referring to characters, and also up through The Idiot and Lust for Life—those three albums—characters from his novels to act in the song as avatars of myself.

In other words, Johnny Yen, you'll find him in *The Ticket That Exploded* and is the venetian green boy who practices the love con on people. And I thought, "hey it sounds like my job!" So I thought I could sing about being him, but not being him, I could sing about him and bring him into the song and kind of identify with him. It's a little way into the song so things aren't so clumsy, and then once you get into the song you're singing about the personal experience. It was Bowie's idea to use that title ("Lust for Life"), and I thought what that means to me is that because I actually enjoy food, sex, intoxication, travel, and freedom—because of those lusts, I'm gonna get into trouble [laughs] which is what I sing about. But again, I know it, here's why, and he gave me a way in there. So you also hear him in "Baby" on The Idiot album. I'm singing about the "street of chance" where the chance is always slim or none. That's directly outta one of his books. He just summed up the alternative position right there. "We're walkin' down a street of chance, the chance is always slim or none. And the intentions of society are unjust." And that's a very good critique, I thought.

Right now I think of him all the time since this trouble started some years ago in the Middle East, and toward the end of his writing career he had these two things he'd harp on: one was Hassan Sabbah, the old man of the mountain who could send a network of assassins all over the world and you couldn't escape 'em, and he could activate them with his control at will and he controlled them with the promise that they would go to paradise after carrying out the assassination themselves ...does that sound familiar?

Left: The inspiration for "Search and Destroy," an article in *Time Magazine*, September 1972. Jeff Gold collection.

J: HOW WILD IS THAT?

I: That was one of his common visions. And he had this other vision, which is really coming to pass now it's just, "Ya know we could just have anybody watch you, you could do a do it yourself border. All you need, you just get a trailer, park it by the road, and get a couple guys with the guns and you got a border. He sees this stuff in a flash and doesn't go anywhere with it. But I always felt he was like a, you know a psychic TV, outta control with the horizontal broken or something. The picture keeps coming in and out and you can't make sense of it but there was pith there.

J: HE CERTAINLY GOT IT.

I: So I was real interested in just his whole thing, and some of the other songs on *Raw Power*- "Penetration," and the song "Raw Power," itself and "Death Trip,"—were inspired by that way of thinking, you know? But "the beat of the living dead" in "Raw Power," that's straight from *Night of the Living Dead*[43]—that's one of my favorite movies—and I thought, "If you're gonna be in the entertainment business—which music is unfortunately a branch of, that's all it is, a branch in the entertainment business—then you're gonna have to respect the fact that the majority exists." And that's that. And when you're young and you're not afraid to just come out, so the idea was, "well, I'll dance to your beat." So those are the sorta things that were going on in my mind. That's where some of that stuff comes from.

J: WERE THERE OTHER AUTHORS OR BOOKS THAT WERE INFLUENTIAL TO YOU?

I: Jim Morrison's book of poetry *The Lords and the New Creatures* was something I had and I thought it was a pretty good book. Some people say it was "faux-etry" but I don't think so, I thought it was pretty damn good. There's a poem in *The Lords and the New Creatures*, about the saying of "modern life is a journey by car," and the passengers occasionally, their seats begin to stink too much, they occasionally try to change seats or even change cars, but you can never really get out of the car. Later I found out a lot of Morrison's stuff came out of, a lot of his best lines come out of French films [laughs] so he went to UCLA film school so suddenly you've got your faux films in there etc.

43) Classic 1968 George A. Romero movie that helped to reintroduce the zombie as a staple of the horror genre.

J: OK, LET'S GO BACK TO LONDON. TELL ME ABUT THE PICTURE WITH LOU REED AND DAVID BOWIE (JULY 16, 1972) AT THE DORCHESTER HOTEL.

I: What happened was that was a press junket that [*Creem* magazine writer] Dave Marsh was included in. And he found me, somehow either on his own or possibly through a groupie/record buyer named Sterling Silver who was an eccentric Anglophile and always seemed to know where all the bands were staying. Sterling was one of these guys. He liked our group, and I think he may have given, somehow he had the phone number at our house in England. He was like a queen. I don't know if he was really a real queen.

So anyway, Dave either called me or sent word. Either I spoke to him or got word. "Hey, I'm coming to this thing that they've invited me to at the Dorchester Hotel at such-and-such a time." And it was a big problem for me 'cause I was like, "Oh no, I don't wanna go to one of those things! I don't wanna see all those people! I hate this sorta crap, but Dave is gonna think I don't like him if I don't go." So my conscience got the better of me, and I put on my T. Rex t-shirt and my jeans and I walked from Fulham, all the entire length of Kensington, and then the whole park to the Dorchester, right? Never been, and went up to the room and knocked on the door. Boy, you coulda heard a pin drop. "Well hello! Iggy, do come in!"

J: DID YOU HAVE ANY RELATIONSHIP WITH LOU OTHER THAN PASSING?

I: Yes, the relationship with Lou was a fascinating hilarity to begin with. Lou, like all of us, when we met the people from England, we were in a stage of our careers—but he's in another level than me, I'm not comparing myself—where we're trying to figure out, "How am I gonna make a fuckin' living and how can we even make it pay enough to do this stuff?" So I think it was DeFries or maybe Dennis Katz at RCA who told Lou, "Listen, you've got extra songs. We've got this guy Iggy. Their songs are no good. They love you." So I think they brokered the idea. Again, somebody came to me, I think it was Tony DeFries that said, "James." He called me James. "James, Lou would like to play you some songs for your new record," and I was like, "No! No, I don't wanna." But I wasn't gonna offend. He was my hero, so I wasn't gonna offend him and also the way I am usually is even if I don't feel something, if I'm in a certain situation where I should consider options, I will consider 'em.

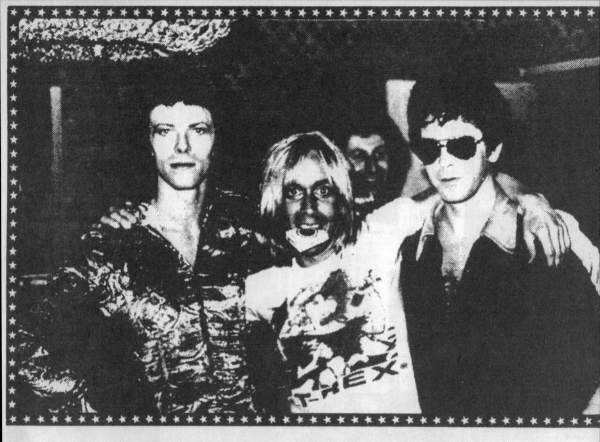

LONDON. DAVID BOWIE/IGGYPOP/LOU REED). DURING
THE RECORDING OF THE LEGENDARY RAW POWER.

Above: David Bowie, Iggy Pop, and Lou Reed at London's Dorchester Hotel, July 16, 1972. From *Iguana #3*, Jeff Gold

J: YOU'VE SAID THAT YOU NEVER KNOW WHEN A GOOD IDEA'S COMING.

I: So Lou came up with his guitar, and he and I sat down in these '70s-style continental chairs on either side of a very small wooden table in the Warwick hotel in Tony DeFries' suite, and Lou either ordered or summoned or brought a bottle of Johnny Walker, I think it was Red Label, and sat it down on the table, and he started playing [hums song and laughs] every fuckin' song and slugging the Johnny Walker. And I was being polite and he was being polite and he's just a very, very sensitive person, and then what happened was he tried to get up at the end of it. He had been sitting there not moving, hunched over a guitar. Drank the majority of the bottle, not the whole bottle, but the majority of it straight, and then he stood up and went headfirst into the table. Had a big gash in his forehead, and they cleaned him up and he left and I never did any of the songs.

JK: DO YOU RECOLLECT ANY OF THE ONES HE PLAYED?

I: No. It was all, it was like Chuck Berry on Valium, y'know? There was a later time, a few years later when I went over to his apartment. I visited him once and he gave me some Valium and I took too much of it and I went to see a show. I think it was the New York Dolls at the Felt Forum, and I ran into the backstage door and I got a big gash in the same spot. In the same spot! Y'know he came to our show, and kinda watched us. It was one of the nicest things in my life where I don't know if he was bitter or just telling the truth, but he gave this famous interview saying, "Well, the thing with Iggy...Don't call Iggy 'music.' Iggy's Iggy, but Iggy's not music." Which is sorta Williamson's line, which is fine. Alright, whatever. And then he said, "Iggy's sweet, but he's really stupid." But y'know later when we did the *Raw Power* reissue, I didn't ask him. Somebody must have solicited a blurb, and he said, "This is really good music by guys that did not want to make stilted music," and he said, "Their vocals are wonderful." So I felt good because it's somebody I look up to as a great artist.

J: IN MARCH 1972, DEFRIES GETS YOU SIGNED TO COLUMBIA RECORDS. I'VE HEARD ABOUT THIS MEETING YOU HAD WITH [COLUMBIA PRESIDENT] CLIVE DAVIS SUPPOSEDLY WHERE...

I: Yeah. Where I sang, "The Shadow Of Your Smile," and I wore a thrift store tux and a little dollar sign rhinestone.

J: IS THE MEETING JUST KIND OF A FORMALITY AT THAT POINT?

I: Yeah, it was a formality, and I've heard this thing about the conversation: "Will you record nice songs like Paul Simon?" I don't know if that's true. I think basically he just, look...you've been in the biz. You know the game. It's the standard move. "Fuck. I missed out on David Bowie. Okay, I'll look better if I could say I'm in with that crowd. We've got their other artist, and we're still in. Maybe I could get him when the renewal comes up." That's all that was. "I'll steal him from RCA if he gets unhappy!"

J: AND YOU GO INTO THE STUDIO FINALLY, TO MAKE THE RECORD. EVERYBODY'S NOT GETTING ALONG, BUT EVERYBODY'S GETTING ALONG FOR THE SAKE OF THE PAYCHECK.

I: Yeah, and we're making a record, and we know it's good and all that.

J: AND DOES IT GO FAIRLY SMOOTHLY?

I: Fuck yeah! It went fast, it went smooth. Everyone, every song was done with between eight and thirteen tracks used, period. Everything was recorded properly for those times, with the possible exception of Ron played a little fast and loose with the bass, and so he had some twanging and some overtones in there that kinda made it hard to get a bottom on. I personally think the reason the mix sounded like that is very simple. Anytime you work with a musician or a producer, except for me, what you're gonna get on the next thing they do is seventy-five percent exactly like the last thing they did. If you listen to the records Bowie was making up until *Raw Power*, you'll find the last two records, same decisions. Small on the bottom because for the kind of music he was making, it would make it easier to get it on the radio.

J: AND HE ALSO DID IT REALLY FAST, OR YOU GUYS DID IT REALLY FAST WITHOUT ANY TIME TO REFLECT I WOULD IMAGINE.

I: We got the takes done really great. Everything sounded great in the studio. When we got outta the studio, I began to panic and worry that they just, it wasn't musical enough 'cause it's not that musical. There are two gears to Williamson, what he has to say musically. One is, "you better look out because I'm thinking about kicking your ass," and the other gear is, "I'm kicking your ass, and it feels good!!" Those are his gears. So I did everything I could as a writer. When the music gets simple or a chord is strummed for more than a millisecond, that's me. So in other words, "Search and Destroy," I'll sing it. Here's what he had [hums guitar line]. Those two parts, and as I said, I deferred to this guy all along until it was time. My turn. You're now the coup de grâce, dude. No, you didn't write it in your fucking bedroom. He brought that much from his bedroom. We were in RG Jones eight-track studio in Wimbledon, and I said, "No. Give me a fanfare, something that tells the people what's about to come."

Right: First page of Iggy's contract with CBS Records. Jeff Gold collection.

CBS RECORDS

A Division of Columbia Broadcasting System, Inc.
51 West 52 Street
New York, N.Y. 10019
(212) 765-4321

RECEIVED

FEB 27 1984

Ans'd............

(1) 72-132 FG

Sharon

Ace Somers March 1, 1972

Gem Music Productions Ltd.
252/260 Regent Street
London W 1, England

Mitchell, Silverberg & Knupp
9600 Sunset Blvd.
Los Angeles Calif — Letter dated 6/11/7_

Dear Sirs:

The following, when signed by you and by us, will constitute the agreement between you and us:

1. This agreement shall commence as of the date March 20, 1972, and shall continue in force for a term which shall consist of an initial period of one year from such date, and the additional period or periods, if any, by which such term may be extended through our exercise of one or more of the options granted to us herein.

2. a) During the term of this agreement you will furnish the services of

JAMES OSTERBERG, professionally known as "IGGY POP"

(hereinafter referred to as the "Artist") to perform at recording sessions in the United Kingdom at such times and places and at such studios as shall be designated by you. In the event you desire that the Artist perform hereunder at recording sessions in the United States, the times and places of such recording sessions shall be mutually agreed upon, and the studios at which such recording sessions will be held shall be mutually agreed upon; provided, however, that to the extent of union requirements, our facilities and the services of our engineers will be utilized. The musical compositions to be recorded shall be designated by you. The lyrics of such compositions shall be subject to our approval in respect of advocacy of illegal activity, patent offensiveness and defamation, which approval shall not be unreasonably withheld. Each master recording made hereunder shall be subject to our approval as technically satisfactory for the manufacture and sale of phonograph records. During each contract period of the term hereof, the Artist will record technically satisfactory master recordings which shall constitute a minimum of two albums. Additional master recordings, during each such contract period, shall be recorded by the Artist by mutual agreement between you and us. No recording shall be made by unauthorized dubbing.

b) (1) During the term of this agreement, we hereby agree to engage you, and you agree to accept such engagement to furnish the services of such person or persons as shall be designated by you, and approved by us as hereinafter provided, as an independent producer(s) (hereinafter referred to as the "Producers") to render services as Producers, as necessary, in

(1) (i) hereof, applicable with respect to such compositions, shall be at the rate of 4%, and (ii) such royalties, less any unrecouped advances, shall be paid in aggregate directly to the Producers. Notwithstanding anything that may be contained to the contrary in this paragraph 24, we shall not exercise such option unless we shall have given you written notice of your failure to fulfill your obligations hereunder and you shall have failed, within a period of thirty days after the date of our such notice to you, to cure your legal and/or financial incapacity to so fulfill your obligations hereunder.

Very truly yours,

ACCEPTED & AGREED TO: CBS RECORDS, A Division of
GEM MUSIC PRODUCTIONS LTD. Columbia Broadcasting System, In

_____ By_____
 President Administrative Vice President

In order to induce CBS Records to enter into the foregoing agreement, the undersigned assents to the execution of the foregoing agreement and agrees to be bound by the terms and conditions thereof including, without limiting the generality of the foregoing, any provisions of such agreement relating to the undersigned in any way, directly or indirectly, performances to be rendered thereunder by the undersigned and restrictions imposed upon the undersigned in accordance with the provisions of such agreement. The under-signed hereby acknowledges that CBS Records shall be under no obligation to make any payments whatsoever to the undersigned, except as specifically provided in sub-paragraph____ ____and paragraph 23 of such agreement, for or in connection with the services rendered by the undersigned and/or the fulfillment of the undersigned's obligations pursuant to and in accordance with the foregoing agreement.

X_____
 JAMES OSTERBERG

In order to induce CBS Records to enter into the foregoing agreement, each of the undersigned jointly and severally assents to the execution of the fore-going agreement and agrees jointly and severally to be bound by the terms and conditions thereof including, without limiting the generality of the fore-going, any provisions of such agreement relating to the undersigned in any

And immediately, I'll say this. With a snide look on his face, he came up with the Stones-like [hums guitar line], so now we had that in the middle. It makes this thing a little more palatable, and then I said, "Okay, now go to your second change." And we go into the second change. I said, "Now, give me your same change as the second change, but in half time." 'Cause the idea was don't mess up the guy's flow, but where is the part that opens up and lets in the people? And that's the chorus. He did that. I said, "Okay, great. Now between those two parts," I said, "You're in a car going fast. I want you to down-shift to first and then come up through the gears until you punch that chorus."

And he immediately did it, and that's how I worked with him on that. On "Raw Power" he had all the active parts, but the part where it just goes to the, "Everybody's telling me what to do," that's me, and it gives him an outro. "I Need Somebody," he had just the two riffs. "Could you please? Could you just play, have one part where you just play the chords?" "Okay." And then when he played the chords, I could sing a melody because it's really hard to sing melody to somebody who's riffing intricately all the time. "Pretty Face is Going to Hell," I said, "Could we play one of these five-chord—." We made a five-chord blues out of it. It was just supposed to be all this monotony, intricate monotony.

"Gimme Danger" was his riff, and then that bridge was gonna be the chorus but didn't make any sense. It was just this monotonous riff and then this violent outburst, so I got him to put in the just real simple stuff. Play the chords as block chords as an intro quickly, then half-time them, then play the half-timed one as an outro like in soul music where you don't repeat four verses. You repeat four verses, you repeat two verses, a bridge, and an outro so the song goes some-where. That was very helpful to those songs. He doesn't wanna admit I did that. That's okay.

So those are the ones I contributed to the most, and then the others were more melodies and arrangements for him. On one hand, I was getting deranged. Starting to take dope again on and off but I didn't have a habit yet, and it just never sounded trebly enough, never sounded bass-y enough. I tried doing Beach Boy backup harmonies to it at one point. *Rough Power* has those. Yeah, I tried everything, and finally it was true.

J: SO YOU GUYS EVENTUALLY GET SICK OF ENGLAND, COME BACK TO LA.

I: I don't know how that happened. I came alone on a plane. I was sick 'cause I thought, "Well I might as well finish the last of my rocks," and I was on to Miami. Straight to Miami 'cause I wanted to go to Miami and meet my parents for a little while and give them a vacation to show that I had made it in rock and roll, and I sat behind George Hamilton, who was travel-ing with Marc Bolan. It was George Hamilton and Marc Bolan together on the plane having a great time, and here behind, I'm like sick as a dog. And I came down here and went to the Americana Hotel and didn't take any dope for quite a while after that. Just took some Valium and gained about ten pounds and got a tan, had my parents down. That was before I went to Detroit to meet up with those people and strip nude and y'know. I finally went to Detroit with the tapes under my arm with DeFries, and I went down to WABX and played 'em [on the radio] while nude, thinking maybe that would help. So at that point they were like, "This guy's deranged. Let's call in Bowie."

Left: Last page of Iggy's contract with CBS Records. They signed him, but not the other Stooges. March 1, 1972. Jeff Gold collection.

Above: The only known photograph from the *Raw Power* sessions; CBS Studios, London, September/October 1972. Robert Matheu collection. **Right:** *Cream* (UK), October 1972. Jon Savage collection.

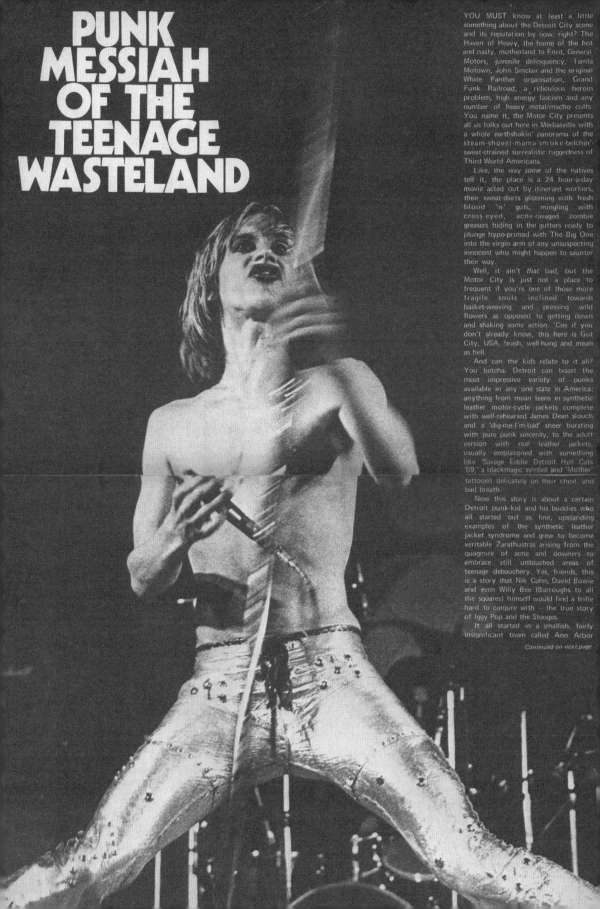

PUNK MESSIAH OF THE TEENAGE WASTELAND

YOU MUST know at least a little something about the Detroit City scene and its reputation by now, right? The Haven of Heavy, the home of the hot and nasty, motherland to Ford, General Motors, juvenile delinquency, Tamla Motown, John Sinclair and the original White Panther organisation, Grand Funk Railroad, a ridiculous heroin problem, high energy fascism and any number of heavy metal/macho cults. You name it, the Motor City presents all us folks out here in Mediasville with a whole earthshakin' panorama of the steam-shovel-mama-smoke-belchin'-sweat-strained surrealistic ruggedness of Third World Americana.

Like, the way *some* of the natives tell it, the place is a 24 hour-a-day movie acted out by itinerant workers, their sweat-shirts glistening with fresh blood 'n' guts, mingling with cross-eyed, acne-ravaged zombie greasers hiding in the gutters ready to plunge hypo-primed with The Big One into the virgin arm of any unsuspecting innocent who might happen to saunter their way.

Well, it ain't *that* bad, but the Motor City is just not a place to frequent if you're one of those more fragile souls inclined towards basket-weaving and pressing wild flowers as opposed to getting down and shaking some action. 'Cos if you don't already know, this here is Gut City, USA, brash, well-hung and mean as hell.

And can the kids relate to it all? You betcha. Detroit can boast the most impressive variety of punks available in any one state in America; anything from mean teens in synthetic leather motor-cycle jackets complete with well-rehearsed James Dean slouch and a 'dig-me-I'm-bad' sneer bursting with pure punk sincerity, to the adult version with real leather jackets, usually emblazoned with something like 'Savage Eddie Detroit Hell Cats '69,' a blackmagic symbol and 'Mother' tattooed delicately on their chest, and bad breath.

Now this story is about a certain Detroit punk-kid and his buddies who all started out as fine, upstanding examples of the synthetic leather jacket syndrome and grew to become veritable Zarathustras arising from the quagmire of acne and downers to embrace still untouched areas of teenage debauchery. Yes, friends, this is a story that Nik Cohn, David Bowie and even Willy Bee (Burroughs to all the squares) himself would find a trifle hard to conjure with — the true story of Iggy Pop and the Stooges.

It all started in a smallish, fairly insignificant town called Ann Arbor

Continued on next page

J: YOU GO TO LA AND THAT'S WHERE YOU MIX IT, RIGHT?

I: I go to LA. At this point, it was typical with MainMan that they would starve or strand the various bands. Any of the band members. It had to be either Ian Hunter, Bowie, or me to get decent treatment. At some point, Williamson showed up and then later for the other two, and I was staying at the Beverly Hills Hotel. Again, either they thought I was Miss Iggy Pop, or MainMan might'a called and said, "Yes, get a room for Miss Iggy Pop." Y'know like playing little games. So I was staying there...

J: THAT'S WHEN YOU GUYS MIXED THE RECORD AT WESTERN?

I: Yeah exactly, and James met Cyrinda Foxe as Bowie had her starring in the "Jean Genie" video and was about to dump her. And he did the best he could, and I was just pissed when it came off because my ego was hurt that they put "Mixed by David Bowie" in bigger letters than they put "Produced by Iggy Pop." And y'know that's stupid. That was stupid, but I'm the only guy in the band that finally decided later that was stupid!

J: BUT YOU KNOW WHAT? I'M GONNA GIVE YOU THE OTHER SIDE OF IT. I'M A DAVID BOWIE FANATIC AT THE TIME. I VAGUELY KNOW WHO IGGY AND THE STOOGES ARE. BUT DAVID BOWIE MIXED THIS RECORD? I GOTTA GO SEE THEM AT THE WHISKY! I GOTTA BUY THAT RECORD!

I: Yeah! He helped! Of course he helped call us to people's attention.

JK: I ALWAYS FELT THAT IT WAS A MIX THAT WAS SUPPOSED TO GET RADIO PLAY.

I: Yeah, it probably would. Yeah, sounds like Bowie. Fine.

J: SO WERE YOU HAPPY WITH THE MIX AT THE TIME?

I: No, we all freaked out. The whole idea of the group, the only person in that group who ever wanted to be vulnerable was me. The rest of 'em want to be world dominators, so it needed to sound incredibly loud and heavy. So everybody hated it. I hated it too because I realized it just sounded wimpy to me, but mainly because it sounded good if somebody had a really good stereo system and you turned it to ten. Then it would sound like what we liked, and that's also because we were deranged.

J: THE ALBUM WAS RECORDED SEPTEMBER-OCTOBER 1972, BUT NOT RELEASED UNTIL FEBRUARY 1973.

I: Yeah, and we sailed on, and just like with the first Stooges album, we weren't in on anything until they just sent us one in LA. And there it was "Iggy & the Stooges."

J: THAT JUST HAPPENED...

I: Yeah, nobody told us. Nobody told me.

Right: *Raw Power.* Jeff Gold collection.

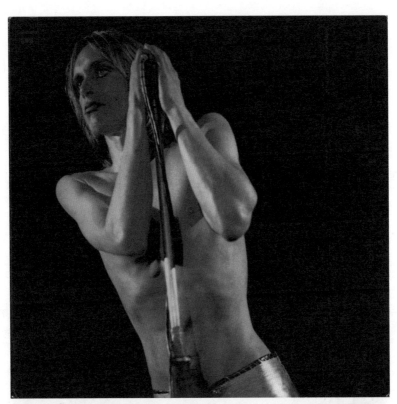

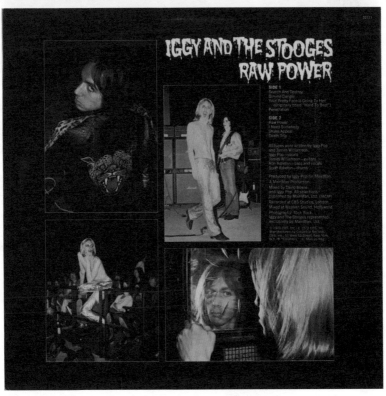

DETR
ROCK C

Detroit, founded in 1736 by a turncoat (to both sides) halfbreed Indian named Quazimodo from the Kuitee tribe which dwelled circa 1670-1777 on the shores of Lake Michigan, was one of the most famous colonies of the French-Indian War. It was here that Admiral Hackensack suffered a defeat at the hands of the bear-trappers which was so ignominious it can't even be found in most history books, and it was here that fort Belle Isle was erected against the wilds. That Belle Isle has since become a rather slezoid amusement park frequented by tourists, deviates, sharpies trying to sell the Chrysler Building to tourists, and hippies intent on finding a secluded place to squat and crack their Boone's Farm bottles (marijuana is virtually legal in Michigan now, but you can still go to the slam for boozing if under 18), should not discourage the serious student of the history of this most storied zone of the United States.

Nothing much happened in Detroit for the next hundred years or so except that it was a terminal for the underground railroad (immediately upon arriving from Dixie and detraining from the subways the ex-slaves were put to work in some of the many textile factories proliferating in the area at the time) and Horace Mann once stubbed his toe here in the middle of a whirlwind lecture tour delivering speeches against the evils of using lead pencils instead of pens in schools (*"They have erasers,"* he said, *"enabling undiligent students to cheat with just that much more impunity."*) But in 1896 Henry Ford invented the automobile, and from then on things began to pop and hop in this part of the country.

Soon the textile industry was all but rendered obsolete, as not only blacks but many whites went to work in the automobile factories springing up in Detroit and environs like so many artichokes. And what was the success of these great centers of industrial enterprise? They choked off art and created a population of slaving zombies, good only for production of precision parts and reproduction of future generations to produce the camshafts and generators of Tomorrow. No art or culture at all was heard from from Detroit for many years, except for the annual Detroit Dog Show and the phenomenal success of a sculptor named Belvedere who applied his genius along more economically feasible lines and went into the aluminum siding business.

It was not until the late 1950's, in fact, that some rumblings of a new generation began to be heard from Motown. At first it was from the blacks who make up 60-70% of the city. They began to put out records by groups with names like the Supremes, the Temptations, the Contours, etc., which sold records in the many of millions and made them much money. Unfortunately, they did it all within the framework of Capitalist honko society, and it didn't amount to a hill of afterbirths in the end. It was plastic. It was prepackaged. It was not art of the *People!*

But hold on. A change was a-comin'. There was a new generation of young whites around Detroit and Ann Arbor who had finally decided that, much as they dug reproducing, they did not want to *produce* one more hubcap! No! And all their lives they had been hearing metallic, mechanical rhythms in the din from the factories that destroys the hearing of everyone in this city just as the pollution of the water in the Detroit River forces them all, much as they might resist, into drinking alcoholic beverages every day and night.

So the young white kids picked up this sheet-metal din, hearing how close it was to the rattly clankings of rock 'n' roll, and turned it into a *new* brand of rock 'n' roll which was more metallic, heavy, crazed and mechanical than anything heard on the face of the earth in 6,000 years of Western history.

Once these young white kids got their scene going there was no stopping them. Detroit became the Mecca of rock 'n' roll, capturing the attention of the media and drawing musicians from all over the country to its incredibly healthy scene. Such dynamite groups as Big Brother and the Holding Company, the Grateful Dead (though they actually hailed from Ann Arbor), the Honeycombs, Lothar & the Hand People, Tommy the Truck, Totall Crudd, and Agememnon & the Handjobs were spawned from these rich, rippling headwaters. But that was only the first generation. The second and third generations were yet to come.

MITCH RYDER

The second generation's ultimate personification and personality was Mitch Ryder, *nee* Bill Bradshinkel, who set fire to Detroit and America and in fact most of the free world of the early Sixties with his dynamite group the Detroit Wheels.

Mitch Ryder did a lot for Detroit. For one thing he looked like Bianca Jagger before that became fashionable, so everybody thought he was a fag in spite of all the *Hit Parader* articles showing him at home toting his kids around on his head saying things like *"Booker T. is the living end."*

So he looked weird enough to be ahead of his time even if the only way he was ahead of his time was in the way his singles made a Little Richard rock 'n' roll revival half a decade before that fad bloomed. He put Detroit on the map as soon as everybody from El Cajon to Bangor got down to trying to figure out if he was really singing *"Everytime she kiss me she kiss me like a* fuck" or what. We had a lot of fun with that.

Ryder never was too smart though. If you wanted to get really racist (and there's no way to avoid it if you live in Detroit) you could say that he was the supreme evidence of miscreant culture which results when Polacks take acid, even though he wasn't pure Polack himself — fact, he had some nergroid blood back in there someplace. Just dig that nose. It's pure, organic. He didn't earn that off a fist.

But Mitch blew it anyway. His trademark was his scream, a pure whitehot searing falsetto wail that rocked from Little Richard to the psyched out primal scream to every queen in tubes' range, and he worked it stone down and on out. Mitch screamed till his face turned beet red a month of one nighters, since he never did really learn how to sing, and by '72 he'd blown the whole shot. More operations on that throat than we can count, finally had to relinquish his new band, Detroit, to some warbly third string shag cut Rod Stewart, and I saw Mitch hanging out backstage at Alice Cooper concerts. Well, rock 'n' roll ain't supposed to last forever, right?

MC5

No it ain't. Detroit knows that, that's why everybody's sitting on their mitts and keeping their traps shut now even though they hit the white light glare late in the Sixties. Long about .68, 69, some of 70 it was, and Detroit was a THREAT. The MC5 weren't so original, but they took the moves and the noise to a whole 'nother level. So good that most folks who seen 'em back when still can't be completely rational about

Lester Bangs' overview of the Michigan scene. *Phonograph Record Magazine*, December 1972. Jeff Gold collection.

it. Go to the Rainbow Peoples' Party House in Ann Arbor and they'll toke you down and show you that 3 minute film of the Five in everybody's Golden Era, all in color and produced and shot by Leni Sinclair, who held down the Hill Street fort while John was in jail those long months. They probably wouldn't speak to the MC5 now, but the flick is a nice reminder of a time when so many feets were ready to *move* to *get down with it* and blast the continent out of space to neon. Pure punk shit, but one of the best fantasies of the decade. So now the Five are trying to come back from Europe and they're still the best rock 'n' roll band in the world after the Stones. And they may make it yet. But everybody's jaded enough that not much is riding on them or any other chips these days.

The Rainbow Party, *nee* White Panthers and Trans-Love Energies, carries on, digging bomb craters in protest of the war all over Ann Arbor and then planting dope in 'em. Biggest one's right in front of their house at 1520 Hill Street and it's got several dozen fine healthy young marijuana stalks standing straight and proud in it. Groovy. At this writing, possession of grass in Ann Arbor is a five dollar fine. Everybody's happy. Call the Rainbow House at certain times of the day, though, and whichever of the faithful answers the phone may be somewhat less than totally helpful: *"uhhh, ruhhhh, whusssss goin' awn, mayun?"* A friend called there the other night and told me that the phone was answered by a stoned out nineteen year old voice: *"This is the police. Don't call here."* Paranoia daze. But John Sinclair is a nice guy, and still the most accessible counter cult politico in America. I was sitting in his office when somebody mentioned a past proposal of mine to hold a *Put John Back* festival, and he just laughed. What a good egg. Just get Rainbow Folks to show you the Five film, where he's captured for all time in the wings of a '68 concert, rearing back and lunging low blowing his guts out through a sax of which couldn't possibly have had more technical comprehension than sheer moxie and irresistible spirit urge. In other words, he lived all our punk fantasies better than most of us, and should be respected for that. So did the Five, come to think of it. The last time I saw them, Wayne Kramer was talking about *"anarchy of the mind."* Roll dem bones.

THE STOOGES

The Stooges wuz a horse of a totally different color. I can recall even from my own South Cal remove them frenetic days of late 68 and early 69, when the word was out across the land that the Five was gonna ball your mama and shake your brains right out your left eardrum and destroy Imperial Amerika while they wuz at it. It was a mighty big offer and you either bought the whole souffle or you sneered and spat from word go. It helped if you lived in the Midwest of course, in fact the closer to the hysteria you were the more sense it all made, and if you wuz somewhat removed you might have a tendency to look on it all as, ah, just *wretched excess.* Jive ass postures. Eric Eneman's cover article in *Rolling Stone* did much to spread the myth and make people suspicious, because Mr. E. portrayed the Five (in his enthusiasm) as even more punky than they in fact were, and it's true that they may have been the punkiest band in history:

"Toke down, mothafucka!"

"The Five are all deeply into William Burroughs..."

"Chicks live with the Five, and besides sewing all their clothes make some of the most destroy barbecued ribs you ever chomped into..."

But that's not fair, judging the madness of them days by the dialectics of the 70s. The Five have never been appreciated on the mass level they always deserved, and when the mania failed to fly that far out of Michigan on any mass level, and John Sinclair wound up in the pen on bogus dope charges, and the band themselves hooked up with future Rolling Stonette Jon Landau to try and make themselves as respectable as any Young Rascals, it became clear that a new derangement was in order. The Michigan scene was still strong and crazed enough to support one, and the Stooges were the inevitable result.

Iggy Stooge is one of the alltime geniuses of rock 'n' roll. He has said that he taught his band every note they played on their two Elektra albums. It may be true. Musical instruments sprawled all over the Stooges' Ann Arbor den, if you happened to be hanging out and it was time to jam Iggy would propel you towards the closest available axe, vibes or guitar or bongos, or whatever, and you would *play* no matter who or what or where, and it would work.

The Stooges worked because they had no program but total chaos, they didn't care, and it was time for that. Their two albums are teenage classics:

It's 1969 okay
War Across the USA
Last year I was 21
I didn't have a lot of fun
Now I'm gonna be 22
I say my my and a boo hoo

Now we're gonna be face to face
And I'll lay right down in my favorite place

No fun to be alone
Freaked out for another day

A thousand lights
Look at you

See that calf
Down on 'er back
She got a TV eye on me

I've been hurt
But I don't care
I've been dirt
And I don't care
'Cause I'm learning'...

It was sheer poetry for the interrupted dry grope of growing up in the Sixties. The Five had poetry too, but at their best they were always solidly anthemic, in the tradition:

left, Iggy Stooge; upper right, the MC5 defy America; middle left, mboy dukes; center right, the Stooges; left, Mitch Ryder; above, Sinclair. Photos by Charles Auringer, Lisa Gottlieb, and Leni ir, courtesy of Creem Magazine.

BY LESTER BANGS

PLEASE TURN TO THE NEXT PAGE, BROTHER........

J: WERE YOU FEELING ANY LOVE FROM ANYBODY AT COLUMBIA, OR YOU'RE JUST DEALING WITH MAINMAN?

I: Yeah, Steve Harris.

J: RIGHT, WHO HAD BEEN AT ELEKTRA.

I: It's the same promo dude, which to me, look. There's nothing sillier in the '70s than the specter of all the various heavily bearded guys from various ethnic areas who bought buckskin fringe jackets, [Laughing] and he would walk around town smiling at everybody! Like, "Hey everybody!" With his buckskin fringe jacket on, and I loved him. I loved him. So nice, but he also was totally, he'd be nice like he was nice to a cat. Like, "Heyyyyy! Heyyyyyyyy!" But I really like him y'know, and then he'd write those, "Let's sit down and think about what we can write about you guys." And all the silly shit he would write. So yeah, he was the only one, but I mean I knew he had, it was obvious he had no power. Our album release party was on the top of the Hyatt House...

J: IN LA.

I: Yeah, and because Clive Davis, I believe because he didn't want anything to do with us. First, I have to explain to you, you've got a little thing in here by the Petite Bon Bons. I was getting cultivated by various theatrical gay people on the West Coast because they'd known about my outré ways and everything, and I liked people like that. So they were these sorta camp artists, and they said, "You need decorations for your party!" So I hired 'em! Somebody had given me, given four hundred dollars, and so they put little plastic pieces of shit around. You had to walk from the top elevator, you had to walk upstairs, so guess who CBS sends? Goddard Lieberson! [The erudite longtime president of Columbia Records, who specialized in Broadway show cast recordings.][44] Yeah!

And Goddard Lieberson comes up there. It was the first time I'd ever seen a properly cut Savile Row suit. And I was like, "Ooh, I like him!" He came, and Robert Plant came. They happened to be in the hotel, and just about nobody else came. And there it was. They record was playing, and Lieberson sorta stood there and looked around. I think he had been kicked upstairs by the time, and it was like, "Well, we have to send somebody." "Well okay. I'll go to this thing." So that was the party.

44) Lieberson (b 1911 - d 1977) was a composer and the legendary president of Columbia Records (1956-71, 1973-5), famed for his production of original cast recordings of Broadway musicals including *My Fair Lady*.

Right: Columbia Records advertisement, 1973. Richard Morton Jack collection.

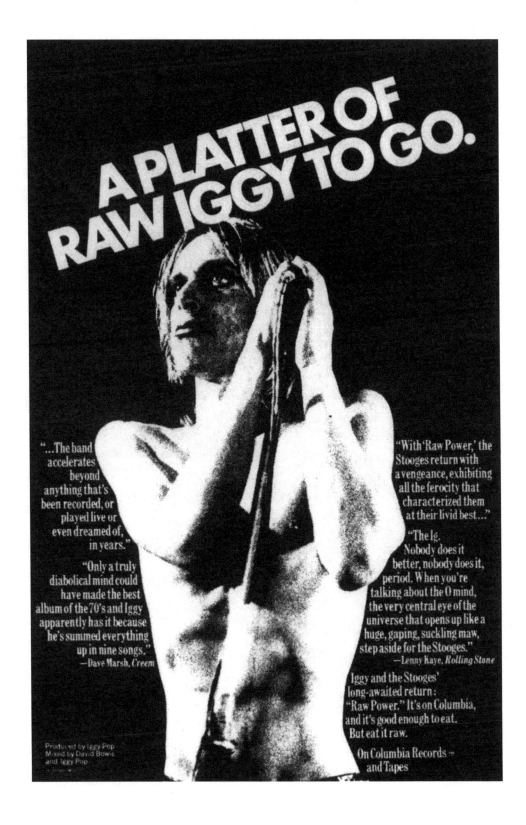

A PLATTER OF RAW IGGY TO GO.

"...The band accelerates beyond anything that's been recorded, or played live or even dreamed of, in years."

"Only a truly diabolical mind could have made the best album of the 70's and Iggy apparently has it because he's summed everything up in nine songs."
—Dave Marsh, *Creem*

"With 'Raw Power,' the Stooges return with a vengeance, exhibiting all the ferocity that characterized them at their livid best..."

"The Ig. Nobody does it better, nobody does it, period. When you're talking about the O mind, the very central eye of the universe that opens up like a huge, gaping, suckling maw, step aside for the Stooges."
—Lenny Kaye, *Rolling Stone*

Iggy and the Stooges' long-awaited return: "Raw Power." It's on Columbia, and it's good enough to eat. But eat it raw.

On Columbia Records — and Tapes

Produced by Iggy Pop
Mixed by David Bowie
and Iggy Pop

‹ 269 ›

LES PETITES BON BONS
present the
IGGY POP
SCHOOL OF TEENAGE
Rebellion

BEARER OF THIS CERTIFICATE HAS RECEIVED THE HIGHEST SCORES IN.........................

- ROCK N ROLL GROUPIEISM
- JUVENILE DELINQUENCY
- PARTY CRASHING
- UNBRIDLED SICKNESS AND PERVERSION
- CRIMES AGAINST SOCIAL DECENCY

bearer _____ bon bon _____

COLUMBIA
® "Columbia," Marcas Reg.

MONO
3:26

45 RP
Radi
Station
4-458
JZSP 15
℗ 1973 CE
Publish
Mainman
(ASCA

NOT
FOR SA

IGGY AND THE STOOGES
SEARCH AND DESTROY
– I. Pop - J. Williamson –
Produced by: Iggy Pop
For MainMan
A MainMan Production

1973 THE YEAR OF THE STOOGES

Confession of An Energy Addict

It started out innocently enough. I turned on my FM radio one day in the fall of 1969, and the sound that came rumbling out of that tiny speaker kicked me in the face and cemented my feet to the floor. The room was filled with screaming guitar and barbarian drums, and though I couldn't quite make out the words, the lead singer was so aggressively whining that there was no mistaking his intentions . . .

When this insanity finally subsided, a confused and dumbfounded dj returned to announce that was "the, uh, Stooges, doing something called 'I Wanna Be Your Dog.'" I'm not sure I understand what they mean by that . . . "

But I understood, and went to see this band the first chance I got. They didn't let me down. They were even more rude in person than on record, with three musicians dressed in black leather, who just stood there and summoned forth wave after wave of crushing sound, and a lead singer who did things I'd never seen done on a public stage before.

This frail human (whose name was later revealed to be Iggy Pop) was clad only in a pair of tattered cut-off jeans and elbow length silver lamé gloves, with demented eyes like that painting in your grandmother's house that looks straight through you no matter where in the room you're standing. He prowled the stage with animal grace, twisting his body in nameless contortions while taunting the audience with laughing abuse and silent contempt. He dove kicking and cursing headfirst into the audience, and every eye in the house followed him into the void.

After that, I rushed out and bought a copy of their first album, (produced by John Cale of Velvet Underground fame), and then proceeded to make an utter nuisance of myself over it. I flooded the local radio station with requests for the record, and I'd slip it on at parties and watch with glee as people were driven out of the room in droves. My friends didn't like it much—"too loud," said one. "They can't play their instruments," piped up another. But this didn't bother me, because I knew that The Stooges could do something to me that no other band could do, and that was enough.

A year later, The Stooges released yet another album, *Funhouse*, which was even more raw and manic than the first. I could no longer contain my wild-eyed ravings to an inner circle of friends, and began stopping complete strangers in the street to assault their sensibilities with tales of Iggy's latest exploits. (One of the pinnacles was the TV special from

the Cincinnati Pop Festival, where Iggy smeared peanut butter all over his body and ran out into the crowd supported on a sea of hands.)

My friends avoided me like the black plague, and kids at school would point me out as I walked down the hall, laughing among themselves when they thought I wasn't looking. I *saw,* but it didn't matter, because I had learned of the existence of others like me. I heard of one somewhere in Minnesota, one in Philadelphia, and a couple were rumored to be in or around Delaware, Ohio. The time for revenge would be soon enough.

What was it about these Stooges that sent the adrenalin rushing at such a fast and furious pace? Nothing that you could hear: that was the mistake my friends had made. You can't hear the Stooges, you have to feel them. Those brutal guitars, Iggy's frenzied screams: it was like plugging into all that dark energy that our parents warned us about when we first discovered rock n roll. It was *alive,* and it filled your body so full of life it could make you dizzy. All I knew was that I needed it, couldn't do without it, and that nothing else really mattered. I was possessed.

Top Left: Bobby Bon Bon of the artist group Les Petites Bon Bons printed this in his *Egozine* #1 Fanzine. Iggy: "I was getting cultivated by various theatrical gay people on the West Coast because they'd known about my outré ways." Jeff Gold collection. **Top Right:** "Search and Destroy" promotional 45. **Bottom:** From *Playback,* Columbia Records' in-house publication, 1973. Jeff Gold collection.

BIOGRAPHY FROM COLUMBIA RECORDS ℗

IGGY AND THE STOOGES

One day in 1968, a young musician in Ann Arbor, Michigan had an idea. He wanted to form a band; not just any band, mind you, but the band. He wanted a band that would be completely unlike anything anyone had ever heard. He wanted a band that could grow along with its audience, a band that could start in his head and grow freely from there.

He'd been in other bands, of course, but none of them came even remotely close to fulfilling the need for a music that was his own. He'd drummed with a frat-rock outfit called the Iguanas, and later with a blues band called the Prime Movers. He'd even gone the obligatory apprenticeship route under blues great Sam Lay (of the original Paul Butterfield Blues Band) on Chicago's South Side. But the kind of music he wanted to play was decidedly not the blues, and bore very little resemblance to rock and roll, at least as people knew it in 1968.

Together with friends Ron Asheton, Scott Asheton and Dave Alexander, he set about the task of committing his ideas to reality. Scott had never played drums before, Dave's grasp of the bass was barely elementary, and Ron's history as a bassist didn't exactly qualify him to be playing lead guitar. But it didn't matter. It was better that way, in fact, because the members of the band had very little in the way of programmed musical knowledge to interfere with the ideas they'd be called upon to execute. The leader of the band called himself Iggy Pop, and he called the band the Stooges.

When they first began to appear publicly, people didn't quite know what to make of them. The band's approach matched its crudeness with an unnerving volume, a wall of non-stop noise which appeared to have little form and even less direction. They didn't have any songs in those days, just primitive sound patterns and occasional chord changes which served as an aural backdrop for Iggy's performance.

Press and Public Information / 51 West 52 Street, New York, New York 10019 / Telephone (212) 7654321

Above: Columbia Records biography from *Raw Power* press kit. Johan Kugelberg collection.

"The only reason I never listen to RAW
POWER is because of the fucking mix
by David Bowie. I think he destroyed
that album. That was a damn good album.
In its raw...studio turn-ups were 100%
better than what Bowie did to that al-
bum. I think that he fucked it over.
He fucked us over. That's how I feel.
I don't listen to it because I get so
pissed off when I hear it...no bass,
no drums...and what it could've been -
what it should 've been. It just pisses
me off. I broke 2 copies already. Just
so pissed off at how we were jacked by
that whole fucking trip. Ha ".

-the incredible Ron Asheton(por-
tion of interview from next D.D.)

THE TOP OF POP

Ray & Iggy: A Pair of Rock Aristocrats

By LILLIAN ROXON

Iggy Pop (▼) and Ray
Davies (⟶) are a pair
of rock personalities
who care only about
what's going on with
their performances,
live or recorded.

IN THEIR OWN ways, they are both aristo-
crats. Last week belonged to both of them,
with Ray Davies and the Kinks playing two
colleges in the New York area and Iggy Pop and the
Stooges making their long awaited comeback in De-
troit.

Neither of them much cares about anything except
what goes up on that stage or what goes down
on that record.

They're really embarrassed by small talk, appalled
by pushy groupies; terribly talented, terribly nice,
terribly unhappy; shot through with all kinds of
self-destructive urges; much too lonely for people
so charming; very involved with the music, and,
at the same time time, the show that goes with
it. They're much more alike than either would want
to think.

Ray, of course, is a lot older, a lot more refined.
He's been in the business a long time and somehow,
despite all the anguish of being underestimated for
years (and still being underestimated now), able to
function pretty effectively. In fact, he's probably
in better shape now than he's ever been.

We sat at his hotel and talked (in the old days,
he never talked to anyone, and he told me the
reason he seems to come to life on stage is because
it's true that only there does he experience any
real happiness. He needs to feel the crowd's emotion
and protectiveness. "It's the one place they can't
get you, isn't it?" he says, looking at me a little
helplessly.

They? Who are they? Well, of course, that
remarkably revealing face tells me, I couldn't be
expected to know. They are the promoters and man-
agers and lawyers from the past who latched on and.
a long sigh here, wouldn't let go, and—he doesn't
want to talk about it, he just wants it taken for
granted there are not too many truly lovely human
beings in show business. Or out of it, actually, be-
cause when I ask him about the friends he has outside
it, he sighs again, looks down at his incredibly thin
and graceful hands, and says there are not too many
of those, either.

He is easily amused, and even loving in that
amusement, by anyone who is a little bizarre or
extraordinary, but not, I can sense, when they start
clutching. Then he withdraws, in politely concealed
but nevertheless very real terror. He's the last person
you'd ever take a liberty with.

Personally, I happen to think he's a genius, and
I genuinely envy people who have still ahead of
them the pleasure of his recorded works. But there's
no way to tell him that. Stu Ginsburg, who handles
his press and has watched him through two days
of interviews, says Ray has no idea, no idea at
all.

Perhaps the old lawsuits and what he calls "people
fighting over us" have forced him to give thoughts
about the genius part of his life the lowest priority.
He doesn't believe he's the only rock star who's
unhappy and worried. He wakes up scared, he says,
but he knows that, say, Rod Stewart or Marc Bolan
are worried men, too.

In London, he lives in a terraced house with
an office built into it, in a deliberately unpretentious
part of town. It carries the entire responsibility
of the Kinks' fortunes, professional and financial.

He reportedly signed with RCA for a lot of money,
but you get the feeling a lot of it was spent buying
the band's way out of problems.

He obviously doesn't have a lot of money, because

then he shouldn't have to be begging quite so hard
for backing for a film version of his LP, "Everybody's
in Showbiz," which is one of the best LPs ever,
and says more about music in the last 10 years
than any I can think of.

He's very seriously into film, especially documen-
taries. The first time his gloomy though elegant
face lights up is when I tell him every one of
his songs is like those documentaries they used to
show during World War II.

"Some Mother's Son" from his rock opera "Ar-
thur" is a documentary in music. A lot of people
didn't respond to that song. "Too much truth," he
says. "You need to lie a bit." Was "Lola" a true
song, then, about a real transvestite? "It was based,"
he says, surprisingly, "on someone I met in Hamburg
and someone I met in London."

A lot of his songs are about real people and,
because they're documentaries, they're inevitably sad
as well as real, and sometimes he'd rather never
have the person guess the song is about him. But
I think, like a novelist, every song he writes is
a little about himself.

There is something very Edwardian about his
style. The romantic soul of an Edwardian poet and

the cold, hard but compassionate eye of a wartime
newsreel cameraman. If he weren't so gentle and
intelligent and beautiful and bitter, it could be very
scary, that combination.

Now, Iggy is something else. Ray, for instance,
likes to write songs so revealing that utter strangers
feel they know him intimately. Iggy likes to reveal
literally. I have never seen him play any way but
bare chested, usually in silver pants and boots and
maybe with silver paint on the skin, but in Detroit,
merely in tiny tights (he has the body of a muscular
12-year-old) worn under red bikini brief and an
old embroidered fringed piano shawl tied into an
insane little sarong.

He's got rid of a lot of the glitter because he
did it first years ago and too many people have
copied it, and he's into something a little bit more
substantial than glitter rock, anyway.

His songs are enraged screams. The new album
is called "Raw Power," which explains it well. The
songs have names like "Gimme Danger," "Death Trip"
and "Search and Destroy." When he sings that he
needs somebody, he's like a bull on the rampage.
It's real teenage fury.

Ray Davies has moments when he comes on like
the master of ceremonies, in "Cabaret," all decadent
sweetness with the anger barely controlled, but con-
trolled all the same. Iggy is the opposite, there
is nothing he wouldn't do on stage. He'll do the
first stage rape one of these days, and don't think
he doesn't get close. In Detroit, he leaped into the
audience like a tiger, snatched a little girl out of
her seat, and embraced her with unbelievable passion.
Then, at the very moment the music stopped, as
if on cue, he threw her away from him with a
gesture so brutal it had to be real.

Unlike Alice, it's not an act. Parents who won't
let their younger kids go to Alice Cooper shows
would probably love Iggy. They shouldn't, except
that the little girl loved it all, even that rejection
at the end. He only spat at the audience twice
that night. Generally, I sit fairly far back to escape
that and the beer throwing.

Ray Davies does it with so much more style.
Iggy has been known to rip hair, leap half-naked
into the laps of business man in pinstriped suits
and, well, worse. Nevertheless, it's a real show and
not a fake, and it always surprised me to see him
after it, being so tiny and boyish and cheerful.

In Detroit, and he's been out of the business
for a while now, though it was a stunning perform-
ance ecstatically received, he was surly after the
show and arrogant, pushing admirers away with con-
tempt and irritation. Actually, I dug it. It was more
honest, I think it's the honesty that make Iggy
and Davies aristocrats.

Top: Ron Asheton complains about David Bowie's *Raw Power* mix in *Denim Delinquent*, Spring 1974, Johan Kugelberg collection. **Bottom:** *Leisure*, April 1973, Jeff Gold collection. **Right:** *Phonograph Record Magazine*, March 1973, Jeff

**RAW POWER
THE STOOGES
COLUMBIA**

By Ben Edmonds

Phonograph Record Reviews

One of my earliest and most special memories is of sitting in front of a big television on a very early weekend morning watching a supposedly harmless Betty Boop cartoon. It was one of those wonderful pre-World War II productions – lots of detail and meticulous shading, as was the custom in the days before assembly-line simplicity took over and people were led to believe that color is compensation for craftsmanship – and it featured our gal Betty (that feisty little bubble with monstrous eyes and a head roughly three times the size of the rest of her body) in the clutches of a typically surrealist situation. She was seated at a table in a nightclub straight out of the Thirties, trying desperately to maintain her composure as spectral figures fluttered transparently in the air performing various acts of mime and choreography.

Suddenly one of the apparitions, done up in blackface with a towel slung over his shoulder like a boot-lick waiter, lunged across the screen in spasms of elasticity. His face contorted in five different directions at once, and out of his hollow mouth came the words of *Saint James Infirmary* to the backing of an ominous piano and wailing chorus. The voice belonged to none other than Cab Calloway (check your parents' record rack for further identification), and it was so beautifully bizarre and perfectly out-of-step that it sent shivers rolling down my spine. It was like nothing I had ever seen before. It terrified me, but the terror paled in the face of a fascination which froze me in my seat.

This new album by the Stooges – aptly titled RAW POWER – had the very same effect on me the first time I heard it. It's like your first hard-on or the first time you get *really* high: an experience so overpowering that it forces new definition for even the most familiar things. At a time when all our heroes seemed destined to disappoint us, Iggy and the boys have returned from the dead with a feet-first assault that will leave its footprints in the center of your skull. There's no doubt in my mind that this is the album of the year, and it's only March.

I'm strongly tempted to say that this is the first Stooges album for non-Stooges fans, but while that's true, it tells only a small part of this story. RAW POWER doesn't go too far out of its way to do anything radically different, in fact it's *exactly* what the Stooges have always done. It's a clarification and sharpening up of a previously fuzzy picture.

The band remains essentially the same. Iggy's up front, ably assisted by drum murderer Scott Asheton and his brother Ron. The former lead guitarist, Ron has been switched to bass, which is the instrument he started out on in a mid-Sixties Detroit band called the Chosen Few. Another refugee from that band (and the Stooges' rhythm guitarist in the last few months before they broke up in 1971), James Williamson, now handles all the guitarwork. Even if you've been a Stooges follower since the beginning, you're gonna have a hard time believing that this is the band you've steadfastly loved even though your closest friends threatened to disown you whenever you brought out one of their albums.

Over and above the consistency of Iggy's vision, the man who makes the biggest difference on RAW POWER is James Williamson. Ron Asheton's guitar was the focal point of the last Stooges incarnation, but he fell back so often on fuzz-tone and wah-wah excesses that the more timid ears of America were forced to the very threshold of pain. If you had even the faintest glimmer of what the band was about, you realized that Asheton's guitarwork was the product of a wholly original consciousness and was therefore outside the grasp of any normal frame of reference. But it was severely unconventional, demanding to be taken only on its own terms.

James, however, plays more direct and, in the end, more effective lines, with the kind of head for simply accessible riffs that made the music of the Troggs and early Stones so appealing. But far from being a mere technician, James' guitar gives vent to intensely *emotional* outbursts. Where most guitarists seem preoccupied with the grace and precision of their steps, James' main concern would seem to be that those steps take him somewhere, no matter how rough or harsh the movement.

The improvement in the music may be directly traced to the role James plays in the internal functionings of the band. Where Iggy probably had to teach the songs on the first two albums to the band note-for-note, I get the feeling that the tunes on RAW POWER were the product of a head-on collision of ideas between James and the Ig. In James, Iggy seems to have found the perfect catalyst for his ideas: RAW POWER sounds exactly like you always thought a Stooges album *should*.

These songs are easily the finest the Stooges have ever come up with. *Search & Destroy* is the best of an incredible lot, with more power and drive than any *three* johnny-come-latelys heavy metal ensembles. James' guitar cuts and slashes unmercifully, pushing the song through its paces at a speed that borders on pure frenzy, providing a powerfully persuasive backdrop for the Ig's screaming assertion that he's the "*runaway child of the nuclear A-bomb.*" This very well could've been the song the Yardbirds performed in *Blow-Up*, but as things stand it'll probably wind up being the soundtrack for the new *Blackboard Jungle.*

But that's only the beginning. What's the farthest-out thing that you could imagine the Stooges doing: recording a rock opera, or maybe having a hit single? Well, how about the Stooges using...*acoustic guitars?* Yet, it's *true!* That's right, the tyrants of electricity have taken up the tools so proudly claimed by folksingers everywhere, but what they do with the instrument may lay any such associations permanently to rest.

Gimme Danger reminds you instantly of *Play With Fire*, but where Jagger's warning was veiled in implication, Iggy is issuing an open invitation to a dark and definitely sinister rendez-vous. The scene is set with double-tracked acoustic guitars which move like the rhythm of fog, and later augmented by an electric lead that swoops and dives like John Cale's violin on those early Velvet Underground sides. Iggy cocoons his way through lines like "*Nothing in my dreams, just some ugly memories/Kiss me like the ocean breeze,*" with a voice so effective in its beckoning fever that this is not so much a song as a trance.

The same electric/ acoustic guitar inter working is featured on *I Need Somebody*, a song which comes off like blues from the Rue Morgue. This is the Stooges at their most degrade, the voice from the very bottom of the pit. More than music, the Stooges have always been capable of creating their own environment, of suspending any outside reality for as long as they held the stage. The degree of their success is the degree to which they can make the listener part of that environment. With *I Need Somebody*, — and the album as a whole — the integration is almost instantaneous. Their wall of sound has become four walls.

I Need Somebody also marks the first time an extended track has ranked among the most dynamic on a Stooges album; its predecessors (WE WILL FALL, FUNHOUSE, and L.A. BLUES) being only marginally successful and occasionally even blatant throwaways. Stooge music was founded on the repetition of absurdly simple riffs, and the sophistication of this music comes not from any imposed complexity, but from the tension created by the arrangement of *many* simple figures. Arrangement/motion, and movement is the reason that long Stooges cuts now work. The two other extended tracks *Hard To Beat* (which, I believe, evolved from an earlier Iggy composition called *My Pretty Face Is Going To Hell*) and *Death Trip* – are manic adrenalin-rushes whose energy is structured according to the same principles.

The short & snappy numbers (which are all to be found on side one, the three extended cuts being neatly grouped on the second side) offer an equally solid fist in the stomach. *Shake Appeal* is a standard Stooges vehicle, a little something familiar to ease you into the record. It's the same kind of flat repetition as *Down On The Street* but when James tears loose with a machete run toward the end, you know something different is happening this time around. The promise is kept by RAW POWER, which lives up to its title in every respect. The Stooges are as raw here as any band you've ever heard, but in their more experienced hands this roughness is manipulated so well that it's almost graceful.

Much has been made of the supposed fact that David Bowie produced RAW POWER, but subsequent research has revealed the true producer to be Mr. Iggy Pop, with Bowie taking credit for the post-recording mixdowns. Between the two, they have captured a sound which is clear enough to be heard but savage enough to be real. This balanced definition has increased the dramatic potential of the music tremendously; the difference in dimension is that between a film on the screen and a play at the theater. Alice Cooper may have temporarily conned the commercial market on menace, but the kind of terror that the Stooges now specialize in is as directly mainstream that I'm thoroughly convinced that they will at long last be recognized for what they really are: the only true originals.

The improvement in the rhythm section is nothing short of remarkable. Drummer Scott Asheton never poked much of a threat to Keith Moon or Mitch Mitchell, but his natural crudeness is employed to maximum advantage here. He's recorded like primitive jungle drums – strong though distant – and you can almost hear barbarians pounding out the message on hollow logs from somewhere out in the darkness. Ron Asheton is the steadiest bassist they've ever had. His bass orientation keeps things on solid ground, while his guitarist's head leads him to fill all the right holes as a base for James Williamson's guitar.

When he was faced with the responsibility of holding the band together, Iggy's vocals often left a lot to be desired. He sometimes sounded more like a frustrated cow-puncher on *Raw Hide* (screaming and cursing to keep the cattle moving in the desired direction) than the singer of a rock and roll band. And while he hasn't yet developed into the kind of vocalist that your parents could feel comfortable with, he's definitely become a master of vocal *attitude*. His face changes with each song, but there can be no mistaking who he is. It's all Iggy Pop.

From the beginning, Iggy was working out of a concept which no other rock and roll band has ever dreamed of. In forming the band he consciously sought out non-musicians with little or no experience, on the thought that the Stooges would be a band which would grow with its audience. He started out with blank slates, writing only as the inspiration dictated and the audience demanded. RAW POWER finds the Stooges at last perfectly eye-to-eye with that mass teenage consciousness, and once that connection is made, look for the energy that's pumped back into the band to function as fuel for a music which will make even this album look like Harry Chapin by comparison.

And there's no way that the connection can fail to be made. A friend with whom I would do frequent radio shows in Los Angeles told me about how he'd bring Stooges albums into various stations he's worked at along the line, and how he'd invariably find that the other DJs felt compelled to scribble such expletives as "*dogshit!*" across the album covers in bold magic marker. Well, RAW POWER is going to force all those smug airwave-squatters (and the rest of the hip intelligentsia for that matter), to eat the dogshit and come up smiling. They may not like it, but they won't be able to avoid it.

I have a vision of a new America. Pre-teen kids, acting on top-secret messages from transistor radios which only they can understand, will be unleashed as an army of mini-zombies hell-bent on wreaking mayhem, destruction and worse. They'll turn on their meek Marin County parents and leave them choking on organic vegetables as they watch their Volkswagen campers offered as flaming sacrifice to rock and roll. In L.A. they'll leave their disk record executive parents floating face-down in their peace symbol-shaped swimming pools. Even Kim Fowley will be forced into hiding in the face of such an onslaught, leaving a farewell message to the effect that he's off on an infallible talent-seeking tour of Zanzibar. And what will these kids do once they've enslaved the entire nation? Nothing. Absolutely nothing. They'll just yawn and go home, turn on the TV to the station that programs only re-runs and commercials, and put on RAW POWER. Real loud.

The demigod of high-energy apocalypse: Iggy Pop. Photo by Richard Creamer

At the Torreyson Drive House, 1973.

11. DEATH TRIP

J: AND THEN YOU GET PUT IN THIS HOUSE ON TORREYSON DRIVE WITH [MAINMAN STAFFER AND PHOTOGRAPHER] LEEE BLACK CHILDERS.

I: Yeah, actually we found the house. I was looking around for places to stay, and as I told James later, what happened was very simply that I got used to a certain lifestyle [laughs], and all the sudden I'm walking the flats of Hollywood imagining myself in like one of those rentals at like Franklin and La Brea. No thank you! So I thought, "Well, I think we need a realtor here," and Williamson is very good at petty things. "Well, we'll just get a realtor and find somebody! Okay!" And he somehow hooked up with this woman, and on her list of homes was this place up on the corner of Torreyson Drive.

J: AND LEEE BLACK CHILDERS IS INSTALLED AS YOUR MINDER ESSENTIALLY?

I: Exactly, which we all hated. I didn't hate him. I just hated having a minder and having to kinda live up all the time.

J: AND THIS PLACE BECOMES THIS LEGENDARY PARTY HOUSE? RODNEY GIRLS AND...

I: I guess. There were Rodney girls, but they were sweet little Rodney girls.[45] They would just, the first time they all came over they just kinda sat on the sofa all together, quiet.

J: AND ARE YOU GUYS GETTING PRETTY STRUNG OUT?

I: Not at first. It happened gradually, and different ones of us met different bad people. I met a bad chick named Johanna that said, "It will be really great. Sex would be better if we had some heroin." And James met a guy named Jackie who is a heroin dealer who he became tight with. We both knew a black guy we met at the Whisky named Johnny who was an ex-Marine heroin dealer who just dealt us a lotta dope. There was me and him doing that more, but not all the time. Intermittently. Scott less. And James was living with Cyrinda in that house, so again it was kinda him with the girl. He's got the chick and we're kinda the other way, and he's starting to act different. The stage clothes that he got at that time and the stuff, the sarong and the fly costume, that was a guy that he pushed me to get together with named Bill Whitten who later designed "the glove."

J: THE MICHAEL JACKSON GLOVE?

I: Yeah, Bill Whitten made that glove, the one that's being auctioned. It's been seized from some Saudi prince and they're gonna auction it. Yeah, so James was going full attack and Bill wanted to fuck me, so we got a deal!

J: I MEAN THAT SPACE OUTFIT OF JAMES' IS THE WEIRDEST THING FOR A GUY SO CONCERNED WITH COMING OFF MACHO.

I: Exactly. Well that's how he is. He'll decide, "Okay! Well okay. If that's the thing." Exactly.

45) Rodney Bingenheimer (b 1947): Los Angeles based DJ and scenester who ran THE LA teenage glam hang out, Rodney Bingenheimer's English Disco between 1972 and 1974.

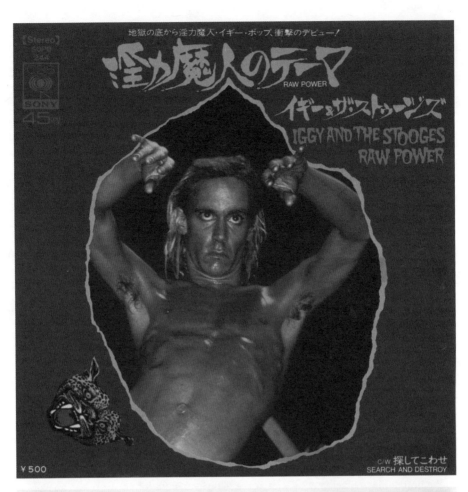

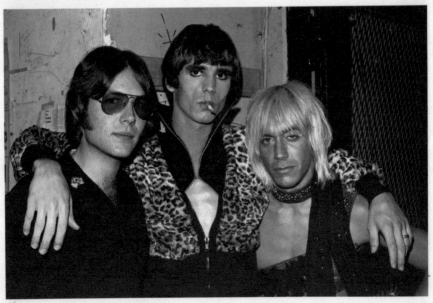

J: SO THE *RAW POWER* ALBUM COMES OUT IN EARLY 1973, AND YOU PLAY THE FIRST GIG WITH BOB SHEFF, ACTUALLY, HIS ONE GIG.

I: I called Bob. A lot of it was like, "People have bigger bands, and they have keyboards!" It was that stupid. All you needed was the four fuckin' people.

J: MAKING A LOT OF NOISE.

I: Yeah.

J: I JUST LOVE THIS JAPANESE PICTURE SLEEVE.

I: Yeah, that's during that time. That picture is from the Ford Auditorium gig that DeFries booked for us. We played two gigs in America for him.

Top Left: Japanese *Raw Power* single, 1973. Ben Blackwell collection. **Bottom Left:** Ron Asheton, James Williamson, Iggy. Max's Kansas City, 1973. Photo: Danny Fields.

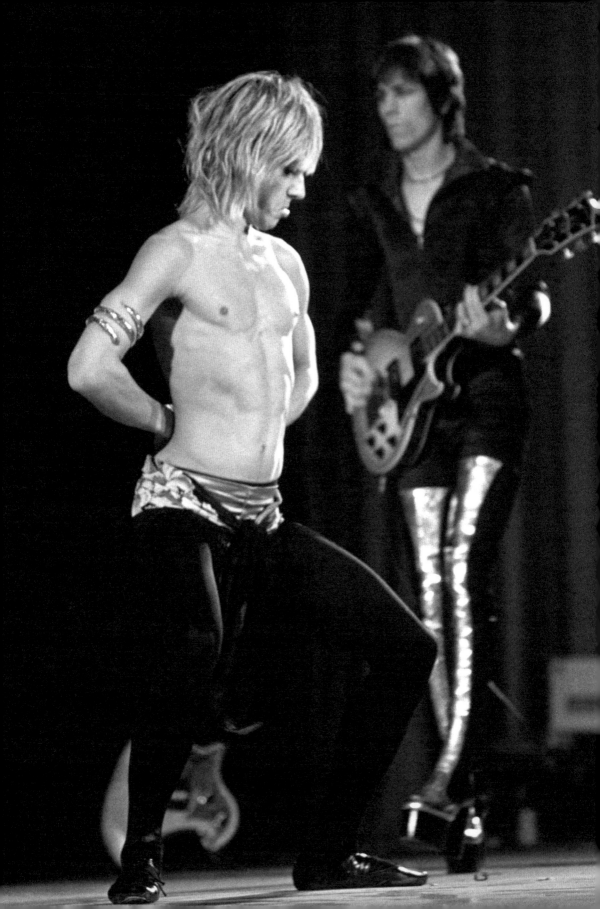

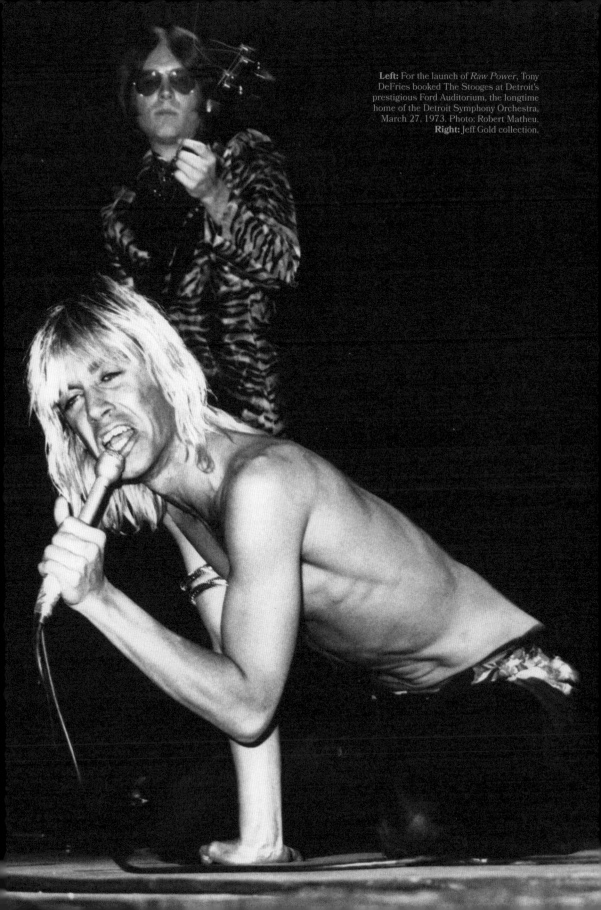

Left: For the launch of *Raw Power*, Tony DeFries booked The Stooges at Detroit's prestigious Ford Auditorium, the longtime home of the Detroit Symphony Orchestra, March 27, 1973. Photo: Robert Matheu. **Right:** Jeff Gold collection.

J: THAT SHOW AT FORD AUDITORIUM IN DETROIT WAS MARCH 27, 1973. WILLIAMSON'S GOT HIS MICK RONSON RIG, AND SUPPOSEDLY AT THE AFTER-PARTY WILLIAMSON GETS INTO AN ARGUMENT WITH DEFRIES THAT ENDS WITH DEFRIES SAYING, "HE'S GONE OR YOU'RE GONE."

I: Probably. I don't remember it happening in Detroit. I remember them telling me back at the house. I just thought, "To hell with it. I'm not ready to just get kicked out in the street right now for this snotty guy." So Williamson left and took with him "Gimmie Some Skin," "I Got a Right," "I'm Sick of You", "Tight Pants" and some other stuff. The other stuff that's come out since hadn't been written yet. And he fended for himself with some help from junkies and bootleggers and different friends and hated us for it ever since. We tried one gig in Chicago [June 15, 1973] with this sort of guy who had, as Kim Fowley said, "the personality of a shoe salesman." Tornado Turner, a guy who could play anything you showed him to play on a guitar. I didn't really feel that, and my instinct was, "Keep moving forward."

And at the same time, DeFries came to have a meeting with me, and he took me out in his limo for a ride around the area and he says to me, "James, I think what we need to do, we're going to take you back to New York, and you will star in a theatrical production as Peter Pan." And I looked at him and I said, "Don't tell me! Don't you get it? I'm not Peter Pan. I'm Charles Manson!" 'Cause again that was me trying to be reasonable. I was like, "Okay, I get it. The band's not working out. They want me to go into theatre? Well I'll try it, but only if I'm not... Peter Pan would be the kiss of death!"

So that was it. I was thrown out of the house with the whole band. But if you check the reviews, Tony Ingrassia mounted a production of DeFries' bullshit starring Cherry Vanilla. They did do Broadway. One day. Closed with the worst reviews probably in the history of, y'know worse than in *The Producers*. Worse! And so yeah, did I do the right thing long term by not letting him? Because he woulda taken me there and made it into something horrible. He had the clique forming around him with these freaks who felt like, "Oh we get it! We get the Bowie thing now!" And [Bowie's wife] Angie was like that. "Yeah! I get it now!" And, "We're just all these wild," and it was embarrassing the shit outta Bowie later.

J: NOW THIS PHOTO—IS THIS AT THE WHISKY? JAMES WILLIAMSON HAS REJOINED BY THAT POINT.

I: The Whisky. The two guys in front who are the most fucked up are the guys who have to do the actual physical work, and we're the two guys at all times who were the most totally committed to the insane romanticism, to the Quixote aspect of the group. Here you have the three little birds sitting on the fence. The vulture, that's James, the magpie, that's Ron, he love to gossip and chat. And [new keyboardist] Scott Thurston. Just imitates whatever he hears and plays along, and that's what I see. They're sitting on the fence and these two guys in the front are taking the hard knocks.

J: YOU AND SCOTT.

I: But what makes the picture amazing, it's me and Scott around the eyes. For all of how James tries with teasing his hair and the Darth Vader thing and his little little pout, it's these guys in front.

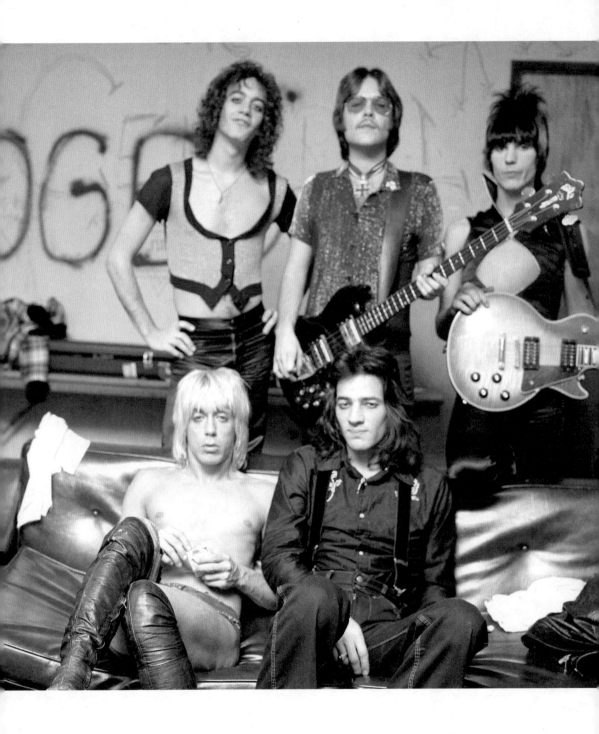

Above: In the infamous dressing room at Hollywood's Whisky A Go-Go, 1973. (L-R) Sitting: Iggy, Scott Asheton. Standing: Scott Thurston, Ron Asheton, James Williamson. Photo: Richard Creamer. Robert Matheu collection.

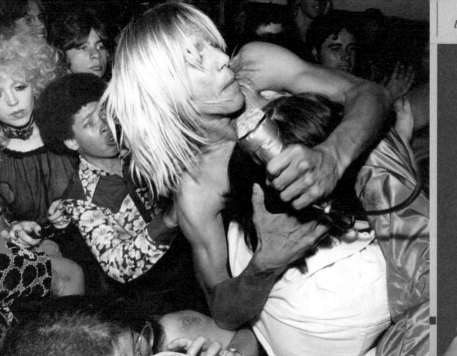

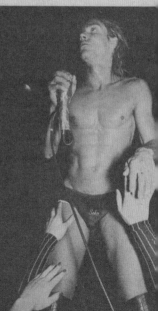

"I didn't go anyplace
because I was kept on a chain"

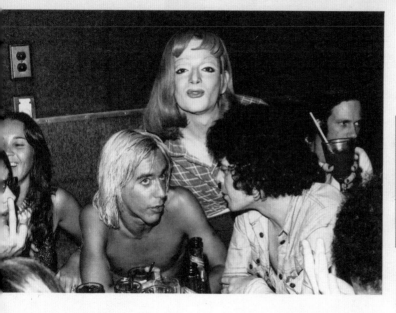

Iggy and the STOOGES
SPECIAL GUEST STAR
BOB SEGER
ALONG WITH CATFISH HODGE

FRIDAY JULY 6
8 PM
St. Clair Shores
Civic Arena
EAST 9 MILE ROAD AND I-94
GENERAL ADMISSION $5.00–TICKETS AT HUDSON'S
AND SCS BOX OFFICE–AN EASTOWN PRODUCTION

Gary Grimshaw/Rainbow Graphics • Printed by Rainbow Press/Ann Arbor

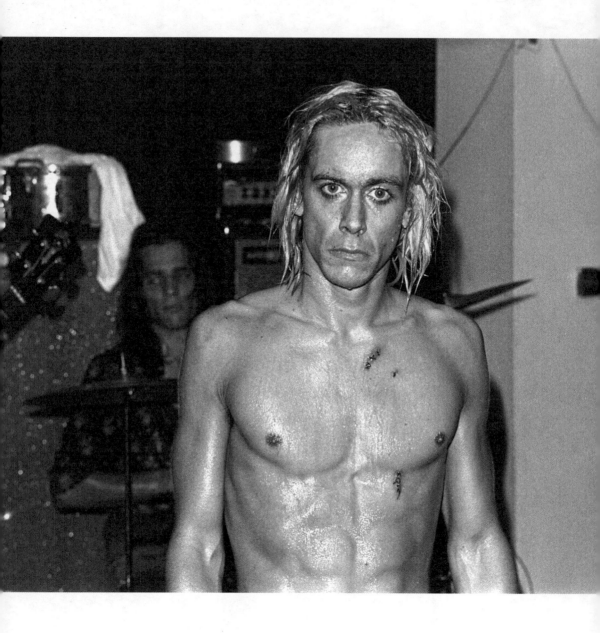

Above: Iggy, stitched up after falling on the margarita glass stem at Max's Kansas City, August 1973. Photo: Danny Fields.

J: IN JULY YOU GO TO MAX'S. YOU PLAY FOUR NIGHTS (JULY 30-31; AUGUST 6-7, 1973). STEVE HARRIS IS THERE. SCOTT THURSTON HAS JOINED ON KEYBOARDS. YOU SEE JACKIE CURTIS AND LOU.

I: Yeah, and then somehow, I can't remember if I'm fucking Bebe Buell and forgetting to pick up Coral Shields at the airport, or maybe I'm fucking Coral and upset over Bebe Buell, or something, but I remember I end up really upset. Look, the room, it was guys sitting down in these little folding chairs. Everybody had glasses. Every single guy, and they were just inspecting me.

JK: ALL ROCK CRITICS ALL THE TIME...

I: Yeah, all rock critics. The hardest crowd I've ever faced I felt personally. They weren't gonna give me bonk, but they paid attention. And at the same time I wasn't all the way I should be, so I think I'd probably taken a 'luude or something. I was surprised when I see the pictures of that gig. I still looked good. It wasn't gonna be long, I was gonna start looking a lot worse.

J: AT MAX'S, YOU FALL ON THIS GLASS AND...

I: Yeah, I think it's honestly that I just fell on it. I think I was doing a stage fall, and they had these heavy margarita-type, these heavy, you know the kind with the stem. It was already broken, and oh my God and "blahhh" y'know? But I didn't stop!

J: AND Y'KNOW I THINK IT WAS PROBABLY A GREAT CAREER MOVE. AS CRAZY AS IT SOUNDS, Y'KNOW IT'S THE SHOT HEARD 'ROUND THE WORLD KIND OF THING. "GO SEE THIS GUY. YOU NEVER KNOW WHAT'S GONNA HAPPEN." IN SOMETHING I READ YOU SAID, "I WAS DOING TO MY BODY WHAT PETE TOWNSHEND USED TO DO TO HIS GUITAR. I WAS USING FINGERNAILS ON MY CHEST LIKE A WINDMILL, AND IT MADE LITTLE CUTS. THE SIGHT OF BLOOD SEEMED TO GET THE AUDIENCE REALLY EXCITED."

I: I used to really wanna get out of my skin, and I was really uncomfortable facing the audiences over and over. They were there to judge you and not to get into it. Sometimes, like Forsythe Junior High (November 30, 1969), that flyer you have, there were only about fifty of 'em, but they were just really watching. It's like, "Hmm." And that was cool, and I was very relaxed, and that's where I got "TV Eye" from 'cause one of 'em was, it's this girl was watching me like I was TV, and I thought, "That was fun!" But a lot of people weren't going for it.

J: IN JULY, CLIVE DAVIS WAS FIRED FROM COLUMBIA.[46] YOU GUYS GET DROPPED. ARE YOU EXPECTING THAT?

I: Uhh, yeah! Of course! And anyway it was just me that was signed. As you saw, I saw. Yeah, I mean basically MainMan made it clear that, "You're not going anywhere." And I felt that if anybody else picked us up, I always felt the way outta that door was the same way I got in.

46) July 5th 1973: Clive Davis (b 1932) is fired from Columbia Records for alleged misuse of company funds.

J: BOWIE?

I: Yes. That's what I felt. Somehow, I didn't know why, but it didn't seem like the symmetry was gonna be there, y'know. Although I was actually probably wrong. Like, let's say Jeff Wald [Helen Reddy's manager and husband] really liked the band. He probably could have cut a deal, and y'know people do this stuff. But I didn't get that, and maybe it's just 'cause I realized y'know I wasn't gonna be duetting with Helen Reddy anytime soon.

J: SOON AFTER THAT, YOU PLAY ATLANTA, (OCTOBER 8-13, 1973) AND EVIDENTLY [DETROIT WRITER AND STOOGES SUPPORTER] BEN EDMONDS ENGINEERS THIS GAG WHERE ELTON JOHN COMES ON STAGE IN A GORILLA SUIT?

I: Yeah, yeah. What had happened was I'd taken too much of something on the down side the night before, so just to even get to the gig, I was shooting myself up with a lot of speed to get to the point where I could mouth words. And I got to the point where I finally felt I could just come out, hug the mic, and deliver the song, and out comes the fucking gorilla. First I thought, "What?" Then I thought it was some idiot in a gorilla suit. "What are they gonna do?" But I was too, I couldn't fight back, so y'know. I think, he had a crush on James. I don't know. I've always liked Elton, and any time I see him, it's always, "Hey babe! How ya doin'? Hey, love ya."

J: AND WHEN YOU FINALLY FIGURE OUT WHO IT IS...

I: I don't know. I didn't register much one way or the other. I'm really not interested in anybody but me when I'm singing. I don't give a fuck.

J: YOU GAVE AN INTERVIEW TO LA TIMES CRITIC ROBERT HILBURN, AND SAID, "AFTER *RAW POWER*, I TOURED 'TIL I DROPPED."

I: After MainMain dropped me, it was a losing game, but I thought I would [still be] doing good work and I was determined to let people see it. Booked myself, took whatever I could get. Crazy. Five nights at the Whisky, four at Max's, five in Atlanta, two in Vancouver. Made no sense. Just do the shows, stumble back to LA with a few hundred and flop until I could go back out. What I didn't spend on motels, I'd spend on drugs.

That's exactly the way it was, until finally toward the end of that I realized the quality was about to taper off. Not that the quality ever got that high, but there were some interesting, some good things about those gigs.

JK: A LOT OF THEM HAVE SHOWN UP ON BOOTLEGS, AND A LOT OF THEM ROCK LIKE CRAZY.

I: Yeah, that's what I'm saying, but by the *Metallic K.O.*, which was the last one, it was starting to get just tinkling piano and on and on riffs and me not knowing how to, y'know. It wasn't good.

Right: *Music Life*. Richard Morton Jack collection.

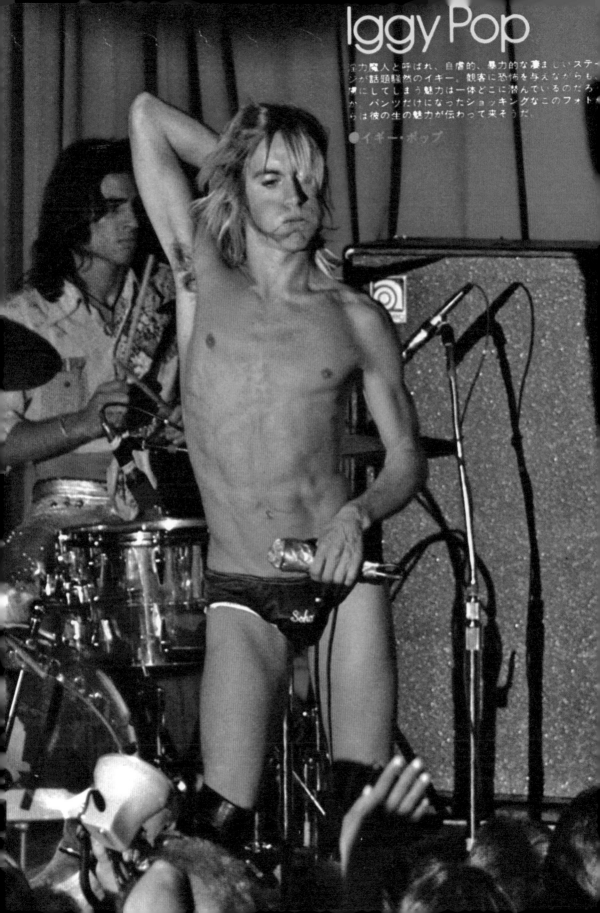

Iggy Pop

暴力魔人と呼ばれ、自虐的、暴力的な凄まじいステー
ジが話題騒然のイギー。観客に恐怖を与えながらも
虜にしてしまう魅力は一体どこに潜んでいるのだろう
か。パンツだけになったショッキングなこのフォトか
らは彼の生の魅力が伝わって来そうだ。

●イギー・ポップ

PERFORMANCES

IGGY
AND THE STOOGES
Whisky a Go Go
Hollywood, California

The Stooges have made the Comeback of the Year, no doubt about it, and their energized stay at the Whisky sealed it. The night before they opened, I got into an argument with a friend who had played the grooves off of FUNHOUSE in years past, and yet couldn't be talked into going to see the Stooges. His argument was logical, but perverse: *"Look, it's all this 1969 Detroit shit that was great in its time, but this is 1973. They're washed up."*

Incomprehensible. How could any group be washed up with James Williamson on lead guitar??? The first sound that hit your ears as the Stooges kicked off their first set on opening night was that of Williamson's guitar, grinding out the chords to *Raw Power*. Fantastic! This guy not only plays as if he invented power chords himself, but with a sound that makes one wonder if he digested *All Day And All Of The Night* whole and based an entire style around it – early Kinks/Who spring guitar to the utmost. Add the fact that James wrote almost all the music on RAW POWER, and you begin to realize what his musical maturity (he's been associated with the Stooges for years, starting as a roadie) means to this group.

Then the Ig. Iggy's still great, surely the best dancer in rock and roll (even if many of his moves appear to be early James Brown cops). That magnetic stage presence is still there: with Williamson riveted to stage left in early Velvets black leather, and Ron Asheton motionless to the right on bass, Iggy took the spotlight as expected. It must be demanding having to live up to your legend, but Iggy did enough every night to keep his rep intact. Whether falling into the crowded dance floor, pouring pitchers of water on himself, doing his famous dive across stage into the mike stand, or dry humping into the thin air, it was the Ig all the way.

On Saturday night, in fact, Iggy's blue fringe bathing suit tore, and his skintight briefs also came precariously close to removal once he fell into the crowd. This was definitely not part of the act. Ron Asheton, nonetheless (who has mellowed since the days when he used to jab Iggy in the back with his guitar between fuzz riffs), remained as unperturbed as the rest of the Stooges, grinding away at a new song slamming Tony DeFries.

So the Stooges still have their prime asset: stark energy. After viewing the group on several consecutive nights, however, some shortcomings became apparent. Most glaringly, they had only a few songs worked up, with the result that both sets every night were almost identical: *Raw Power/I Need Somebody/Search And Destroy/Gimme Danger/Creatures Of The Hollywood Hills*. Some imagination might work wonders, like say the addition of a few oldies. The absence of *Death Trip* should also be amended at once.

Iggy's vocals, strangely enough, were the other weak part of the show. The PA was constantly screwed up, with his voice often inaudible as a result. And when it was working, Iggy simply didn't pay enough attention to his singing. His stage act is equally important, sure, but for someone who's as great a vocal stylist as Iggy is in the Dylan/L. Reed monotone tradition, he should get down and get with it. He wasn't even doing dog barks anymore!

But that's all pretty irrelevant. What's important here is that the Stooges have come back from the dead to become one of the most powerful groups in the world today. Williamson's addition has made them a potential supergroup, and Ron Asheton has proven to be an equal dynamo on bass, playing it almost as if it were rhythm guitar. If they can ever develop a feel for dynamics, and if their material keeps improving until it matches their indisputable capacity for mania, the Stooges might etch their name into the annals of rock history in a big way.

Meanwhile, *Search And Destroy* has been released on 45 RPM (Columbia 4-45877) with an Iggy re-mix. All Stooges fans should acquire a copy, if for nothing else to nail it up on the wall beside *My Generation*. You won't be sorry!

– *Mike Saunders*

The Stooges have come back from the dead, and Iggy is his old self all the way – falling onto the dance floor, pouring water on himself, and diving across stage into the microphone. What more do you punks want??

STORIES
Warehouse
New Orleans, LA.

But one more bombshell was unleashed – Stories' impending followup to *Brother Louie*, which turned out to be the widely popular European composition *Mammy Blue* (a rather irritatingly melodramatic ditty which was a minor American hit by the Spanish group Los Pop Tops in 1971 and was covered by scores of other stalwarts, including James "Gidget!" Darren). Stories' version was far superior to any of the foregoing, even sustaining some rocking intensity at times, but esthetically it's an unfortunate and disappointing choice of material (especially with such pop delights as *Love Is In Motion, Hey France*, or *Please Please* languishing on the ABOUT US LP ripe for follow-up conscription).

which he probably shouldn't have to be judged.

Trower's new trio is named Robin Trower, and they embarked upon their first American tour in order to make themselves rich. Their Chrysalis album, an ethereal, steamy affair produced by former Procol-organist Matthew Fisher, is plenty good enough to make one wonder if they could live up to it. As it turns out, they are up to it technically but not cosmically; Trower can indeed play Hendrix riffs, but the elevated, swirling album sound is simply too muted by reality to strike home on stage.

Trower's top pair of tunes are the exceptions to this rule: the magnificent radio rocker, *Man of the World*, and the spacey album title song, *Twice Removed From Yesterday*, come across nicely. The latter features Trower's most noticeable Hendrix riff, and it works brilliantly, spanning the end of each chorus and an instrumental bridge. Other tunes, like the moody *Daydream* and the absolutely blatant version of *Rock Me Baby*, don't seem to sustain any emotional flow, and thus become mere exercises admirable mostly for their ability to synthesize the band's technique with their influences. Bassist-vocalist Jim Dewar and drummer Reg Isidore are both functional without being particularly distinctive.

It can be said that Trower and company have hit upon what is currently a novel concept while still being generally unoriginal. True, true. The album proves that it sounds like no other power trio you've heard since the demise of the Experience, and it doesn't even really sound like them either! In person, it ain't bad, but it ain't great.

– *Jim Bickhart*

DOUG SAHM
JOHNNY WINTER
Boarding House

"Well, nothing like snatching defeat from the jaws of victory. Luck of the Stooges!"

Above Left: *Phonograph Record Magazine*, October 1973. Jeff Gold collection. **Above Right:** *Creem*, April 1974. Jeff Gold collection.

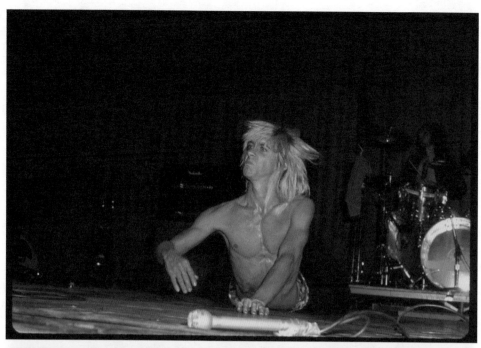

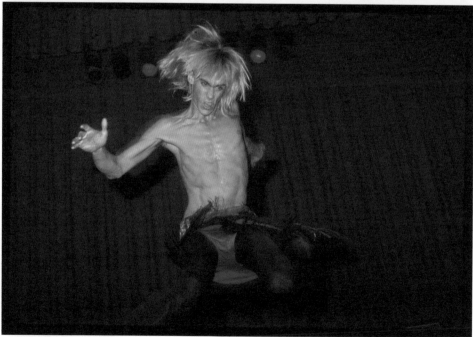

Above: Ford Auditorium, March 1973.

WARNING

iggy and the
stooges
with
the tubes
JAN. 11 & 12
at bimbo's

ADULT
ONLY

X

FOR INFORMATION: (415) 752-7436

12. THE END (AGAIN)

J: SO AT THIS SHOW AT BIMBO'S IN SAN FRANCISCO (JANUARY 11 -12, 1974) SUPPOSEDLY SOMEBODY PULLS DOWN YOUR "SOHO" UNDERWEAR AND STARTS GIVING YOU A BLOWJOB.[47]

I: A-ha!! Well, y'know. Yeah, could'a happened. Probably not the actual blowing because I don't get a hard-on when I play. When you play, you use all you energy, at least for me y'know...

J: AND A FEW WEEKS LATER, YOU PLAY THE BAND'S SECOND TO LAST SHOW, AT THE ROCK AND ROLL FARM (WAYNE, MI. FEBRUARY 4, 1974) WHERE YOU GET INTO THIS BIKER ALTERCATION. CAN YOU TELL US YOUR VERSION OF THAT?

I: One guy throws eggs, and I said, "Wait a minute! Okay, wait a minute. Let's see who this is," and there he was. He was bigger than your boy here [Johan] with similar physical type, and he had a knuckle glove, studded knuckle glove, and his colors [motorcycle club jacket] on, and he had a carton of eggs. And he just fuckin' decked me. I was wearing a Danskin ballet outfit with little girl dance shoes. Not shoes, just little slippers. Ballet slippers, but not pointed ones, and a little floppy hat with flowers on it, and then what happened was hilarious. I felt I had to get outta there quick after, and I was trying to date a beautiful, cultured, educated young lady from that general area from a very straight family. And I jumped in her car. I said, "Take me to your house!" And I spent the night in that tutu at her parents' house and woke up in the morning, and I had nothing, no other clothes, and met her mother in the fuckin' tutu [laughs].

J: AND SO THE STORY GOES YOU GO ON WABX...

I: The next day, yeah, and did my version of Dick the Bruiser [a '60s Detroit area tough-guy TV wrestler]. "I dare you motherfuckers. Blah, blah, blah, blah, blah." The Scorpions, they were called, and of course we had friends, Scott Asheton had friends in a biker gang called God's Children, and I knew a guy named Big John, and I knew he'd be coming down with us [to the next show]. I knew we had some muscle. I thought, "Well hey now, wait a minute. I gotta keep this career goin' here!"

47) From rockprosopography102.blogspot.com: The [January 1974 Bimbo's San Francisco] shows replaced the canceled Matrix shows from the previous Oct 31-Nov 1, 1973. By the time the band returned to the West Coast in January 1974 for these two shows (two sets a night) at Bimbo's 365 Club, their audience had dwindled, with just a few dozen fans in the seven-hundred-capacity club, all of them clustered around the stage. Joel Selvin was there to review the show for the *Chronicle*; he remembers that despite the tiny audience, the band was ragged but on the rampage, and that Iggy was as committed as ever. At one point he jumped out into the crowd, where-upon a fan pulled his bikini briefs down. The singer shouted a running commentary over the microphone: "Somebody's sucking my dick, somebody's sucking my dick!" Finally, bored of the attention, he screamed, "Give me my cock back, you bitch!" and continued the performance. Selvin wrote up the incident in his review, with heavy use of asterisks. The next day after the story runs, Selvin get a phone call from a guy who says, "That was no girl that did Iggy, that was me and my cousin Frankie!"

Left: A handbill for the Stooges at Bimbo's, San Francisco, January 11, 1974. Grant McKinnon collection.

J: AND SO THAT LAST SHOW IS THE *METALLIC K.O.* SHOW AT THE MICHIGAN PALACE, THE LAST STOOGES SHOW UNTIL THE REUNION [FEBRUARY 9, 1974, MICHIGAN PALACE, DETROIT]. DO YOU HAVE ANY RECOLLECTIONS ABOUT THAT SHOW IN PARTICULAR?

I: Yeah, after the show, I was out in the parking lot. Brother Wayne Kramer walks up to me, "Hey, pretty good show man. Gimme that money you owe me right now."

J: OH MY GOD. WITH A GUN?

I: Yeah, right in my gut. He has since apologized, and I totally accept it, and he was right. I owed him a buncha money. And I said, "I don't got it." He said, "Well get it." And he took me somewhere to get it, and I got it, and then he was cool.

I've had guns twice. The other time was in what is now the Mondrian [hotel] when it was the Sunset Plaza across from the Coronet. Some prostitutes were taking care of me, and one of 'em had a very large jar of this stuff. Took me to another apartment, and a gang burst in with guns. It was stolen coke, and they made everybody, "Okay, everybody freeze." The guy had one right to my temple, and then the leader of the gang said, "Hey!" You know what he said right?

J: YOU'RE IGGY POP!

I: That's right! I was like, "Yes!" "That's Iggy Pop! Let 'em go!" I was like, "Oh fuck," y'know.

J: UNBELIEVABLE.

I: So that's what I always remember, but he was right. Y'know he's been open about the fact he got into dealing at some point. I waited 'til he was out of town once, and I talked his girlfriend into giving me his stash, and I didn't pay for it, and it's fine y'know. But it's scary when you're around those things. They're horrible. So things were getting...You know what I mean?

J: AND I CAN SEE WHY YOU MIGHT SAY, "I'M DONE." AND SUPPOSEDLY YOU CALL RON AND SAY, "THIS IS IT." AND RON SAYS YOU WERE PHYSICALLY AND MENTALLY WRECKED ON DOWNERS, TOO MUCH PRESSURE.

I: Yeah, that's true.

J: WAS ANYBODY SURPRISED? WAS THIS JUST THE LOGICAL CONCLUSION?

I: No. No, nobody was surprised. Yeah, nobody was surprised.

J: THE STOOGES COME TO AN END, SCREWED UP ON DRUGS. THEY WERE NOTORIOUS FOR THEIR DRUG USE. HOW DID THAT AFFECT THE GROUP, IN RETROSPECT?

I: I think that the different drugs functioned as keys to both open up certain things and to bring down curtains on other things, but that the very big problem is simply quantity and incidence of use. Excess, absolutely, excess and over-dependence. If the same things had been used and it had only been half, you would've found more vitality, more work ethic, more stamina, more money to spend on a roof over your head.

J: IF ONLY IT WORKED THAT WAY.

I: Yeah, if only it worked that way. And then later, the other stuff, like heroin, downers and alcohol hasten the demise of everybody that uses it. I can tell you this much. I don't believe there was ever a time when any of us picked up an instrument to write any of the songs on the first two albums when we weren't stoned on marijuana to some extent, and then to me the acid came in as a kind of a performances and thinking stimulant, and then alcohol was always back there lurking and made me negative.

During the writing of *Raw Power*, those songs were written musically speaking without the drugs by a couple of junkies on a break, and we were using, after I got off the Dolophine from the pharmacist, I had a doctor, I think he was in Livonia, and he prescribed Valium and an anti-depressant for me—it might have been Elavil, but I can't remember—and James and I called them dream pills. They made you pretty happy, and he gave me a big prescription to take to England.

I was never searched, and James and I were cruising along. That was the only time he was ever nice to me. He said, "Can I have one of your dream pills?" Yeah, so we had something to calm us down, and at the same time, we were cocooned. Everything was taken care of. They could complain about having no gigs, but when you do have gigs, you don't always get to pick when they are. And sometimes they're right when you should be doing the fuckin' album, so we were cocooned.

We developed our art, so in other words, and as soon as things got a little rougher, or things started going bad, these people are gonna go back to what? Being junkies. And who were the two main junkies? Me and James. And who's the Junior junkie, the third level of junkies, the meathead junkie was Scott. Ron never did it, but Ron had also cultivated that type of a habitual, cloudy lifestyle through, "I sleep late. Don't hassle me. Don't make me think too hard." He used to hate, "Jim is always thinkin'! God, don't let him come over. He's always thinking. It drives me crazy." So we were all like that.

J: ON A DIFFERENT FRONT, HOW IMPORTANT WAS YOUR BEING A DRUMMER TO THE STOOGES SOUND?

I: Really, really, really, really important, and Scott Asheton knew it too. And he was always trying to get me, "Why don't you write our albums instead of James 'cause I love the way you play like a drummer." Yeah, it was very key to the sound.

JK: THE SOUND OF THE BAND TO ME WAS ALL ABOUT THE RHYTHMS.

I: Yes, it's the rhythms, and I think I just willed that on the others, and I also think I suggested it through the dancing. They were my best audience, y'know.

J: DID YOU HAVE ANY FEELINGS ABOUT THE SUCCESS OF BOB SEGER AND ALICE COOPER AND THESE OTHER GUYS FROM DETROIT?

I: I was really impressed with the success of Alice Cooper. They came to England while we were there before we recorded *Raw Power*, and all of the sudden they're playing arenas, they've got "Eighteen," which reviewers were openly calling Stooge-esque. And I thought, "Wow. They did it," and they doing "us" better than we did. They've got it together, and it was pretty hard for me to take. But Alice was always very nice to me. Seger, no. That's just a different world.

J: A DIFFERENT WORLD, BUT IT'S A GUY YOU CAME UP WITH.

I: Yeah, but I never thought about it one way or the other. The only thing I've ever thought about Bob is, "Thanks, Bob, for coming to my high school." He was playing with the Decibels, his greaser band. I saw 'em at sound check all alone in the school auditorium, and that really hooked me to be in a band. Yeah, I was in eleventh grade, and I had the Iguanas and everything, but I saw a real band playing, those Fender guitars played well in unison in a big, open, acoustically proper space, and I thought, "Oh, it's so beautiful." So Seger was, Seger was just a, man, a positive force, that cat, and nice. Always nice.

J: SO WHAT HAPPENED AFTER THAT LAST SHOW?

I: So we were all out on our ass, and I pursued a miserable course in a hateful relationship with James living hand to mouth. First place we went to was Howard Rents on the corner of El Centro and Santa Monica. You get a room the size of the guest bathroom there with a cot-type bed with a rubber sheet that's changed once a week. So yeah, that's thirty-three dollars a week.

J: AND WHEN YOU CALLED JAMES BACK, IT'S JUST LIKE, "OKAY, I NEED THE MONEY AND…"

I: Oh, we both knew we were stuck with each other for a while, and basically we went out and tried all these different managers including Jeff Wald and we had a booker named Ken Sunshine. They took me up once to meet Neil Bogart [of Casablanca Records] and an agent maybe. He was a legendary guy. I think his name was Bill and he had steer horns on his desk, and they played acetates by a band they were putting together called KISS, and they said, "They need a singer like you!" And I was like, "I don't wanna be in KISS," y'know.

Right Top: Iggy gives the finger. Johan Kugelberg collection. **Right Bottom:** *Creem*, April 1974. Jeff Gold collection.

CREEM

MATE of the MONTH

人の仮面を片っぱしからはぎ
イギー・ポップ。彼の周囲に
の子たちや恐怖を欲しがって
くる。ステージでの彼の狂暴
影がうすいだろう。

●イギー・ポッ

IGGY POP

Above: Iggy with then-manager Danny Sugerman (pictured left), after the "Murder of the Virgin" show at Rodney's Bingenheimer's English Disco, August 11, 1974, *Music Life*, November 1974. Richard Morton Jack collection.

J: AND THIS IS THE *MURDER OF A VIRGIN* SHOW YOU DID AT RODNEY'S. IT'S THE BEST BLOODY PICTURE I COULD FIND.[48]

I: Yes, I'm still trying to make art there. The idea was "keep making art." Boy, was that bad! So we were doing all these horrible gigs and really didn't like each other, and I was taking downs and James would be out of tune and the band would be out of money and they'd throw me in the bushes and everybody hated everybody and somewhere along the line there, there were these demos that he wanted to make, but to me they were not demos. It was always—this was after the final blow-up of all the gigs—it was always, "Don't stop making art. Don't turn into one of those Hollywood musicians who waits for the system to pick him up." You know the type.

Like there was one guy at the time called Velvert Turner, and Velvert was just waiting for his deal. Hollywood is a company, and it's very efficient if you're an actor, an actress, a working director or writer, or a viable commercial musician actively producing the stuff, but if you're somebody coming there, hoping to get some sorta brass ring, then you better be Ava Gardner good looking or Donna Summer talented. So I just kept going, but while we were doing that, I would have, like Loree Rodkin wanted to manage me and do a production deal through Alice [Cooper], but I didn't feel it. I thought, "No, this is just too...That will bury me in professionalism." Brian Wilson wanted to meet me. I went out to his house. Well, Danny Hutton [of Three Dog Night] was thinking about picking me up, and so I went to Danny's house and we tried some things. And we went to Brian's, and we sat there, tried to write an American anthem. Brian said, "Okay, we'll start with Schoenberg."

J: WAS HE WASTED AT THE TIME?

I: Yeah, uh huh. Wasted. He was in bad shape, but he was still a nice guy. And we sat there for a day and a half.

J: WHAT A BIZARRE COMBINATION. IT'S LIKE YOU AND CHUBBY CHECKER AGAIN.

I: Yeah, yeah. I think Alice showed up later to that. At least Alice says he did. And I also tried various things with [Doors keyboardist] Ray Manzarek, but I just felt it was all too straight and it wasn't gonna, no.

J: SKIPPING FORWARD TO 1976, THIS FRIEND OF RON'S, MICHAEL TIPTON, HAD RECORDED THAT LAST SHOW, AND SUPPOSEDLY WILLIAMSON BORROWS A TAPE, AND SELLS IT TO MARK ZERMATI, WHO RAN THE SKYDOG LABEL OUT OF PARIS. AND THUS THE LEGENDARY STOOGES BOOTLEG ALBUM, *METALLIC K.O.* COMES INTO EXISTENCE.[49]

I: Yeah, I can't swear who paid him for it or how much or if he was paid at all. All I know is that one guy who runs an LA area indie told me, "Well, he sold the same box of tapes three times." And another guy, [British rock writer] Nick Kent, says, "They were paid." I wasn't. I started getting tiny royalties from it many years later when I finally had enough clout to tell the guy, "Look, you're getting shut down." This was mid-'90s. He started sending me a thousand here or there.

48) After the Stooges breakup, Iggy Pop performed an improvised play called *Murder of the Virgin* at Rodney Bingenheimer's English Disco on August 11, 1974. Baiting the audience, Iggy asked "Do you want to see blood?" He ordered guitarist Ron Asheton, dressed in his own Nazi Afrika Korps uniform, to whip him repeatedly with electric wire and accost him with a noose the singer had brought along. Reportedly the show only lasted 15 minutes. 49) The original 1976 issue of the *Metallic K.O.* album contains material from two different shows at the Michigan Palace: the first side is from October 6, 1973, while the second side is from the final Stooges show, February 9, 1974.

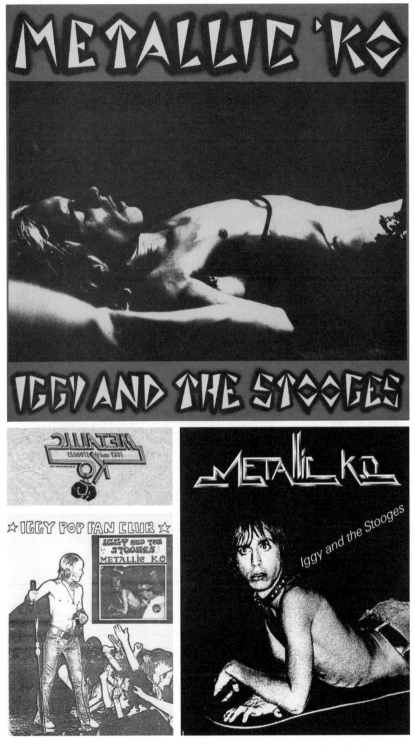

Above Top: Iggy out cold on the *Metallic K.O.* cover. Jeff Gold collection. **Bottom Right:** *Metallic K.O.* promotional poster. Johan Kugelberg collection. **Bottom Left:** #3, Iggy Pop San Francisco fan club, October 1976. Jeff Gold collection. **Above Center:** Iron-on t-shirt transfer included in the original US Release of *Metallic K.O.* Grant McKinnon collection.

J: HOW DID YOU FIND OUT ABOUT *METALLIC K.O.*, AND WHAT'D YOU THINK?

I: Can't remember how I found out about it, but the first thing was, I thought was, "Hey, I love the picture."

J: WHICH WAS SUPPOSEDLY TAKEN AFTER YOU WERE KNOCKED OUT AT THIS SHOW.

I: Yeah, and the music I just noticed how it went on and on and on. I didn't like the piano. But when I heard the parts that everybody was talking about, I thought, "Tee hee." Y'know I thought, "Hey, pretty cool!"

J: I THINK IT'S A REALLY IMPORTANT ALBUM, BECAUSE I WORKED AT A RECORD STORE FROM '73 TO '81, AND THE TWO STOOGES ALBUMS YOU COULD BUY, THAT WERE IN PRINT, WERE THAT AND *RAW POWER*. THE FIRST TWO WEREN'T AVAILABLE.

I: He did well with it, he says. Y'know it's funny, I mean there was this guy, this French guy who was James' friend at that time called Philippe Mogane, whom I can't stand. He was supposed to be a photographer, and he was staying at the Tropicana, and he and James formed a company together called Siamese Records.

J: RIGHT.

I: And they put out "I Got a Right" with James' name on it as the writer. And he was kinda trying to steal something from me, but all he did was help me. All he did was help me because it's a great lyric, it's a great song, eventually I got the credit straightened out, and it was real important for our group. And they did the same thing with the other stuff and the same thing with *Metallic K.O.* And y'know I didn't ask anybody to call it Iggy and the Stooges either, but there it was again.

J: I INTERVIEWED JOHNNY MARR ABOUT *RAW POWER* FOR MY *101 RECORDS* BOOK, AND HE SAID THAT WAS THE RECORD THAT FOR HIS GENERATION YOU COULD GO INTO THE RECORD STORE AND BUY.

JK: SAME THING HERE. IT WAS REALLY HARD TO FIND THE FIRST TWO ALBUMS. *RAW POWER* YOU COULD FIND IF YOU CALLED AROUND AND DUG AROUND, BUT *METALLIC K.O.*, YOU COULD BUY ANYWHERE.

I: Yes, that was because WEA [who distributed Elektra] totally gave up on us, and even when the reissues were done, WEA never did as good a job with it. They didn't put as much into it as Sony Legacy [who reissued *Raw Power*]. Never. And now Sony Legacy repackaged some of that stuff together with my solo stuff too, so there are these things out, y'know.

13. DAVID BOWIE'S DRAINPIPE

J: SO YOU'RE JUST WAITING FOR THE RIGHT VIBE.

I: I was waiting for the right vibe, and during those times, I would once in a while crawl up David Bowie's drainpipe. Or I knew where he was, and once in a while I'd visit him. And eventually he said, "Let's do some demos." And I cut some demos with him on an eight track, and James came over. Oh, and James was furious because I was gonna be his meal ticket.

And he came to this demo session and tried to basically pick a fight with Bowie, criticizing the sound of the demos we were making. The demos were interesting, but they weren't a direction for me, given the person I was at that time.

More time went by, and one day I'm walking on the street, and Bowie rolls down the window. I'm walking down Sunset. "Hey Jim! Come and listen to my new album!"

He was out of the English management by then, working with Michael Lippman, and I staying in touch with him, and the way the final hook-up happened was that I was crashing on the floor of a male hustler named Bruce who had a little room off the lower garage level of old our old stucco rental on Kings Road, on Flores between Fountain and Santa Monica. And I went to the Mayfair Market there across from Irv's Burgers, and I was on two 'luudes, I stole two apples, and stuck 'em in my balls and a big thing of American cheese and stuck it in my butt and tried to walk out with it. They nabbed me and put me in the Beverly Hills jail, and I called Freddie Sessler.

Do you know who that is? Well, Freddy Sessler was a survivor of Auschwitz who was the best friend of Keith Richards for many years and had mysterious connections in the American intelligence services and also with Merck Pharmaceuticals.

J: RIGHT. HE WAS THE GUY THAT GOT KEITH THE BOTTLES OF PHARMACEUTICAL COCAINE.

I: [In a voice] Yeah, and he talked just like Chico Marx. [Back to normal voice] He was a corny guy. He's in Keith's book. And he's also probably the nicest bad boy I ever met. He stole some books from Westinghouse, their customer books for GE actually for all their motels up and down the East Coast, and I was supposed to sell...Anyway, he tried to make me a telemarketer. I called Freddy to bail me out. It took him a day to come over, but he did bail me out, he brought me to his apartment where all hell was breaking loose, and he said, "David would love to see you. I want you to get on the phone and say hi to David."

Well, I was proud. I said, "I don't want..." So I said, "Okay, hi." "Hey Jimmy, how ya doin'? Blah, blah, blah." So I came down to San Diego with Freddy, and David played me "Sister Midnight" and I thought that I could sing it and also that groove would not be completely disconnected from where I've been already. I should mention that I was going back and forth to San Diego sometimes because I was dating Lisa Leggett, who was the daughter of Charles Leggett, a former Federal Treasury agent from Chicago.

IGGY'S BACK!

Devotees of the Stooges hailed the news that their main man, Iggy Pop, was returning from Angeleno exile to once more spread mayhem across the performing stage. With the new album "recorded" by David Bowie, and the aforementioned Thin White Duke filling in on keyboards during Iggy's groundbreaking U.S. tour, it looks as if the Ig is back to stay among his fans forever.

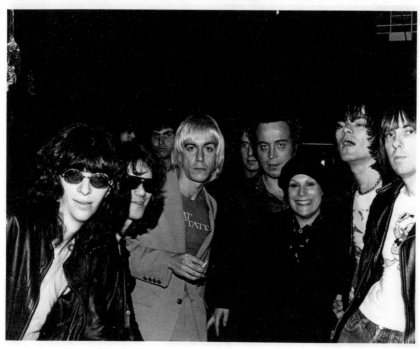

Above Top: *Rock Scene*, July 1977. Jeff Gold collection. **Bottom:** Iggy at a party held in his honor at CBGB, with (L-R) Joey Ramone, Tommy Ramone, Ramones co-manager Danny Fields, Sire Records co-founder Seymour Stein, Ramones co-manager Linda Stein, Dee Dee Ramone, Johnny Ramone. April 1976. Photo: Roberta Bayley.

And Leggett had bought the former home of the head of Royal Inns. I was living on a cliff top mansion in La Jolla. It was like a hotel with astrological signs in the swimming pool, and she tookme in. As part of putting the brakes on my drug habit, which was diminishing at the time, she paid for me to take one of those three-day motivation courses where you learn to speak and you learn to be successful and you learn little tricks like visualizing, I did that. And I did it straight, and it helped. It helped me be ready for that opportunity.

So I went to Bowie's hotel, the San Diego Hilton, and I went to the gig, and then after that, the next morning he said, "Get a little bag, and just go report to this guy in the morning." And I reported to his tour manager, a little Scotsman named Eric Barrett, and I got to know Eric. And Carlos Alomar was very nice to me, and Dennis Davis, the drummer, would always sing this song, "Iggy, Iggy was a punk rocker." And then they'd laugh! And all these black guys got a big kick outta me.

J: SO THE BAND HAS BROKEN UP, YOU'RE WORKING WITH BOWIE, RON STARTS THE NEW ORDER WITH JIMMY RECCA AND SCOTT THURSTON, SCOTT IS IN SONIC'S RENDEZVOUS BAND, JAMES IS DOING WHATEVER HE'S DOING, AND A FUNNY THING HAPPENS. THE STOOGES LEGACY BEGINS TO GROW. AS PUNK EVOLVES IN THE US AND ENGLAND, THE STOOGES BEGIN TO BE CITED AS A CRITICAL INFLUENCE. ROCK ZINES AND THE ENGLISH MUSIC PRESS START TO WRITE ABOUT THE BAND MORE AND...

I: And I told Ron, a lot of the pictures helped it stay alive. Yes, there I am being a solo, and I'm in New York, and [the press] keeps bringing up the idea of the thing again. I had gone on Bowie's Station to Station tour all the way across America, [Bowie] was taking the Italian liner of some sort to Genoa, he left me with a plane ticket, and a room in the Royalton, which at the time was twenty-five dollars a night with that thin toilet paper. And this group of people wanted to have a party for me at CBGB's. John Holmstrom of *Punk* magazine, [Sire Records head] Seymour Stein, [Ramones manager] Linda Stein and the Ramones.

So I went, and one point sometime later, Seymour tried to buy the *Kill City* album,[50] and I should'a signed it up with him. But anyway, at the same time, Johnny Thunders was cruising me, and he wanted to go jam, and I was willing to jam with him not to insult him, but then he tried to get me to get high with 'em, and that would've been the end of my career right there, 'cause other people would'a smelt it, and it would'a been in New York, everybody knows everything, and I said no.

J: GOOD IDEA!

I: And Thunders looked at me, he said, "Don't trust that Bowie. He tells everybody he's gonna produce their...He's not gonna produce your record. Stay here with me, and make," y'know. And it was a lot of pressure. But I trusted Bowie. I trusted him, and my trust was justified. I never pressured him about doing that shit. A lot of his people were going, "What the fuck do you want with this guy for?"

50) *Kill City* was the album put together from the 1975 demos that Iggy did with James Williamson under the aegis of Ben Edmonds. It was eventually released by BOMP records in November 1977.

Above Left: *Iguana* #3. Jeff Gold collection. **Above Right:** Ron Asheton cover story in Swedish zine *Anarki & Kaos*. Iggy: "I told Ron a lot of the pictures helped it stay alive," circa 1980. Johan Kugelberg collection. **Bottom:** from *Iguana* #3, October 1976. Jeff Gold collection.

J: AND YOU START HAVING MORE SOLO SUCCESS THAN YOU EVER HAD IN THE STOOGES. DID YOU EVER CONTEMPLATE GETTING THE STOOGES BACK TOGETHER?

I: No, for the simple reason that there wasn't enough money to support partners, and there never was in my career right up until the Coachella thing. I wanna make it clear that all during the entire length of the Stooges reunion, I have never made more personally, per gig, than I was making in my solo career in those years preceding it. And the way that our price went up was very simple. Coachella had had me once. They'd had me for forty [thousand dollars]. I tell it like it is. That was, my area at that time was usually forty to sixty and then occasionally I was already worth a hundred if somebody needed like, "We need you in Norway! Ray Davies beat up Dave!!" or whatever. But it was all mine. I only paid other people, right?

So they offered me sixty with the Stooges, and everybody's all excited, and I said, "No." I said. I've learned the ropes now, I know what it costs to do a gig, and the money, I said, "Look, sorry everybody. You give me this six figure sum and then I can afford to pay 'cause I wasn't gonna say to Ron and Scott, "I'm Iggy, and I'll get more, and you'll get less." Cos they were waiting for me to try that, and I said, "No, I won't do that." So that was it. Ever since I said no, even the agents were like, "Geez." And I said no ever since.

It started in '95 or '96 when EMI suddenly wanted to put out a greatest hits on me. They called it whatever. Then Time Magazine's like a major label wants to put out this guy? The bleeder? Whatever. Y'know, the pee-er...y'know, whatever they think I am! And then it just started, then it was suddenly Reynolds Tobacco. They wanted to sponsor a tour, and I knew the tour was gonna fail, but I knew that was gonna turn heads that a corporation with big money wanted me to present them.

Scott came to me in the late '80s just before I was gonna do the "Instinct" tour and tried to get the band back together again. And he looked rough, and I jammed with him out of respect, but I said, "It's just not the time." And he said, "Well I'll work for you." And I didn't wanna tell him he wasn't up to it. I needed somebody younger and stronger, and he should never be my employee.

So y'know basically the Stooges got really expensive. I had already opened up the festival niche myself. Listen, you get a hundred thousand people in Belgium on a hot day, and they're gonna sit through Sting and Paul Simon on one bill. They needed me! They needed me, and I gave it. I hit 'em hard without the group. Also I thought they were inactive, and the big thing that helped get it back together was that suddenly Ron was out with J Mascis [of Dinosaur Jr.] on the same tour [route] I was on, about two weeks ahead of me.

J: AND THEY WERE PLAYING STOOGES SONGS.

I: Yes, playing Stooges. And I was at kind of a loose end of my career, and I also heard they'd been doing the festivals with Watt. So, y'know, they were out there.

Above: In 1981, Iggy played the Second Chance Saloon in Ann Arbor, and caught up with Scott and Ron Asheton. Stooges author and photographer Robert Matheu recalled, "When The Stooges reformed Ronnie said over and over in interviews that he hadn't spoke to Iggy since 1974. When I showed him this photo, he said 'sure I was there, doesn't mean I spoke to him.'" Photo: Robert Matheu.

14. THE REFORMATION

J: YOU GET THEM TO PLAY ON YOUR ALBUM *SKULL RING* (2003).

I: Yeah, well what happened was there was a new stiff in charge of EMI. He wanted to have a meeting about my direction, and I realized if I don't take the bull by the horns, they're gonna stick me with some horrible producer and ruin my cred. So I went in there, "I wanna do a duets album! I'm gonna call up every great artist that I know that really likes me, and there are lots of 'em! And not only that! I'm gonna call up Justin Timberlake and P Diddy!" And the guy was looking at me like I was crazy.

And so that's how that started, and I fulfilled some of that. I knew Green Day, and we were friendly. Basically I started seeing that Ron was out there, and I thought, "Well if I'm doing all these other people, why not somebody I really, really like? I guess they're out playing. Okay!" So that was how that went. We went in for "Skull Ring," he had this one riff, and the two brothers are going, Scott's going, "That sounds just like 'Peter Gunn.'" And Ron says, "It is NOT 'Peter Gunn!'" And Scott's going, "Is too." Is not, is too, is not.

And I was like, "Guys! Guys, let's just play, whatever it is." So we played it. He had a change for it that didn't work that we saved for the next album, and I said, "Just play it over and over." And we went out old school into a studio at Hit Factory out here, used to be Criterion, with drums, guitar, and a live vocal in the room, and I sang it that way with them. And it just didn't feel like anything until Ron sat down and overdubbed the bass. And [claps hands] instantly, when he played that bass with his own guitar riffs, suddenly, "Whoa!" And then he put these wonderful leads on it.

After that, y'know I was already at the point in life where I need breaks. The company was going, "This is great!" Before they had been, "Well, if you're really bust, we'll give them an economy ticket." Now it's David Walters, the A&R head of EMI/Virgin saying, "This is great! Rolling Stone's calling my office! This is great! People want the Stooges! Can you get some more songs?" So I gave [the Ashetons] the studio for four days. Just left them alone, the two of them. Let them make, and it wasn't as good, that stuff, but they were on the spot.

And then later they wanted me to scrap the whole album and make an entire new Stooges album produced by Jack White, and I wasn't willing to do that to [longtime Iggy guitarist and collaborator] Whitey Krist. It wasn't fair. I have my ethics. I had this backup band that worked hard for me, and the trade-off was I said, "Look, I can never be a band with you guys, but we will write, and when we write, you will own your own publishing and your own writer's share. I don't want anything from you."

And I've done that with all my backup bands. I give them a chance to write, and I was gonna do the whole album with that backup band. I'd done *Beat 'Em Up* (2001) already, but he had to settle for half. But I was not gonna take that away from someone who has no ongoing career. I just won't do that.

J: SO COACHELLA CALLS IN RESPONSE, I'M IMAGINING, TO *SKULL RING* **AND THIS EXCITEMENT ABOUT THE STOOGES REUNION AND THEY ANTE UP EVENTUALLY AND YOU PLAY. THE LONG AWAITED STOOGES REUNION [APRIL 27, 2003],[51] YOU, RON, SCOTT, AND MIKE WATT ON BASS. WITH STEVE MACKAY TOO. AND IT WAS INCREDIBLE. JUST AMAZING. I REMEMBER SAYING TO JOHAN DURING THE SHOW, "THIS MIGHT BE THE FIRST SHOW THAT THE STOOGES EVER PLAYED STRAIGHT!"**

I: Yeah, I was just sorta trying to cope with all the, there's a lot of Hollywood stars, a lot of music biz people. The best worst part for me was, y'know, we get to "Dirt," and fuckin' Watt is outta tune. So right in public, I learned this from my high school conductor who used to get so irritated. He was a very sensitive, good looking, probably gay guy, and when we'd be at a competition and we just completely fucked up the piece, I was in the orchestra, he'd just go, "[Non-verbal signaling]." So I always used that on the band. When all else fails, I would just, so I just thumped him, and I said, "I think you need to tune." And Jack White loved it. "The best part was when you told him to tune up!"

JK: HAD YOU BEEN IN TOUCH WITH STEVE MACKAY THROUGHOUT THE YEARS?

I: No, no, no. I just told somebody, "Find MacKay."

J: WHEN, BEFORE COACHELLA OR AFTER COACHELLA, DID THE NOTION STRIKE YOU THAT, "HEY, MAYBE THIS IS A GOOD IDEA TO CONTINUE?"

I: As soon as we did Coachella, yeah, and these big festivals, they're not gonna let you fall. They prop you up, so the next day there was a full-length picture of Jack White. It was a whole page, and then the other page was a full-length picture of me 'cause they're gonna tie the story in. It's a little marketing. Brought back the older guy to anoint the newer guy, and it all happened out here in the Coachella Valley. Ba-da bing, ba-da boom, and that's fine. That's good.

J: AND WERE YOU ANTICIPATING IT WAS GONNA BE A ONE-OFF?

I: No! I was thinking if we were gonna do it then we should, let's try to do it. Yeah, absolutely. What I had to do right after that for the fuckin' record company was, and this has been a theme ever since the reunion, I work twice as much as the group, because I'm twice as much in demand. I've been doing this and they haven't. So I went out on a late winter to early spring, ultra low budget, free record company tour where I play thirteen gigs with my backup band free of charge. Really playing gigs, staying in these places like where you get the food out of a vending machine, Hampton Inns of whatever, for the company. And then when I got done with that, I had two weeks off and did the summer with the Stooges, another thirteen, and it's been like that ever since. I'll work with a group and then I have to go do the photo session or do the whatever, the meeting, or my own album or whatever it is. I'm not complaining, but I'm a little beat.

51) The lineup was the same as the very first Stooges, with Mike Watt (b 1957) of the Minutemen and Firehose replacing the late Dave Alexander on bass. Alexander died in 1975, after being admitted to an Ann Arbor hospital for pancreatitis, which was linked to his drinking. He was 27. At Coachella, Watt played in a t-shirt with Alexander's photograph. Songs played were: "Loose," "Down on the Street," "1969," "I Wanna Be Your Dog," "TV Eye," "Dirt," "Real Cool Time," "No Fun," "1970," and "Fun House." Steve McKay played sax on the final two numbers.

Left Top and Middle: The Stooges finally reunited at Coachella; top Iggy with Ron Asheton, middle with Mike Watt. Photos: Tom Mosenfelder. **Bottom Left:** At the Vegoose Music Festival, Las Vegas. October 27, 2007. Photo: Jeff Kravitz.

J: AND YOU DO A NEW STOOGES ALBUM, *THE WEIRDNESS* IN 2007.

I: Yeah, that was all, that was completely Ron's ideas, Ron in charge. I just served the band. The way he became in charge was he called the telephone on that kitchen table eight times overnight when I was sleeping here and each time saying louder and more wildly, "Steve Albini! Steve Albini!!!" He's yelling into my earpiece, and I'm like, "Oh God...STEVE ALBINI!"[52] And over and over and over, and then at the same time, I had kept trying to put it off 'cause I didn't think we were ready, and he gave me this rap. He says, leaves me this other message, and he says, "It's like Pork Chop Hill. You've gotta run up the hill and take the hill. You can't wait no matter what the cost."

So I thought, "Oh God. Steve Albini, who had given an interview once about how, 'Yeah, I saw Iggy Pop try to fuck a chick on a pool table, and he couldn't get it up.'" So I didn't really wanna meet Steve Albini, but I looked at his website, and they had a cheap studio. I thought, "Well the price is right. I'm gonna do what this guy wants to do." And that was it, and Steve is an interesting grump, and I kind of like him in a weird way, and we did this thing in his studio. It was not comfortable for me. I was surrounded by hawk-eyed interns just staring at this cultural figure, and I'm trying to make my fuckin' record, y'know? So the thing was kind of a mess, but we made the record.

J: AND WERE YOU HAPPY WITH IT?

I: Not really. But I don't mind it, and what's important is that we made the record. I wasn't particularly happy with it, but I did feel, I felt like we really tried to have the spirit. I do think that.

J: IT WAS THE FIRST STOOGES ALBUM THAT HAD OUTRIGHT HUMOR IN IT TOO. THE LYRICS, YOU KNOW.

I: Punk News, who hated it when it came out, has already published a revisionist article saying, "Actually y'know, looking at it again, *The Weirdness* wasn't that bad, and the only thing that makes [the next Stooges album] *Ready to Die* (2013) better is that it's so together." Unfortunately it's not responsible of me to the record company that gave us money to make it for me to say, "It's better because James just took a computer and absolutely just computerized everything." Auto-tune, digital vortex, every trick in the book. And that's why it also flat-lines when you listen to it.

52) Steve Albini (b 1962) founder of Big Black and recording engineer and producer on records by Nirvana, the Pixies, P.J.Harvey, Cheap Trick, Robert Plant and Jimmy Page, among many others.

Left: In Electrical Audio, Chicago during the recording of *The Weirdness*. Photo: Robert Matheu.

J: SO YOU CONTINUE TO TOUR VERY SUCCESSFULLY, AND THEN RON DIES IN 2009. WAS THAT UNEXPECTED?

I: Yes. I knew Ron liked a drink more than he should, and that's all I can say to you. I think I can say that much because I'm telling a lot more about myself. On the tour preceding it, on the end of the tour, one day he had an unstoppable, dire nose bleed in France, and we took him to the doctor, and the doctor saw that his blood pressure was very, very high. We have good people around us. I have very good people that work with me, very nice people. We got him good medical care and good meds.

I believe that when he went to Michigan with the lack of a good support person, and his Stooge-iness that he didn't take those. That he didn't take the warning seriously enough to refill the prescription, that's just my guess, and that in combination with his lifestyle for many years led to the heart attack.

So I was really surprised. We had seven gigs booked for the New Year. I called two guitar players. It's not as Williamson says. I called two guitar players, him and [Radio Birdman's] Deniz Tek,[53] checking availability should I wish to do the gig. It's just what you do as an administrator first. You cover all the bases. And Williamson wasn't available but said he might be later for something. Tek was available, and I decided not to do the gigs. Henry McGroggan [Iggy's longtime tour manager] told me, "Look, you don't have to do this."

But once I get on a roll, one of the big things that I tried to do to help myself, and it carried over into the new Stooges, once I got going again in showbiz, I wanted to be one of those artists where my word was my bond. You know I'm gonna show up. You know I'm gonna hit it hard. You know you're gonna get paid. And you build that up little by little, and your agents start to notice, managers start to notice, companies appreciate it, the relationships get better, and you can operate. So we did the same thing in the Stooges, and I'm just like, "Oh my God, cancel gigs? Oh my God, oh my God." But in that case, it was justified. People understood, and we were back up by the end of the year in Brazil.

J: THEN JAMES JOINS AGAIN. AND WAS GOING BACK TO JAMES A DEEP SOUL-SEARCHING EXPERIENCE FOR YOU?

I: No, not at all. All I do is this. What I do, I learned these things. I learned a lot working with Bowie, and then kind of adapted it to my own personality. What I do is I look at the material, ignore the people. Just ignore it at this stage 'cause it's not that other thing anymore, so I just laid out, I had *Metallic K.O.*, I had *Raw Power*, I had all the bootlegs, I had *Kill City*, and I just laid it out, and over two days, I listened to it all twice through, and I thought, "Time to do this." That was it. And I called him up, and he was all like, y'know he's had a Dale Carnegie course or something, he's all Texas business-friendly, and it's all fake, and that was okay. I can work with that.

53) Deniz Tek (b 1952) is the founder member of Radio Birdman. He was raised in Ann Arbor before moving to Sydney, Australia in 1972.

Right: Hammersmith Apollo, London. Photos: Robert Matheu, May 3, 2010.

J: I WANTED TO ASK ABOUT BEING INDUCTED INTO THE ROCK AND ROLL HALL OF FAME (MARCH 15, 2010). I'M A VOTER AND WAS ONE OF THE PEOPLE INDIGNANT THAT YOU GUYS WEREN'T IN. WAS IT MEANINGFUL TO YOU WHEN YOU FINALLY GOT IN?

I: It was meaningful. Again, it was like pulling teeth. I think the politics I went through helped, and Ron hated that.

J: PLAYING FOR MADONNA'S INDUCTION...[54]

I: Yep, playing with Madonna. I had already turned down accepting for Blondie one year because I found out—the invitation was a form letter from the Hall of Fame. Everybody got one [laughs]. So I was furious. And yeah, I think our playing for Madonna helped the tenured sort of people who vote for that thing know who we were and that we were okay guys! I didn't bleed. I went up and sang a song very nicely. Okay, one was out of tune. Well, the other one was pretty good, so yeah.

[Being inducted] meant a lot to me and I thought it was a great validation for Scott, and the real shame was the year after we played for Madonna, we didn't even get nominated, and Ron had a hissy. Ron had a full-blown nasty old hissy about that. He was angry, so he didn't get to live to see [our induction]. But that institution was and will continue to be helpful to the process of getting the group's music heard for a little longer, a little wider than it would, and it also helped the group in getting certain sort of bookings. And it's been helpful to me, individually, and I think it's now very helpful to James Williamson in this thing he's trying to do [his solo album of Stooges outtakes, *Re-Licked*] that he is a member of the Hall of Fame.

JK: YEAH, MASS MARKET AMERICA. AND KATHY ASHETON WAS THERE FOR THE INDUCTION, RIGHT?

I: Yeah. It was Williamson and his kids, Scott and his wife and his kid, Me and Nina, and Kathy at the table. The Boss [Bruce Springsteen] congratulated me and said, "That's long overdue." The Boss is a class guy.

54) When Madonna was inducted into the Rock and Roll Hall of Fame in March 2008, Iggy and The Stooges covered two of her hits, "Burning Up" and "Ray of Light." Michigan native Madonna personally asked Iggy to perform her songs at the ceremony as a protest against the fact that the Stooges had never been inducted despite being nominated several times. Ron Asheton gave an interview ahead of the performance and said that Madonna was "using us for business purposes."

Above: The Rock and Roll Hall of Fame induction ceremony. Waldorf-Astoria Hotel, New York City. March 15, 2010.
Photo: Michael Loccisano.

J: CAN YOU TELL ME WHAT HAPPENED WITH SCOTT ASHETON?

I: I had to tell Scott, "Look, for your health and for your legacy, you don't belong on the road right now."

JK: I SAW THE RAY-BAN SHOW IN WILLIAMSBURG WHERE HE WAS SUPERB FOR THE FIRST TWO-THIRDS OF THE SET. HE WAS MAGICAL, AND THEN HE JUST CRUMBLED.

I: He had that problem with his stamina right from the start in Coachella.

J: WHAT HAPPENED ON THE ROAD WHERE HE HAD HIS MYSTERY ILLNESS?

I: We were at a heavy metal festival, a very good one in France. Ozzy headlined one night, we headlined one night, et cetera, et cetera. And we have a way that we come on. It's supposed to be this instrument, that instrument, then this. Then there's a certain pickup note. He was late. He wasn't there for his pickup, and then—I think he wasn't feeling well—and then when he did get ready about two measures late, he came in with the snare. It was a stutter. It was a little off time, and then it deprived me of a certain pickup, something I wanted to react to visually, and threw me a little off. Then he caught it, got in there, and then on the fourth song either I fucked up 'cause I do sometimes. Not as much as the other ones because I'm more seasoned, but it was either James or I made a mistake where we were supposed to start "Gimme Danger" and "Open Up and Bleed" was started instead.

Now an interesting side comment is that any musicologist or just a common person who listened to "Open Up and Bleed," "Penetration," "Gimme Danger," or "Beyond the Law" will begin to notice they're all the same song. Very similar riffs, but everybody does this right? So there was that, and Scott just sort of slumped.

Because James had started the wrong song, well, it might have been James and it might have been me. But he just gave up, and I was mad. But I didn't say anything. We finished the show. Did a good show and I got off stage and [Scott's] really hard to talk to anyway and toward the end of his time with us most of the time he had his wife and kid out with him and they became a camp.

So I cornered him literally by running. They tried to leave 'cause I started to say to him in the dressing room, "Where were you on the pickup?" It's the same thing as with Dave, there's gotta be something here, some order. "Where were you on the pickup and why were you late?" And he just got up and started leaving, so I ran ahead of them, circled around, and got right in his face and said, "Why weren't you?" And he just said something like, "'Cause I was late," or, "'Cause I just couldn't make it." And he got on the bus to go to England, and the rest of us were gonna fly over and he was taking the bus on the channel, the tunnel, with the crew and a couple of the extra guys. He didn't like to fly.

And on the bus, he began bleeding profusely, and luckily it was far enough into the trip and he was going to London where we have very good connections and we got him very, very, very good medical care. And that was that. He did have a procedure done, and whenever you have a procedure done, that has a big effect on your chi energy. And he was not the kinda guy who was gonna lift weights. He just wasn't that sort of person. And then he had a back problem that was related, which is very typical with drummers. You get lower back problems. I have some spinal things. Guitarists get 'em. Guys who travel too much get 'em and also when you sit on a drum stool and do that long enough. So he also had a back operation, which went fine for him, down here in Florida, but those things slow you down. He had a doctor and he recovered a stability, but that was that. So anyway, he was never a basket case or anything, but we also noticed he was a little different, a little quieter.

J: WHICH IS SAYING SOMETHING WITH HIM.

I: Yeah, quieter than he was already. When he wanted to show you his personality, he was just a terrific guy. He was a great guy. He was the only guy in that whole fuckin' group that never gave me any shit, and he was the only one who finally owned up at the end. He still had his, y'know...He hated everybody. "Watt is not a good bass player. James...Why do I get the feeling James is about to stab me in the back? This music on the new album is way too conservative," which I kind of agree with. "Your vocals are okay, but you need to whoop." But that's nice. I like it. "You need to be whooping more. I want you to do some whoopin'."

Y'know it was all very nice and then y'know I got him to do some footage down here for Jim Jarmusch in case he ever is able to document the band. I thought it was my duty to the group to have somebody intelligent and knowledgeable with their own...a free integer.[55] Anyway, he said, "Well, y'know we lost our father when we were young. We never had the proper guidance. Made a lot of mistakes." He got that.

Anyway, that's the nutshell of what happened to him. That was in 2011, and he did come back for the one show. He did not want to communicate much prior to making "Ready to Die," and it was I who had to write him an email and basically threaten him in a really nice way to get him to call James and go into the studio. And then when he did, "'Cause he told me," he said, "I'll go in, and I'll be professional." And he apparently showed good attitude and did his best, and most of those tracks or a good half of 'em had already...James didn't wanna wait for Scott to get well. I can see his point. He might've known he wasn't gonna get well, and James is a guy in a hurry. Everybody's different. So half of 'em had been recorded already with [drummer] Larry Mullins[56] and he removed Larry and put Scott in, and the other half were actually done first time with Scott and that's how that was done. [Scott Asheton died from a heart attack at age 64, on March 15, 2014.]

There are some tapes of Ron and Scott that I have and am still trying to decide what to do with them. I made one into a song when I heard there was a Three Stooges movie.[57]

55) At the time of writing, director Jim Jarmusch (b 1953) is finishing up a documentary on The Stooges. 56) Larry Mullins (b 1966) aka Toby Dammit—born Lawrence Edward Crooke, drummer with Iggy Pop 1990-1999. He also replaced Scott Asheton for live Stooges shows. 57) Ron Asheton's final song, written with Iggy and Scott, was "3 Stooges," and appeared during the credits of the 2012 comedy film *The Three Stooges*.

What I really wanted, we finally got during the reunions. It was the public. The wonderful thing was whenever I couldn't play with the group, or enjoy the group, because Guy X was giving me shit, or they wouldn't learn the ending or things were backwards or something, I played for the public. And by the time we were all done, I played with the public. They and I traded all sorts of licks. The two reasons that it was hard for me to even think about hanging this thing up at this point was one, I needed to support Scott financially. He did receive over a million dollars from the group after he left off playing shows, and to be fair, Williamson carried his share of that. And the other thing was that I thought, "Well, we've finally gotten this about as good as it's gonna be. We finally united the repertoires." This is what I like. We were playing *Fun House*, *The Stooges*, *Raw Power*, and little extra bits, and we even threw in one of mine finally, because it helps, because everybody likes it and people knew it.

J: YOU KNOW, FROM A FAN STANDPOINT, TO SEE THE STOOGES GET EMBRACED LIKE THAT WAS INCREDIBLE...WERE RON AND SCOTT BLOWN AWAY?

I: I think they were. I think, as with James, what happened was that not having had any success and glory for some while, they had a nice large portion of that for a long time, and the other three principal fellas developed a hunger which is insane, which could not be assuaged. Their sense of injustice could not be fully righted. Ron got close. I got closer. I got to the point where, never with the second group, but with the first group when we would do those reunions, I'd be in tears because of the acceptance, because for whatever reason, something to do with struggle, the nature of struggle. But Ron got close, and Ron would say in interviews, "This is fine. This was the way it should be." Now I'm going to go out and buy three houses, get a mistress [laughs].

J: "I'M GONNA GET THAT ROCK AND ROLL LIFESTYLE I NEVER GOT TO..."

I: Exactly, and, "I'm gonna make a record. No more records with these weird Iggy ideas in 'em. I'm gonna be a real rock star like these," sort of things. And that's okay. That's okay. I just tried to serve. I tried to serve and be businesslike, and I just made sure that the live part was done as well as it could be.

J: WHAT DO YOU THINK THE LEGACY OF THE STOOGES IS?

I: Well, I think it's the eyes of a kid looking at the world. That's what I would say. The feel of the group emanates from looking at everything from a childish perspective. That's what I would say. There are good and bad things to come from that. 🐗

ESSAYS

What Does It Mean to be Iggy Pop by Johnny Marr 321

Josh Homme on The Stooges .. 322

Dave Grohl on The Stooges. .. 327

Joan Jett on The Stooges ... 332

About *Fun House* by Jack White ... 336

How Michigan is the Fifth Member of the Stooges – OR – A Cultural Cycling Through
Three-Hundred Years of Bullshit Historical Anecdotes and Arbitrary Facts to Argue
that Geographic Demarcation Can Be Personified as the Embodiment of a Musician
by Ben Blackwell ... 337

Stooges 1974 - 1977: Flesh Becomes Myth by Johan Kugelberg. 341

The Flesh Machine: Surveying the Indubitable Style of Iggy Pop by Jon Savage 345

WHAT DOES IT MEAN TO BE IGGY POP

by Johnny Marr

What does it mean to be Iggy Pop—five decades of being "the wildest man in rock"?

Iggy Pop is many things: Rock Star. Singer. Rebel. Primitive. Stooge. The Jean Genie. Passenger. Legend.

When someone sits across from him to interview Iggy Pop who are they talking to? A 21st century projection of an icon? A real wild child? The Idiot? I've been a fan since I was fifteen and discovering The Stooges helped change my life. I've been to many shows and seen him in his power.

A few years ago, I took to finding as much audio and video footage of him being interviewed as I could to go back and hear what he's said about his life and see how he deals with it. What I noticed first was just how often he's called on to discuss things that have little to do with his work and process, but seemingly define him. Drugs, blood, degeneracy, more drugs and trousers—and I was struck by how he always elevated the tone of the exchange, raising the conversation up to explain craft, songs, the life of a working musician and the machinations of the music industry if only to keep it interesting for himself and to maintain his own sanity, even if the interviewer didn't realize it.

He's a brilliant interviewee, interested and remarkably patient, and someone who obviously knows about people.

What does it mean to be Iggy Pop? Five decades of being "the wildest man in rock"? Rock star, musician, songwriter and craftsman. Philosopher, professional, James Osterberg.

Johnny Marr is a guitarist, songwriter and producer. In 1982, he co-founded The Smiths: the most influential British group of the 1980s. He has since worked with The Pretenders, Bryan Ferry, Beck, Electronic and Modest Mouse. His most recent solo album is *Adrenalin Baby: Johnny Marr Live*. He is currently writing his autobiography.

JOSH HOMME ON THE STOOGES

Jeff Gold: Thanks for agreeing to talk about The Stooges. I read that you first got _Raw Power_ at age 11. Is that right?

Josh Homme: I did, I bought the Misfits' _Legacy of Brutality_, Cramps' _Off the Bone_ and _Raw Power_ all in one go at Tower Records in San Diego.

J: You were the world's hippest 11-year-old! What made you buy those records and specifically _Raw Power_?

JH: Well I think just that the cover was so expressive and it seemed wild. I had luck buying an album called _Eastern Front_ that had someone with a haircut I had never seen that turned out to be a mohawk on it. I loved the music; it was a live compilation of all these bands and so in my 11-year-old brain, I thought, "Ok, so basically all you have to do is, if you like the cover you'll like the music." And what was really interesting is how off that idea was.

When I heard _Raw Power_, I didn't understand it. I guess it almost scared me at 11. Because I think in particular that record, and the mix of it, which I've heard many people say, "Yeah, well the mix is terrible etc." And I think to myself, "You must be out of your mind." That's a record that sounds the most like its album title of any record I'm aware of.

J: I completely agree. I saw them back then and that's what they were like. It was a big mess.

JH: I also think that if you were to rip a thick electrical wire out of a wall and shock someone, I just associate it with complete raw power. It's all guitar solo, vocal, guitar solo, and a little bit of snare and goodbye, that's it.

J: When did it start to make sense to you?

JH: I started to go down this path listening to Black Flag and things that were very DIY, and Black Flag had played the desert [where I lived], so I got into this pattern of just listening to punk rock music for years, and then started playing in a band. And Kyuss was a very strange band, and outside the rules of rock 'n' roll or things like that, so you make up your own. One time someone called and said we sounded like Black Sabbath. At the time, I think they were trying to give us a compliment, but I was offended. I'd never heard of Black Sabbath before, so I thought, "I'm not gonna listen to any music; that way I can say I haven't heard anything." And when I came out of that sort of 'forced exile' with music, right at that moment in time was when I really started listening to The Stooges' records. At 11 I'd heard _Raw Power_ and just put it away, and didn't listen to it again for years. So when I came back to it, and I understood it, it was like learning a foreign language and all of a sudden you can speak that.

J: You've said two of your favorite albums are Iggy's _Lust for Life_ and _The Idiot_ and that in fact, _Lust for Life_ had such a big influence on you that you quit your band Kyuss after that.

JH: Well, it wasn't just because of that. I was having all these struggles and was kind of on the fence, then I heard this music that really spoke to me and thought, "Geez that's the best it could be said, I can't say it any better than that." Those first three Stooges records are, to me, perfect rock 'n' roll —absolutely perfect. It's sweet enough for the girls and tough enough for the guys. It doesn't care about you, you have to care about it. It's on the outside, it's not a mainstream anything. It's not trying to fit in. It's the opposite, it's trying to amplify the parts that are different about itself.

J: Did you go back to The Stooges after getting into the Iggy solo records?

JH: It all happened right at once. I literally took all five of those records and I went in deep—it was the only thing I could listen to for about a year. 'Cause there's enough music there, song-wise and as a songwriter too. And then you start putting The Stooges in a time frame—in their time frame—and you realize it's the summer of peace and love in '67, they would have recorded [The Stooges] in early-'69, so the hippie movement is going full-on and the answer to the hippie movement from Ann Arbor is that.

J: That's true. The first Stooges album was released two weeks before Woodstock.

JH: What a wonderful answer to a beautiful idea. Hippiedom is a beautiful idea but the translation of it is kinda like a mess, you know.

J: It's such an amazing counterpoint.

JH: It's the most articulate counterpoint possible to me. And you know, for people looking to music for some awakening, or some sort of way to express their views or broaden their horizons, The Stooges would have been a scary thing. Something where you would have been like, "I don't understand this!" And it could have made you angry.

J: When I heard them, I didn't understand it, but I was really interested in it.

JH: Art to me is simply defined by a piece of work that elicits a reaction. Whether that's positive or negative, it's just you can't be stagnant as a reaction to it. And I think The Stooges—in any time—made this wonderful music that represents someone—it's real, but then you put it in that time frame and you go, "oh my god," they are completely by themselves.

It can never be done again. It embodies that time so well, that everyone hated it. In my first band, in our hometown, people you knew liked it OK, but when we left our hometown no one liked our band for three years. I don't care where we played—people hated it. And when I understood that that's what occurred for The Stooges, and that people that did like them were part of some dirty little guild, I was just so drawn to that notion that I soldiered on.

J: Did it give you hope?

JH: Well I always felt, "You don't like it because you don't understand." And if everyone, if a bunch of people don't like it, it's almost like an endorsement. You're very idealistic at Iggy's age, at Ron and Scott's age [when they made The Stooges]. I was about the same age, 19-20, and I never thought, "well, you're right we suck." I thought, "No, you suck, we're going somewhere you can't understand." And to know that the Stooges were doing that in that in 1969 seems heroic.

J: I saw a quote where you said, "If you take the craziest band you've ever heard and you play _Raw Power_ first, your craziest band ever will sound like a bunch of pussies."

JH: Absolutely. That's the Pepsi challenge to me. Listen to _Raw Power_. And then compare it to somebody else's record—and they're supposed to be wild and crazy—and it just doesn't work. It doesn't matter what it is, I feel like there's something so singular about that record in terms of it's title and where it's pointed. Because I know there's the purist idea of _Fun House_, and that record is impeccable. And Ron on guitars is a wonderful, primitive thing. It's very primitive and caveman-ish, with that Stooges elegance. But _Raw Power_ is fluid, and it does have that shake appeal to it.

J: I worked in a record store in the '70s and you couldn't find the first two Stooges albums; they were long out of print. So your choices were *Raw Power* and *Metallic K.O.* Was it hard for you to find those first two Stooges records?

JH: It wasn't because we had, unbeknownst to our town, a little store called The Record Alley, and it was so chocked full of imports, rarities, and had such an extensive punk rock, underground, no wave, and new wave [selection]...it would be harder to get Whitney Houston than it would be to find Stooges records. You're growing up, you don't have a reference point and it was just a beautiful gift by the owner. He went to high school with my mom, and he was a local dude who was like, "I impose good taste on the desert." It was very simple to get those records, and then I remember hearing that the band had been dropped. That the records had come out and someone at the record company, Elektra, was like "What the hell did you just pay for?" Kyuss was on Elektra, and they didn't understand us either. There's something to making something your record company can't stand. You know that all the work is on you. You saw The Stooges back in those days, I mean you're among a very small group of people.

J: I had this really interesting experience where I had sort of heard of Iggy and The Stooges, but I was really into David Bowie, so when he endorsed them and mixed and—I thought—produced *Raw Power*, I went to see them at the Whisky. It was mid-'73 and Iggy was so out of it. He sang this song with lyrics about butt fuckers and the Hollywood Hills that I had never heard, they played for 20 or 30 minutes max, and then he collapsed and Ron Asheton helped him off stage. It was an incredible spectacle.

And maybe 12 years later, I was working at A&M Records and we signed Iggy. I worked pretty closely with him. And one night, we were at a video edit and I and made a suggestion and he said something to the effect of, "Oh man, what do you know, you're not a fan of mine." And I said, "Hey, in 1973 I paid $2.50 to see you play for 20 minutes at the Whisky 'til you fell down." And he looked at the video editor and said, "make the change!" We never disagreed after that.

JH: See that's why I love Iggy. You know there's three truths: yours, mine and what actually happened. And it's important to try to live in that third truth as much as you can. And I found a really kindred spirit with Iggy, because he's not just gonna give it away. But if he understands the situation he totally will live in that third truth. And it doesn't matter if that's being very gracious about, "Oh this person did that, I didn't do that, my idea was this, but really he finished that," and so his story's that kind of truth you hear in the music...I mean that lyrical bent on those Stooges records is so easy to relate to when you're in the middle of nowhere, walking on the street with nothing to do. Why is there nothing to do? I'm searching. I've never seen anyone with that kind of willingness to take such vaulted risks just to see, if I take this giant risk will I find it? What is it? I don't know what I'm looking for. Where the hell is it? That search and that kind of leap—I've never seen anyone leap that far and that hard before.

J: Earlier this year, you told a writer for *The Guardian*, "Lemmy is gone, Bowie is gone"—I'll add Prince to that list— "Iggy is the last of the one and onlys. He made the shit that influenced more bands than any other person. Bring on the statues." And I was wondering, after making a record with him and touring with him, what you'd say about him as a person.

JH: Well, as I told Iggy in the beginning, "I'm a fan of your work, but that just means I'm going to be really honest with you, because I care what's going on." So from the outset, he and I have had this really wonderful relationship. And because of just being honest and kind of discussing things, what I've come to understand is this: He's a lover of women, but like a romantic—without being a creep, he's not a creep! He's fascinated by these creatures that ar-

en't us. He's kind to animals, he's compassionate in that way. He is not a pussy, but he has no interest in fighting with somebody, he'd just split like, "I'm outta here, fuck you, I'm not gonna stay here and argue with you, I'm not gonna waste my time on it." I respect that. And as I've gone through things in my life, I've kind of used Iggy as a litmus test for intake, for standing up again when you get knocked down. I've always thought of him as a success story, because no one's taken bigger chances and gotten knocked down more, but here we are doing this now. It would be very simple for him to have done this and brought his ego to the table, and instead he's still like, "Let's take a chance, let's make something that's different than that." I mean our record deliberately sounds nothing like The Stooges because you can't do it better than that.

J: And is that why you didn't play any of their songs live?

JH: I don't think he would have wanted to, but I just upfront was like, "I'm not gonna do that," because I'm also not gonna cover Bob Marley, or Jimi Hendrix. There's just certain people you just...in my opinion, if you love them, you listen to them.

J: Leave well enough alone?

JH: Yeah. I also am not a huge fan of reunions. I love moments in time and I think it's important to appreciate those. And once you have a legacy like that, if you were able to be a part of a classic moment in time, you preserve it, you don't destroy it. You don't dry hump it...it's better to parlay that into something else than to destroy that fragile thing.

J: But then there's the Stooges reunion. When I saw them for the first time in 1973, it was this disastrous show, but it was kind of incredible too. They played to maybe two or three hundred people at the Whisky, and the next year they broke up to complete indifference; no prospects, no record label. And 29 years later, the next time I saw them was the first reunion show at Coachella, and they're playing to 30,000 people going bezerk. And I'm kind of scratching my head going, "This is almost inconceivable." Did you see the Stooges' reunion? What'd you think of it?

JH: We played with them in Italy and you know, the first thing is I think is The Stooges have the longest time-release of any rock 'n' roll band ever. I think it took what, probably 35 years or more for the mainstream [to catch up], to have it be a sizable enough audience for them, where people understand it now in a very conscious way, now it's, "The Stooges are awesome." Because you were there—people didn't like them, they got dropped, and no one wanted to touch 'em. But artists like Bowie and all these other artists saw something that they themselves could not do, and that was primal and intelligent, articulate but sloppy. But rhythmic like that. These are special albums, and you saw a show that was 20 minutes of a mess, but I'll take that over a James Taylor show. Nothing against him.

J: —No, it was unforgettable—

JH: Yeah—that's right—unforgettable, the only goal. The only goal for being here. The reason to be here. I have not a single interest in making sure that I'm in something competent or sturdy, or well-represented. Success, for me, it doesn't have anything to do with money or being big. In fact those things are dangerous because they fuck up art. That show you saw was unforgettable, that means it was fucking perfect. It starts with, "what a mess."

One thing I spoke to Iggy about was how the Hendrix family has been trying to white-wash Hendrix now...like he was just a guitar player. And the stories of wildness and experimentation, regardless of whether or not that's drugs or just psychological, artistic...are sort of

put on the back burner, so that he's just a "dumb idol" or [on a] poster. We were talking and Iggy's like, "Well there's some stuff that's embarrassing, some things that I've done." And I said, "Yeah, well people get fucked up, but you were an elegant fuck up." You watch the Tom Snyder interview, with his tooth missing and the bloody lip, and his lips are sticking to his teeth because he's so high. But he's so eloquent and amazing and the energy is so cool, it's the most watched Tom Snyder [episode]...and it would have been considered a disaster in the time, certainly.

J: You talked about The Stooges being time-release; here we are in 2016, and the album you just made with Iggy is the highest charting record of his career.

JH: I don't like to tell someone what "the truth" is, because it's like noise coming out of your face— "You know, the truth is blah..." I'd rather have an event occur, and then we stand next to each other and we look at it, and talk about what it is, for us. So Iggy was saying to me, "I've never put out a record that was recognized in it's time. Ever." He just started going through his list, and though I knew it, [he] sort of compressed into one conversation: "*The Idiot* came out and it was too weird, then *Lust for Life* came out and all these other big records came out the same week, and then from there it was downhill, and I never expected anything to happen." We had this conversation right after the Colbert [appearance] and the Internet just went on fire. And I said to him, "Many people have put out a record and it was huge and then they're gone, they copied themselves, they lose the plot, they fade out, they die, whatever. But you're the guy that wins at the end. Congratulations, that never happens." Once again, he's doing the only thing no one else does.

J: And it's real with 0% calculation.

JH: Yeah, it's going with your gut, even though you have a brain—a big brain—but just saying, my brain says go with your gut, there you go. I'm a bit of a fatalist, and some people are born to do it. And he's this confluence of events, this amalgam of things; some are physical, some are mental, some are things that happened. He was raised in a trailer for god's sake; that'll make you work. And not one to fit in. So many people feel safer fitting in, but what do you get there? What do you get?

J: Knocked down a thousand times and each time he gets back up.

JH: Often the hurdles in front of you are handmade by you; they're tailored just for you to fuck you up. And he's like a hurdle-maker as you know, but also he's found a way to get on it, over it, under it, through it, who cares, just keep going. And I understand that, I know it well. For me, it's a great honor to be part of him having his first success in his time, because it would be very difficult for you to find someone who is more deserving of that.

Josh Homme is a song-writer, guitarist and founder of Queens of the Stone Age. His other groups include The Desert Sessions, Eagles of Death Metal, and Them Crooked Vultures. His credits as a producer include albums by the Arctic Monkeys and Iggy Pop.

DAVE GROHL ON THE STOOGES

Jeff Gold: Last year, in a *Rolling Stone* article about Joan Jett, you talked about watching the reformed Stooges at a European festival with Joan and Pat Smear. You said, "In that moment I understood the lineage." You talked about Iggy's influence on Joan and The Runaways, her support of the LA punk scene that produced the Germs and Mike Watt, and in turn their influence on Nirvana. And that none of it would have happened without Joan as a rung on the ladder. And I'm thinking that the Stooges were the bottom rung on that ladder. A lot of people have cited them as the beginnings of punk.

Dave Grohl: Well I think that, that night in particular [at the 2011 Isle of Wight Festival]—sitting on the side of the stage—it really was a huge revelation to me, how this is handed down from one person to the next over generations. You connect with an artist for different reasons when you're young and you're listening to music. You are connecting to things that you relate to, you're searching for identity and you feel comfort in knowing there's someone else out there that feels the way you do. So the energy of Iggy and the Stooges is, I think, the genesis of so many rock 'n' roll bands today and you know, in 1969 or whatever it was, back in the late-'60s, I don't know anyone else who had reached that level of cathartic chaos on stage. I know there are Jim Morrison comparisons, but [The Stooges] took it to a place that no one else ever had. I think that made such a lasting impression on musicians for decades to come. It's something that you search for, and that night as I was sitting on the side of the stage I was fixed on Iggy and the band, but at one point I looked and I saw Joan, and I saw Pat, and I saw Mike Watt. And it really was—all the dots were connected in that moment. I thought without Iggy, and that energy and that band, I don't think any one of us would be doing what we do today, the way we do it. It was really cool just to be within 30 yards of that experience. I think that listening to those albums, when you're young and you wanna play music, you're overcome with this feeling of unworthiness like, you just think wow, you're listening to *Sgt. Peppers* thinking, "God how on earth could I ever do anything that could even get close to George Martin and The Beatles." It's unattainable. And you're rifling through Yes records, and Rush records, and Genesis records, albums that are based on proficiency and a technical musicality. And then you hear something like the Stooges, and you realize that's not necessarily what it's all about. Of course they are songs, and of course they're great players, but it's so raw and so real, and you realize that you're capable of doing this as well.

J: That it's within striking distance.

DG: Yeah, I think that basic human element is what inspires people to try. And I know, as a kid, the allure of punk rock and garage rock when I was young was that I could learn these songs and I could play them in my bedroom by myself, and that inspired me to write songs of my own. And that didn't necessarily happen with—you know I didn't pick up a guitar when I was 11 playing fucking "Blackbird." That took me 20 years to figure out. So I think that that basic, raw energy and the fucking passion of the band is what lit the fire under a lot of people's pants. And I was one of them for sure.

I can imagine Joan listening to *Raw Power* for the first time, and then I can imagine Pat seeing The Runaways for the first time, and then I can imagine Watt seeing the Germs for the first time, and me getting my first Minutemen album. It makes so much sense. It's the perfect equation and it goes on and on. And it's not often that happens, when you get that many people in one space, that bestow the line like that.

J: It's funny, I was a huge Bowie fan and a huge Iggy fan, and in 1977, when Iggy toured with Bowie playing keyboards in his band, I was waiting for them at the Santa Monica Civic before the soundcheck. And the other people waiting to see them were [The Germs'] Pat and Darby Crash.

DG: I knew Pat and Darby used to hang out at this record store in LA called Licorice Pizza.

J: They also hung out at Rhino Records, where I worked.

DG: There you go!

J: ...and shoplifted records!

DG: Did you ever hear the story about when I jammed with Iggy in Toronto? This is the fucking best. Ok, so before I was in Nirvana, I was in a band called Scream from the Virginia/Washington DC area. And we did a lot of van touring through Europe, America, Canada. I think it was 1990, we had a gig in Toronto so we drove up to Toronto from Virginia, spent the night at a friends' house and had the gig the next day. I kinda wanna say it was at Bovine? I don't remember exactly what club it was but, so our singer calls the club the night before and says, "what time should we come in for soundcheck?" And they said to come in at noon for soundcheck. And he said, "ok...wait what time do we play?" And they said 11 o'clock at night. And Pete said, "well could we come a little later?" And he said, "no, if you're not here at noon you don't get to soundcheck; we have an event at the club." So we said OK, got down there early afternoon and we were setting up our stuff on stage, and they were putting up all these [Iggy Pop album] *Brick by Brick* posters in the club. Empty club. And they're just putting up *Brick by Brick* posters. So eventually we asked someone who worked there, what was up with all the Iggy Pop shit. And they said, "oh, well he's having a record release party here before your gig." And we thought, "Oh my god we get to stay and see Iggy Pop, that's amazing!" And they told us, "no you guys have to leave, it's only for the label and the band." And we said, "well wait, we have to watch our equipment and make sure nobody steals it!" Nobody's gonna steal you're fucking gear. So we left. We went out back and we were sitting in our van in the parking lot, with nothing to do in the back alley, and here comes this limousine. Pulls up, trunk pops open, Iggy Pop jumps out and grabs a guitar. And we can't believe that it's Iggy Pop in the flesh, in the same alley we're sitting in. We think, "oh my god that's amazing!" So he goes inside, we have nothing to do so we're sitting in our van, a couple minutes later someone from the club walks out to the van, knocks on the window and says, "hey, who's the drummer?" And I said me—I think I was 19 years old—he said, "do you wanna play drums with Iggy Pop?" And I said, "OK!" So I jump out of the van, run into the club, and Iggy is standing there onstage with a guitar and a Marshall stack, by himself, trying to get sound on his amp. He's got his glasses on and the guy from the club says, "hey, this is the drummer." And Iggy says, "Hi, my name's Jim." And I said, "Hi, I'm Dave." And he said, "Do you know my music?" And I said, "Yeah I know your music!" He goes, "You wanna jam?" And I said "sure," so I sat down and we started jamming on like, "I Wanna be Your Dog," and "1969," a couple things, it was just really fun, just guitar and drums. Then he starts showing me some new stuff like "I Won't Crap Out," and there was another one too... I think it was "Candy." I can't remember. So we jam on stuff for maybe a half hour, forty-five minutes and then he says, "Ok we go on at 5 o'clock." And I said, "Oh you wanna do this tonight, in front of the people?" And he said, "yeah." And I said, "Don't we, don't you want a bass player?" And he's like, "oh you got one?" And I said, "yeah!" So I ran out to the van and go "Skeeter!"—(who's the bass player)—"Get out here! We're fucking jamming with Iggy Pop!" And so, we have four or five songs, and I remember when the party started the record company thought Skeeter and I were his band. And it's funny because, at this point in my life, I was working in a furniture warehouse and I think my per diem on the

road was $7 a day. I don't think we had a record company, I'm not sure. And so the record company guys would come up and say, "Can we get you guys anything?" And Skeeter and I would look at each other and I'd say, "Could you get me a carton of Marlboro Reds?" And they'd say "sure!" And then Skeeter would say, "Oh well then I need a bottle of Hennessy and a 12 pack of..." and for that one night we were treated like rock stars. It was fucking awesome.

J: I've never heard that story...

DG: Oh my god, it was fucking great. And the funniest thing is that Iggy, of course, was the nicest, sweetest person in the world. And I couldn't believe that we were hanging out with one of our heroes—it was fucking insane. This was not meant to be—or it was meant to be—it happened. I couldn't believe it like, and he was so sweet to us the whole time. And when it was time to go on, Skeeter and I started with the bass and the drums, and I just had this wonderful, pleasant afternoon with 'Jim' and then 'Iggy' jumps up on stage and the first thing he does is grab the mic and goes, "FUCK YEAH MOTHERFUCKER," to the room full of record company people. Oh god, it was amazing. It was fucking crazy. And I don't think I saw him again, I honestly think the next time I spoke with him was when I was at the Isle of Wight show, and it was like 21 years later. I hadn't seen him since then.

J: Did he remember it?

DG: Yeah he did! It's funny because I guess the guy remembers everything. I mean I'm sure you've got a couple lost weekends here and there but...

J: Even not factoring in his drug addiction and his self-abuse, you'd be hard-pressed to find someone who remembers as much. But when you factor those things in, it's almost impossible.

DG: Exactly. It kind of blew my mind. We talked about it a little bit and I don't know, I just saw him recently on tour with Josh—the show was fucking great. But I haven't hung out with him since I was 19.

J: You and Iggy both started out as drummers in your first bands, and evolved into lead singers and frontmen, which is pretty unusual. Iggy told me being a drummer was "really, really, really important" to the sound of The Stooges. I wondered if starting out as a drummer in some way influenced the music you made later, after you stepped to the front.

DG: There's a certain responsibility as a drummer that I don't think you carry with any other instrument. It's your name at the bottom of the check, and you create the feel and dynamic in the band. I think drummers get a bad rap for being Neanderthal fucking hoodlums. Most of us are, but there's a subtle science and magic to creating dynamic in a song on the drums. It's not how hard you hit something, it's not necessarily how many fills you throw in there, there's a lot of space, a lot of feel—it's like dancing. I think that the best drummers are the ones that close their eyes and just let go. Scott Asheton's a perfect example. When you hear those songs, they don't sound the same when someone else plays them. Not to say they don't sound good, but I think drumming should be a direct extension of your personality, and I don't think it has anything to do with technical proficiency. I think it has to do with the way you would tell a joke. The way you would tell a story, except you just do it with your eyes closed and with two sticks in your hands. I think that the drums can be a very expressive instrument that maybe is misunderstood. I think that as a drummer, it's almost like you're the goalie, you don't really get all that much of the fame and glory back there...

J: ...but the whole thing falls apart without you.

DG: You're that link in the chain that you hope holds out for the whole set. I don't know that I relate to drummers more so than I relate to any other musician, just because I can stand on a stage in a stadium and go round up a bunch of people to sing the chorus of a song. But at the end of the day, I always turn around and get my head in the drum set because that's where I feel at home. I think maybe also as a drummer Iggy is a pretty physical human being, and all that energy he has, I'm not sure if he could have contained it much behind a drum set. I think that a lot of singers that started out as drummers become really energetic frontmen, because they need to fucking put it somewhere and they don't have those two sticks in their hands anymore.

J: On the list of his favorite albums, Kurt Cobain picked *Raw Power* as number one, and called Iggy a "total hero." I wondered if you have any thoughts on how Iggy or the Stooges influenced Nirvana.

DG: Well in that same way that I think there's an honesty about that music, that was something we strived for as a band. When when we sat down to jam in our rehearsal space in Tacoma, Washington, there wasn't a lot of specific or technical conversation about songwriting or arranging. We just started playing something and maybe it came together into a song. And you could just feel where the change was supposed to be, could feel when the chorus was coming, that quiet/loud dynamic that people talked about a lot came from just jamming. I could tell when the chorus was coming, because I saw Kurt's Converse sneaker about to hit the distortion pedal, so I did a big fucking slam and then it came in big you know. There wasn't any detailed conversation about arrangement. It was just feel. And I think that came from albums like *Raw Power* and a lot of the punk rock records we listened to back then. Clearly there is a connection between the two. You can tell that it was more than just going into a studio and then jumping up on a stage. It was a lot of something else in there for sure.

J: Last question. I'm really interested in the myth of the Stooges, this crazy dichotomy of how they broke up in 1974 to total indifference, drug addicted, out on the street, virtually homeless. But people kept listening to the records, citing them as an influence, playing their music live, and Iggy kept making records, and 29 years later they reunite and play at Coachella in front of 30,000 people going nuts. While they were defunct, they turned into gods and reemerged as conquering heroes. I wonder if you have any thoughts on that.

DG: As with any good record, those albums should be considered documents. I think they represent a moment in time that, thank god, was captured on reel tape, and that is timeless. If I were to play those albums for my 10-year-old today, she would get it. We live in an different world today, and the next generation of kids or musicians are growing up in an entirely new world. But what those albums contain and represent is timeless. When you listen to those albums, you have a visceral, human reaction to it. You know what it means. You don't even have to understand what he's saying, you hear the sound and you know what it means. I think myths are a funny thing, legends are a funny thing. But when you stand in front of it as it's happening, there's no denying the reality of it. For people to get the chance to see The Stooges for the first time, I'm sure that they understood completely why they were headlining in front of 30,000 people. Ask one band on that bill at that festival, try to find one band on that bill at that festival that wasn't influenced by The Stooges or Iggy in some way. I don't think that festival would be there if it weren't for fucking Iggy Pop, to be honest. So yeah it's crazy.

I got a record player for my daughter when she was maybe six or seven years old and watched her discover The Beatles for the first time, on vinyl. Someone had given me this box set as a

gift, and she already loved The Beatles' music, but hadn't done the vinyl thing yet. So I hooked up the record player, put the box set in her room and just closed the door. And I came back a couple hours later and there she was, sitting on the floor, looking at the booklet of the *Magical Mystery Tour*, reading all the lyrics, looking at all the pictures, trying to find her favorite song on Side A, Side B. And what I realized is that she was doing exactly the same thing I did in 1975. We do live in an entirely different world than back then, but we're still human beings, we're not robots. Even though the world is flooded with new technology and modern change, human beings will be human beings, until the end of time. There are some things that just don't change. The human reaction. The first time you hear "Let it Be," "I Wanna be Your Dog," first time you hear "No Fun," it happens to them the same way it happened to us back then.

It gets me kinda choked up sometimes. I went to go see Dylan, and the first time I saw Dylan I was in tears, because I felt like I was watching Abraham Lincoln give a speech, like I was watching Martin Luther King. I feel like I was part of history in that moment, and I think Iggy has the same effect.

Dave Grohl is a songwriter, a multi-instrumentalist and the founder and frontman of the Foo Fighters. Between 1990-94 he was the drummer in Nirvana - all through their spectacular success - and has since worked with David Bowie, Paul McCartney, and Iggy Pop among others. His film work includes a director's credit on the 2013 documentary feature, *Sound City*. He was inducted into the Rock and Roll Hall of Fame in 2014.

JOAN JETT ON THE STOOGES

Jeff Gold: I've read that before moving to L.A. in 1974, you were reading *CREEM* and *CIRCUS*, both magazines that wrote a lot about Iggy and The Stooges. I wonder if they'd made it on to your radar before you moved West?

Joan Jett: Oh—they definitely made it on my radar. But where I lived at the time (Rockville, Maryland), I really had no way to find the records or the music that was being written about. You know what I mean? So it was just something I would read and fantasize about someday— either doing those things or getting to a place where I could hear that music. So I knew about Iggy and The Stooges, but I didn't know—I hadn't heard the music before I moved to L.A.

J: And pretty soon after moving, you start going to Rodney's English Disco in Hollywood, which you'd read about. You were 14 and got your mom to drive you there.

JJ: Well yeah. As soon as I had made a few friends that were willing to go to Hollywood with me—you know it wasn't on the radar of any of the people that I knew—it was just something that I was into, and I really didn't know the kids around me, what they were into, but they didn't seem to be interested in this sort of stuff. So eventually I talked my mother into driving me to this place, and I described that Rodney's was a rock 'n' roll disco for—really for under-age kids, who couldn't get into other clubs. They didn't serve any booze or anything like that, it was just really a rock 'n' roll disco, and Rodney would play mostly English music, but some American too, obviously, with Iggy and The Stooges, but all the stuff that you couldn't hear in the States really. Like David Bowie, and The Sweet, T. Rex, and Suzi Quatro, just a million bands that you weren't really familiar with, you didn't hear on the radio. Stuff like that. I'd heard David Bowie—his first singles, "Space Oddity," and "Changes," and all that stuff. It was starting to connect that I'd heard this artist on the radio, but once you went to Rodney's—vi-sually—it was so visually stimulating. The music was like nothing I'd ever heard before and I completely was enamored and in love with the whole thing.

J: Was your mom dubious about letting you go there?

JJ: She was probably a little nervous, like most parents probably would be letting their kid out. But I think that she was living a little vicariously through me, in a way. She was really into it—remember, my parents bought me a guitar for my birthday when I was thirteen, so I'm not sure that they were surprised that I wanted to go to places like this. And I'm sure I was babbling about it as I was reading about it back in Maryland. You know, talking about it, "If we ever go to California, I'm gonna wanna go to this place" [laughs]. So when I got out there, you know, she let me go and I was able to go back many times.

J: And do you remember what you first thought when you heard The Stooges and Iggy?

JJ: "Wow, now it's great to hear some American guys do this kind of music." I just thought Iggy and The Stooges were so authentic and real. And obviously when I was at Rodney's they would play all The Stooges stuff. You know, "No Fun," and we'd get on the dance floor and dance. I also loved that Iggy was so free with himself on stage, and to see such a reckless band that was connected to the music was...it felt very familiar to me. Because I think that's how I feel about music when I do it. You just get really connected to it, and into it, and not thinking too much—just being the music. And that's what I thought Iggy was, you know, just so—it showed live, you know? Not that I ever saw them, but I saw many, many videos, or whatever you would call it, back in the day.

J: I know Iggy was around that scene, kind of peripheral to it, but the one time I went to Rodney's, I saw Iggy there. Did you see him? Or did friends of yours have Iggy sightings on the strip?

JJ: You know, it's kind of hard to remember. I know at one point, while doing The Runaways, I heard that Iggy and Bowie came to a gig. I'm not sure where it was, and I'm not sure if that's true. But after The Runaways, when I started the Blackhearts, we got the opportunity to tour with Iggy. In 1980, it was our first real tour after The Runaways. And we played, maybe ten or fifteen gigs with him. And it was awesome, because you got a chance to, not only play with him, but then get a chance to watch him afterwards, which is really the treat.

J: And it was kind of a vote of confidence for you guys, too. Right? Because you weren't established at that point.

JJ: Oh absolutely. It was a big vote of confidence. Yeah. I mean, Iggy—you know—I can never thank him enough for making me feel legitimate...in the way I wanted to feel legitimate. You know, like playing with Iggy Pop was cool.

J: And what was it like when you finally met him? When you went out on the road together?

JJ: He was very, very nice, down to earth, and funny, and just sort of awe-inspiring to me. You know, it was kind of scary, but something you just had to do because you looked up to him so much. But you know, it can be intimidating to meet people you look up to, but I felt very comfortable with him, and consider him a friend.

J: He's surprisingly easy to talk to, I find. Considering his onstage persona all these years.

JJ: Well yeah. And I can speak to that just from my own experience, that no matter how close your real persona is to the image, I know that the image can really affect how people are with you, obviously. If you've got a really intense image, people can be kind of scared or intimidated to talk to you, and can be very pleasantly surprised when you're approachable. I think that's how Iggy seems to me—approachable. Once you pass that sort of, "Oh my god, it's Iggy Pop." You know? And once you get over that hump, he's very down to earth and comfortable.

J: In reading Todd Oldham's book on you, which I really enjoyed, you talk about guitar playing being sexual. You say, "It's the raw power. Makes me think about 'I Wanna Be Your Dog,' just raw emotions, raw hormones, raw potential." You mentioned being glad that The Stooges were an American band doing this stuff, but...can you elaborate a bit about how you see the sexuality of it?

JJ: Oh yeah. I mean, the strange thing is—at least when I was growing up, it's probably different today, [because] kids are aware of things at a much earlier age than I was. But I remember, I think it was the song "All Right Now," by Free, and sort of the out of tune guitars. I can't really explain it, but there's something in hearing a certain kind of loud guitar, the way it's put together... The guitars with the bass and the drums, and obviously whatever that music is, it's an intangible thing, so I can't point to exactly why some songs have it and some songs don't, or some bands have it and some bands don't. It's just a raw power, that's exactly the perfect way to describe it. It just sort of hits you...in the crotch! You know, as a twelve-year-old, or thirteen-year-old, you weren't really aware of those connections. You just knew that it made you crazy. It's the kind of music—I just want to fling myself against the walls and just bounce around to. I can't really explain it, but it definitely speaks to sexuality. It's something that's deep within, it kind of turns you on. And as I got older, I was able to sort of, figure that out, but at the time I just knew I loved it.

J: To me, the most meaningful music is the stuff that affects you in some way you can't quantify, and is kind of the opposite of a lot of the stuff that's coming out today, that's done by formula.

JJ: Yeah, and you know, something so straightforward. Like, "I Wanna Be Your Dog," that's so... forward. So primal. It's so right there with what is being spoken about. It's raw sexuality. And I guess it was at that point, as you start to listen to lyrics, and you start to figure it out. Dancing to something like, "I Wanna Be Your Dog" with my friends all those years ago, and then you [think]..."Damn, I wish I had written this song!" That's led me to definitely cover some things that I would have loved to have written, like "I Wanna Be Your Dog." It's always such a fun song to do, because people do get really, really into the lyrics, you know? They know right where you're coming from.

J: There was an article about you in _Rolling Stone_ last year. They asked Dave Grohl about you, and he remembered standing with you and Pat Smear at a European festival watching the reunited Stooges. And Dave Grohl said: "In that moment, I understood this lineage." He talked about Iggy's influence on you and The Runaways, your support of the L.A. punk scene that produced The Germs and [future Stooges bassist] Mike Watt, and their effect on Nirvana. And he said, "None of that would have happened without Joan as a rung on the ladder," which I thought was really right on and true. I wondered if that's something that resonates with you?

JJ: It resonates in that, it makes me feel...[laughs]...a little uncomfortable. In the sense that, I don't think of myself in that way, and it's hard for me to go, "YEAH! I'm a rung on the ladder!" You know, it feels a little too...too boastful to me. You know, I'm really—I really—I appreciate it. I get what he's saying... I really get it. But for me to say that, I—I can't do it, you know? That I would inspire other people to feel that way is...in and of itself, I think, enough. Do you understand what I'm saying? I'm not in any way, criticizing it—

J: —Completely.

JJ: I just feel funny accepting it. But I'm glad if other people think that—that's amazing! Especially someone I respect as much as Dave.

J: I was in L.A. at the time, working at a record store, and I knew the guys in The Germs a bit, and it seems like a really—I wouldn't have put it together—but a really kind of trenchant observation. I buy it.

I know you and Iggy admire each other. You contributed two songs to the 1997 Iggy tribute album and acknowledged him in your speech when you were inducted into the Rock and Roll Hall of Fame. And a couple of years ago, when he presented you with an award from PETA (People for the Ethical Treatment of Animals), he said, "I came out because I'm a huge fan of Joan's, and I really wanted to show my support. When they asked me, there was no way I wasn't going to attend." So I just wanted to ask, as a closing question, what Iggy and The Stooges' music means to you? And what Iggy means to you as a person?

JJ: Wow. That's kind of an epic question. I mean, to me, sometimes too much analysis of something so basic as that sort of pure rock 'n' roll raw power thing that exists, it's...kind of hard to analyze it. I would absolutely say that for me, Iggy and The Stooges have to be one of the greatest American rock bands that have ever been. You know, because of what I think is—the whole reason you play rock 'n' roll—the sort of guttural, primal thing that connects with other people. And that's the main thing, for me. I play music to connect with people. People that are

different than me, maybe in other respects, but here in this one place we totally come together. I think that's what everybody is really looking for in life, some level of connection with other people. So, for me, he really speaks to me in that way...that I get it. I get what he's—what they were sort of putting out, and it was very obviously inspiring to me. So, in a way, I can't thank them enough for helping to make me who I am. I've said it before, but I consider Iggy a friend, someone to look up to, someone to emulate, if you want to be a rock 'n' roller. And I'm just really proud that he's been part of my life, my career...and he's an essential part. You know, if you remove that aspect, who knows if I'd be who I am.

Joan Jett is a guitarist and songwriter. In 1975, she co-founded The Runaways, the pioneering all-girl group. In 1979, she formed her own group, Joan Jett and the Blackhearts: their best known record is the 1982 US number one record, "I Love Rock 'n' Roll." She was inducted into the Rock and Roll Hall of Fame in 2015.

ABOUT *FUN HOUSE*

by Jack White

I found the first Stooges album when I was 16, in a dumpster in the alley behind my house. I was enthralled to discover such a gem with no help from anyone (thanks, St. Anthony), but it took two more years before I bought *Fun House*. Boy, was I upset that no older brother had ever rested that record on my pillowcase. I put it on a cassette—a format that I hate—but that's what I had in the truck. And that tape lasted about three months before it fell apart. I played the hell out of it, like someone was gonna break in and take my tape deck while I was driving. I remember screaming in my head, "This is Detroit!" And that's what *Fun House* is to me, the very definition of Detroit rock 'n' roll, and by proxy the definitive rock album of America.

The record's passion, attitude, power, emotion, and destruction are incalculable. A milestone in rock 'n' roll so overlooked it's despicable. We live in an age where people like James Taylor are inducted into the Rock & Roll Hall of Fame before The Stooges. We watch a music TV station that's never heard of "TV Eye." We shop at record stores where those who have only imitated Iggy's power are selling by the truckload, while *Fun House* didn't move enough copies to prevent The Stooges from being dropped by their label. Well, by we, I mean not me—I mean them. If you bought this record you're no longer them, you're it, like in tag. Give it to your little brother and run freely.

(Reprinted from the 2005 Rhino reissue of *Fun House*)

Jack White is a songwriter, guitarist and co-founder of the White Stripes. His subsequent groups include The Raconteurs and The Dead Weather; he has also released two solo albums. He founded Third Man Records in 2001 and Third Man Books in 2014. His most recent studio album is *Lazaretto*.

HOW MICHIGAN IS THE FIFTH MEMBER OF THE STOOGES – OR – A CULTURAL CYCLING THROUGH THREE-HUNDRED YEARS OF BULLSHIT HISTORICAL ANECDOTES AND ARBITRARY FACTS TO ARGUE THAT GEOGRAPHIC DEMARCATION CAN BE PERSONIFIED AS THE EMBODIMENT OF A MUSICIAN

by Ben Blackwell

The borders of Michigan are arbitrary...the survey lines of the Northwest Ordinance of 1787, a southeasterly adjustment for a bloodless war with Ohio for the desirable international port of Toledo (the loss of which Michigan got its Upper Peninsula as compensation) and a veritable shit-ton of lakes cut a cute geographic form that can equally be called America's high-five or America's hand-job.

Despite this, the entire state of Michigan is incredibly average. There's nothing of note that really makes it any different from Ohio or Wisconsin or just about any other boring state that doesn't have mountains or an ocean or hieroglyphs or any sort of cultural accelerant.

So, too, with Ron, Scott, Iggy and Dave. They all came from an entirely average, middle class world. That is the only place from which they could emanate. To be more specific, Michigan is the only place a cultural roundhouse kick like the Stooges could ever be birthed.

As the birthplace to both Domino's and Little Ceasar's pizza chains (two of the top four pizza dispensaries in the world, both raking in BILLIONS of dollars every year), it is the unique incubator of Michigan that has a knack for taking what may have been considered low-brow or intended for the edges of society in the mid-1900s and perfecting it, simplifying it (the $5 Hot'n'Ready is marvel of modern economics) and making it understandable for a widespread global audience. As some of the first Western records pressed in the newly opened Russia after the fall of communism in 1991, the hand-illustrated, Cyrillic-bedecked covers of the band's first two albums are proof positive that this is exactly what Iggy and the Stooges did with their brand of juvenile delinquent-inspired rock and roll. Which coincidentally, goes hand-in-hand with pizza.

And being birthed in Ann Arbor is fitting. With the University of Michigan looming large over the entirety of the town, everything in that city has an air of elitist self-importance. The classic joke goes, "How do you know someone went to the University of Michigan? Let 'em talk for five seconds...they'll tell you!" Coupled with the town's overwhelming left-leaning politics (the Stooges were close friends with folks who bombed a CIA office in the city in 1968) and it's clear the only place to birth the Stooges, wholly unconcerned with politics or elitism, is a town boiling over in it.

The Unabomber, Ted Kaczynski, was educated at U of M, leaving the institution in late 1967. The possibility of him crossing paths with Iggy are nil, but it's not too big a stretch to correlate that the anarcho-primitivism argued in Industrial Society and Its Future ("The Unabomber Manifesto") is in some bizarre way in concert with the precisely sparse lyricism and uncluttered instrumentation of the Stooges' self-titled album. That's not to say "I Wanna Be Your Dog" is tantamount to serial killing...more like the absolute inverse. As Kaczynski and Iggy are on completely opposite ends of the spectrum, but both so completely laser-focused, so singular, so undistracted by the noise clouding around them that it's clear the environment had to be somewhat instrumental in fostering those traits.

Jack Kevorkian went to U of M too, but I can't find the connection there.

This cannot happen in socially-conscious San Francisco of the same era. It would not happen in the fading Village folk scene in NYC as it slowly transformed into glam and punk. Ann Arbor, Michigan, where the rural abuts with the avant-garde on a daily basis, was the only incubator that could birth these bozo geniuses. Michigan is not just where important and relevant moments of this band and its story happened to take place, it is a driving factor and overbearing presence throughout their existence, whatever the locale may be.

You see, Michigan is not a state where anything happens. Outside of Detroit, and a much lesser extent Ann Arbor, it's all ho-hum humdrum non-descript bullshit. So of course, leave it to Halloween night, 1967, at a house party in Ann Arbor to be the moment this wrecking ball descends into public consciousness. Of course this primitive shit music is taking place at an "invite only" party. Of course John Sinclair and the MC5 (both already important leaders in the countercultural underground of the time) are there. Of course joints are being passed around liberally. Of course it sounded like the Melvins, (as Iggy himself would claim decades later). Of course, of course, of course. Because all roads of all these variables intersect in Michigan.

With the Grande Ballroom in Detroit acting as the de facto Fillmore Midwest, every major rock group of the era stopped in town. Out of sheer stubbornness, dumb luck, or not knowing any better, the Stooges (in tandem with the MC5) were able to act as the unofficial house band for 1968-1969, opening for just about anyone and everyone...Butterfield Blues Band, Blood, Sweat & Tears, Sly and the Family Stone, The Fugs, Blue Cheer, Love, Cream, the James Gang, John Mayall, BB King, The Who, Frank Zappa and on and on and on. No need for U of M, that's a college education right there. You learn how to perform. Day in, day out. A working band. Imagine that.

Not only did the Stooges figure out how to play, while on stage, in front of a crowd, but also had an almost weekly opportunity to glean from whatever hot-shit or shit shit touring act was coming through town at that moment. The Stooges are not a band that made their bones on tour. They were by no means even "reliable" at home. Old-timers in Detroit took pride in re-laying stories of HOW BAD the band actually was saying things like, "we would purposefully show up LATE to the Grande so as to AVOID seeing the Stooges for the umpteenth time." Only in Michigan would you have the greatest band in the world playing weekly and folks bragging about avoiding it.

So for Iggy to expose his dick (purposefully or not) onstage in Romeo, bumfuck of a town if there ever was one, population just shy of 4,000 back in 1968...it boggles the mind. This is a town known for a Peach Festival and being the home of Kid Rock. Nothing happens there and nothing will continue to happen here until the end of time. It's the kind of town where someone would make the trip to the police station to let them know the lead singer's dick is hanging out. Only in Michigan.

The Goose Lake International Music Festival of August 1970 took place in Jackson, Michigan a burg fittingly known for being the longtime home of the state penitentiary and the birthplace of the Republican Party. Before a crowd of upwards of 200,000 people, Dave Alexander fails to play a single note on stage. Be it because of nerves, chemicals, a combination of the two... it's irrelevant. This would be the biggest crowd the Stooges would see in any iteration (includ-ing reunions) and they utterly blew it. Dave was fired, probably rightfully so, but the fact that

Right: The 1991 Russian issues of *The Stooges* and *Fun House*. Ben Blackwell collection.

Студжиз дот кайфа

Студжиз

barely two years prior merely thirty miles down the road these guys were playing their first show in a living room with no prepared material...these guys traversed the entire gamut of a show business career, a musical lifetime, in the span of time it takes to potty-train a child, across a space that'd render as a speck on a map of the United States, Earth or the Universe. All self-contained in Michigan.

Sadness reigns outward from Alexander's exit. Roadies, also rans and ne'er do wells filter through the ranks, pathetically culminating in a show at Wampler's Lake Pavilion in Onsted, Michigan, population 555. In an embarrassing adherence to the contractually obligating dictum "the show must go on," Ron, Scott and Jimmy Recca play the gig without Iggy or James Williamson. A fan (Steve Richards) sings with them for a portion of the night. There are recordings to evidence this. The jams are actually not totally shit. What happens in Onsted doesn't necessarily need to stay in Onsted.

And *Metallic K.O.*? What a glorious implosion, swiftly aided by the menacing pressure of local biker gang the Scorpions, at where else...the Michigan Palace, the same spot in Detroit where Henry Ford built his first car back in 1896. It's captured on tape and does kinda sound like shit. But beer bottles breaking against guitar strings is an apropos sound/image in a co-incidental building at a time where the city and region are falling apart, as the domestic auto industry begins its freefall in the thick of the Oil Crisis.

Nigh-on three decades would need to pass for the band to wholly prove themselves to their Michigan brethren. In a way that belied maturity or progress, the Stooges performance at DTE Energy Music Theater (I die a little just from having to type such a bummer of a name) was proof-positive that the band had their shit together. One wouldn't want them to become cerebral or philosophical and thankfully, the band understood that.

As my first live experience of about half a dozen with the band, it was not only the best performance I'd ever see from the Stooges, it is still the best performance I've seen by anyone in my thirty-four plus years. Sure, the show takes place in a huge embarrassingly-named shed, too far out into the exurbs to feel culturally like anything other than a blob of land, with $15 beers (watered down) and $10 parking (clusterfuck), but all the corporate grabby-ness of dollars could not sully the metaphorical boot mark the Stooges imprinted across the entire state of Michigan. America's high-five has appropriately been met with a swift kick and it'll never be quite the same.

Ben Blackwell is a drummer, journalist and record label executive. Originally from Detroit, Blackwell has been a member of the Dirtbombs since 1999, playing hundreds of live shows and on dozens of recordings. Blackwell's writing has been featured in numerous books and publications and won him the 2004 Rolling Stone college journalism award. As an executive at Third Man Records in Nashville, he's directly overseen the release of over 400 different titles and the pressing of over 3 million pieces of vinyl.

STOOGES 1974 - 1977: FLESH BECOMES MYTH

by Johan Kugelberg

January 1973 – Lester Bangs in *Phonograph Record Magazine*:
"... and it's true that they (The Stooges) might have been the punkiest band in history..."
"The Stooges worked because they had no program but total chaos, they didn't care, and it was time for that."

The Stooges trajectory from implosion to punk inspiration might have only taken three years, but a gigantic seismic shift in cultural currency and perception took place from the final show at Michigan Palace, February 9, 1974 to the unveiling of Iggy Pop as the throwback icon of the punk era with the double whammy of the *The Idiot* and *Lust For Life* albums in 1977.

In 2016, with any obscure music you'd ever want available on your screen, it is almost impossible to understand the dynamics between the mainstream record shop, the independent record shop that carried imports, the cut-out mail order clearing houses that sold deleted albums, and the specialist record collector mail order lists. All these forms of commerce converge in the history of how the Stooges legend snowballed in the mid-'70s alongside the powerful motivators of international rock and roll fandom and the non-mainstream music press.

It was really hard to buy Stooges albums in the mid-'70s. The first album and *Fun House* were long-deleted, and in rare instances available in specialized import record shops as (usually) copies of the German or French pressings. *Raw Power* was swiftly deleted upon release. The UK pressing was difficult to find already by 1975, and the US pressing ended up in cut out clearing houses* a year or so after its release.

February 1974 – Scott Duhamel in *Beyond Our Control* #3 fanzine:
"Last summer in late June I was looking at a bunch of $1.99 records in a number of record stores. I spotted *The Stooges* and *Fun House* and decided to take a chance. (...) I began to think along the same lines as everyone else – isn't rock and roll supposed to be something completely different, even crude, like the Stooges music?"

Spring 1974 – Ron Asheton in *Denim Delinquent* #3 fanzine:
"The only reason I never listen to *Raw Power* is because of the fucking mix by David Bowie. I think he destroyed that album."

September 1974 – Cary Baker's "A Year After *Raw Power*" in *Boogie* #7 fanzine
"I suppose I am an idealist among punko-destructoids, but among idealist peers, I'm cynical as to be unfathomable. (...) And the wheat jeans and penny loafers of the mid-'60s in America, I'm afraid, aren't the fallout shelter that we seek and desperately need. I detect a perpetration of a myth, and I am beginning to get a might concerned as I listen to "Penetration" end, and the needle lift and place itself back on "Search and Destroy.""

In 1976, Marc Zermati released the live Stooges album *Metallic K.O.* Rock writer Nick Kent had made Zermati aware of the tapes. Marc Zermati's record shop, Open Records and independent record label Skydog Records, is an extraordinarily important cog in the machinery of the construction of punk as inspiration and catalyst for the mid-'70s punk narrative. The refined rock and roll aesthetic of early-1970s hipster culture was slowly becoming more and more focused by fanzines and record shops. Hardcore rock and roll fans started fanzines and labels and record shops and formed bands based on a cultural aesthetic of what was to come to be known as punk rock, in real time.

January 1976 – Harald Inhulsen in *Honey, That Ain't No Romance* #1 fanzine:
(...) what we want, above all, good boys and girls, we want you to enjoy in looking at the hot photos of IGGY, THE STOOGES, NEW ORDER and some others, and to tell you the news of the mighty IGG. But the hottest thing at (sic) all, we can't give you – it's IGGY himself who will do that: listen to the music! Listen to *THE STOOGES, FUN HOUSE* and *RAW POWER*, this music will change your life and dreams!"

These record shops sold copies of Lenny Kaye's *Nuggets* compilation of mid-'60s American teen garage punk bands (issued by Elektra in 1972, reissued by Sire Records in 1976) alongside cut out copies of albums by the Standells, the Seeds, the Chocolate Watch Band etc. This fandom had grown out of the wake of the American rock fanzines that started mushrooming in the late-1960's, and who originally coined the term "punk rock" to describe American crude mid-'60s bands formed in the wake of the British Invasion. Bands that are now firmly placed in the upper pantheon of awesome crude rock and roll like the Stooges, the MC5 and the Flamin' Groovies were contextualized within this rock and roll fandom as a continuation of the American '60s garage punk sound, which made perfect sense then, and certainly still does. Listening to the sublime primitive thud of the first Stooges album shows a true kinship with the Seeds or the Sonics, and naturally, all members of the Stooges came from that very musical milieu: Iggy released a fine garage punk cover version of Bo Diddley's "Mona" with his high school band the Iguanas.

The divide between rock and roll fanzines and the professional rock press during the first half of the '70s was truly fluid: pro-writers wrote for zines, zine writers wrote for nationally distributed rock magazines and no one really knew who was who. Publications such as *Creem, Fusion* and *Crawdaddy* had celebrated the Stooges since the beginning, providing the band with press coverage that by far overshadowed how limited their record sales actually were.

The Stooges media narrative was mighty. Their fans were a fanatical inside few, driven by urban demimonde, by insiders, by the hipsters and the fabulous of the time. Iggy was certainly a romantic hero, a non-airbrushed Wildman in the age of earth shoes, mood rings and James Taylor. The notoriety of the band existed on several planes by 1975. A great rock and roll disaster, certainly, but also a slew of exceptional albums that were held as magnificent touchstones by anyone who wanted their rock raw and unfiltered. That the records were very difficult to get ahold of added to the legend. Rock fandom by 1975/1976 was an international affair, and limited edition homemade zines on underground music would get distributed internationally, available in tastemaker independent underground shops. These existed in cities around the world. Ted Carroll had Rock On in London, Greg Shaw opened Bomp Records as an extension of his mail order service (it in turn an extension of his fanzine), Mark Taylor's White Heat in Sydney, Los Angeles' Rhino Records, Zermati's Open Records in Paris, Lennart Persson's Musik & Konst in Sweden, all outposts of punk rock thought in the middle of a laid-back post-hippie wilderness.

What punk meant in 1974 was not the same as what punk meant in 1975. And by 1977, punk did not mean what it meant in 1974 or 1975. The metamorphosis of punk meaning was ongoing until the term stabilized and came to describe what we all think it does with its buzz saw guitars and spikey hair and leather jackets. Prior to that, anything went, and anything goes, I remember rock press articles in 1976 describing AC/DC, Skyhooks and Kiss as punk bands. Casting a long shadow was the legend of the Stooges, and by 1976, any vinyl Stooges artifact that was published (*Metallic K.O.* on Skydog, "I Got A Right" 7" on Siamese and

Right: Johan Kugelberg collection.

‹342›

I WaNNa be YOUR DOG

NUMERO 1 . OCTOBRE 76 . 4F.

RUNAWAYS

SEXPISTOLS

IGGY AND THE STOOGES
METALLIC K.O

INTERVIEW :

IGGY

DOLLS 76

RAMONES

Festival Mont de

honey, that
AIN'T NO ROMANCE

£1·15

the fan
magazine of
Europe's Only
IGGY POP
FAN CLUB

the James Williamson/Iggy Pop *Kill City* LP to follow in November of 1977 after Iggy's solo albums *The Idiot*, March 1977 and *Lust For Life*, August 1977) was received as a missive of serious aesthetic importance. Alongside the records, the fanzine groundswell was global, and the musicians, fans, writers, artists and music biz people who came to define the events of 1976/1977 were certainly paying attention.

November 1976 – *I Wanna Be Your Dog* #1 fanzine (translated from French by Mark Iosifescu):
"You now hold in your hands the first issue of the magazine of the IGGY POP FAN CLUB. Initially envisioned as a simple fanzine dedicated to the divine STOOGES, we've decided to expand our scope and dedicate ourselves to the creation of a new rock revue."

September 1977 – Mike McDowell and Jim Heddle in *Ballroom Blitz* #22 fanzine:
"Since the release of their trend-setting "I Wanna Be Your Dog" in 1969, Ann Arbor, Michigan's Stooges have become the most successful, most copied and truly most misunderstood punk band in the history of rock and roll. Many of the New Wave bands like the Sex Pistols and the Clash, owe their style to Iggy (Jim Osterberg) Pop's incredibly energetic stage act and Ron Asheton's fervent bass and rhythm guitar efforts. The Stooges' long out-of-print albums were commanding prices as high as $25 until several months ago, when the overwhelming demand for them forced dealers to import European pressings."

The constant name check of the Stooges by the mid-'70s punk bands (Stooges covers were a rite of passage, Sex Pistols performed "No Fun" as the flip-side of "God Save The Queen," The Damned recorded 1970's "I Feel Alright," everyone covered "I Wanna Be Your Dog" live) were a means of showing how the quantum leap of punk had roots in raw musics of yore, and that the obliterating ground zero of the new wasn't a dictatorship, but a break from a previous dictatorship. The instigators and agitators alongside the originators had successfully encouraged the class of '76/77 to get on with it. Punk happened with the Stooges and their true believers as midwives.

Johan Kugelberg is an archivist, a writer and founder of the Boo-Hooray Gallery, New York. In 2007 he helped to institute the Cornell Hip Hop Collection at Cornell University. His books include *Punk: An Aesthetic* and *The Velvet Underground: New York Art*. His new book, *God Save Sex Pistols"* will be published in autumn 2016.

THE FLESH MACHINE: SURVEYING THE INDUBITABLE STYLE OF IGGY POP

by Jon Savage
(*Vice*, February 2012)

Some people might ask: What does a guy who's been shirtless for at least two-thirds of his life have to say about fashion? If you're one of them, this interview is not for you. Read it some other time, after you've listened to *The Stooges, Raw Power, Fun House, Lust for Life,* and *The Idiot,* and realize that Iggy Pop's animalistic physicality has informed style for decades, and will continue to do so well beyond the last time he writhes and slithers across a stage.

Iggy's ubiquitous uniform—pants so tight they could have been spray-painted on, a sinewy bare chest that didn't start aging until his 60s, and Beatle boots or bare feet depending on his mood—undoubtedly looks at least five times better than whatever you're wearing right now. It was also carefully calculated, like a sleek, stripped-down hotrod built with the single-minded goals of efficiency and speed.

A thorough peruse of archival photos and video of Iggy reveals that he took the same care in his appearance offstage, where he tends to wear a bit more clothing; almost every outfit seems iconic in some way, but also natural and unforced. As far as I can tell, over the last four decades he hasn't worn anything that could be considered embarrassing or dated circa 2012. I'm not sure there's anyone else on earth—save menswear designers who never stray from suits—whom you could say the same thing about.

But Iggy's not just a historical figure. In the 21st century, he has worked hard to revitalize his name, with Stooges tours, records, and collaborations with various clothing brands. His argument for participating in these unabashedly commercial enterprises is that the Stooges never got the recognition and the sales they deserved in their brief lifetime. So if this is the way to finally achieve some payback, he has no problem jumping onboard.

As far as I could tell, no one has interviewed Iggy explicitly and exclusively about fashion, so that's precisely what I did.

Jon Savage: Do you remember the first time you understood the concept of fashion or at least being cool?

Iggy Pop: When I was in elementary school, I saw two older boys who were dressed in the 50s, delinquent look—jackets with the collar up, dark blue Levi's with the cuffs turned up, and winkle-pickers—and they were leaning against the wall of my elementary school for some reason. They were too old to be there, and one of them said "shit." I'd never really heard the word but it sounded bad. I wouldn't say I thought they were cool, but there was electricity in the air at that moment. Let's put it that way. Then they disappeared, and I thought, "Oh my God, what are the implications?"

When I was about the same age, my Great Uncle George Osterberg came to visit my father from Chile, and he brought his daughter with him who looked and dressed exactly like a male greaser. She had the greasy pompadour, like a young man, and spent a lot of time just laying around, sneering at everything. On a woman, I thought, "Woah, she's bad. That's cool." I was very impressed; I found it attractive.

JS: How about the British Invasion? Did it influence your sense of style, or were you more into American trends?

I: I always liked Charlie Watts's look. I'd go to thrift stores and try to buy suits so I'd look more like him. I was a drummer at the time, so I liked that almost-Savile Row look very much, which he'd taken from American jazz players. The others had a good look, too, and there was this store in New York called Paul Sergeant that imported most of their stuff from London. It was a good place to shop.

There were two chains for shoes in America at the time: The best was one called Cancellation, which was where black people went in the inner city to buy their cheap, flashy Italian models, and then there was something called Flagg Brothers. I didn't know this fact, but there's a new film out about William Burroughs that I participated in where they mention Flagg Brothers, so I guess it was also a place... Anywhere with good style is where boys tend to meet boys. A lot of that goes on.

JS: During the early days of the Stooges would it be fair to say that your look was a lot more put together and less raw than it came to be?

I: Well, I was careful about what I wore. From our second gig on, I looked a lot more like what I've looked like, on and off, since: no shirt, a pair of tight, slim jeans, bare feet, and I had permed hair and a white, painted face. By the third or fourth gig, I lost the perm and the white face, and I started wearing this same pair of shoes that you can see in every photo of the Stooges from mid-'69 to the end of '71. They were these authentic Anello & Davide Beatle boots. Dave Alexander had brought them back from England because he and Ron [Asheton] had skipped their senior year of high school to go to Liverpool and see what was going on. I used to wear them over and over, and they had holes in the bottom, like a cartoon hobo.

Then, as I began doing more gigs, these flimsy pants I like to wear would start to rip, and I left the rips in. I thought it looked right. It was the thing at the time for people like PJ Proby or Jackie Wilson, or even James Brown, to leave loose basting instead of proper stitching in the crotch of the pants. Before the end of the show they'd rip on stage and that was part of the gig. But I was the first one to just come out with the rips, as far as I know.

JS: Some perceived your style as machismo, but you weren't particularly macho onstage.

I: No. I actually think there shouldn't be any genders. Male dogs smell each other's dicks and stuff, and then they jump female dogs and do everything to everything. That's the way humans really are, but there have been elaborate codes adopted to weed out parts of behavior that don't match whatever gender or social group you want to belong to. And I think that actually cuts both ways, straight and gay—each cuts out or emphasizes certain bits. It's sort of like using hair spray on your personality. But no, I never wanted to look particularly macho. For one thing, I realized the girls don't really go for it [laughs]. I think ideals of beauty in our society are dictated by those who identify themselves as feminine, at least in their thought processes. Whether those are gay people, or women who are thinking in a particularly devious, savage, amoral manner, which is how women think when they really get down to business. And that's where the bread is buttered, so I wanted to look kind of smooth, slinky, and super forward.

JS: Then there was your silver period, which seemed to be the evolution of this point of view.

I: Yeah, I first had these silver gloves when I lived in the Midwest, before I started hanging out with glitter people and compete more in New York, and then internationally. More glamour

became necessary. I was using Nestle Streaks 'n Tips on my hair, and that gets a great effect on stage, but it takes four showers to get that stuff off your body. I don't know if it was popular with streetwalkers, but there it was. It was an actual silver paint that you sprayed on your hair. You could get it in gold and silver at all the cheap drug stores. Then, eventually, it was the silver pants and later sarongs. I had this pair of underwear I bought in Piccadilly Circus at a little kiosk, where they sold peanuts and cigarettes and souvenirs. They just said "Soho" over the penis. I guess they were women's, but I didn't really think about that. I just thought about how cool I would look in them. And I would see pictures of women in knee boots and would think, "I want some. I want to wear knee boots and have my legs show." And vice-versa. I'd see biker stuff, the Hell's Angels using, like, wolves' heads or something, and I'd think, "Hey, what about a horse tail?" so I had one of those made up. I'd get stuff out of old Greek and Egyptian books as well.

JS: Where did you get the now-iconic leather leopard jacket featured on the back cover of *Raw Power*?

I: James Williamson and I were staying in Kensington and there was a market. I went over there and, it was like Steve Martin in *The Jerk* or something, you know? Like, "Hey, it's me! It's who I am." I bought it that day, and I bought a man purse, like a shoulder bag made out of—honestly it looked like it was made out of a black-and-white chinchilla cat. So I had that, I would walk around Kensington, Hyde Park, Mayfair, and Bayswater in my dressed-down leather pants. I had two pairs of leather pants, I had silver glitter leather, which were for, like, special state occasions like a Stooges gig or going out to a really big gig. I also had black leather pants, but instead of stitches there were rivets; they were heavy duty. And by this point I'd been to Anello & Davide and bought a new pair of Beatle boots because they still had some left over. I would sort of mince, or trundle, or slink around those neighborhoods, going on long walks, trying to figure out what I was doing, wearing the cheetah jacket, leather pants, and Beatle boots [laughs].

JS: I'm sure you drew some attention.

I: Occasionally lone men in cars would slow down and stare at me intently, and I had no idea what that was about. Occasionally [it happened with] the other gender too. One day, in Fulham, I ran into a Men Only cover girl and I was going with her for a while, but I'd never really hang out with people for any length of time.

JS: I wanted to ask, did you go to Malcolm and Vivienne's shop, Let It Rock—or whatever it was called then—on the King's Road?

I: Yeah, it was Let It Rock, and you walked in the door and he had a huge, dirty cardboard bin full of winkle-pickers with no laces in them. Most of them were, like, frozen solid; there was absolutely no flexibility left in the shoe, and I'm pretty sure it was £5 per winkle-picker. Then he had all the rock stuff. James loved it and went more than I did, but I was over there regularly for some reason, just kind of snooping around. I remember there was some guy there and it was probably Malcolm, and then there was a woman there, who could have been Vivienne, or not. Then later she was kind of an item with James. I also remember there were a lot of extremely skinny guys walking up and down Fulham High Street, King's Road, in every sort of old, American boy scout uniforms, gas station attendant jackets, old bowling shirts. All this weird shit that I recognized from my youth. You would go into thrift stores and find very, very small sizes all of this American gear that was incredibly expensive, so people were doing that too. It was odd.

JS: Hearing you talk about this makes me think of the too-small jacket you're wearing on the cover of *The Idiot*.

I: I borrowed that jacket from my girlfriend at the time, Esther Friedmann. It was a women's jacket. It was probably French, or it could have been vintage German. The idea was that it didn't get in the way. The waist was kept short, and the arms were too short so that it emphasized the hand and length of the whole arm.

JS: In the late-'70s and the early-'80s, when a lot of people were trying out god-awful looks, you still had a good sense of style. You've always kept an interest in fashion, haven't you?

I: I had a nice look for a while in the early-'80s—Americans really hated it. I was still going with Esther, and I would just buy all her clothes and go out on stage with moderate heels, fishnet stockings, a miniskirt, a little leather jacket, and a mini leather cap. Sometimes I'd wear a little white shirt underneath. I looked like a temp secretary or something. That was a good look.

JS: Why did Americans hate it?

I: When I played my own gigs it went down fine, but when I went and opened for the Stones one night [laughs] people threw bottles, everything they could at me. They were very keen on the macho look in that era. And once rock 'n' roll became rock, once it became that one word, it kind of took all the play out.

JS: Do you think that Americans are more reserved than the Brits when it comes to clothes?

I: Absolutely. It's a bigger country and harder to move. It's not a flamboyant place. That's a good word for what I was saying about before, what got lost around 1975. If there was ever an American flamboyance, it happened in that 25 years from '50 to '75, and it had to do with the blues, R&B, rock 'n' roll, big cars, and giant breasts.

JS: Nowadays it seems like some people think it's a sin if you're a musician explicitly wanting to look good, to have real style. Do you think that's an important part of being in a band?

I: Abso-fucking-lutely, yes. I mean, God, I was so disappointed. I was reading a promotional interview with the singer of Coldplay in the Guardian, and the interviewer asked him about his shoes—he had some cool sneaks on—and he just went, "Oh, I don't know, the stylist just gave them to me." It's like, come on dude, give me a break. I thought, "Gee-whizz, can't we have somebody better than that at the helm of guitar music?" So yeah, it is really important, and it can be achieved in any number of ways. You could look hideous; that's OK too. You could have one guy that looks really good and one guy who looks hideous, but he'll start growing on you. It's important to look amazing, or astonishing, or intriguing, but mainly interesting in some way.

JS: Is the goal to look sexy?

I: There can be some sex in there, but there can also be some humor. Also, I think maybe some sort of canned spirituality is in there. Like if a religious person sees a light when they find God, well then some guy in the hood can just buy some hubcaps, you know what I'm saying? A lot of it is also something about being a human—the spiritual need to shine a little.

JS: And now we've kind of come full circle. It seems like every brand and designer on the planet wants to work with musicians like you who were at the forefront of style in the late-'60s through the mid-'70s. How do you feel about these types of collaborations?

I: To be very to the point: People are hearing our music through different media, bypassing the old media that refused us entry, and what I've done is two things: One is to push through any door that's opened in this new type of media, and the other thing is to do things that make it OK for what's left over from the old media.

JS: You recently worked with Vans to make some shoes and a few articles of clothing. How'd that come about?

I: It came through some channels. I was asked to OK something, and I was happy to because I used to wear their shoes in 1977 in Malibu. I was in a phase when I was trying to break out of the rockist mold. I'd just made *Lust for Life*, and I was about to tour behind it and was stuck with this standard American baseball cap-wearing road crew. So I had this concept: Get me rental furniture and home lighting, and we arranged this stage in the rehearsal room that looked like a living room. I was going to sing the songs on a couch, and I had a little attaché case I had this character in my mind, the rockin' realtor [laughs]. Anyway, I saw these shoes one day and they were cool. They were like a deck shoe, but they didn't have the shape that implied a paunch and a lack of hair, so it was a sneaker shape but what was really cool was that the canvas was a black-and-white checker, and you just didn't see checkers around.

JS: Except for S. Clay Wilson's Checkered Demon in Zap Comix.

I: Yeah, it reminded me of the Checkered Demon! He would fuck people with his tail. [laughs] That's what he would do. He'd come in and some really nice guy would be having an evening out with his date, and the checkered demon would jump in with his tail, which had a spade on the end and would sort of lash out between his legs toward wherever he wanted to put it—to do the deed to his victim. I always loved him.

Jon Savage is an author and a film-maker based in North Wales. His books include the award-winning *England's Dreaming: Sex Pistols and Punk, Teenage: the Creation of Youth 1875-1945*, and *"1966: The Year The Decade Exploded."* His film credits include *The Brian Epstein Story, Teenage*, and *Joy Division*.

15. PAST TO PRESENT: HENRY ROLLINS AND JEFF GOLD EXPLORE WHY WE'RE STILL TALKING ABOUT THE STOOGES

Henry: Giving Iggy visuals to spark his memory and establish a timeline seems to have allowed you to get great access to not only his history, but also his unique perspective.

Jeff: I think so. I'd worked with Iggy at A&M, so I knew he was an amazing storyteller. My original concept for the book was, here's a visual, and here's a paragraph of whatever Iggy has to say about it. I figured I'd show him a hundred things, maybe he'd have something to say about seventy-five, and we'd fill in the rest with captions.

I'd wanted there to be an element of surprise, but a couple days before the interview, he asked to see everything first, so I sent him printouts. He emailed back that he was blown away; he hadn't seen most of this stuff, ever, and the memories were flooding back. Scott wasn't healthy and Ron had died, and I think he'd been thinking a lot about the Stooges.

He'd agreed to an eight-hour interview—over two days. I'd interviewed him for my previous book, *101 Essential Rock Records*, which included two Stooges' albums, and he knew me from A&M. So, I was a known quantity, he knew about my reverence for the band, he'd seen all these incredible visuals we had. So, by the time Johan and I arrived, he was feeling good about the project.

When I showed him the first image, I was thinking, "I'll probably get maybe two or three minutes on it." Fifteen minutes later, he's still talking. I'm looking at my watch, thinking I've got eight hours, there are 100 things to talk about—how am I going to get through all this stuff? At the half hour point, I realize we're never gonna get through everything, but the good news is he remembers much, much more than any musician I've ever spoken to. And the thought popped into my mind that maybe we could turn this into an oral history of the Stooges.

So, I interrupted him and said, "change of plans; since you remember so much, I'm going to try and expand this into an oral history of the Stooges. I'm sure there will be some things I'll miss, because that wasn't what I was planning on, so if it's OK, I'll call you about those later" and he said "no problem." And we had a couple of phone calls afterward. Like yourself, I've had lots of incredible fanboy experiences, but this was one of the high points.

H: What was it like hearing him call up all those names and details with such consistent exactitude? Beyond what might have happened at the show, the location of the venue, the promoter's name and so on. This is fifty plus year old information. And let's not discount marijuana, cocaine, whatever you can put in a pill for decades; as an enthusiast, that can wipe out a lot of information, but his memory is incredibly intact.

J: Amazing. You meet musicians, and sometimes their stories—they've told them so many times that they begin to morph and change, and the new version becomes the reality. But not Iggy. About fifty percent of time, I'd show him something and he'd say, pretty quickly, "Here's what I remember." Thirty-five percent of the time, he'd go, "Hmm," and think for a minute or two; you could almost see the gears turning in his head, and he'd say, "I remember this." The rest of the time, he'd say, "No idea, I don't remember anything." He wasn't trying to be performative or give

me answers that he thought would resonate with his fans. His recall blew me away. And he was having so much fun. It seemed cathartic for him to tell these stories. I don't think he'd thought about some of these things for a very long time. He'd remember a specific gig—where the band was playing, while he's having sex with a girl in a men's room stall, and laugh...

H: It's just the three of you.

J: Just the three of us. Iggy has a house that's kind of his workspace house—not where he lives with his wife. It looks like a conventional tract house, but when we walked in the front door, he says, "There's my mom and dad," and points to two urns with the ashes of his parents. You turn left into another room and there's a full size, knitted stuffed woman lying on a couch, splayed out. There's stuff from throughout his career; he's got a door with a self-portrait painted on it. He told me, "that's the door from the first condo I bought. It was the first time I was able to buy any place to live. When I moved out, I kept the door, because it was symbolic to me." And then we went outside to a thatched roofed hut in the backyard, by a creek. We sat in it, on reclining chairs, and talked, and I showed him things.

Very occasionally, he would misremember something, but it would be trivial. Here's a perfect example: Search and Destroy. He told me he got the title from an article in Time Magazine about the Vietnam War. I found the article; it turned out it was about the war on drugs, though there was an article in that same magazine about the Vietnam War. To me, conflating the title of two magazine articles forty-five years after the fact is nothing.

H: Iggy seems at once, completely in the moment, yet at the same time, quite focused and calculating. He ends up down and out more than once, yet at the same time, he's always looking around for the next thing. And then that great comment he made three fourths into the book: "Keep making art." Like when he's out here in LA. Don't wait for someone to throw you a bone. Keep making art. That Death of a Virgin show, where he was all bloody at Rodney's club—keep making art, no matter what. He's trying to do stuff with Ray Manzarek, trying to get something going. He has an almost feral resourcefulness. One who has learned to survive on the Serengeti, while not being the apex predator. He's not Elton John. He's not selling out the Forum. He's bumming quarters. And this is not talking out of class. Throughout this book, we get this portrait of Iggy, self-described. "I liked his shoes, I liked his sunglasses." He's aware of look; he's aware that making a visual impact has importance. "Well, I had to jump off the stage because I wanted them to remember me. So, I landed on the guy and broke my head open"—or whatever the story is. "I went up and kissed the girl because everyone was looking and you have to be memorable. I was in New York; I had to make an impression." And contrast that with the Ashetons, who had no concept of this. He was the one who had to make the splash, candle, wax, whatever it took to be unforgettable.

So, in a way, he's calculating, trying to get a result. Yet at the same time, he goes into a show, jumps off the stage, lands on the barricade—wrecks himself. He didn't think it through, didn't think about gravity and the ramifications of running into the thing and what might happen, or what's going to happen the next day when you're still high from the night before. Because he's got no net. But no net means you might not get up. So, he's looking for a result, yet at the same time, he'll take his hands off the motorcycle handlebars and go full Evel Knievel. Like he's half together, and half, "screw it, let's see what happens." It's insane, two different ideas together, in one guy, at the same time.

I had no idea before reading the book, how purposeful he was, like Bowie, this look, this music, this outcome—it blew my mind. He's not messing around. Yet at the same time, he's completely wild.

J: I've thought a lot about what the key ingredients were for the Stooges, why it worked so well. I like the quote at the beginning of the book, where Iggy says, "If I didn't make a complete break with the music that was going on, I wasn't going to ever make it as a musician. So, we had to stop what was going on and make up something new. And it was done with drugs, attitude, youth, and a record collection." I think that what may, in hindsight, seem deliberate or calculating should be viewed through the lens of a guy who knew he had to do something different, something original. A guy who was ballsy and not content to take the easy way out. They started out playing a vacuum cleaner and a Waring blender, oil drums, and a Hawaiian guitar with all the strings tuned to the same note. He was trying to get a reaction, and if he wasn't getting enough of a reaction, he would do literally anything to get *that* reaction. He wasn't interested in playing derivative blues songs like every other band. And through the sheer force of will, he carved out his own niche.

He traveled long distances on the bus and then by foot, every day, to get to the Asheton's—then woke them up, and had to get them high before they would rehearse for twenty minutes. Just forcing this immovable boulder uphill, the myth of Sisyphus, at every stage of the game. And just not being willing to be ignored.

I see Bowie as somebody much more calculating. If I do this and this and this, then this might happen. Iggy was more of a raw nerve. At the Cincinnati Pop Festival, he's on acid, he's never been on a stage that puts him above the crowd, and somewhere in the back of his mind, he's aware this is being televised. So, he decides spontaneously, "I'm gonna walk out on top of that crowd and see what happens," and invents crowd surfing. Then somebody holds up a jar of peanut butter, and he starts spreading it all over himself. That is definitely not the kind of thing David Bowie would have ever done. Bowie's show was plotted out in an exacting way; for him, spontaneity and live performance didn't agree. I see Iggy more like John Coltrane, improvising in the moment, and not just musically, but with his presentation. If he needs to fall down and flop around like a fish out of water, because the audience isn't giving them enough response, he does. If he jumps onto a table and is impaled by a martini glass, and has to be taken away bleeding, to be sewn up, so be it. I see it kind of like free jazz, rather than deliberate and calculating. He'd put himself into these situations, and would do what whatever it took to get a response, without thinking about the consequences. I think that's part of what made the Stooges so legendary; he was not going to let anybody forget that they'd seen them. There's a line in the book where he says, "If we weren't going to get a positive reaction, we're going to give them a performance that wouldn't let them sleep at night." He's reading the crowd, he's very much in the moment, reacting to what's going on, and not thinking about the consequences.

He talks about how Ron and Dave and Scott were one side of the Stooges, and he was the other. He was the front man who had to do all the heavy lifting, but the three of them together created a "third mind," quoting William Burroughs. And they just locked in together, those three guys became one. He's not interacting with the three of them individually, he's interacting with this other single entity. To me, it feels very spontaneous rather than calculated. He's not thinking, "Here are the five things I'm going to do during the show that are gonna get people's attention."

H: That makes perfect sense.

J: When you were in Black Flag, I'm imagining there was some similarity to what I'm describing, where you're trying to get a reaction from the crowd, but you weren't walking in with seven moves that you were going to do

H: No moves, it just happened. I think we were relatively boring by comparison, in that we were a lockstep utilitarian music delivery unit. We were like a weapon of war. It always fires. The AK, you can freeze it, put it under water. It'll always fire. Black Flag's doing twenty-eight shows a month, sometimes two sets a night. It has to fire at 8:00 PM every night. I'm wearing shorts. "Oh, you're wearing shorts 'cause you're showing your body off." I'm wearing shorts because I have one pair of pants, one pair of socks, and some shoes which the sweat rots out. I can't afford another pair. So that's why I don't use them on stage. Because I'd slosh around for the rest of the night. Shorts I can wash off in the Denny's sink before my five dollar per diem meal. So, it's all utilitarian practicality. Our goal was to execute the songs, King Crimson tight, by the angriest people you've ever met, like '74 King Crimson with attitude. We're going to hit it with that exactitude every night. We're eating your face off your skull. So, am I gonna throw myself off the stage and do something? Probably not. Will I get pulled off the stage and punched out? One to two nights a week. I was more reactive to stuff. It was basically a kind of a battle, for as long as a set lasted, things would happen.

J: I think it was for Iggy, too. And the Stooges.

H: Totally. He was at war with the audience and the music and the elements. He's just reacting too. I would never do anything like jumping off the PA stack or any of that very much. I did a few times when I started, but I quickly concluded that it was far more important to be onstage and part of the unit. Some of my colleagues in other bands do that kind of stuff, or climb up and hang from the rafters of the venue. That was never me. Because the songs are so hard to get through physically, you just had to go, "Okay, four songs into the set, there's no breathable air in this 120 degree club in Dallas." The ceiling is low. The drummer is about to pass out. And then he would. You'd be playing, all the sudden, what's going on? Oh, Anthony. "Hey man, get up? 'Cause you can't say that you don't feel well. You have to keep playing." I passed out once in London and pulled myself up using Greg's leg. He just looked at me because I wasn't singing. That's how we were. One time in New York, I caught a great concussion. I was out of it, but had to keep playing. "Am I awake? Keep playing, vomit later, or vomit now. Keep playing." But Iggy's unique. That was perhaps the main thing of the book that struck me, how deliberate and unrelenting he was. "The Ashetons will not wake up. I'm going to wake them up; Ron doesn't want to go to New York City. We're going to New York City; he wants to sit and watch TV all day. No, they're going to do this. Because I know what they have. I know what they can deliver. They don't know it, but I do, and they're going to do it; we're going to do it." It's like he had them by the scruffs of their necks and dragged them to greatness. And with the original Stooges, you've got three very capable, but not always dependable people. Dave Alexander was a real deal badass, died young, and the Ashetons were natural musicians, both brilliant, but what a tough bunch. And Iggy had to be the troop leader.

J: And Iggy is not somebody who tries to take all the credit. He's very generous in describing who did what, what each person's contribution was. But it's amazingly apparent that at every stage of the game, he is not just the front man; he's the manager, road manager, motivator, chief bottle washer; the one keeping this thing from the precipice of collapse, every second of every day. While, during the live shows and recording sessions, being the guy who has to ensure the quality and make sure that people cannot ignore this band.

COLUMBIA RECORDS

A Division of Columbia Broadcasting System, Inc.
51 West 52 Street
New York, New York 10019
(212) 765-4321

Kip Cohen, Vice President
Artists and Repertoire, East Coast

Dear Tony:

Having not been able to reach you by phone, I felt I should take this opportunity to tell you how strongly we feel about referring to your artist as "Iggy and the Stooges" and not simply "The Stooges" as Iggy is now insisting. I know that this problem exists only in Iggy's mind out of deference to his band, and that you are not creating this problem yourself, but I would like to run down why we feel so strongly about this:

1. Iggy so clearly is the out-front leader of the group that it is foolish marketing to promote the image of the whole act when basically we are dealing with Iggy as a personality.

2. The name "The Stooges" connotes a very dated and unsuccessful image of four years ago. If anything, now is the time for Iggy Pop and we would choose to treat the situation ala '72, not yesterday.

3. The whole poster campaign, as you know, features a sole picture of Iggy, and it becomes ludicrous to refer to the act as "The Stooges."

4. Our contract, as you know, does not even refer to the Stooges or any other musicians.

Please support us in this point of view and give us the leeway to really do a job promotionally on Iggy as a performer. If it would be helpful for me to contact him, please let me know and I would certainly be glad to meet with him the next time he is in New York; but the album is scheduled for release and it makes no sense whatsoever for it to say "The Stooges -- Raw Power."

Sincerely,

Mr. Tony DeFries
Mainman
240 East 58 Street
New York, New York

cc Messrs. Davis, Teller, Lundvall, Devito, Krugman - Columbia
 Mr. Mick Rock - Mainman

December 18, 1972

CBS RECORDS

A Division of Columbia Broadcasting System, Inc.

51 WEST 52 STREET · NEW YORK, NEW YORK 10019 · (212) 765-4321

COPYRIGHT LICENSE CONTRACT

CONTRACT made and entered into this **3rd** day of **January, 1973**
between **MAINMAN, LTD.**
(hereinafter called the "Licensor") and CBS RECORDS (hereinafter called the "Licensee")

1. Licensor warrants and represents that it is the proprietor of a valid copyright in the musical composition**s** (including the words and music thereof)XXGXXXX **contained in the album entitled "RAW POWER"** ＊

*See titles on reverse side

(hereinafter called the "Composition"), further identified by Copyright Registration Certificate Class E

., and further warrants and represents that Licensor has the right to grant the license herein contained and has the right to, and hereby grants to Licensee the right to, use such title.

2. Licensor grants to Licensee the nonexclusive right, privilege and license, during the term of said copyright and all renewals and extensions thereof, to use the Composition, and to make and/or use arrangements thereof, in the manufacture and sale of parts of instruments serving to reproduce the Composition (hereinafter called "Part" or "Parts") throughout the world.

3. Licensee shall pay to Licensor royalties at the following rates on the basisXXXXX of net Parts manufactured and sold (excluding free and no charge records distributed for promotional purposes) by it in the United States during the term of said copyright and all renewals and extensions thereof: Two cents (2¢).

4. It is further agreed that the copyright royalty rate for extended play records containing more than one selection on a side shall be 1½c per selection; for long playing 33⅓ rpm records containing more than one selection on a side and carrying a suggested retail list price(a) of not more than $2.85 the royalty rate shall be 1½c per selection and (b) of more than $2.85 but not more than $3.00 the royalty rate shall be 1¾c per selection.

5. In respect of records manufactured and sold or distributed as free or bonus records through any mail order and/ or club operation carried on by Licensee or its subsidiaries or affiliates, the rate(s) shall be 75% of the rate(s) specified herein and shall be payable on the basisXXXXX of net Parts manufactured and sold or so distributed.

6. Licensee agrees to render to Licensor quarterly statements, and payments therefor, of all royalties payable hereunder, within 45 days after March 31, June 30, September 30 and December 31, for each quarter for which any such royalties accrue pursuant to the terms hereof. All royalty statements and all other accounts rendered by Licensee to Licensor shall be binding upon Licensor and not subject to any objection by Licensor for any reason unless specific objection in writing, stating the basis thereof, is given to Licensee within one year from the date rendered.

7. a. As to Parts manufactured in the United States and sold by Licensee for export to other countries, royalties shall be payable pursuant to this contract, except with respect to Parts exported to countries which require the payment of copyright royalties in connection with the import or sale of such Parts, in which event no royalties shall be payable hereunder.

 b. As to all mechanical devices (such as masters, mothers and stampers) which are exported by Licensee to companies in other countries for use by such companies for the manufacture and sale of Parts, no royalties shall be payable hereunder with respect to such export or with respect to the manufacture and sale of Parts by such companies.

8. Licensor indemnifies, and shall hold harmless, Licensee from loss, damage or expense (including attorney's fees) (a) arising out of or connected with any claim by a third party which is inconsistent with any of Licensor's warranties in paragraph 1 hereof, or (b) by reason of any adjudication invalidating the copyright of the Composition.

9. This contract is assignable by either party, and shall be binding upon the heirs, legal representatives, successors and assigns of the parties hereto.

Artist: ~~THE STOOGES~~
Record No.: KC 32111

MAINMAN, LTD.
· · By ·

· ·

CBS RECORDS, a Division of
Columbia Broadcasting System, Inc.

By ·

CR-721 REV. 7/66

UNDERHILL REHEARSAL STUDIOS

1-3 Blackheath Hill London SE10 tel: 01-691 1313

Mainman Ltd.
2. GUNTER HALL STUDIOS
GUNTER GROVE S.W.10.

INVOICE

| Our Ref 1667. | Your Ref | Date August 1st 1972. |

Description	£	p
'1667 Pop n' the STOODGES.'		
Tuesday July 25th.		
Wednesday " 26th	6.	00.
Friday " 28th.	6.	00
Saturday " 29th	6.	00
	6.	00
	£ 24.	00
Paid		
1 Aug 72		
	£ 24.	00

First receipt (top):

372
40.00
2.40

WILLIAMSON JAMES
2109 MEDFORD
ANN ARBOR, MICH
11/8

ADV
WED
JM

The Beverly Hills Hotel
9641 SUNSET BOULEVARD
BEVERLY HILLS, CALIFORNIA

James R. Williams (signature)

BILLS ARE PAYABLE WHEN PRESENTED

MEMO		DATE	DESCRIPTION			CHARGES	CREDITS	BALANCE
	1		—					*2,221.19
	2	NOV 26-72	REST'R	—	—	* 2.26		
	3	NOV 26-72	REST'R	—	TIP	* 1.00		*2,224.45
	4	NOV 27-72	REST'R	—	—	* 10.34		
	5	NOV 27-72	REST'R	—	TIP	* 2.00		*2,236.79
	6	NOV 27-72	—	DRUGS	—	* 2.58		
	7	NOV 27-72	REST'R	—	—	* 9.03		
	8	NOV 27-72	REST'R	—	TIP	* 1.50		*2,249.90
	9	NOV 27-72	REST'R	—	—	* 15.65		
	10	NOV 27-72	REST'R	—	TIP	* 3.50		*2,269.05
	11	NOV 27-72	ROOM	—	—	* 40.00		
	12	NOV 27-72	RM.TAX	—	—	* 2.40		*2,311.45
	13							
	14							
	15							
	16							
	17							
	18							
	19							
	20							
	21							
	22							
	23							
	24							

A – LIQUOR B – HERTZ
F – POOL G – POSTAGE

Second receipt (bottom):

272
INCD

POP, MR IGGY
6363 SUNSET BLVD.
LOS ANGELES CALIF.
10/18 DW

ADV
WED

O.K.

The Beverly Hills Hotel
9641 SUNSET BOULEVARD
BEVERLY HILLS, CALIFORNIA

INCIDENTALS ONLY

BILLS ARE PAYABLE WHEN PRESENTED

MEMO		DATE	DESCRIPTION			CHARGES	CREDITS	BALANCE
	1		—					*2,140.57
	2	NOV 25-72	REST'R	—	—	* 7.25		
	3	NOV 25-72	REST'R	—	TIP	* 1.50		*2,149.32
Car & driver service	4	NOV 25-72	—	Pd Out	—	* 28.00		*2,177.32
	5	NOV 25-72	TR.CHG	●●●●	—	* 0.00		*2,177.32
Service + Tip	6	NOV 26-72	—	Pd Out	TIP	* 1.60		*2,178.92
	7	NOV 26-72	L'DIST	—	—	* 0.92		*2,179.84
cab fare to airport mgr	8	NOV 26-72	—	Pd Out	—	* 20.00		*2,199.84
	9	NOV 26-72	—	DRUGS	—	* 0.50		*2,200.34
	10	NOV 26-72	—	MISC.	—	F* 15.00		*2,215.34
	11	NOV 26-72	REST'R	—	—	* 5.93		
	12	NOV 26-72	REST'R	—	TIP	* 1.25		*2,222.52
	13	NOV 26-72	—	Pd Out	TIP	* 2.00		*2,224.52
	14	NOV 26-72	L'DIST	—	—	* 14.58		
	15	NOV 26-72	REST'R	—	—	* 4.36		
	16	NOV 26-72	REST'R	—	TIP	* 1.00		*2,244.46
	17	NOV 26-72	PHONE	●●●●	—	* 0.90		
	18	NOV 26-72	REST'R	●●●●	—	* 15.59		
	19	NOV 26-72	REST'R	●●●●	TIP	* 3.00		*2,263.95
cab	20	NOV 26-72	—	Pd Out	—	* 9.50		
	21	NOV 26-72	REST'R	—	—	* 4.62		
	22	NOV 26-72	REST'R	—	TIP	* 1.00		*2,279.07
	23	NOV 27-72	REST'R	—	—	* 4.20		
	24	NOV 27-72	REST'R	—	TIP	* 1.00		*2,2°'

A – LIQUOR B – HERTZ C – PHARMACY D – POOL RESTAURANT E – REX MEN'S SHOP
F – POOL G – POSTAGE H – CANDY SHOP X – NEWSPAPERS

After finishing the recording of *Raw Power* in London, MainMan put up Iggy and James Williamson at the very expensive Beverly Hills Hotel. They quickly ran up huge bills, and their concerned management moved them to the famous party house on Torreyson Drive. (The charges for 'Drugs' are for items purchased in one of the hotel's shops.)

(357)

H: At the end of the book, when you're bringing the past to the present, Iggy seems quite aware of the band's impact on culture and music. From all the hours you spent with him, what were your impressions of what he thought the Stooges achieved?

J: He's clearly very proud of the Stooges. These guys, from 1967 through 1974, are just hitting barrier after barrier after barrier. From Scott Ashton plowing off the top of their truck, hitting that bridge, that's one of the physical manifestations, but it was just an incredibly unrewarding, uphill battle. In 1974, he finally says, "enough, I can't do this anymore." And they break up as this drug addicted, never successful group who left behind three great records, but they break up to almost total indifference. And twenty-nine years later, I'm at Coachella watching them play to 30,000 people who are going absolutely berserk.

I spent a lot of time thinking about how this happened. Ron and Scott Asheton had been living in Ann Arbor, trying to eke out an existence, and are now suddenly revered rock stars. Iggy, at least, had an upward career trajectory. I can't think of another band that broke up to complete indifference, and nearly thirty years later plays their first reunion gig as conquering heroes—headliners at arguably the most important rock festival in the world.

H: And got to go around the world, receive a hero's welcome every time they hit the stage, get paid and get this roaring affirmation, I can't think of any band who had this happen to them. I saw the Stooges at festivals in Australia, Poland, South Korea, wherever I could and the audiences were always the same. Bonkers.

J: And they were INCREDIBLE, just incredible. It was shocking how good they were.

H: I didn't expect it to be that good.

J: At Coachella, my expectations weren't high, but I thought, "I've got to be here for this thing." And as they're playing, and they're just shockingly great, and the audience is going bananas, this thought crossed my mind that I later mentioned to Iggy—that this was probably the first show they had ever played straight. And Iggy corroborated that. It was such a "does not compute" moment.

And then we're backstage to say hi—Jack White's there, and all the stars of Coachella are lined up to get a moment of face to face time with Iggy. In the arc of their career (and the arc of music history), it was so emotional to see that happen. Having seen the original Stooges once, in as dysfunctional of a show as you could ever imagine—and then thirty years later, to see this incredible triumph was really moving. I can't imagine what it was like for them.

H: The first time I saw them was 2006, which I know is years after they got back together, but I'm on tour a lot. I was in Australia, I was at the Big Day Out Festival, as they were. I'm hours before them, of course. When the Stooges hit the stage, the other bands are watching from the wings. It was like school was in. White Stripes, Beasts of Bourbon, they're all there. Where else would you want to be? The first time I saw the Stooges play, I was watching from stage left, right next to Steve Mackay. I felt something on my face. I had tears running down my face. It was incredibly moving. Just to see Scott back there. The Australians were going crazy. And Ron just played it off. At the end of every show, he took the guitar pic and just kind of flicked it—as if it was so easy, like he can take it or leave it—and just walks off stage. It was so cool.

J: Prior to the reunion, the whole time, Iggy's been making art, getting positive feedback. He might not be selling millions of records, but his catalog is selling, they're starting to use his

songs and Stooges' songs in commercials. He's had three hit albums with Bowie. He's got a stable, solid career. The Ashetons are in Ann Arbor, they've had next to no validation or positive feedback. And halfway through the set at Coachella, I'm thinking every festival in the world is going to be sending them huge offers the next morning. I'm sure they're going to go out on the road, and if they do, Scott and Ron are going to be millionaires. I love what Josh Homme says in the book, "the Stooges have the longest time-release of any band ever. It took thirty-five years for the mainstream to catch on. Iggy goes with the gut, not the brain, and wins in the end." It must have been so life-affirming for Iggy, the guy rolling this boulder up the hill for so many years, to see this kind of validation for his vision, exploding out of 30,000 people. But for Scott and Ron, who had this long stretch with next to nothing happening, it must have been such an incredible mindfuck to get the first real attention of their careers, on that kind of level.

H: They got these beautiful victory laps. And not just one, they got to tour over and over. And everyone loved them. What a great way to finish.

J: Justice.

H: One of the things that you and I talked about is to try to answer, to the best of our abilities, why? Why are we still talking about the Stooges? Why is *Total Chaos* such a compelling read? Why do we put on *Funhouse* and still can't figure out how any band could be that damn good, song after song? Why do those albums still hit as hard as when you first heard them? What is it? Where did this music come from? Why these guys? Was it the isolation of the Midwest? Vietnam? Young people watching their generation die halfway around the world? I have no idea if any of these things had any effect on the band. I've spent a lot of time trying to figure out the ingredients, or the alchemy, and I've got nothing. For me, at least, the Stooges are like the Velvet Underground, where they arrive with something that utilizes guitar, bass, drums, etc. but is completely singular and exclusive to them.

J: I've thought a lot about this and I think alchemy is the right word. The Stooges kind of emerged from the primordial sludge. What are the key ingredients? First and foremost, Iggy's extraordinary intelligence, his drive and laser focus, and his early recognition that he'd never get anywhere doing what everybody else was doing. I've got to give him most of the credit; there was zero chance the Stooges would have happened without him.

I think another key ingredient was Ann Arbor, and in particular, his job at Discount Records. He talks about how people working at the store could play any record they wanted. So, he's hearing Balinese gamelan music; he's hearing Howlin' Wolf and Muddy Waters; he's hearing Harry Partch, (with his handmade instruments) and John Cage. And these people he's working with, everybody's got a specialty; they're all playing something different. I'm listening to Top 40 stations at the time, while he's getting bathed in all these different things. He talks about the booklets inside those Harry Partch Records that show these handmade instruments. So, what he was exposed to was very different from what 99.9% of the other kids thinking, "hey, let's start a band," were exposed to.

And, Ann Arbor is a hotbed of the Avant Garde; Andy Warhol is coming to town with the Exploding Plastic Inevitable and the Velvet Underground; Karlheinz Stockhausen is coming to town, Robert Ashley is there and Iggy meets him. So, Ann Arbor's primordial sludge is different from all but a handful of other places. And Iggy's in the middle of it. I think that's a big deal.

You've also got these different personalities in the band; Ron talks about how he was the weirdo, and Scott was the stoned punk. And Iggy was the guy with drive. Yes, he was a drummer

in a pop band who becomes a drummer in a blues band. But he goes to Chicago and meets Sam Lay, and plays with some of these older, established Black blues musicians. Whereas Jagger and Richards were trying to start an R&B band, and the Beatles were trying to be a pop band, Iggy had been exposed to so many different things, and all these different elements are beginning to coalesce in his mind.

And then the drugs. Ron Richardson, who sort of managed the group, is a licensed drug experimenter at the University of Michigan involved in LSD studies, and seemingly has unfettered access to pure LSD and DMT, to give to the guys. So, they're having a different drug experience than most other young people, getting pure and different stuff. And Ann Arbor real estate is cheap enough that they can rent band houses and create in this kind of hothouse atmosphere.

Ultimately, I think all of this adds up to make the primordial sludge for Iggy and the band different from that of countless other garage bands from the era, The Seeds or The Litter or you name it, who were really just trying to be their own version of the Stones or the Beatles.

H: That makes a lot of sense. Admittedly, I'm looking at the thing from such a long way off, with little information. I have listened to those records I don't know how many times, and they still amaze me. They have all they need and nothing more.

On my limited finances, I tried to listen to as many different kinds of music as I could when I was in Black Flag. I was fascinated by approaches of musicians in different genres. The more I listened, the more I wanted to hear. It's not the worst thing, but frustrating when your appetite far exceeds your wallet's capability. In those days, I was hanging out with Deirdre O'Donohue at KCRW. She turned me on to a lot of music like Harold Budd, Fripp's solo work, Laurie Anderson, and a ton of others. With my pitiful savings, I'm going to Rhino Records. People like Phast Phreddy and other music brainiacs are working there. "Hi, I got eighteen bucks. I'm an idiot but I want to learn about Albert Ayler." Someone suggests _Greenwich Village_, that album; it became my soundtrack. Byron Coley was working there. He would give me the records that were too wrecked to sell. "Here, some records fell out of the back of the store." And I'm so Boy Scout, "what, they fell?" And he says, "We buy them for twenty-five cents. You were asking about Nico and John Cale solo records—having read the _Uptight_ book, here," and he brings me a grocery bag of LPs, Marble Index, Honi Soit, just totally crunched up. I was living at SST, sleeping on the floor, relatively broke and rabidly curious. "Byron, have you ever heard the Marble Index?" And he's like, "Have you ever had water? It's good." I didn't know, I had no budget. I wanted to hear everything. Thankfully, I was around people who made me cassettes or loaned me records and books. I was just inhaling all of this. That was the '80s for me, where I expanded my appreciation of music.

J: You're talking about exactly what happened to Iggy at Discount Records.

H: I had to kind of like, clutch it, and drag it to me. Meanwhile, I'm on tour playing the same twenty-two songs every night.

J: But while everybody around you is only interested in maybe four groups, you, like Iggy, are ravenously curious, saying, "I want all of this stuff." And that's what informs and elevates your career and the multi-dimensionality of it, as opposed to people who are just interested in three or four inputs.

H: Thank you. Let me flip this around on you. You basically said that without Iggy, the Stooges wouldn't have happened. What do you think Iggy would have achieved with other people, without Dave Alexander and the Ashetons?

J: I don't know, I think he would have achieved something really interesting, but it would have been different. The first Stooges album, which I rate very, very highly, is basically one thing—except "We Will Fall." And in the book, Iggy says that they wanted to give Dave a song, and that song came from Dave. So, that's a really simple example of what he brought to the group. Adding a really big color, *Funhouse* is a radical departure, or progression, from the first album. But "We Will Fall,' is a radical departure from all the other songs on the first album. So that's an example of how it would have been different, for sure. But, I think Iggy was the one person without whom the Stooges as we know them couldn't have existed. It would have been different. You see how different it gets when Williamson takes over guitar, and Ron moves to bass.

H: There are few bands who get away without sounding dated, or are allowed to keep moving into future generations, as far as reissues, RSD releases, and overall awareness. The Stooges seem to be with us like carbon. The million-dollar question, Jeff, if you agree, why do you think that is so?

J: First, as I said, it's primordial, the elements were simple, basic, essentialist, and honest. There wasn't any artifice. I read an article about Jobriath the other day—100% artifice—somebody coming up with a concept and trying to execute it to get attention. The Stooges, onstage and on record, were making this simple, basic, honest music. They were completely unprecedented and original. The closest you can get is maybe the Fugs or the Mothers of Invention, in terms of doing something nobody had ever done before.

H: Iggy talks about both those gigs being very instructive

J: Yes, but Zappa was very deliberate, very unspontaneous. And Iggy, I see as the polar opposite of that.

H: He says about the Mothers show: I saw that and realized I've got no excuse.

J: "I gotta up my game." I think, from that point on, Iggy worked very hard to make sure anybody who saw a Stooges show, like it or not, would never forget it. He talks about seeing pictures of the Pharaohs and thinking, "Hey, shirtless—this is a good look." Nobody had ever consistently been shirtless in a band before, nobody had ever worn torn jeans. Silver gloves, glitter, writhing on the ground, taking off all of his clothes, spreading peanut butter on himself. The broken glass, the blood, there was nothing he wouldn't do to get a reaction.

Think about that in the context of other big bands at the time. The Who? Yeah, Pete Townsend would smash his guitar, but that was the climax of the show. Otherwise, it was pretty conventional. Look at the Jefferson Airplane, Crosby, Stills and Nash, Santana the other groups headlining festivals at the time. Some great music, but none were remotely like the Stooges, visually or musically. That "third mind" thing really resonated with me. Simple, but great, memorable songs, easy to sing to yourself, really catchy, filled with big hooks.

And Iggy mentions how important the photos were in spreading the story. Nobody had ever seen a guy writhing around on the ground like that, bleeding profusely, covered in cuts. At the Cincinnati Pop Festival, people were watching TV, seeing this guy walking on top of a crowd, spreading peanut butter on himself. Elektra smartly sent out press photos of those moments. If you were reading rock magazines at the time, they ran articles about this phenomenon. There's a New York Times headline, 'Iggy Pop Has Become the Freak to Watch.' *In the New York Times!* Pictures of a guy smeared in silver hairspray, covered in glitter, writhing on the ground wearing silver gloves. They stood out like a sore thumb. I think that really fed the myth.

5 April 1973

Clive Davis, President
Columbia Records
51 West 52nd Street
New York, New York

RE: Iggy Pop

Dear Clive:

Shortly before his recent Detroit concert it became apparent to me that Iggy
and several of his musicians had made a return to drug dependency.

I endeavoured to give Iggy the opportunity to rectify the situation within
his musicians but he did not choose to do so.

I have, therefore, indicated to him that I do not wish to manage him or deal
further with his affairs and advised him that he is in breach of various agree-
ments subsisting between us including that which concerns his recording activity.

I have dictated this letter immediately before leaving for Japan. I can be
reached at the Imperial Hotel, 1-1, 1-chome, Uchisaiwaicho, Chiyoda-ku, Tokyo,
Japan, phone number 504-1111, and will be back in New York around the 14th of
April.

Sincerely yours,

Tony Defries

TD:acb

cc: Alan Grodin
 David Braun
 Lawrence Myers
 Stevie Phillips
 Iggy Pop

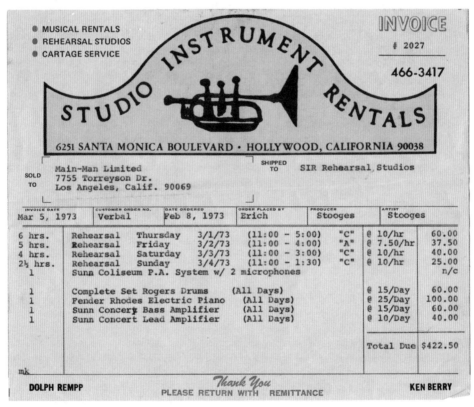

Top: A ticket for a Santa Monica Civic Auditorium Stooges show that never took place, possibly because of MainMan dropping the group. A few weeks after this they played a number of nights at the much smaller Whisky A-Go-Go. **Bottom:** A bill for Stooges rehearsals at Studio Instrument Rentals in Hollywood, three weeks before the *Raw Power* launch concert at Detroit's Ford Auditorium.

And Bowie. You can't underestimate the impact that endorsement had. I'd heard of the Stooges, but never paid attention to them. In 1973, Bowie was my hero; I read that he'd produced *Raw Power* [he actually mixed it], so I went to see the Stooges. He introduced so many people to the Stooges. Then he brought in more people when he toured with Iggy; I went to that show at the Santa Monica Civic; there's David Bowie, the biggest thing since sliced bread, playing piano in Iggy's backing band!

And then punk. The Ramones, The Clash, the Sex Pistols, The Damned, all the biggest punk bands are bowing at the feet of the Stooges and Iggy. The B-side of "Pretty Vacant," is a Stooges song, "No Fun." The first Damned album has a cover of "1970". Johnny Rotten's wearing an Iggy t-shirt. Gaye Advert has an Iggy button. And Iggy became the punk icon. The band, Those Naughty Lumps, released a single called, "Iggy Pop's Jacket!"

H: I love that record; it's one of my "take me to my happy place" songs.

J: And magazines like *Creem and Circus* are running those pictures, over and over again. Iggy crowd surfing, getting throttled, bleeding, licking people's boots. Then, the birth of zine culture, and the various Iggy fan clubs. For what the punks aspired to be, the Stooges were the most punk rock thing imaginable! Iggy was a beacon for them.

Here's something I've thought a lot about. In the punk era, the first two Stooges albums were out of print; occasionally, they'd be reissued in France and you might find them as imports. But *Raw Power* was in print for a long time, and it remained so in England. So, it was available to the punks who were reading about it. Even more so, *Metallic K.O.* was ubiquitous, and that is by far the most punk rock Stooges record, and perhaps the most punk rock record ever. Iggy's baiting the audience, and telling the bikers to keep throwing eggs at him. Those were the easiest Stooges album to find. In the '70s, I was working at Rhino Records in LA. Darby Crash and Jeffrey Lee Pierce used to come in and buy punk singles. They're inspired by the English punk bands, and kind of doing their warped version of that. The English bands are inspired by the Stooges. When you think about it, *Metallic K.O.* really is what Johnny Rotten is trying to be, on some level. It's the most punk record there is, and the easiest to find Stooges record. And it was released in America, so it's cheap. I think that that record being in print, being the quintessential document of just how punk and crazy Iggy was at that time, is a really important reason why the Stooges became legendary.

Dave Grohl does this really nice recitation about the steps on the ladder. The Stooges influenced Joan Jett, she formed the Runaways and they influenced the Germs, the Minutemen, Black Flag, who in turn influenced Nirvana. He lays out how this happened in real time. And finally, Iggy kept making art, kept touring, kept making records, kept doing interviews. His career kept building alongside the myth of the Stooges. And then at Coachella, everything explodes.

H: That's the brass ring. I always wonder about cause and effect because I was in one of those bands that gets written about now. All those things you said, I've never heard anyone put it in one box. But I also think the insulation between the coasts..."we're gonna go to New York. Whoooooah...what's that going to be like?"

J: The first time they went to New York, they'd played I think one show outside of Michigan. That's how insular the scene was. That's my record collector/music historian perspective. Do you have any thoughts, as a musician who was in that scene, about how the influence of the Stooges manifests or grows, the legend?

H: I can only give you my perspective. We would listen to *Metallic KO* before we went on stage. Just to get pumped up, like the audience is gonna do to us what they did to the Stooges, and we would get the bottles. Well, the singer would get the bottles, the chairs. Henry's testicles must be cold, let's warn them with a lighter. That's fun. Oh, there's no ashtray. Let's put the cigarettes out on Henry's leg. I've got these amazing scars. You paid $4 to do that to me? And so *Metallic KO*, that's us. I lost count how many times I went to the hospital in that band. Because of the crowd abuse and the hostility, the Stooges, that's my band, where I know, I feel you man. The Birthday Party, Nick Cave could be very confrontational. Nothing like Iggy. As far as a band versus their audience? Besides the Stooges, I can only think of one. I was in it for five years.

J: It seems less like, "I was inspired musically," and more, "I was inspired, attitude-wise," or, "I was inspired to go out there and do it because these guys had done it." So, is the example of the Stooges or the example of Iggy in the Stooges, the never say die, face the abuse, equally important to you as the music?

H: Yes. It was his ethos of, "don't ever stop." People told me for years, "Man, he just goes on stage, and there's no pain—he pays later." I had my version of that, but nowhere near as severe, of course. I would be playing with an ear infection, because we don't have enough money to get me to the doctor. Dukowski's tuning pegs came off his bass and the stubs went into my arm, it became infected. Now and then, Greg would get sick. Nothing could stop him. You'd have to kill him. Greg plays the entire show with a summer cold, sweating, soaked, goes backstage, vomits into a trash can. "No encore, we're done. Greg, we're done." "No, no, I'm okay." "Greg, you can't stand." "No, no, I'm okay." He goes out and kills it for another twenty minutes. And this is us, you'll have to kill us to stop us. I got that from Greg and Chuck, and from the Stooges and Iggy. I'm listening to bootlegs of *Open Up, Bleed, I Got Nothing, Joanna*, and it made me know that I could never stop. That's why, to this day, Iggy's the man. Total inspiration and instruction.

J: I'm curious, how did you start learning about them? And their incredible work ethic and refusal to back down?

H: Reading the book, *I Need More*. Reading any article I could find.

J: When did you read *I Need More*?

H: When it came out in 1982. I saved my money and bought it. I read it. I read it. I read it. My publishing company reissued it years later. So into that! And I got the work ethic. The oil can, all those early songs like *Big Time Bum*. I want to hear them! And thankfully, through the Easy Action label, I got to hear some of them. Trouser Press had a great thing on *Funhouse*. "There's a song called 'Lost In The Future' that was recorded in the sessions." It pained me that I would never hear it. I'm some guy with my broken tape deck trying to trade tapes with people, like we had like two sticks. "I'm never gonna hear that." And finally, I got to hear it. In those days, you would hear things about him from people who had seen him, or had him play in their venue. At the 688 Club in Atlanta, someone told me, "Yeah, Iggy was here three years ago, he ran up to that horn with the microphone, stuck it in and blew up our system."

When I first heard *Funhouse* all the way through, I was in Black Flag. I was basically told, here are the first two Stooges albums. If you don't get these records, you won't understand this band. I sat alone in the van with our wounded tape deck and listened to the first Stooges album and *Funhouse*. Both albums, back to back. It's like, there's a vacant

spot that I didn't know was vacant. When the albums finished, I was sure that the Stooges were THE band. They're as essential as carbon or water to life, and I'm never going to do anything nearly as memorable. All this turned out to be true. It was the first time I was right as a young person. I'm just going to die trying, not to imitate, but to be that ultimate. And it sounds like it's going to hurt, because that's the realest thing I had ever heard. I was raised on Miles and Chopin because of my mom—killer music and the Sex Pistols and all the cool punk rock stuff later. I was chapter and verse. And I heard the Stooges, and it took all of that and went, "No, no, no, no. There's this. And then there's the rest of your record collection." Bad Brains, UK Subs, the Damned. And then you get a whole other understanding of Black Flag, like how many knobs can we turn off and throw out? How many things can we go without? So it's, we can't be anything but essential, no niceties, cold water, no elevator. So, it can't escape, and we can't escape it. We're going to have to do pull-ups to get everything. And we're going to earn this music. And I think in some ways we did. That was the Chuck-Greg ethos. I thought I knew work from minimum wage jobs, like sixty hours a week. But, Black Flag kicked my ass, and I was in shape. Young. The first six weeks I thought, I was in boot camp. How long are we practicing today? Six hours. That's not possible. We get to the end of six hours. It's like doing push-ups for six hours. Like, what's for dinner? Whatever you're going to shoplift from the Mayfair near the Troubadour. I don't shoplift! Well, then you starve. I would go to Oki Dog and eat off people's plates. You get that hungry, you become okay with other people's food. So, that's the influence, that whole, "and you'll have to kill me, and I'm not afraid." Starvation, or death. But, we're going to do this our way.

In the liner notes I wrote for the 2020 reissue of *Funhouse*, I talked about watching Iggy at Big Day Out, he waves goodbye to the crowd, walks behind the wall of the stage, and drops. Everyone wants to meet him. He's on the ground in a heap and receives people from there, but he can't get up. Henry McGroggan, his manager, is hovering around—Iggy's legless because he left it all on stage. But he's happy to say, "Oh, hey, thank you so much." Midwest, you know. "Thank you for watching. Thank you for enjoying the show." He's, what, fifty-something then? And that's it. That's profound.

BIBLIOGRAPHY

A number of books, magazines and websites dedicated to The Stooges and Iggy Pop exist. They vary in quality, but we consulted and highly recommend the following ones:

BOOKS

Iggy Pop: Open Up and Bleed by Paul Trynka; Broadway Books, 2007
Iggy Pop: The Wild One by Per Nilsen and Dorothy Sherman; Omnibus Press, 1988
I Need More by Iggy Pop and Ann Wehrer, Karz-Cohl Publishing, 1980
The Stooges: The Authorized and Illustrated Story by Robert Matheu; Abrams, 2009

WEBSITES

The Stooges Forum, particularly the gig list compiled by Jim Lahde and Per Nilsen, with help from Natalie Schlossberg:
http://stoogesforum.freeforumboard.net/t583-stooges-gig-list

Bruno Ceriotti's Stooges' Family Tree site:
http://rockprosopography102.blogspot.com/2010/03/stooges-performance-list-1967-1974.html

The Iggy Fan Homepage:
http://goto.glocalnet.net/iggy-fanpage/

Wikipedia's pages on The Stooges, Iggy Pop, The Prime Movers, and various members of The Stooges

And for information on the Prime Movers, Bruno Ceriotti's excellent site:
http://brunoceriotti.weebly.com/the-prime-movers.html

CREDITS

For Third Man Books: Chet Weise

Art Direction & Design by Nathanio Strimpopulos

Layout by Amin Qutteineh

Interview transcriptions by Dillon Watson and Kim Baugh. Joan Jett interview transcribed by Cleo Gold.

Photo Liason: Robert Matheu

Cover photograph by Dustin Pittman

Inside cover photograph by Ron Sobol

ACKNOWLEDGEMENTS

Special thanks to:

Iggy Pop. You are a hero to pretty much everyone involved with this book. It's been a great pleasure in every way.

Johan Kugelberg, who came up with the idea, made the Iggy interview all the more fun, and contributed so many great things from his collection.

Jon Savage, who came through as always, and was a superb consigliere in bringing this concept to reality.

Chet Weise, who had the vision to make a deal for this book, and provided invaluable help and support at every stage.

Ben Blackwell, a Stooges fan and collector par excellence, and irreplacable co-conspirator on this project.

Nat Strimpopulos, who designed a beautiful book, and was a pleasure throughout.

Mark Goldstein, a friend and trusted advisor.

With love to Robert Matheu (1955-2018). "He was kind of an extra Stooge. I dunno, the fifth Stooge, the seventh Stooge? The ninth Stooge?" - Iggy Pop

Rosemary Carroll, Spencer Weisberg and Henry McGroggan, who represent Iggy with aplomb. I couldn't have done it without you.

Kind thanks to Dave Grohl, Josh Homme, Joan Jett, Johnny Marr and Jack White for sharing your insights.

Thank you Henry Rollins, for your friendship and Stooges Superfandom.

Lee & Whitney Kaplan, for always being there.

Thanks also to:

Steve Ades, Bill Allerton, Mark Arevalo, Jeff Ayeroff, Colin Baker, Steven Baker, Leee Childers, Steve Bober, Jack Bodnar, Lorrie Boola, John Brett, Beverly Brown, Ed Caraeff, Bruno Ceriotti, Larry Clemens, Bryon Coley, Art Collins RIP, Nikki Collins, Zach Cowie, CREEM, Richard Creamer, Jim Edwards, Michael Erlewine, Stacy Fass, Danny Fields, Richard Foos, Getty Images, Gil Friesen RIP, Ken Gold, The Gold Family, Lisa Gottlieb, Gary Greenberg, Lenny Kaye, Jac Holzman, Peter Hujar Archive—Pace/MacGill Gallery, New York and Fraenkel Gallery, San Francisco, Robin Hurley, Gary Johnson, Anastasia Karel, Lenny Kaye, Howie Klein, Barbara Kramer, Howard Kramer, Kenny Laguna, Andy Leach, Pat Magnarella, Johnny Marr, Gillian McCain, Grant McKinnon, Guapo Meyer, Richard Morton Jack, Jim Northrup, Barry Ollman, Caitlin Parker, Rupert Picken, Dustin Pittman, Julie Rader, Mick Rock, Bob Say, Natalie Schlossman, Erin Schneider, Gene Sculatti, Sara Sigman, John Silva, Ron Sobol, Gary Stewart, Mike Storeim, Ben Swank, David Swartz, Don Swickerath, Paul Trynka, Bryan Ray Turcotte, Gregg Turner, David Weinhart, Chet Weise, Geoffrey Weiss, Kristen Welsh, Laura Woolley and anyone I forgot—sorry.

BIOGRAPHY

Jeff Gold is a music historian, author, former record label executive, and Grammy Award winner. He has been profiled by *Rolling Stone* as one of the five "top collectors of high-end music memorabilia."

As Executive Vice President/General Manager of Warner Bros. Records and a VP at A&M Records, Gold worked with Iggy Pop, Prince, R.E.M., The Red Hot Chili Peppers, The Police, and Cat Stevens. A four-time Grammy nominated Art Director, he won the 1990 Best Album Package Grammy for Suzanne Vega's *Days of Open Hand*.

Gold has consulted for the Rock & Roll Hall of Fame and the Experience Music Project, and appeared as an expert on PBS' *History Detectives*. Gold and colleague Laura Woolley also appraised *The Bob Dylan Archive* now housed at the University of Tulsa. His discovery of previously undocumented tapes has led to major label releases including *Bob Dylan in Concert at Brandeis University 1963*.

Gold's 2012 book *101 Essential Rock Records: The Golden Age of Vinyl, From The Beatles to the Sex Pistols* was one of eight books chosen by *Rolling Stone* as "the year's best reading material."

All Music Books called his 2020 book *Sittin' In: Jazz Clubs of the 1940s and 1950s* "Astonishing and revelatory."

Gold owns music collectibles website Recordmecca and writes about topics of interest to collectors on its blog.